1
PREVIEW

Every photograph you take is a trial solution of four problems: *technical, equipment, technique, artistic*.

Your photo is a trial solution because it may not work and because there are other possible approaches. When one answer must fit four problems simultaneously, the answer is usually not simple and obvious—part of the fun and interest of photography and part of its challenge.

Technical problems relate to films, exposure, light, optics and similar matters. All can usually be solved by application of basic ideas and principles. Formulas, charts and tables supply many of the answers.

Equipment solves most technical problems of photography if a solution is possible. This book is based on the understanding that you plan to use Canon equipment, which is a good choice.

Technique is how you use the equipment. It can be something very simple and general such as not shaking the camera while taking a picture. Or, it can be more challenging: An interesting exposure problem in difficult lighting is one example.

Artistic aspects of photography relate to your intentions regarding the message of the photo and its effect on a viewer. It involves creativity or craft in arranging the elements of a picture and blending the technical factors, equipment and technique to get the result you want. Because the artistic ingredient is based on what you want, nobody can tell you exactly how to do it.

A more modest goal of this book is to give you mastery of the basic technical facts of photography with a thorough understanding of Canon equipment and the technique of using it effectively. This will help you take good pictures, meaning you have control over every controllable thing.

Having control and using it effectively are, of course, two different things. In many picture-taking situations, visualization of the desired end result helps in two ways. When you have a preconception of the photo you intend to make, you are much more likely to make a composition and arrhange the lighting so the end result is effective. If you can "see" the complete image in your mind, you are less likely to overlook major or minor things that are part of that image.

A second form of visualization is to "see" in your mind the end result of technical factors and control settings. The world looks different through a wide-angle lens, or a telephoto lens, and so do photos.

When you can visualize the result of using different lenses, shutter speeds, focus settings and camera angles before you make the exposure, you are well on the way to using the technical camera controls in a satisfying and creative way.

This book is both a buyer's guide and a user's guide to Canon equipment. If you are shopping for a camera or accessories, the information about Canon hardware and how to use it culminates in complete specifications in Chapter 18.

The science of photography is only a means to an end. When you set camera controls to get a desired result, the accomplishment is not in setting the controls that way. It is the picture.

Fundamentally, this is not a book about Canon equipment. It is a book about how to take pictures with Canon equipment. I think the distinction is important.

2
THE CAMERAS

Canon 35mm SLR cameras are available in three series: A, F and T. This chapter shows photos of the camera models that are included in this book, with a brief description of each model. The remainder of the book discusses how SLR cameras work, how to use them, and presents the camera models shown here in greater detail.

For many years, the Canon SLR designed for professional use has been designated the F-1. A new version of the F-1 was introduced in 1981, advertised as the New F-1. This book discusses the New F-1.

More than one model is available in each of the A and T series. Each model offers a different range of features and capabilities. This book will serve as a guide to help you select and use the model best suited to your preferences.

The T70 is both versatile and easy to use. You simply focus and press the shutter button. An LCD display on top of the camera and an LED display in the viewfinder guide you through all camera operations. There's automatic film loading and automatic film-advance and rewind. The camera has three automatic "programs". This means that the camera will do most of the "thinking" for you. There is manual exposure control for those situations where you want to take charge. The T70 can make fully automatic flash exposures, using a Canon flash unit.

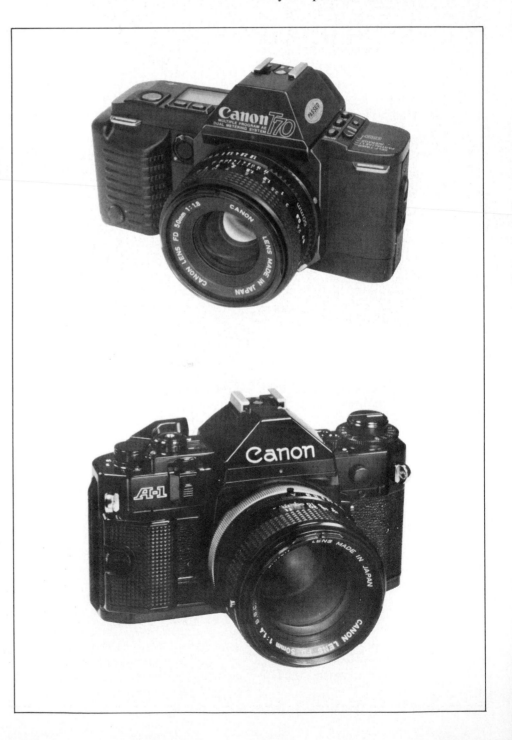

The Canon A-1 is versatile and technically advanced. It sets exposure for you, automatically, in *five different* ways or modes of operation. Or, you can switch it to non-automatic and set exposure yourself—which is called *manual* exposure control. The A-1 can use a motor drive or power winder to advance film. It can use any of the wide range of Canon flash units, interchangeable lenses and many other accessories so you can set up the camera for virtually any kind of photography. Even though it seems complicated at first, by the time you reach the detailed description of the A-1 in Chapter 18, you'll understand all of its advanced features and its versatility.

EXPOSURE— THE BASIC TECHNICAL PROBLEM

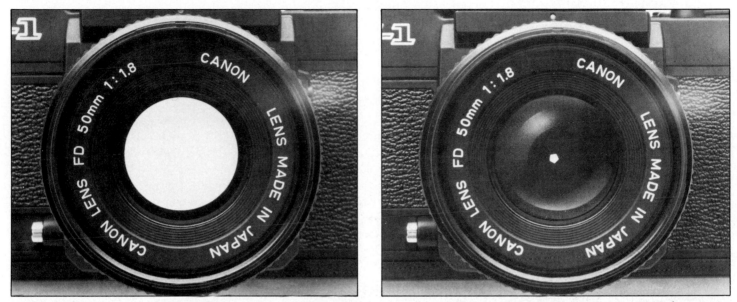

Inside each Canon lens is an adjustable *aperture*, sometimes called a *diaphragm*, which controls the amount of light passing through the lens. At left, aperture is wide open and admits a lot of light to the film. At right, aperture has been changed to a very small opening.

Everything about a camera serves in one way or another to get proper exposure of light onto the film. The camera body excludes stray light or leaks that can affect the film. The lens admits light from the subject being photographed.

One control setting of lenses, called *f*-number or *f*-stop, is an indication of how much light the lens collects and relays to the film surface. Smaller *f*-numbers allow more light to pass through the lens.

This is done by an opening inside the lens that can be made larger or smaller. This adjustable opening is called the lens *aperture*. You change the size of the aperture by turning a control ring on the outside of the lens unless you are using a camera that controls aperture size automatically.

The effect of light on negative film is to create a record of the light pattern in the light-sensitive layer, called *emulsion*, coated onto a clear base.

Normally there is no visible change in the film due to exposure until the image is made visible by a chemical procedure called *development*.

Exposure of film to cause an image after development is not just a matter of how bright the

The simplest film structure is a light-sensitive layer of emulsion supported by a film base. Most films are more complex than this. Color film, for instance, has three layers of emulsion—each sensitive to a different color.

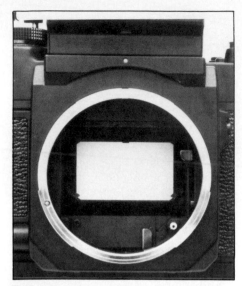

This camera has the lens removed so you can see into the camera. In this photo you see the mirror, which is in the down position where it reflects the image upward into the camera viewing system. This is described in the next chapter. Behind the mirror is the shutter, which is closed to prevent light from reaching the film.

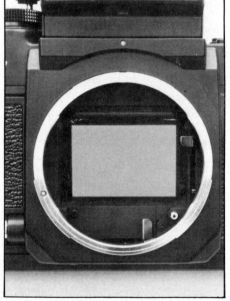

To make an exposure, the mirror moves up out of the way. Then the shutter opens so light from the lens can reach the film, as you see here. The size and shape of the image on film is determined by the rectangular "window" that admits light to the film. When the correct length of time has passed, the shutter closes again.

light on the film is. Exposure is determined both by *how bright* the light is and *how long* it is allowed to fall on the film.

The length of time light is allowed to fall on the emulsion is measured in seconds or fractions of a second. It is controlled by a *shutter* inside the camera body, just in front of the film.

The shutter opens to allow light to expose the film. After the desired length of time, it closes again to end the exposure.

RECIPROCITY LAW

The amount of exposure can be expressed by a simple formula that is a basic fact of photography:

$$Exposure = Illumination \times Time$$

Illumination means the brightness of the light that falls on the film. *Time* is the length of time the shutter is open.

This formula is often written in abbreviated form as: $E = I \times T$, where the letters stand for the words given above. This is called the *reciprocity law*.

To get a certain amount of exposure on the film, no particular amount of light is required and no particular length of time is required. The requirement is that the amount of light multiplied by the length of time must equal the desired exposure.

This means you can use less light and more time, or the reverse. When there is not much light, you expose for a longer time so the product of the two values is the desired exposure.

In practical photography it is customary to control both illumination and time by controls on the camera. When either illumination or time is changed by a full step, the camera will either double the value or cut it in half.

This leads a basic rule for changing exposure controls without changing total exposure: If you double the amount of light on the film, cut exposure time to half. If you double exposure time, cut the amount of light in half. This is the essence of the reciprocity law.

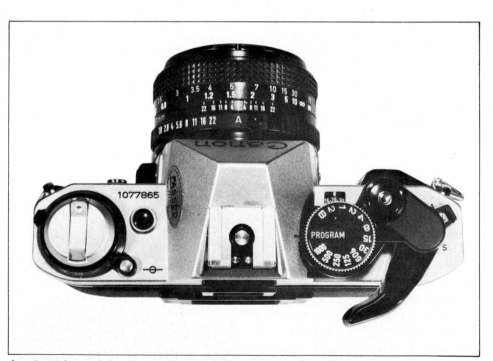

Aperture size and shutter speed are exposure controls. You select aperture size by turning the Aperture Ring on the lens—the ring nearest the camera body—to one of the numbered settings. Some automatic cameras can set aperture for you. To prepare the lens for this mode, set the ring to A as shown here. You select shutter speed by setting the dial on top of the camera to one of the numbers, or B. Some models can set shutter speed automatically. To select this mode, use a special setting of the dial. This dial is set to PROGRAM.

HOW FILM REACTS TO EXPOSURE

This discussion of how film responds to exposure applies to any kind of film, color or black and white (b&w). It is simpler to describe and understand when related to b&w film, but the same basic ideas also apply to color film.

If negative film is not exposed at all, but put through development anyway, it will be clear. Not perfectly clear, but practically clear.

Increasing exposure causes b&w film to become increasingly dark when it is developed. It will change from light gray to medium gray to black. There is a limit to how black it can get, just as there is a limit to how clear it can be.

It is convenient to change exposure in a series of definite steps and then observe the amount of darkening that results at each step. The technical word for darkening of the film is *density*.

There's another reason to consider exposure and density as a series of step-increases: We can relate these steps to what the human eye can see and the brain can respond to. There's not much point in getting involved with density changes that nobody can see anyway.

All human senses, including vision, operate in a way that's surprising when you first learn of it. Suppose you are looking at a source of light such as a light bulb. It is making a certain amount of light and it gives you a certain sensation or mental awareness of brightness. Assume the *amount* of light coming from the source is *doubled*. It will look brighter to you. Not twice as bright, but you will notice a definite change.

To make another increase in brightness that you will interpret as the *same amount* of change, the amount of light must be *doubled again*. Successive increases in brightness that all appear to be equal changes must be obtained by doubling the actual amount of light and continuing to double each value to get the next higher

step. This is a fact about the way we see and therefore tells us what must be done on film to make *equal steps* of brightness to a viewer of the film.

In photography, we don't worry much about numerical differences between light values or time values. We pay attention to *steps*, defining a step as either double or half of the preceding value, depending on whether we want a step-increase or a step-decrease.

Shown below is a test made by exposing each frame at a different exposure, doubling the exposure each time. The subject is a white piece of paper.

The result shows how film behaves over a wide range of different exposures that were made in orderly steps for convenience. You can see that the negative reaches a point where it doesn't get any blacker even with more exposure. It also reaches a point where it doesn't get clearer with less exposure.

These two limits of the film—maximum black and maximum clear—are practical limitations in photography. Normally, you try to fit the different brightnesses or *tones* of a scene into the range of densities the film can produce.

This is done by adjusting the

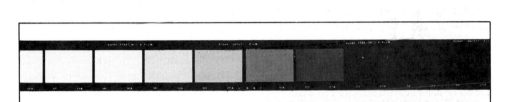

Black-and-white photographic materials record shades of gray, ranging from white to black, according to the amount of exposure received. On negative film, "white" areas are clear. When the amount of exposure is doubled, that is one standard step-increase. In this test, using standard steps, increased exposure causes negative film to become darker until a point is reached where additional exposure has no effect. Similarly, reduced exposure makes the film less dense until it finally becomes as white (clear) as it's going to get. Real-world scenes can produce any amount of exposure within this range whether the amount of exposure is a standard step-value or not.

In this real-world scene, you can see many shades of gray, from white to black.

camera controls with a rather simple idea in mind. The film can produce a range of different densities between maximum and minimum. One of these densities on the film is the middle one. The scene you are photographing also has a range of brightnesses or tones that are going to be transformed into densities on the film. One tone in the scene is the middle one.

If you arrange exposure so the middle tone of an average scene is transformed into the middle density on the film, exposure is just right. When the negative is made into a print, lighter tones of the scene use lighter densities on the print—above the middle value. Darker tones of the scene use the darker densities of the print.

The only technical problem that can result from exposing film this way is if the brightness range of the scene exceeds the density range of the film. In that case, the film doesn't have enough different densities to match the different brightnesses of the scene. That can happen when part of a scene is in bright light or sunlight and another part is in shadow.

Usually, if you align the middle tone of the scene with the middle density of the film, the scene "fits" the density range of the film. You do this by controlling exposure on the film.

CONTROL OF EXPOSURE

Getting a desired exposure on the film depends basically on three things:

The amount of exposure the film needs—it varies from one type of film to another.

The amount of light reflected toward the camera by the scene or subject.

The settings of the camera exposure controls.

Film Speed—Film manufacturers publish numbers called Film Speed, a way of stating the amount of exposure needed by each film type.

Film speed is a number such as 25 or 400. Higher speed numbers mean the film is more sensitive to

light and requires less exposure. Doubling the film-speed number means it requires half as much exposure.

The standard series of film-speed numbers is 12, 25, 50, 100, 200, 400, and so on. It can be extended in either direction by doubling or halving the numbers.

Canon cameras have a film-speed control on the camera body that you use to set in the film-speed number of the film you are using. This sets the camera to give correct exposure to that film.

DX Coding—Most film cartridges have a checkerboard pattern called DX coding. It conveys film speed, number of exposures in the cartridge and other information to a camera that is equipped to read the DX coding, such as the T90.

The coding is read by electrical contacts inside the camera and film speed is then set automatically. If you are using film without DX coding, or if you prefer to use a different film-speed setting, you can set the speed manually.

Amount of Light from the Scene—After film speed is set into the camera, the next essential is to measure the amount of light reflected by the scene. Canon cameras do this automatically, inside the camera. They measure light that has come *Through The Lens*. This is sometimes called *TTL* metering.

Exposure Controls—With film speed dialed into the camera, and the amount of light coming through the lens measured inside the camera, the camera itself can now figure the correct settings for the exposure controls. It indicates the correct settings on a display in the viewfinder as you adjust the camera controls. Or, a camera set for automatic operation will control exposure for you.

One exposure control is lens-aperture size, adjusted by turning the aperture control ring on the lens. This ring is marked in *f-numbers* and each *f*-number represents an aperture size.

The other exposure control is shutter speed or exposure time, set by a dial on top of the camera.

Film is labeled to show its film speed, both on the carton and on the film cartridge inside the carton.

These two exposure controls are used together to arrive at a pair of settings that produces the desired exposure. Several pairs of settings can produce the same amount of exposure.

There is an advantage to having several pairs of *f*-numbers and shutter speeds available to make the same exposure on the film. In addition to setting exposure, these controls have other effects on the picture. For example, at slow shutter speeds, meaning long exposure time, subjects in motion can be blurred on the film.

Based on these side-effects of the two exposure controls, the photographer makes settings and shoots the picture. The side-effects are discussed in more detail later.

f-NUMBERS														
1		1.4	2		2.8	4		5.6	8		11	16	22	32
	1.2		1.8	2.5		3.5	4.5		6.7	9.5		13	19	27

Figure 3-1/The top row shows the standard series of *f*-numbers in full steps. To write this series, start with *f*-1 and *f*-1.4, then double them alternately. In other words, 2 is double 1; 2.8 is double 1.4; 4 is double 2; and so forth. Intermediate half-steps are shown on the bottom row. For example, *f*-2.5 is halfway between *f*-2 and *f*-2.8.

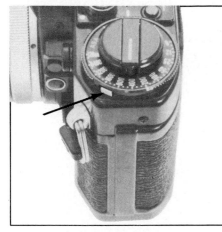

To set film speed on an A-1 camera, depress the ASA Lock Button with your fingernail while turning the ASA Film-Speed Scale to the desired number. Film-speed range is 6 to 12800. This camera is set for ASA 200.

THE *f*-NUMBER SERIES

Aperture size is indicated by a standard series of *f*-numbers on the control ring. It is useful and practically necessary to memorize the series, but it is easy to do. See Figure 3-1.

Larger *f*-numbers mean smaller lens openings—another fact you should remember.

The series of *f*-numbers is chosen so the *area* of the opening is doubled with each full *f*-number step-increase, such as from *f*-4 to *f*-2.8. Because the area of the opening doubles, twice as much light passes through. Changing the lens aperture setting in the other direction, such as from *f*-11 to *f*-16, reduces the light to one-half.

Notice that there is an approximation between 5.6 and 11 so that 11 is not exactly double 5.6, but it is close enough and easier to remember.

The *f*-numbers are often called *f*-stops. Changing the *f*-number setting of a lens to allow less light on the film is called *stopping down*.

Changing from *f*-22 to *f*-16, the nearest larger opening, is a change of one stop. Earlier I defined doubling the amount of light as an exposure change of one *step*. The words *step* and *stop* mean the same thing in photography. I prefer to use *step* to mean doubling or halving exposure. International standards for the photographic industry use *step* rather than *stop*. Popular literature and most books cling to *stop,* and we will probably never eliminate it from our vocabularies.

The ASA method of stating film speed was developed in the United States. The DIN system was developed in Germany. They are two different ways of giving the same information about film. In the ASA system, each step is *double* the next lower value. In the DIN system, the steps mean the same thing, but are obtained by *adding* 3 units to get the next higher number.

With either system, higher speed numbers mean the film is more sensitive and, therefore, requires less exposure. The ISO system combines ASA and DIN.

Recent camera models use ISO to refer to film-speed settings. The actual setting is the first of the two numbers used in an ISO rating—which is the same as the ASA method of stating film speed. In other words, ISO 400/27° is the same as ASA 400.

FILM SPEED RATING

ASA	DIN	ISO
12	12	12/12°
25	15	25/15°
50	18	50/18°
100	21	100/21°
125	22	125/22°
160	23	160/23°
200	24	200/24°
400	27	400/27°
800	30	800/30°
1600	33	1600/33°
3200	36	3200/36°

FILM SPEED

6			12			25			50			100			200			400			800			1600			3200			6400			12800
	(8)	(10)		(16)	(20)		(32)	(40)		(64)	(80)		(125)	(160)		(250)	(320)		(500)	(650)		(1000)	(1250)		(2000)	(2500)		(4000)	(5000)		(8000)	(10000)	

Standard film speeds in full steps are shown on the top row. Film with a speed of 25 requires twice as much exposure as film with a speed of 50. Intermediate film speeds in 1/3 steps are on the bottom row. Film with a speed rating of 64 is 1/3 step "faster" than film with a speed of 50.

Setting the Aperture Ring—The aperture ring has click-stops, or *detents,* at full *f*-stops along its range. Halfway between marked detents are unmarked detents that are half-steps. The detent between *f*-4 and *f*-5.6, for example, is a half-step higher than *f*-4 and a half-step lower than *f*-5.6.

When you choose an aperture setting by turning the lens aperture ring, you can set any value—including between detents, if you wish.

SHUTTER SPEED

Shutter speeds also change in standard steps so each longer time is double the preceding step (see Figure 3-2). For simplicity, there are some approximations. For example, 1/60 is not exactly twice as long as 1/125.

Intermediate Steps—When you select shutter speed manually, most camera models allow using only the standard steps such as 125 or 250. The T90 allows manual selection of intermediate shutter speeds in half steps. For example, a shutter speed of 180 is available between 125 and 250.

Stepless Shutter Speeds—When the camera is set to an automatic-exposure mode, it may choose a shutter speed automatically. If so, it is not limited to the standard steps and half-steps. It can use any shutter speed, such as 1/323 second, to provide correct exposure. This is called *stepless* operation. When the camera is setting shutter speed automatically and steplessly, the nearest half-step is displayed.

The B Setting—Just beyond the slowest numbered shutter-speed setting is a B symbol, which stands for *Bulb.* In the old days, shutters were operated by air pressure from a rubber bulb and the shutter remained open as long as you squeezed the bulb. When set to B, the shutter will remain open as long as you hold the shutter button depressed.

Time Exposures—The shutter can be controlled remotely by a control on the end of a cable. A-

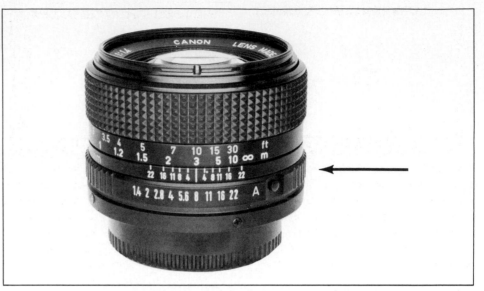

The aperture ring (arrow) rotates to set aperture size manually. This lens has a maximum aperture of *f*-1.4 and a minimum aperture of *f*-22. The aperture setting is read against an adjacent index mark. This lens is set at *f*-8. The letter A and the adjacent pushbutton are used to set the lens on automatic, so the camera can set lens aperture size automatically. The lens is focused by turning the knurled ring near the front.

SHUTTER SPEEDS

1000	500	250	125	60	30	15	8	4	2	1"	2"	4"
	750	350	180	90	45	20	10	6	3	0.7"	1.5"	3"

Figure 3-2/Shutter-speed values represent exposure time in seconds. Except where full seconds are indicated by the symbol ", these are fractions. 1000 means 1/1000 second, 500 means 1/500 second, and so forth.

The standard series of shutter speeds in full steps is shown in the top row. Each standard step is twice as long, or half as long, as the adjacent values. For example, 250 is twice as long as 500 but half as long as 125.

Intermediate shutter speeds, in half steps, are shown along the bottom row. For example 750 is halfway between 1000 and 500.

series cameras and the F-1 use a mechanical cable release that screws into the top of the shutter button. T-series cameras use an electrical cable with a switch, called a *Remote Switch,* that screws into a connector on the camera body. With the camera on B, either type of cable can be locked to hold the shutter open for long time exposures.

In the T70 viewfinder, the M symbol indicates that the camera is set for manual exposure control. P indicates that one of the programmed automatic modes has been selected. The red asterisk glows when you have chosen selective-area metering to get good exposure of non-average scenes. The number at the bottom normally indicates lens aperture. This viewfinder display is supplemented by the LCD display on the camera top.

The T50 viewfinder display has only three symbols. M is a warning that the lens is set incorrectly. The P symbol glows steadily when it is OK to shoot. The "lightning" symbol is used with flash. This camera sets both aperture and shutter speed automatically.

Glowing LEDs in the AE-1 PROGRAM give you status and exposure information. M means manual—you set both shutter speed and aperture. P means the camera Is set for programmed exposure—it sets both shutter speed and aperture automatically. On automatic, the shutter speed number you select glows and the camera chooses the correct aperture. The flash symbol at the bottom works with Canon flash units as described later.

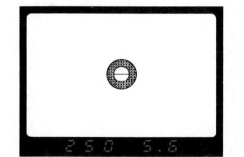

The exposure display in the A-1 is below the image area. It uses glowing red "computer" letters and numbers. The number at the left is shutter speed. At the right is the lens aperture setting. Exposure will be correct for an average scene unless the display gives you a warning by flashing one or both of the numbers.

In one of the F-1 automatic modes, you set shutter speed and the camera sets aperture automatically. Shutter speed appears in a window at lower right. The exposure display uses a single moving needle to show the aperture size selected by the camera. Over- or underexposure is indicated if the needle moves into a red zone.

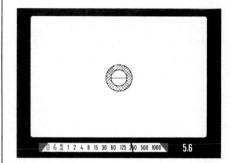

You can also set the F-1 so it chooses shutter speed after you set aperture. The display appears below the image area. Aperture size appears in a window at the right. A moving needle shows the shutter speed selected by the camera. Over- or underexposure is indicated if the needle moves into a red zone.

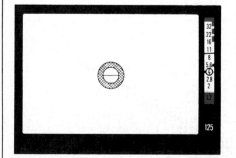

The F-1 display for manual exposure control uses two needles in a *match-needle* display. As you adjust the exposure controls, both needles move. When the plain *meter needle* passes through the center of the circle on the end of the *aperture needle*, exposure is correct for an average scene. Over- or underexposure is indicated when the meter needle enters a red zone.

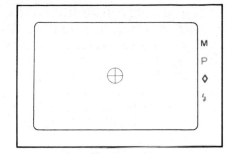

The T80 provides automatic exposure and automatic focus, using Canon AC-type lenses. An audible beeper indicates good focus. If the P symbol glows steadily, automatic exposure is working and it's OK to shoot. The M symbol means that exposure must be controlled manually. The diamond symbol is a warning, discussed in Chapter 18. The arrow symbol is used with flash.

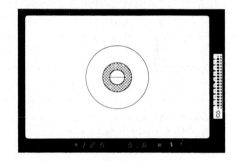

In the T90 viewfinder display, the shutter speed and aperture to be used—such as 125 and 5.6—are shown at the bottom. The M symbol means that exposure is controlled manually rather than automatically. The green arrow is used with flash. The other symbols are discussed in Chapter 18.

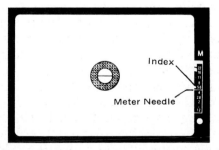

The AE-1 uses a moving needle to show aperture size selected automatically by the camera, after you choose shutter speed. On manual operation, the needle shows the aperture setting the camera "thinks" you should use, but you can set the aperture at any size because you are controlling exposure yourself.

13

4
HOW A SINGLE-LENS-REFLEX CAMERA WORKS

The main feature of a single-lens-reflex (SLR) camera that distinguishes it from other types is: You view and focus through the same lens used to cast the image onto the film. This has several important advantages.

The word *reflex* is a form of the word reflection and indicates that the image you see in the viewfinder is bounced off a mirror in the optical path between the lens and your eye.

Single-lens-reflex cameras are designed as shown in Figure 4-1. The lens captures light from the subject being photographed. A focusing control moves the lens closer to or farther away from the film.

To view, a mirror is moved to the "down" position to intercept light traveling from the lens toward the film. This intercepted light is bounced upward by the mirror to a focusing screen and then through a special prism, called a *pentaprism,* to a viewing window where you can see what is coming in through the lens. You get the same view the film will get when you take the picture.

The pentaprism not only reflects the light rays internally so they come out the viewing window, it also causes the image you see to be correctly oriented—top to bottom and left to right. Like wealth, it's easy not to appreciate the benefit of correct viewing until you have to do without it.

The focusing screen, is just below the pentaprism. The camera

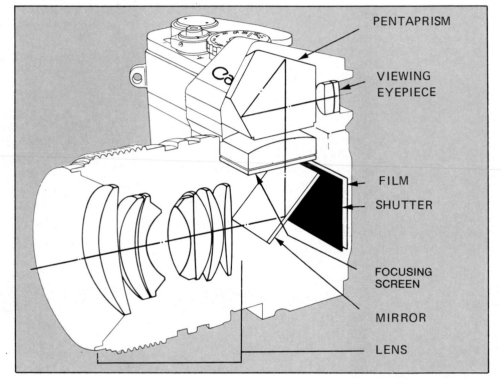

PENTAPRISM

VIEWING EYEPIECE

FILM

SHUTTER

FOCUSING SCREEN

MIRROR

LENS

Figure 4-1/When viewing the scene in an SLR viewfinder, light from the scene travels through the lens to the mirror, which is in the down position. Then it bounces straight up from the mirror due to reflection. Above the mirror is the *focusing screen.* This screen intercepts the light rays and forms the image that you see when looking in the viewing eyepiece. Above the focusing screen is a *field lens* that makes the image uniformly bright. Multiple bounces in the *pentaprism* produce an upright and correctly oriented image.

is built so the distance from lens to focusing screen by way of the mirror is the same as the distance from lens to the film in the back of the camera. Therefore, if the image is in focus as you see it on the focusing screen, it will later be in focus on the film when the mirror is moved out of the way to take a picture.

A convenient way to think about it is this: You look through

the pentaprism to examine the focusing screen, which is showing you the image that will fall on the film when you trip the shutter. If you like what you see, squeeze the shutter button and several things happen very quickly:

The mirror moves up out of the way. As it swings up to its parking place, you lose your view of the image. When the mirror is out of the way, the *focal-plane shutter* in

While viewing and composing the picture, lens aperture is wide open, shutter is closed, mirror is down. Dark rectangle represents closed shutter. Depress the shutter button and . . .

Mirror moves up so light can travel from lens to film . . .

Lens aperture closes to selected aperture size for correct exposure, *then* shutter opens for selected length of time . . .

Then shutter closes and lens aperture returns to wide open so you can view again with maximum scene brightness and . . .

Instant-return mirror swings to down position, ready for next shot. Operate the Film-advance lever to bring the next frame of film into shooting position.

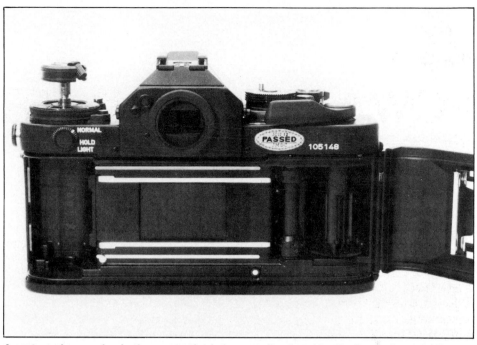

A rectangular opening in the camera body is normally closed by the focal-plane shutter, as shown here. The film cartridge fits in the cavity at left. Film travels behind the opening to the takeup spool at right. To expose each frame, the focal-plane shutter opens and then closes.

front of the film is opened so light from the lens falls on the film. When the desired amount of time has passed, the shutter closes.

The mirror then automatically swings back down to the viewing position. Even though you lose sight of the scene while the film is being exposed, this time is usually brief and you quickly learn to ignore the "blackout." It's as if the camera "blinked."

The camera mechanism also lets you view the scene through the widest possible lens aperture for maximum scene brightness in the viewfinder. When you press the shutter button, the camera automatically closes lens aperture to the *f*-stop you previously selected to make the exposure. For example, if *f*-11 is required for correct exposure, the lens will automatically close down to *f*-11 after you depress the shutter button but before the shutter opens.

With an image on one frame of the film, use the film-advance lever to move the next frame of film into position for the next exposure. This prepares the camera mechanism for the next exposure.

Canon SLRs have a focusing screen below the pentaprism. With some models, focusing screens are interchangeable so you can use different types. This is an F-1 with the viewfinder removed and the focusing screen lifted partially out of its seat, so you can see it.

15

5
HOW A FOCAL-PLANE SHUTTER WORKS

Focal-plane shutters are mounted in the camera body very close to the surface of the film. Focal-plane shutters are virtually standard on SLR cameras, including all Canon SLRs.

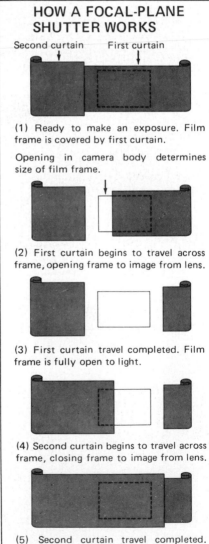

HOW A FOCAL-PLANE SHUTTER WORKS

Second curtain First curtain

(1) Ready to make an exposure. Film frame is covered by first curtain.

Opening in camera body determines size of film frame.

(2) First curtain begins to travel across frame, opening frame to image from lens.

(3) First curtain travel completed. Film frame is fully open to light.

(4) Second curtain begins to travel across frame, closing frame to image from lens.

(5) Second curtain travel completed. Film frame covered by second curtain. Exposure completed. Advancing film to next frame resets shutter to (1) ready to make another exposure.

The basic idea is illustrated in Figure 5-1. Two opaque curtains are mounted on rollers. Normally, the first curtain is positioned so it covers up the surface of the film and does not allow light to reach it.

To make an exposure, the first curtain travels from one roller to the other. The first curtain moves across the film frame and stops at a location that leaves the frame open to receive light from the lens.

When the desired time of exposure is ended, the second curtain is released. The second curtain moves from roller to roller and covers the film frame, which ends the exposure.

Exposure time is measured from release of the first curtain to release of the second curtain. For a relatively long exposure time, such as one second, the first curtain has time to reach the end of its travel before the second curtain starts to move. There is a period when neither curtain is moving and the entire film frame is uncovered and exposed to light from the lens.

Figure 5-1/This drawing shows operation of a two-curtain focal-plane shutter which travels horizontally. When exposure time begins, the first curtain is released to start its travel. As it moves, the first curtain passes across the film frame, allowing light to fall on the film. When the first curtain has completed its travel, the frame is fully opened. When exposure time ends, the second curtain is released to begin its travel and close off light to the film.

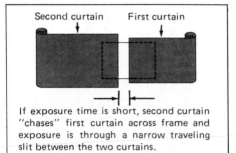

Second curtain First curtain

If exposure time is short, second curtain "chases" first curtain across frame and exposure is through a narrow traveling slit between the two curtains.

For short exposures such as 1/500 second, the second curtain follows so closely behind the first curtain that the entire frame is never open to light all at the same time. The frame is exposed by a traveling slit of light formed by the narrow gap between the two curtains.

For a very short exposure time such as 1/500 second, the first curtain will not have traveled very far before the second curtain starts chasing it across the frame. The film frame will be exposed by a narrow traveling slit of light formed by the gap between the two curtains. At no time is the complete film frame exposed all at once to light from the lens. For most picture-taking situations, it doesn't matter that the frame was exposed by a traveling slit of light. In Chapter 15, you'll see that it does matter when you are using electronic flash.

A-series and F-series cameras use horizontal focal-plane shutters that travel across the long dimension of the frame. T-series cameras use vertical focal-plane shutters. Because vertical shutters travel across the short dimension of the frame, they operate in less time. This affects use with electronic flash.

GETTING ACQUAINTED WITH LENSES

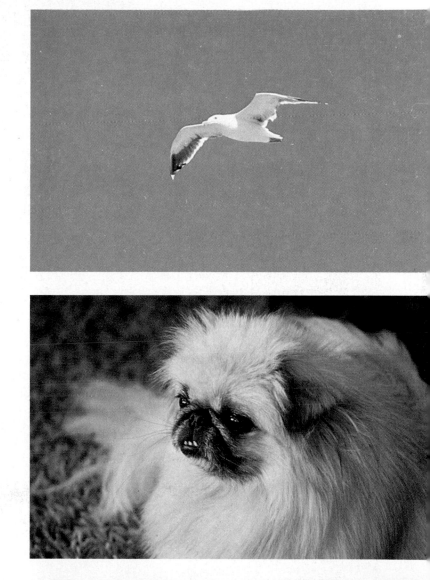

An important feature of Canon SLR cameras is interchangeable lenses. Canon offers more than 50 different lenses that can be used on any Canon camera. Some are designed to capture a distant subject and record it on film as though it were only a short distance away. Others are designed for close-up photography—to make a relatively large image of a very small subject. Between these extremes are lenses for ordinary applications and several special types including zoom lenses and a lens for shooting architecture. Available Canon lenses are described in Chapter 14.

Lenses now in production are called FD lenses. They replaced an earlier lens design called FL lenses. Both types can be used on current cameras and both are discussed in this book.

When you look into the viewfinder, preparing to take a picture, you focus on the scene and compose the picture you intend to take. To get the right composition, you may change the location of the camera, change lenses, or try different focal lengths of a zoom lens to see which gives the most pleasing image. Then you take an exposure reading of the scene using the camera's built-in light meter, and set the camera exposure controls. These two procedures are called *viewing* and *metering*.

Photography is more successful and more fun with lenses for different shooting situations. Photo of the seagull was made with a 200mm lens, the Pekingese with a 50mm, and the grasshopper with a close-up supplementary lens described in Chapter 10.

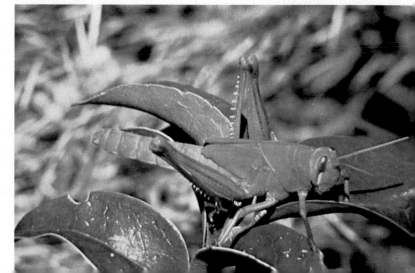

For viewing, it is usually best to keep lens aperture wide open because that gives the brightest image on the focusing screen in the viewfinder. With lenses that have no automatic features, you can open lens aperture *manually* by turning the aperture ring on the lens. Then, after viewing, you manually close down lens aperture for correct exposure. The aperture you use to make the exposure is sometimes called *shooting aperture*.

FL Lenses—An improvement over manual aperture control uses a lever in the camera to operate a lever on the back of the lens. Working together, these levers provide a feature called *automatic aperture*. It does what I mentioned earlier: The lens remains wide open until the moment of exposure and then the levers close down the lens to shooting aperture. Of course you must measure the light some way and set the aperture you intend to use.

In 1964, Canon announced a new series of lenses with a lever on the back for automatic aperture and called them FL lenses.

Stopped-Down Metering—A big advantage of modern SLR cameras is a built-in meter to measure light from the scene after it has come through the lens. This eliminates the necessity for separate accessory light meters and makes camera adjustments much simpler. When using FL lenses and lenses that require manual aperture control, you can't measure the light coming through the lens with the aperture wide open because it won't be the same as the amount of light that comes through later, at shooting aperture.

With these lenses, you must stop down to shooting aperture while you take the exposure reading. The camera light meter measures the actual amount of light that will be used to make the exposure. This is called *stopped-down metering*, sometimes *stop-down metering*. You view and focus at full aperture and then stop down to take a meter reading.

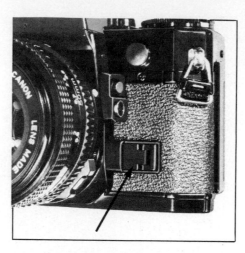

Some A-series cameras have a Stop-Down Lever (arrow) in this location. Push it toward the lens to stop down to shooting aperture as selected by the lens aperture-control ring. There are special procedures for metering stopped down in A-series cameras—described later in this book.

FD Lenses—Introduced in 1971 and still the standard Canon lens design, FD lenses have additional levers and pins on the back. I won't discuss them specifically until Chapter 10. For now, I just want to tell you what the lens does. FD lenses allow you to take an exposure measurement at wide-open aperture, after composing and focusing. This is called *full-aperture metering*.

Because you normally shoot at a smaller aperture than wide open, full-aperture metering requires cooperation between lens and camera body so the lens "knows" what the shooting aperture will be.

Here's how it works: Focus and compose the image with the lens wide open. Then adjust shutter speed and lens aperture until the exposure indicator in the viewfinder display indicates "correct exposure," as shown on page 13. If you are using an automatic camera, it may select aperture size for you automatically.

Either way, the lens aperture remains wide open and the viewfinder image remains at maximum brightness Because of mechanical linkages between camera and lens, the camera "knows" what *f*-number has been selected. The light meter in the camera measures at full aperture but *anticipates* and corrects for the reduction in light when the lens stops down to shooting aperture. This simplifies using the camera and is very convenient.

FD lenses allow both full-aperture viewing and full-aperture metering. These automatic features depend on mechanical linkages between lens and camera body. Some accessories fit between lens and camera but do not make the mechanical connections so the camera "knows" what is happening at the lens. When using these accessories, you must meter stopped-down even with an FD lens. These accessories are used to get higher image magnification and are discussed in Chapter 13.

With some exceptions I'll get to later, FD lenses work the same way on automatic cameras. When the camera is choosing lens aperture automatically, the camera first measures the light at full aperture, then it decides what the shooting aperture should be, then it sets shooting aperture just before the exposure.

LENS MOUNT

Canon lenses mount with a breech-lock mechanism in which the critical surfaces that locate the lens on the camera never rub against each other. Therefore, wear is minimal.

The mounting surface of the lens is pressed against a mounting surface on the front of the camera—without any turning or sliding friction between the surfaces. The back of the lens has three cutouts that mate with three similar projections on the camera. Turning the lens body causes these projections to work against each other like screw threads. This clamps the mounting surface of the lens

against the mounting surface on the camera.

The Canon Breech-Lock lens mount is an outstanding design because: Wear at the mounting surface is eliminated; therefore, the lens-to-film distance never changes. The mount is large and stable. There is plenty of room for mechanical linkages and signaling devices between lens and camera body. The lens is precisely located on the camera.

LENS-MOUNTING METHODS

Early lenses to fit the standard Canon breech-lock mount used a metal ring on the back of the lens, called the Breech-Lock Ring, to mate with the projections on the camera body and mount the lens. After the lens is placed on the camera mount, the Breech-Lock Ring is turned clockwise until snug. The lens body itself does not rotate—only the separate metal ring on the back of the lens rotated.

This mounting arrangement was used on all SLR lenses, including FL types, and on all FD lenses up to mid-1979. At that time, a new series of FD lenses was announced, called New FD Lenses.

The camera body design was not changed. Both New FD lenses and "old" FD lenses fit the lens mount on any Canon SLR body.

This breech-lock mount for lenses has been standard since 1959. The three projections on the camera fit into three matching cutouts on the lens. Then the mounting ring on the lens is turned so lens is clamped onto camera. The precision mounting surface of the lens itself does not rotate during installation.

New FD lenses and old FD lenses are mechanically interchangeable. The basic difference is in the method of mounting New FD lenses onto the camera.

This book covers both types of FD lenses. On this page, you can see how to mount the old style lens.

New FD and "old" FD lenses have the same basic mounting arrangement. You can see the three cutouts on the lens mounting ring. This is an "old" FD lens.

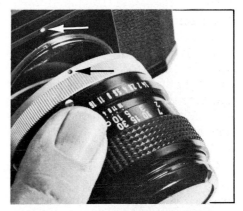

To mount an old-style FD Lens, first be sure the Breech-Lock Ring is turned fully counterclockwise as viewed from the front. Align dot on ring (black arrow) with similar dot on camera (white arrow). Press lens against camera body and rotate the Breech-Lock Ring clockwise.

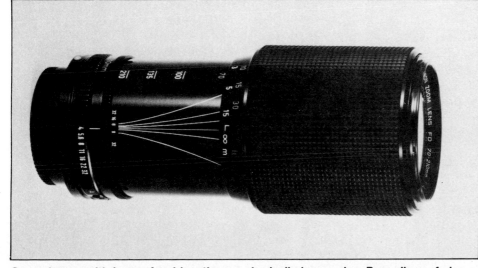

Canon lenses with longer focal lengths are physically longer also. Regardless of size or special features, all mount on the camera in the same way. This is a New FD lens. It's a 70mm to 210mm zoom lens.

When mounting an old-style FD lens, it's not necessary to use force when tightening the Breech-Lock Ring. Turn it until it's tight, but don't force it.

NEW FD LENSES

As shown on this page, to mount a New FD lens, place it on the camera and then turn the *entire* lens body clockwise until it clicks into place. This takes about one-quarter turn. The Lens-Release Button on the lens body will pop out when the lens is mounted correctly. Usually you will hear it click. If not, check visually to be sure the button has moved out.

Only the outside of the lens barrel turns. The inside does not rotate—in fact, it cannot rotate against the camera mounting surface because the positioning pin on the lens fits into a groove on the camera mount to assure correct orientation and prevent rotation. When mounting a New FD lens, it feels like the entire lens is rotating but it isn't. New FD lenses are breech-lock, just the same as any other FD lens.

New FD lenses have a positive mechanical lock when mounted so they can't rotate counterclockwise by accident. To remove a New FD lens, you must first depress the Lens-Release Button on the lens body, then turn the lens counter-clockwise.

WHICH IS WHICH?

Visually, you can easily see the difference. New FD lenses are all black. "Old" FD lenses have a bright metal Breech-Lock Ring on the back.

This book covers both types and you will see both in photos. Canon calls the original design "FD" and the new type "New FD." In this book, the term FD will apply to either type. When it is necessary or helpful to refer specifically to one type or the other, I will refer to them as New FD lenses and old FD lenses.

LENS IDENTIFICATION

The standard lens that comes with some Canon SLR cameras is an FD 50mm *f*-1.8. In that designation, 50mm is the focal length of the lens, and *f*-1.8 is the largest aperture that can be selected.

The pins and levers on a New FD lens are the same as the earlier FD lenses. The three projections at the outer edge of the mount are turned by turning the entire lens body when you are mounting or removing the lens. A pushbutton at top left in this photo serves to release the lens for removal (arrow).

Lens identification is engraved on the front of most Canon lenses. This is a New FD 50mm *f*-1.8. You can tell it's a New FD because it doesn't have a separate Breech-Lock Ring, and it's all black.

To mount a New FD lens, align the red raised dot on the lens barrel with the groove and red dot on the camera body, as shown. Then turn lens clockwise until it clicks into place.

The prefix FD means the lens has the automatic features that allow both full-aperture viewing and full-aperture metering.

The basic specifications of a lens are focal length and *f*-number.

EFFECT OF FOCAL LENGTH

Focal length is expressed in millimeters, abbreviated *mm*. Technically, focal length is the distance between a certain location in the lens and the film in the camera, when the lens is focused at infinity.

One practical value of focal length is a label or name for different types of lenses.

Lenses are grouped by focal length into three classes:
Short: 35mm and shorter
Medium: 45mm to 85mm
Long: 100mm and longer

The differences are *angle of view* and *magnification*. Short-focal-length lenses such as 20mm and 28mm have wide angles of view and low magnification. Let's discuss these one at a time.

Angle of view, as shown in the accompanying drawing, is the angle between the two edges of the field of view. It varies with focal length. Angle of view is measured from corner to corner of the film frame.

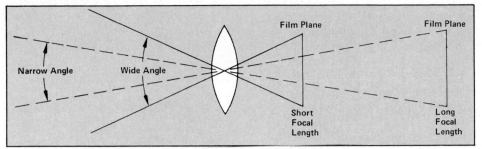

Angle of view is the angle between the outermost light rays which can enter the lens and form an image at the film plane. Short focal-length lenses have wide angles of view, long lenses have narrow viewing angles.

Use wide-angle lenses to show a lot of the scene being photographed. They are handy in taking interiors when you want to get a lot of the room and the walls prevent you from backing up very far.

You can get a feel for angle of view by testing your own vision. With both eyes open, hold your arms straight out to the sides and then move them forward until you can just see your hands while looking straight ahead. The angle will be less than 180 degrees.

Do it again with one eye closed. The angle will be a lot less. Clear vision for a single eye covers an angle of around 50 degrees or so, depending on where you decide you can't see clearly enough to call it vision.

A 50mm lens has an angle of view of about 46 degrees. This is sometimes called the normal lens for 35mm cameras and the reason given is the angle of view is about the same as the human eye. For this to be true, you have to go around with one eye closed or inoperative.

I prefer to consider a 50mm lens as *standard* for 35mm cameras rather than normal because it is a good general-purpose lens and a compromise between wide and narrow angles of view. You can't do everything with a 50mm lens, but you can make a lot of fine pictures with it.

Long lenses such as 200mm and 300mm have narrow angles of view. A 200mm lens has an angle of about 12 degrees. A common type of lens with long focal length is called *telephoto*. Not all long lenses are of the telephoto design but most are and the word has come to mean the same thing as a long lens in popular terms.

We think of a long lens as one that can "reach" out and fill the frame with a distant subject such as a mountain climber high up on a rock face. It excludes most of the mountain because of its narrow angle of view. What that really means is the lens has high magnification.

Magnification is the size of the image in the camera divided by the size of the subject. Canon literature uses the term *reproduction ratio* to mean image size divided by subject size. It is typically stated as a proportion such as 1:5, where the colon between the numbers means *divided by*.

A reproduction ratio of 1:5 says the image is one unit tall and the subject is 5 units tall. The unit of measurement can be inches or centimeters.

If you perform the indicated division, 1 divided by 5, you get 0.2, which I call magnification. In other words, a reproduction ratio of 1:5 and a magnification of 0.2 mean the same thing.

One frame on a 35mm negative is 24mm tall by 36mm wide, which is about 1 by 1.5 inches.

If you photograph a 6-foot (72 inch) person so he fills the 1-inch dimension of the frame, then the magnification is 1 inch divided by 72 inches or 1/72. That isn't much. The image is smaller than the real-world subject—in fact, it is only 1/72 as tall.

From a practical standpoint, to make an image larger on the film you have two choices: Move the camera closer to the subject or use a longer-focal-length lens with more magnification.

An obvious advantage of an SLR camera is that the viewfinder shows you the angle of view and magnification. When you own more than one lens and become familiar with what they do, you will almost automatically select the best lens for each picture-taking situation.

ZOOM LENSES

A special type of lens called *zoom* changes focal length by a control on the lens. One Canon zoom lens lets you use any focal length from 100mm up to 200mm. If you want the subject to fill the frame, zoom until it does.

MAXIMUM APERTURE

Lenses are specified according to the smallest *f*-number that can be selected—the largest aperture.

With Canon cameras, one standard lens is 50mm, *f*-1.8. For more money you can get *f*-1.4, or an *f*-1.2 lens.

Lenses with larger aperture are sometimes called *faster* because they let in more light and therefore make the exposure in a shorter time.

Some photographers like to shoot in available light, meaning whatever amount and type of light they find. Often, available light also means dim light such as inside buildings, barns, factories, and at twilight. If you enjoy shooting with the realism of available light, the *f*-1.4 lens is better than the *f*-1.8. Choose the *f*-1.2 if the cost is not too much for your budget.

15mm 100mm

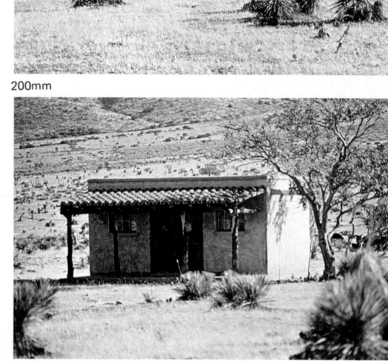

28mm 200mm

50mm 400mm

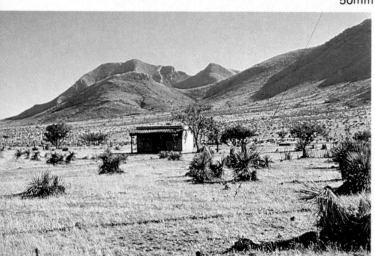

This series of photos shows the pictorial effect of different angles of view. Camera location was not changed while the scene was photographed with various lenses ranging from a 15mm fisheye lens to a 400mm. When camera location is not changed, the *only effect* of different focal lengths is greater magnification at smaller angles of view. The view and perspective of the cabin in the 400mm shot is *exactly the same* as any of the other shots if the other pictures were enlarged to make the cabin the same size. There is some fisheye distortion in the 15mm shot which makes the power pole curve.

A peculiarity of lens nomenclature is that aperture is indicated in two ways. The aperture ring shows *f*-numbers such as 1.4 and 2.8.

On the front of most lenses, engraved on the ring surrounding the glass, is the manufacturer's name, identification for that lens, a serial number, focal length in millimeters, and a symbol such as 1:1.4, called *aperture ratio*.

Ignore the first 1 in the aperture-ratio designation. The 1.4 part is the maximum lens aperture, stated as an *f*-number.

In other words, a lens marked 1:1.8, is an *f*-1.8 lens.

There are several common ways of writing *f*-numbers in publications: *f*-4, *f*/4 and *f*:4. Canon uses *f*/4. Because this book is part of HPBooks' series on photography and we had already settled on *f*-4 as our standard way of writing it, we use *f*-4.

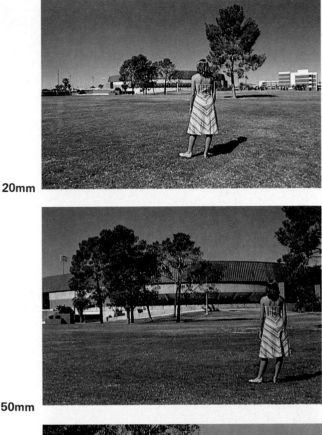

20mm

50mm

135mm

200mm

The T80 camera focuses the image automatically when used with special Canon AC (Automatic Control) lenses, as discussed in Chapter 18. AC lenses have a built-in focusing motor in a housing on the side of the lens. The T80 camera has a standard Canon lens mount which can accept either AC or FD lenses.

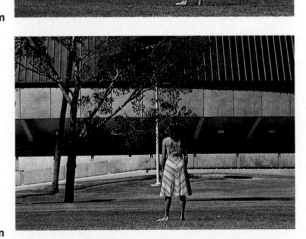

If the camera location is changed, perspective is changed. This scene shot with four different focal lengths, moving the camera each time so model was the same size in the viewfinder.

7
FILM HANDLING

Films carry a date on the carton, referred to as the expiration date. The date means the film should perform satisfactorily up to that time under normal conditions of storage. Because film characteristics usually change slowly, the film will probably be about as good during the month after its expiration as during the month before.

Expiration dating of films intended for amateur use is based on storage at temperatures comfortable for people—about 70F (21C) and about 50% relative humidity.

Higher temperature and higher humidity accelerate the aging process and humidity is the worst culprit. Film is sealed in a pouch or can to protect it from external humidity changes. If the emulsion dries out excessively, that's not good either.

Storing film at reduced temperatures—such as in your refrigerator—slows down the aging process, and is recommended both before and after exposure if you hold the film a long time before shooting or a long time after shooting and before development. After development, room-temperature storage of photographic materials is normally OK.

An exception to the above is color films intended for professional use and some special b&w films. These should always be stored at reduced temperature. Follow the film manufacturer's instructions.

Film should be sealed before storage and allowed to return to room temperature before breaking open the seal. Otherwise, moisture may condense in the package and the film may be ruined. If you buy film in quantity, storing it in a refrigerator is a good idea provided you observe this precaution.

Cameras with manual rewind have a Rewind Knob. These are the A-series, F-series and the T50. To open the camera back on these models, lift up the Rewind Knob.

LOADING FILM

A-series and F-series cameras have manual procedures to load and rewind film, discussed in this chapter.

T-series cameras have built-in motors that automatically perform some or all of the manual procedures. For that reason, film loading and rewinding for T-series cameras is discussed in Chapter 18, along with specific camera models.

A-series and F-series Cameras— Lift the film-rewind knob and the back cover of the camera will open. A crank in the top of the knob folds over and fits into a groove. If you have difficulty grasping the knob, unfold the crank and use it to pull upward on the knob.

Open the back cover all the way and inspect the interior of the camera. Occasionally it's a good idea to clean out the interior carefully with a soft brush, a puff of air from a rubber squeeze bulb, or a puff from a pressurized can of dust remover.

When cleaning the interior of the camera, remember that the focal-plane shutter mechanism is delicate. Avoid touching it or blasting it directly with air.

Drop the film cartridge into the chamber on the left side. Push down the rewind knob and rotate it slightly, if necessary, to get it all the way down. Turn the rewind crank clockwise slowly until the film end is drawn partway back into the cartridge. It should move about an inch.

Then grasp the end of the film and pull it across the back of the

T-series cameras, without a Rewind Knob, have a Back-Cover Release on the side of the camera body. To open the camera back, press the round button and move the grooved lever downward.

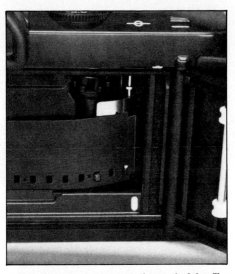

A T-series camera grasps the end of the film automatically and winds it on the takeup spool. A built-in motor advances the film, so these models don't have a film-advance lever. The film-loading procedure is described in Chapter 18.

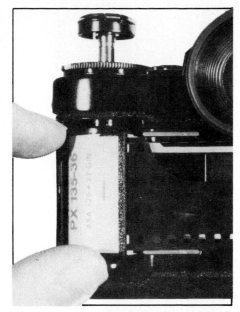

With A-series and F-series cameras, drop in the film cartridge. Then push in the Rewind Knob, turning it, if necessary, to make it go all the way in.

camera to the takeup mechanism on the right side.

Place the free end of the film into any slot on the spool and operate the film-advance lever with your right thumb to turn the takeup spool one revolution, thus trapping the free end of the film in the slot of the spool. Use your left thumb or forefinger to place the sprocket holes of the film over the teeth of the sprocket that is beside the takeup spool.

When you are sure the film is caught in the takeup spool and is engaging the sprocket teeth on both sides, close the back of the camera.

The frame counter on top of the camera should read S. It is automatically reset to S each time the back is opened. The first frame you are supposed to shoot is number 1.

Operate the film-advance lever and shutter-release button, alternately, while watching the frame counter until it indicates that frame 1 is in position for exposure. The exposures leading to frame 1 are usually called blank shots.

Watch the rewind knob as you advance the film to frame 1. It should turn, indicating that the film is actually moving out of the cartridge onto the takeup spool. If it does not turn, open the back of the camera to make sure the film leader is caught in the takeup spool.

It is important to understand that the frame counter does not actually count frames of film as they go through the camera. It counts the number of times you have operated the film-advance lever. If the film leader is caught in the takeup mechanism and film is moving through the camera each time you operate the lever, the frame counter will be correct. If the film is not grasped by the takeup, it will not move through the camera as you work the advance lever, but the frame counter will keep on indicating higher numbers.

When you are loading a camera, all of the film you pull out of the cartridge becomes light struck. When developed, it will be black.

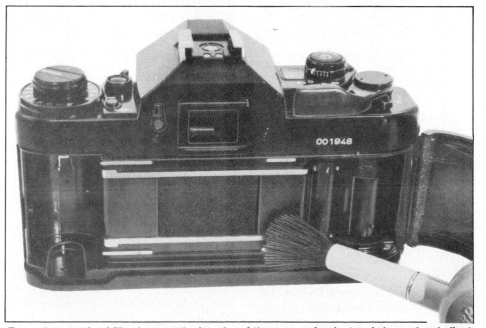

Every time you load film, inspect the interior of the camera for dust and clean when indicated. A clean, soft brush is handy. Do not touch the shutter curtain.

1/Grasp the free end of the film, pull it across the back of the camera, and insert into any slot in the takeup spool at far right.

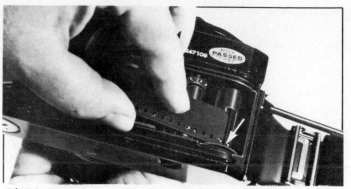

2/With the end of the film in a slot of the takeup spool, rotate the spool so it traps the free end of the film. This can be done with the Film-advance Lever or with the knurled flange (arrow) on the takeup spool. Correct direction of rotation is shown by an arrow on the takeup spool. Before closing the camera back, advance the film far enough so teeth on *both* ends of the sprocket are fitted into sprocket holes in the film. Also, be sure the film is pulled *flat* across the back of the camera, without any slack in the path. If there is slack, advance the film a bit more.

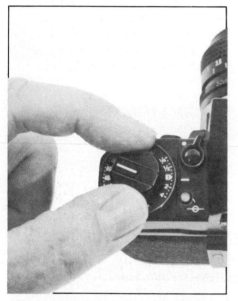

3/Close the back and turn the rewind knob clockwise until you feel slight resistance. This tensions the film and lets you verify proper loading by watching the rewind knob turn counterclockwise as you advance film.

Loading the camera automatically resets the frame counter to S, which means *start winding.*

The purpose of advancing film after you close the camera is to move the light-struck portion onto the takeup spool, so you can start taking pictures with unexposed film.

Loading and unloading a camera should always be done in subdued light. If you have to do it outdoors, shade the camera to avoid direct sunlight on the film cartridge.

The cartridge should be left in the package until you are ready to use it, and returned to the package or some other light-tight container as soon as you remove it from the camera.

It's a good idea to protect the front of the lens by installing a lens cap when you are not shooting and when loading film. If the camera is set for manual exposure control, you can leave the cap on the lens while advancing to frame 1. Choose a fast shutter speed such as 1/500 or 1/1000. Then you don't have to wait for the shutter to close so you can advance the next frame.

If the camera is on automatic, in the mode that lets the camera choose shutter speed, leaving the lens cap on can cause long delays while you wait for the shutter to close. The camera will try to make an exposure with no light coming in the lens. It will hold the shutter open as long as possible. To avoid this, change to manual operation or remove the lens cap.

When firing blank shots with the lens cap off, point the camera at a plain surface. Otherwise, you may get images of somebody's feet or a handsome navel. I once got an excellent blank shot I was tempted to exhibit with the title "Tree Shadows on Feet." I was certain the picture had a message and you know what it is.

FILM GUIDING AND FLATNESS

There are four polished metal rails, two above and two below the focal-plane shutter opening in the back of the camera. The film rides on two inside rails. They are separated enough not to be in the picture area—in fact, they are directly underneath the sprocket holes. The outer two rails are edge guides. They stand slightly higher than the inner rails so the edges of the film are guided in a straight path from cartridge to takeup.

A spring-loaded pressure plate is on the inside of the rear cover of the

camera. When the cover is closed, this flat smooth plate gently presses against the two outer guide rails and contacts the back of the film. The two outer guide rails hold the pressure plate a small amount away from the two inner rails to allow for the film thickness. This creates a channel to keep the film traveling straight across the camera and hold it flat while being exposed.

REWINDING FILM

With A-series and F-series cameras, the film-advance lever will become difficult to move when you have exposed the last frame. Don't force it!

Film on the takeup spool is not protected from light. If you don't rewind immediately, and later forget that you didn't, you can ruin the entire roll by opening the back of the camera. Rewind immediately.

On the bottom of A-series cameras is a Rewind Button. On the F-1, this control is on top of the camera and is marked R.

Depress the Rewind Button and turn the Rewind Crank clockwise until you feel the film end come free in the takeup. Then it is safe to open the camera back and remove the film cartridge. If you turn the crank farther, it pulls the free end all the way into the film cartridge. This is OK.

With A-series cameras, the frame counter moves backward when rewinding. Rewind until the counter backs up to S and you feel the film end come free. You can rewind it all the way into the cartridge if you wish.

The motor drive unit for new F-1 will rewind the film for you if you wish. It leaves part of the film leader sticking out of the cartridge.

CAUTION

During the loading procedure, check what's going into the camera. Read two things on the cartridge: the film type, such as Kodachrome 25, and the film-speed number, such as 25. On closing the camera back, immediately check the film-speed dial on the camera to be sure it is set at the right number.

Flip up the Rewind Crank and turn it clockwise to rewind. Rewind slowly, particularly when the humidity is low, to avoid static electricity discharges inside the camera which will mark the film.

With most Canon models, the Rewind Button is on the bottom. To prepare the camera for rewinding film, push the button in.

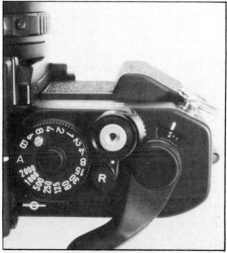

The Rewind Button on the F-1 is in a different location. It's on top, labeled R, just behind the shutter button. To prepare for rewind, turn the button clockwise while pressing it down.

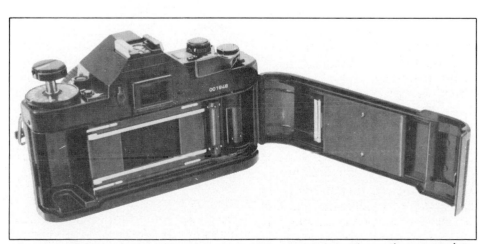

Metal rails on camera body guide film and hold it straight. Smooth metal pressure plate on inside of back cover presses against film in camera to hold it flat when cover is closed.

8

EXPOSURE CONTROLS AND THEIR EFFECTS

Suppose you have just set the exposure controls. The aperture is set at ƒ-5.6 and the shutter speed is set at 1/125. Those settings determine some total exposure on the film—an *exposure value,* which we abbreviate EV. Any other pair of settings that give the same EV will make the same exposure on the film.

Because there are usually several pairs of f-stop and shutter-speed settings that give the same exposure on the film, it is convenient to have some way of saying how much exposure it is—rather than reciting all possible pairs of settings that produce that exposure.

Canon doesn't use EV numbers on the cameras, but they are used in specifications, so you should have some idea of what they are about. An EV table is shown below.

Pairs of f-stop and shutter-speed settings that represent the same amount of exposure and the same EV number are in this table.

EV numbers themselves are just labels for exposure steps in sequence. Because EV numbers represent a combination of aperture and shutter speed to give an exposure, we can say:

Exposure Value = Aperture Value + Time Value

which can be abbreviated

EV = Av + Tv

EV NUMBERS & EQUIVALENT EXPOSURE SETTINGS

$$EV = 3.3 \, \log_{10} \left(\frac{f^2}{T} \right)$$

SHUTTER SPEED

EV	4 min.	2 min.	1 min.	30 sec.	15	8	4	2	1	1/2	1/4	1/8	1/15	1/30	1/60	1/125	1/250	1/500	1/1000	1/2000
-8	ƒ·1																			
-7	1.4	ƒ·1																		
-6	2	1.4	ƒ·1																	
-5	2.8	2	1.4	ƒ·1																
-4	4	2.8	2	1.4	ƒ·1															
-3	5.6	4	2.8	2	1.4	ƒ·1														
-2	8	5.6	4	2.8	2	1.4	ƒ·1													
-1	11	8	5.6	4	2.8	2	1.4	ƒ·1												
0	16	11	8	5.6	4	2.8	2	1.4	ƒ·1											
1	22	16	11	8	5.6	4	2.8	2	1.4	ƒ·1										
2	32	22	16	11	8	5.6	4	2.8	2	1.4	ƒ·1									
3	45	32	22	16	11	8	5.6	4	2.8	2	1.4	ƒ·1								
4	64	45	32	22	16	11	8	5.6	4	2.8	2	1.4	ƒ·1							
5		64	45	32	22	16	11	8	5.6	4	2.8	2	1.4	ƒ·1						
6			64	45	32	22	16	11	8	5.6	4	2.8	2	1.4	ƒ·1					
7				64	45	32	22	16	11	8	5.6	4	2.8	2	1.4	ƒ·1				
8					64	45	32	22	16	11	8	5.6	4	2.8	2	1.4	ƒ·1			
9						64	45	32	22	16	11	8	5.6	4	2.8	2	1.4	ƒ·1		
10							64	45	32	22	16	11	8	5.6	4	2.8	2	1.4	ƒ·1	
11								64	45	32	22	16	11	8	5.6	4	2.8	2	1.4	ƒ·1
12									64	45	32	22	16	11	8	5.6	4	2.8	2	1.4
13										64	45	32	22	16	11	8	5.6	4	2.8	2
14											64	45	32	22	16	11	8	5.6	4	2.8
15												64	45	32	22	16	11	8	5.6	4
16													64	45	32	22	16	11	8	5.6
17														64	45	32	22	16	11	8
18															64	45	32	22	16	11
19																64	45	32	22	16
20																	64	45	32	22

COUNTING UP AND DOWN THE EXPOSURE SCALE

You don't need to memorize any EV numbers, but please notice the plan so you can figure or "count" pairs of camera settings quickly in your mind. As we get further into how things work, you will see that your camera equipment can do a lot more if you back it up with a little brain work of your own.

EFFECT OF APERTURE SIZE

Field of view of a lens means the total width and total height of the scene as viewed through that lens. Different lenses have different fields of view.

The camera lens also "sees" near and far objects, so there is some depth or distance within the view of the lens—from the camera all the way to the most distant object in the scene or to infinity if you point the lens at the sky.

Not all objects between zero distance from the camera and infinity will be in sharp focus on the film. The distance between the nearest object in good focus and the farthest object in good focus is called *depth of field.*

Depth of field is controlled by aperture size. When you become used to having control of depth of field in your pictures, it will become as important to you as any other photographic control on your camera.

For example, if you are taking a portrait of a person against a foliage background, the picture will often be improved by "throwing" the foliage out of focus.

Smaller lens apertures give more depth of field. With some lenses, when shooting at *f*-22, virtually everything in view will be in good focus—beyond a certain minimum distance. When shooting at *f*-1.4, depth of field will be greatly reduced. Objects both front and back of the subject will be out of focus.

You need to know the depth of field that is actually on the film at the moment you take the picture.

These three pictures show depth of field being used as a photographic control. In the top photo, focus is pretty good everywhere. A small aperture—*f*-16—was used to give maximum depth of field.

In the center shot, a large aperture was used—*f*-1.4—to give short depth of field. Subject of interest is the barn, so the lens was focused on the barn.

In the bottom photo, large aperture was used again but the lens was focused on the flowers. The barn and some of the flowers are beyond the depth of field and are out of focus.

Good photography nearly always requires *deliberate* control of depth of field.

The Stop-Down Slide (arrow) on the F-1 is convenient to operate with the forefinger of your left hand. After focusing, reach under the lens, press the slide and then release it. It will pop out, as shown here, and the lens will stop down to the aperture size set on the aperture ring. Then you can see depth of field. To restore normal camera operation, press the slide in until it latches.

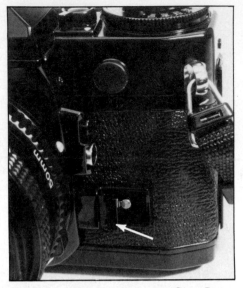

A-series cameras have a Stop-Down Slide, also called Stop-Down Lever, indicated by the arrow in this photo. To stop down the lens, fold out the end of the slide so you have a place to press, then push the slide inward until it locks. To restore normal operation, depress the small chromed button. The slide will pop out again.

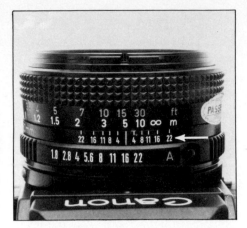

Figure 8-1/This lens is set at f-16 and focused at a distance of about 5 meters. The depth-of-field scale (arrow) is the set of numbers on each side of the index mark, ranging from 22 to 22.

Depth of field is indicated by a pair of numbers on that scale with the same value, such as 4 to 4 or 11 to 11. Use the pair with the same number as the aperture setting of the lens. In other words, if the lens is set to f-11, depth of field is indicated by 11 and 11 on the depth-of-field scale.

Depth of field is found by reading the focused distance scale opposite the two numbers on the depth-of-field scale. In this photo, lens aperture is f-16. Depth of field is from about 2.7 meters (m), which is opposite 16 on the left, to infinity (∞), which is opposite 16 on the right.

If you prefer to read the scale marked ft. for feet, depth of field is from about 9 feet to infinity.

After the picture is shot, it's too late to change it.

Because Canon cameras allow viewing through wide-open aperture so you get the brightest image on the focusing screen, you are not seeing the depth of field that will result when the camera closes aperture to make the exposure.

After composing, focusing and setting exposure, the last step should be a check of depth of field to see if it's satisfactory. If you have too much depth of field and a distracting object in the background is in sharp focus, you may wish to use a faster shutter speed and larger aperture to get less depth of field. Or the depth of field may be too limited for your purpose and you may wish to use a smaller aperture to get more.

The way to see how much depth of field you will get at shooting aperture is to stop down the lens by operating the stop-down control on the camera. Not all models have this control, as you can see in Chapter 18.

When stopping down the lens, the image on the focusing screen gets darker because less light comes in the smaller aperture. The depth of field you see in the viewfinder changes to what it will be on the film. With some practice, you learn to ignore the change in brightness of the image and judge depth of field.

In dim light, or if you are using a very small aperture, the viewfinder image may be too dark to judge depth of field. Or, you may be using a camera without this control. If so, you can use the *depth-of-field scale* on the lens.

There are some precautions and procedures to observe when stopping down the lens with the camera set for automatic operation. These result from the way the levers on lens and camera work together, as explained in Chapter 10. This affects operating procedures of the various camera models in different ways—described in the description of each camera in Chapter 18.

HOW TO READ THE DEPTH-OF-FIELD SCALE

Depth-of-field varies with lens focal length. Shorter lenses have more depth of field. For any particular lens, depth of field is affected both by aperture size and the focused distance of the lens.

You will get more depth of field when the lens is focused at greater distances from the camera. Therefore the depth-of-field indication on the lens is affected by the setting of the focusing control.

Depth-of-field is shown by pairs of lines engraved on the lens, centered on the index mark that you use to read focused distances. Rather than read that again, look at Figure 8-1.

RULES ABOUT DEPTH OF FIELD

Smaller apertures give more depth of field. Shorter focal lengths give more depth of field. Longer distances between subject and camera give more depth of field in the vicinity of the subject.

EFFECT OF SHUTTER SPEED

Shutter speed has three effects: It determines how much a moving subject is blurred on the film. With a hand-held camera, it determines the amount of image blurring of a stationary subject due to your inability to hold the camera absolutely steady. And, it affects the aperture size you can use because aperture and shutter speed together must give the desired exposure.

Blurring of a moving subject is most noticeable when the subject is moving directly across the field of view of the camera—in other words, at right angles to the direction the camera is pointed. If blurring is a problem and you can't solve it any other way, move your shooting location so the subject is traveling more nearly toward or away from your position.

Both shutter speed and lens focal length determine blurring due to camera shake when you are hand-holding. Also, how steady you are and the way you support the camera. Some people simply do better than others and some improve by adopting good camera-handling technique through attention to the problem and some practice.

It's easier to hand-hold with shorter focal lengths because they magnify less. Shake is magnified by longer lenses just as the image itself is. Slight jiggling of the camera produces a visual effect on the print very similar to being out of focus. More pictures are harmed by camera shake than any other cause.

A guide to shutter speeds when hand-holding the camera is to take the reciprocal of the lens focal length. The reciprocal of any number is that number divided

If the camera is stationary, shutter speed is low, and a moving subject is in the field of view, the subject will blur while everything else is sharp.

Following subject motion by moving the camera is called *panning*. If you pan at the same speed as the subject, background is blurred and subject is sharp. However panning horizontally only corrects *horizontal* subject motion. Arms and legs moving vertically are blurred just as much as if the camera were not panned. Pictures like this are fun.

into one. The reciprocal of 50 is 1/50 and so forth. Use the reciprocal of focal length as the *longest* time of exposure that can safely be hand-held unless you have proved to yourself that you can hold the camera steady at slower shutter speeds.

With a 200mm lens, use 1/250 because 1/200 isn't an available shutter speed—you must set the shutter-speed control exactly on the marked speeds.

With a 50mm lens, you should not have any trouble shooting at 1/60, and most people who are careful about it can shoot at 1/30. By bracing yourself, you can do better and by pressing the camera against the side of a building or a post, you can do still better. Don't pass a good shot by on account of this rule of thumb. Give it your best effort and get the picture. If it blurs, you can always say you did it on purpose.

Sometimes there is conflict between the aperture you would like to use for depth-of-field effect and the shutter speed you need to stop motion or to hand-hold the camera. The two adjustments together must satisfy a third requirement—correct exposure.

However, exposure is not the same for all film types because films have different speed ratings. It always helps to select a film speed for the kind of shooting you intend to do.

EFFECT OF FILM SPEED

The film-speed rating is assigned by the manufacturer as a way of stating how much exposure each type of film requires. When you dial the film-speed number into your camera, you set up the camera light-metering system so it gives the correct exposure for that film type.

Among commonly-available film-speed ratings, ASA 25 is considered slow, 125 is intermediate, and 400 is fast. More exposure is required when you have ASA 25 film in your camera than when using ASA 400.

Choosing film speed for the kind of photos you intend to make is helpful. A way to eliminate background is, use large aperture to reduce depth of field. In bright daylight, slow film helps.

Here's another rule of thumb that's worth remembering:

To photograph a subject illuminated directly by sunshine, use *f*-16 and a shutter speed that is the reciprocal of the ASA film speed. If you are using ASA 25 film, shoot at 1/25 second—1/30 will be close enough. If you are using ASA 125 film, shoot at 1/125 second, and so forth.

Naturally, you don't have to shoot at *f*-16 and 1/30 with ASA 25 film, even if you use the rule. You can change *f*-stop and make compensating changes in shutter speed to end up with a long menu of possible settings in sunlight as follows:

f-16	1/30
f-11	1/60
f-8	1/125
f-5.6	1/250
f-4	1/500
f-2.8	1/1000
f-2	1/2000

These pairs of exposure settings will all give the same amount of exposure because each step toward larger aperture is balanced by one step toward shorter exposure time. Therefore, they should all have the same EV number. In

the EV table shown earlier, you can see that each of these pairs is EV 13. You can also see other possible pairs of control settings that give EV 13.

Without putting film in your camera or even going out in the hot sun, you can use the menu just figured to see what it's going to be when you go out there.

Assume you intend to shoot action with a 200mm lens. You decide to shoot at 1/500 or 1/1000 so you can hand-hold the camera. Depth of field will be poor because you also have to shoot at large aperture—*f*-4 or *f*-2.8. If you close down to *f*-11 or *f*-16 to get better depth of field, the action will blur at the slow shutter speeds and you will not be able to hand-hold that long lens.

The only way out of this problem is not to use ASA 25 film because the film is too slow. With some films, you can deliberately underexpose to operate at faster shutter speeds than normal exposure requires. For these films, most labs can make a compensation called *push processing*.

Let's try the whole deal again with ASA 400 film, which is faster by 4 exposure steps. You have to double four times to get from ASA 25 to ASA 400.

Sometimes artistic effects result from slow shutter speeds. These dancers are from the show "Up with People."

The choices in sunlight then become:

f-16	1/400—use 1/500
f-11	1/1000
f-8	1/2000—F-1
f-5.6	1/4000—T90
f-4	No shutter speed available
f-2.8	No shutter speed available
f-2	No shutter speed available

As you can see, using ASA 400 film in sunlight forces you to small apertures and fast shutter speeds. That neatly solves the problem I just mentioned.

But if you are photographing people or flowers in the garden, you may not want depth of field from here to the back fence. A more artistic photo usually results when the competing background is thrown out of focus due to less depth of field from a large aperture. With the settings required for 400 film speed, you can't reduce depth of field because you don't have fantastic shutter speeds. You can reduce the amount of light entering the camera by using a neutral-density filter on the lens as de-

scribed in Chapter 15.

An oversimplified rule is to buy fast film for shooting in dim light such as indoors and slow film for shooting in bright light. But the amount of light alone is not the determining factor. You also have to worry about depth of field and shutter speeds.

RECIPROCITY FAILURE

By now it may seem that you can shoot at virtually any shutter speed you choose, simply by counting up or down the exposure scale, adjusting aperture to compensate for shutter-speed changes.

The reciprocity law indeed says so, but here is the fine print that takes it away:

People once thought the law applied to all values of light and time, but there are exceptions when the shooting light is either unusually bright or unusually dim. These exceptions are called reciprocity-law failure, usually known as *reciprocity failure.*

The problem lies in the nature of film, not in the camera. It is always due to light that is more or less bright than the design-range of the film emulsion. Even though

reciprocity failure is caused by the amount of light, the best clue to the photographer is shutter speed because unusually fast shutter speeds mean there is a lot of light, and unusually slow shutter speeds mean the light is dim.

As a general rule for most amateur films, if you are shooting faster than 1/1000, or slower than 1 second, you should think about the possibility of reciprocity failure. Consult the film data sheet supplied by the film manufacturer. Some films have a more limited "normal" range of exposure times than stated above.

The basic effect of reciprocity failure is always less actual exposure on the film than you expect. Therefore, the basic cure is to give more exposure by using larger aperture, more time, or both. For example, if an exposure meter or an exposure calculation suggests using *f*-4 at 4 seconds, the data sheet packed with the film may say to give one step more exposure than that to compensate for reciprocity failure. Use *f*-2.8 if it is available on the lens, or shoot at 8 seconds.

With b&w film, the film data sheet may call for more exposure and also a change in development. With color film, reciprocity failure can cause both underexposure and a color change on the film. The recommended compensations may be more exposure, use of a color filter on the lens, and a change in development.

Canon cameras and accessories will meter in dim light and make exposures that are well into reciprocity failure for most films. To be sure, check the film data sheet or ask the film manufacturer. Even if you have the latest information, it usually pays to bracket exposures —meaning shoot one frame at the exposure you think is correct and additional exposures at more and less exposure. You can bracket in full steps with b&w film; half steps with color film.

SHUTTER PRIORITY

When shutter speed is important for a photographic effect, such as stopping motion, you should

choose a shutter speed that gives the desired effect and then use whatever aperture size is necessary for correct exposure. This is called *shutter priority*. With an automatic camera set to operate with shutter priority, you set shutter speed manually and the camera then sets aperture size automatically.

APERTURE PRIORITY

When depth of field is important, the aperture setting has priority. With an automatic camera set to operate with aperture priority, you set aperture manually and the camera sets shutter speed automatically.

PROGRAMMED AUTOMATIC EXPOSURE

Some Canon models, shown in the table below, set both shutter speed and aperture for you, automatically. This is called *programmed automatic exposure*, sometimes *programmed AE*. Programs for these models are shown in Chapter 18.

When you use this mode, you shouldn't have any particular shutter speed or aperture setting in mind, because the camera will select whatever it chooses according to a plan or *program* built into the camera.

The graph below is the program for the A-1. Shutter speed is represented by the vertical lines. Aperture size is shown by the horizontal lines. EV numbers are shown by the diagonal lines.

Starting at the upper right corner of the graph, the three values are: EV 18, 1/1000 second and *f*-16. To see what happens as the light becomes less, follow the line down past EV 17 and stop at EV 16.

Aperture has opened one step to *f*-11 and shutter speed has slowed down one step to 1/500 second.

These changes in aperture and shutter speed are made *steplessly*, meaning the values don't jump from one step to the next. They change gradually, in very small increments.

Notice that the program makes equal changes in aperture and shutter speed until the aperture is as large as it can get. The graph is for an *f*-1.4 lens and ASA 100 film in the camera. If you use a lens with smaller maximum aperture, the camera will open it as far as it will go and then stop.

MULTIPLE PROGRAMS

Some T-series cameras have multiple programs that give you the convenience of programmed automatic but allow you to *favor* either

PRINCIPAL EXPOSURE MODES	
AE-1	Manual Shutter-Priority Auto
AE-1 PROGRAM	Manual Shutter-Priority Auto Programmed Auto
F-1	Manual Optional Shutter-Priority Auto Optional Aperture-Priority Auto
A-1	Manual Shutter-Priority Auto Aperture-Priority Auto Programmed Auto
T50	Programmed Auto
T70	Manual Shutter-Priority Auto Multi-Program Auto
T80	Manual Multi-Program Auto
T90	Manual Shutter-Priority Auto Aperture-Priority Auto Multi-Program Auto

NOTE: Exposure modes shown here are those commonly used. In addition, these models offer automatic exposure with flash and automatic or manual exposure with the lens stopped down. See the camera descriptions in Chapter 18.

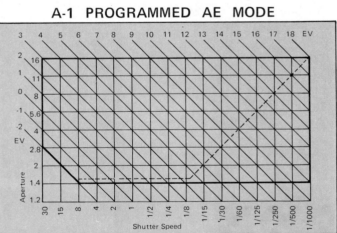

A-1 PROGRAMMED AE MODE

When set for Programmed AE, the A-1 camera sets both shutter speed and aperture automatically, following a built-in program shown by the dotted line.

A fast shutter speed ''stops motion'' and gives a sharp image of a moving subject. Because faster shutter speeds require larger apertures you may find a depth of field problem. Notice the vaulter's foot is out of focus. 200mm lens.

Sometimes a little bit of image blur helps the picture. It conveys the feeling of motion and adds realism to a subject which is obviously moving. I moved the camera to follow the running dog. This blurred the terrain. 200mm lens.

Reciprocity failure is not always a disaster and sometimes not even noticeable. This scene was exposed automatically. The camera timed itself and ran 15 seconds. Underexposure due to reciprocity failure made the sky color more intense.

To select Programmed AE with the A-1 camera, operate camera controls so the letter P appears in the window as shown here.

shutter speed or aperture.

For example, the T70 has three programs. The Standard program is similar to that shown for the A-1. The Tele program uses faster shutter speeds than the Standard program, with larger apertures. Faster shutter speeds reduce image blur due to movement and make it easier to hand-hold long-focal-length lenses. The Wide program uses smaller apertures with slower shutter speeds. Slower shutter speeds are OK with wide-angle lenses and smaller apertures give more depth of field.

Programs for individual camera models are shown in Chapter 18.

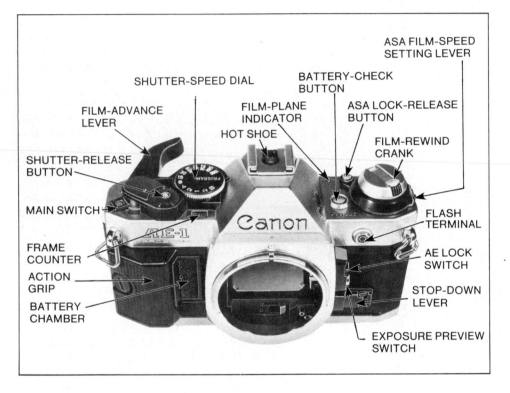

FILM-ADVANCE LEVER

SHUTTER-SPEED DIAL

ASA FILM-SPEED SETTING LEVER

BATTERY-CHECK BUTTON

FILM-PLANE INDICATOR

ASA LOCK-RELEASE BUTTON

HOT SHOE

SHUTTER-RELEASE BUTTON

FILM-REWIND CRANK

MAIN SWITCH

FRAME COUNTER

FLASH TERMINAL

ACTION GRIP

AE LOCK SWITCH

BATTERY CHAMBER

STOP-DOWN LEVER

EXPOSURE PREVIEW SWITCH

CANON SLR CONTROLS

With the preceding chapters as background, this is a good time to identify and discuss the controls on Canon SLR cameras. As examples, the illustrations show a T-series camera, and an A-series camera which is generally similar to the F-1.

Although both types use electronics on the inside, the A-series cameras have more mechanical controls on the outside such as film-advance and film-rewind controls. T-series cameras have built-in motors to transport the film and tend to use pushbuttons and switch-es instead of mechanical levers and dials.

FD LENS CONTROLS

Most current Canon lenses are the FD type. They have the following controls and indicators:

Focusing Ring—Focuses the lens at various distances from the camera. Minimum distance varies among lenses. All focus to infinity.

Focused-Distance Scale—Shows the distance from the film plane in the camera to the subject point in best focus—in feet and meters.

Depth-of-Field Scale—Works with the Focused Distance Scale to show depth of field at various lens apertures.

Aperture Ring—Used to set aperture size manually. To prepare the lens so the camera can set aperture automatically, set the Aperture Ring to the A symbol while depressing the adjacent AE Lock Button.

CAMERA CONTROLS

As you will see, the same function is sometimes performed in different ways, depending on the camera type and model.

Main Switch—Only the location varies among models. When set to L (Lock) the camera is turned off and the shutter locked. When set to A (Advance, meaning proceed) the camera is turned on and can be operated.

Film-Advance Lever—Used to advance film on A-series cameras and the F-1. Not used on T-series cameras because they have a built-in film-advance motor.

Shutter Button—Press to make an exposure. T-series cameras use a built-in film-advance motor to make a continuous series of exposures if you hold down the Shutter Button. A-series cameras and the F-1 use accessory motor-drive attachments for that purpose.

Exposure Mode Selection—The AE-1PROGRAM uses the Shutter-Speed Dial and the A setting of the lens to set the exposure mode. For example, with the dial set to PROGRAM and the lens set to A, the camera is on programmed automatic exposure.

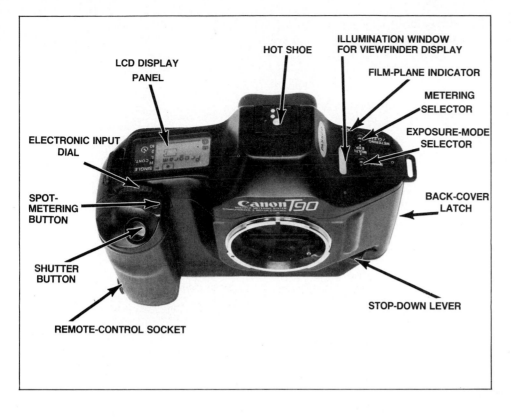

To select an exposure mode on the T-90, depress the MODE button on top of the camera while turning the Electronic Input Dial until the desired mode, such as PROGRAM, is displayed in the LCD Display Panel on top of the camera.

Hot Shoe—Provides a mount for electronic flash and electrical contacts. The T90 has more electrical contacts in the hot shoe because its companion flash, the 300TL, has more automatic features than earlier flash units.

Setting Film Speed—A-series cameras use a mechanical control with a lock button.

To set film speed on the T90, press the ISO button on the back of the camera while turning the Input Dial until the desired speed is shown on the LCD Panel.

Rewinding Film—With an A-series camera, depress the Film-Rewind Button on the bottom of the camera, then turn the Film-Rewind Crank clockwise. The T90 uses a built-in motor to rewind auto-matically, immediately after the last frame of film is exposed.

AE Lock Switch—When the camera is measuring exposure before making a shot, the exposure reading will usually change when metering different parts of a scene. Pressing the AE Lock switch locks the exposure reading so it cannot change. This allows you to meter on a subject at the center of the frame and then recompose so the subject is at the edge of the frame while retaining correct exposure for the subject.

On A-series cameras the AE lock is a switch. On T-series cameras with this capability, AE Lock occurs when the shutter button is pressed partway.

Exposure Preview—On most Canon cameras, depressing the shutter button partway turns on the exposure meter and the viewfinder display that shows the metered exposure settings. Pressing the shutter button farther makes the exposure. To see the metered exposure without the possibility of accidentally making an exposure, press the Exposure Preview button or switch. The location varies. It's on the back of the T90.

Stop-Down Lever—Allows viewing the scene through the selected shooting aperture to see depth of field before making the shot. Among T-series cameras discussed in this book, only the T-90 has a Stop-Down Lever.

Frame Counter—On A-series cameras and the T50, this is a mechanical dial that rotates as film is advanced to show the number of frames remaining. Other T-series cameras show the frame count in an LCD display on top of the camera. The T-90 also shows frames remaining in the viewfinder display.

Self-Timer—When set, the self-timer provides a time delay between pressing the shutter button and making the exposure. A common use of this feature is to take your own picture. The countdown is indicated by a beeper or a flashing red light on the front of the camera, or both. Location of this control varies among models.

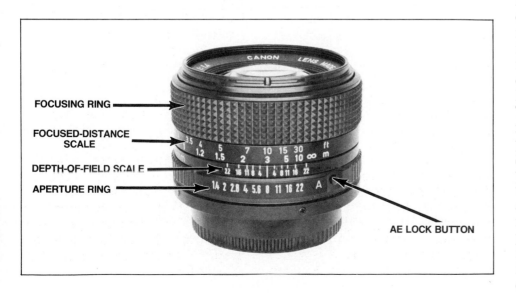

10
HOW LENSES WORK

So far, the discussions of lenses have been either descriptive or practical information on how to attach and remove them. Focal length has been treated as a label that indicates angle of view and magnification. That's all you really need to know to use lenses in normal photography.

Pretty soon, I'm going to discuss close-up and macro photography, and for that you need more basic information about how a lens makes an image, types of lenses, and what focal length means in the technical sense. This requires some formulas and simple math but it has a practical payoff in several ways. The most important is in photography with attachments to the camera. Sometimes you have to think your way through a problem that a recipe won't solve.

If you are interested in more information on most of the technical matters discussed in this book, I recommend another book, entitled *Understanding Photography,* that has impressed me favorably. It is from the same publisher as this book, and by the same author.

LIGHT RAYS

We assume that light travels in straight lines, called *rays,* and light rays do not deviate from straight-line paths unless they are acted on by something with optical properties such as a lens or a reflector.

Light rays that originate from a source such as the sun, or reflect from an object such as a mountain, appear to be parallel rays after they have traveled a considerable

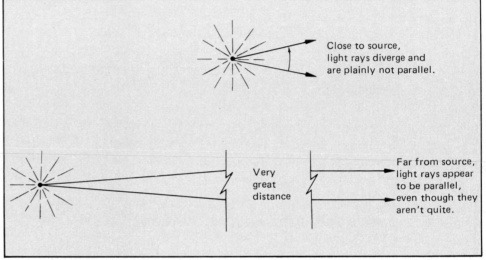

Figure 10-1/Light rays from a point source obviously diverge when you are close to the source. At a great distance, they still diverge, but *appear* to be parallel.

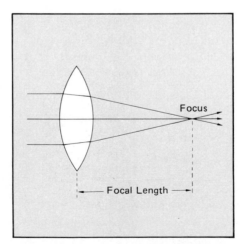

Figure 10-2/Lenses treat rays which appear parallel as though they actually are parallel and bring them to focus at a distance equal to the focal length of the lens.

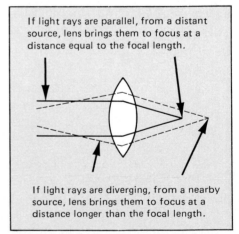

Figure 10-3/Light rays from a distant source are brought to focus closer to the lens than rays from a nearby source. Because the film plane is a fixed location in the camera, focusing is done by moving *the lens* inward or outward, depending on the distance to the subject.

Figure 10-4/A diverging lens causes rays to diverge as they pass through the lens.

distance. In explaining how lenses work, the simplest case is when the light rays reaching a lens have traveled far enough to appear parallel as in Figure 10-1.

CONVERGING LENSES

If you photograph a distant mountain, each point on the surface of the mountain reflects light rays as though it is a tiny source of light. The rays that enter the lens of your camera are effectively parallel. Rays from each point of the scene are scattered all over the surface of your lens but all those that came from one point of the scene should be focused at one point on the film. Here's how a lens does that.

Figure 10-2 shows a simple single-element lens, which is convex on both sides. This is called a *converging lens* because, when light rays pass through, they converge and meet at a point behind the lens.

Focal length is defined as the distance behind the lens at which *parallel* light rays will be brought to focus by the lens. That implies a subject that is far enough away from the lens so the light rays appear to be parallel. We label that distance infinity on the distance scale of a lens, but it actually doesn't have to be very far away.

For example, the farthest marked distance on a Canon 50mm lens is 30 feet and the next symbol is ∞, which indicates in-

finity. Any subject beyond 100 feet or so from this lens appears to be so far away that the light rays from it are effectively parallel.

Because the focal length of a 50mm lens is 50mm, that's how far the lens must be positioned from the film to form a focused image of a distant subject—which we say is at infinity even though it may be close enough that we could hit it with a rock.

Figure 10-2 shows what happens to parallel rays when they are brought to focus by a converging lens. This lens will also image subjects closer than infinity, but it takes a greater distance between lens and film to bring nearby subjects into focus.

Most lenses focus by an internal screw thread called a *helicoid*. When changing focus from a distant subject to a nearby subject, most lenses become physically longer to position the lens elements farther from the film.

Figure 10-3 shows why. Light rays from a nearby subject appear to diverge as they enter the lens. The lens will still change their paths so they come to focus, but because they were diverging rather than parallel, it takes a greater distance behind the lens to bring them all together at a point.

Focusing a camera moves the lens toward or away from the film so there is the needed amount of distance between lens and film. This will bring light rays from the subject into focus at the film, whether the subject is near or far.

Please notice that the *shortest* distance ever required between lens and film occurs when the subject is at infinity and this distance is equal to the focal length of the lens. All subjects nearer than infinity require a longer distance between lens and film. To change focus from a distant subject to one nearby, you move the lens *away from* the film.

DIVERGING LENSES

Diverging lenses are shaped the opposite way and do the opposite thing. Parallel rays entering a diverging lens emerge on the other side as divergent rays—angled away from each other, shown in Figure 10-4.

The image made by a lens for a 35mm camera is a 43mm circle. The part of the circular image which actually falls on the film is defined by a rectangular window in the camera body, opened and closed by the focal-plane shutter. The dimensions of this window and the film frame are 24mm by 36mm. Exceptions are: The 7.5mm fisheye lens and the TS 35mm lens, both discussed later.

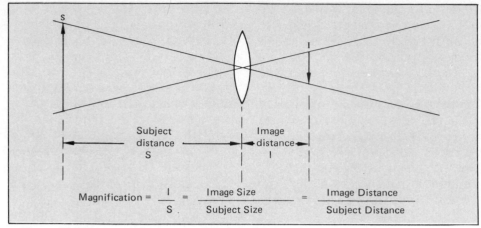

Figure 10-5/Because a lens angle of view is the same in both directions, the ratio of image size to subject size is the same as the ratio of their distances from the lens.

FOCUSING A LENS

The focusing ring on the lens operates on an internal screw thread called a *helicoid*. To focus closer to the camera than infinity, the lens travels outward on the screw thread. When the end of the thread is reached, that's as close as you can focus with that lens. With different lenses, the shortest focused distance varies, ranging from inches with short-focal-length lenses to feet with long lenses. There are accessories to focus a lens closer than the minimum distance on the focus scale, discussed in Chapter 13.

THE IMAGE

A circular lens makes a circular image of a circular portion of the scene. In the camera, a rectangular mask or opening in front of the film allows only part of the circular image to fall on the film.

Even though the camera viewing system shows you an image with correct orientation, the image on the film is upside down and reversed left-to-right.

MAGNIFICATION

Magnification is illustrated with the outside rays of the lens, Figure 10-5, in which the subject is an arrow and the image is an upside-down arrow. The arrows extend across the field of view.

Magnification is a ratio or fraction: *the size of the image divided by the size of the subject.*

The angle of view is the same on both sides of the lens. The sizes of image and subject are therefore proportional to their distances from the lens. If image and subject are the same distance from the lens, they will be the same size.

This leads to two ways to think about magnification. You can compare sizes or you can compare distances. Either way, you get the same answer. A simple formula to figure magnification, M, is:

$$M = I/S$$

where I is either image size or image distance from the lens, and S is either subject size or subject distance.

FLATNESS OF FIELD

Canon cameras are very carefully designed to hold the film as flat as possible while it is being exposed. Lenses would work better and require less correction if the film were curved in both directions as though it were a section of a sphere. Nobody has figured out how to make and handle film that way, so lenses are corrected for flatness of field. This means that if you photograph a flat surface such as a newspaper, all parts of the image should be in good focus on the flat film in the camera. If not, the lens correction for flatness of field is poor.

This is not of concern in most photography of nature, people and other non-flat objects. In close-up photography, many people copy things like postage stamps. For this purpose, Canon offers several *macro* lenses with special correction of flatness of field.

FLARE AND GHOST IMAGES

Light arriving at the air-glass surface of a lens is partly reflected at the surface and partly transmitted in the direction we want it to travel. This happens at both surfaces of a piece of glass, so there are internal reflections within a single glass lens element and multiple reflections in a compound lens with several glass elements.

In general, light that is deflected or scattered from its original path of travel will land somewhere it doesn't belong. This tends to put light on the film where there would otherwise be less light. The stray light has been "robbed" from areas where it should have been. Therefore, light areas on the film are not as light as they should be and dark areas are not as dark. The result is a general reduction in *contrast* between light and dark areas.

If the light that is scattered around by lens reflections forms no definite image on the film but is an overall fog or even a fog over a relatively large area of the picture, we call it *flare*.

Sometimes the reflections from lens surfaces happen in a way that causes a definite shape on the film. Images of this sort are called *ghosts*.

The cure is to reduce light reflection at each glass-air surface, which is done by lens coating.

LENS COATING

The first lens-coating method was a single very thin layer of a transparent material such as magnesium fluoride, applied by vacuum deposition.

Canon refers to a single coated layer as Spectra Coated, abbreviated S.C. A single layer is most effective at a single color of light.

A more recent development is multiple-layer coating, called Super Spectra Coating, S.S.C. This type of coating is effective at more than one color of light and generally superior to a single layer.

On old-style FD lenses, the type of coating is indicated by engraved letters: S.C. or S.S.C. With current FD lenses, this indication is not used. All current FD lenses have S.S.C. multicoating with the exception of the 50mm *f*-1.8 lens, which has S.C. coating.

LENS ABERRATIONS

To photographers, lens aberrations are like the boogie-man: mysterious, threatening and always lurking around trying to do something bad. Aberrations of a lens cause defects in the image.

There is a long shopping list including *spherical aberration, chromatic aberration, coma* and *astigmatism.* All lenses have all of these defects to some degree. Total elimination is probably impossible but partial elimination of these defects, called *correction,* is part of the design of each lens and, for more money you get more correction.

Part of the problem is the fact that the surface of conventional lenses is spherical, mainly for ease of manufacture. Another part of the problem is lens glass that does not behave the same with different colors of light—called chromatic aberration.

Correction of lens aberrations is done three ways. Basic is the design of the lens itself, using multiple pieces of carefully-shaped glass, called elements, to make a complete compound lens assembly in a mechanical housing.

To correct some of the lens aberrations, glass of differing chemical composition is used for the various elements in the lens. A limitation in the past has been the range of different types of glass.

Fluorite is a transparent crystal found in nature that has certain optical properties that are superior to lens glass. Use of a fluorite element in the lens greatly improves the correction for chromatic aberration.

A way to reduce aberration caused by spherical lens elements is to use aspheric (not spherical) elements in a lens. Canon has lenses in production using aspheric elements.

The manufacture of spherical lenses whose surfaces are "round" has been pretty well standardized. To make an aspheric lens surface and hold the dimensions of the surface to a few millionths of an inch requires special manufacturing methods and quality control. Canon aspheric surfaces are glass, not molded plastic, and producing them in quantity is a technical achievement.

As a practical matter, there isn't anything the user can do about the construction and design of a lens except to buy lenses from a reputable manufacturer such as Canon. Canon is a leader in lens design and has won world-wide recognition for the high quality of Canon lenses.

Most lens aberrations have less effect on the image if the lens is used at small aperture. Using ordinary films, it's hard or impossible to see any difference, but theoretically it is better to shoot at an aperture smaller than wide-open.

L-TYPE LENSES

In the nomenclature of old FD lenses, the words *fluorite* and *aspheric* were used. Today, Canon uses these improvements along with other techniques such as special ultra-low-dispersion glass in lens elements. To simplify nomenclature on some FD lenses and all New FD lenses, the letter L is now used to designate lenses that are specially constructed to give unusually good performance, no matter how accomplished.

DIFFRACTION

Diffraction happens when a light ray makes grazing contact with an opaque edge such as the lens barrel and the edges of the aperture. Rays that contact the metal edge of the aperture on their way into the camera are changed in direction slightly, bending toward the metal edge.

Canon L-type lenses have a red ring engraved around the barrel, near the front of the lens. This is the FD 300mm *f*-2.8L.

Ghost images are unpredictable. Shooting into the morning sun caused one near the bottom of this picture.

Macro lenses are designed to allow closer than normal focusing so you can get pictures like this.

Also, a pattern of alternating light and dark bands of light is formed.

Light rays from any point of a scene should converge to a point-image on the film. Because of diffraction, some of the rays will be diverted and the image will be spread out. Only those rays that pass very close to the edge of the aperture are affected—those that go through the center of the lens are not diffracted.

Therefore, the amount of image degradation due to diffraction depends on what proportion of the rays graze by the edge of the aperture and what proportion pass through the center part of the hole.

As an aperture is made smaller, there is more edge in proportion to the center area, so the total percentage of rays that are diffracted is higher.

OPTIMUM SHOOTING APERTURE

If a lens is tested for image quality, starting at maximum aperture, the image will improve as the lens aperture is closed because the effect of aberrations is reduced. It varies among lenses, but typically at around *f*-5.6 or *f*-8 the image is as sharp as it's going to get. Further reductions in aperture size cause diffraction effects to degrade the image. This degradation is gradual and even at *f*-22 it is unusual to identify diffraction effects with the unaided eye.

Usually there are other compelling reasons that determine aperture size, but if you have none and you want the best image, set the lens at an *f*-stop near the center of its range.

LENS NODES

As you remember, the technical definition of focal length is the distance from a certain location in the lens to the film when the lens is focused at infinity.

All lenses mount on the camera the same way and at the same place, so you may wonder how a long-focal-length lens finds additional room behind the lens to make the image.

Image distances are not tiny. As a rule of thumb, 25mm equals one inch. A 50mm lens needs about 2 inches between lens and film. A 200mm lens needs about 8 inches behind the lens to make a focused image.

Each lens of different focal length does have the correct distance between lens and film when mounted on the camera, but it's done optically rather than mechanically. There is a point in the optical path from which the distance to the film is figured. This point is called a *node,* and its location is determined by the optical design of the lens rather than its mechanical construction. To get a longer optical distance between lens and film, the node is moved forward by scientific trickery. You can't see a node and you can't find

it to measure from, but it's there. You can always assume that the optical distance between lens node and film is equal to the focal length of the lens—when the lens is focused at infinity.

TELEPHOTO LENSES

The basic requirement to make a long-focal-length lens is to have a relatively long distance between the lens and the film. This can be done in a clever way by using a diverging lens element in the lens as shown in Figure 10-6.

The first lens converges the rays so they would come in focus as shown by the dotted lines. Before reaching the film, the converging rays are intercepted by the diverging lens element, which causes them to converge at a greater distance as shown by the solid lines.

Lenses built this way are called *telephoto*, although in popular language the word has come to mean any long lens. The telephoto principle has two advantages. A lens can be physically shorter than it would be without the diverging element. The node can be located where it needs to be so the focused image lands on the film plane in the camera body.

Telephoto lenses can be identified by looking into the front and back of the lens while holding it away from your eye and pointing it toward a window. At each end of the lens you will see a spot of light, called a *pupil*, which is actually the lens aperture seen through that end of the lens.

With a conventional lens, the two pupils will be the same size or nearly so. With a telephoto lens, the pupil seen looking in the front will be plainly larger than the pupil seen looking in the back. If you change aperture while looking at a pupil, you will see the size of the pupil change also.

RETROFOCUS LENSES

The telephoto design can be used to move the lens node forward so there is enough space between the node and the film plane to accommodate a long focal length.

Figure 10-6/Telephoto lenses use a diverging lens element which increases the lens-to-film distance and gives a longer focal length.

The problem is reversed with very short focal-length lenses. For example, a 24mm lens has a focal length of about one inch. The distance between the lens mounting surface and the film plane on Canon camera bodies is about 1.5 inch. A conventionally-designed 24mm lens would make a focused image about one-half inch in front of the film plane in the camera—with the lens set at infinity.

The design principle of the telephoto lens can be reversed to move the lens node toward the film plane rather than away from it. A *reversed telephoto* lens design is often called a *retrofocus* lens. The design is used primarily to fit a short focal-length lens onto a camera body whose dimension between lens mount and film is longer than the focal length of the lens. It moves the node closer to the film.

With a retrofocus lens, the pupils are not the same size either—the rear pupil is larger than the front.

TELE-EXTENDERS

Accessory lenses called *tele-extenders* fit between a camera lens and the camera body. Tele-extenders are diverging lenses placed in the optical path to give the same effect as the diverging lens in a telephoto design. The focal length of the lens and tele-extender combined is longer than the focal length of the lens alone.

The optical effect of a tele-extender is to multiply the focal length of the lens it is used with. The identification number of a tele-converter is also the focal-length multiplier. A 2X tele-extender used with a 50mm lens gives it an effective focal length of 100mm.

A disadvantage of tele-extenders is that they also multiply the effective *f*-number of the lens. An *f*-1.4 lens used with a 2X tele-extender behaves like an *f*-2.8 lens and you lose two steps.

Canon has made two types of tele-extenders. One is intended only for use with a specific lens and is packed with that lens. Another type is intended for use with a group of lenses.

Recent advances in optical design allow production of a tele-extender for use over a specified

If the disc of light seen looking into the front of a lens is considerably larger than the disc seen from the back, it's a telephoto lens.

This tele-extender can be used to double focal length and *f*-number of any Canon FD lens with focal length of 100mm or longer.

All lenses are optically and mechanically complex, but zoom lenses are more so. This is a cutaway view of the FD85-300mm *f*-4.5 zoom lens.

range of focal lengths without visible reduction in image quality.

Canon currently offers three tele-extenders. Each preserves all automatic features of FD lenses.

Extender FD 1.4X-A—For use with any FD-type fixed-focal-length lens with a focal length of 300mm or longer.

Extender FD 2X-A—For use with any FD-type fixed-focal-length lens with a focal length of 300mm or longer. Also for any FD-type zoom lens that includes 300mm in its zoom range.

Extender FD 2X-B—For use with any FD-type fixed-focal-length lens with a focal length of less than 300mm. Also FD-type zoom lenses

that are shorter than 300mm.

Exceptions—A-type tele-extenders are recommended for the FD 200mm *f*-4 Macro lens. The FD 2X-B tele-extender is recommended for the FD 300mm *f*-2.8L lens.

Accessory tele-extenders not made by Canon are available to fit Canon cameras and lenses. There is no assurance that all of these units will preserve satisfactory image quality and accurately transmit mechanical movements between lens and camera body.

ZOOM LENSES

All I will attempt to do here is give you the general idea of what happens inside a zoom lens. As you probably know, these lenses can be focused on a subject and then the lens focal length can be changed to alter the magnification and the size of the image on the film.

If you will please refer back to Figure 10-6, which shows how a diverging lens alters the focal length of a converging lens, it will be apparent that the distance between the converging and diverging lens controls the focal length of the combination.

Zoom lenses are complex, using many glass elements in a mechanical assembly that requires high precision and extremely close manufacturing tolerances. They work by moving lens elements inside the lens tube to alter focal length. It would be ideal if nothing changed except focal length when zooming the lens. Focus should remain sharp while image size changes; the *f*-number of the lens should remain constant; and aberrations should not increase.

In practice this is difficult to accomplish. A lens design can preserve good focus at one or more points along the zoom range, but it is difficult to keep sharpest focus at all focal lengths.

Focus a zoom at its longest focal length where depth of field will be smallest and, therefore, the focus adjustment will usually be more accurate. Then zoom to shorter focal lengths.

If you do it the other way, you can miss exact focus slightly when starting at a short focal length, because of the greater depth of field available. Then when you zoom to a longer focal length and get less depth of field, your subject may be outside the zone of good focus.

It would be ideal to have a zoom lens with a zoom range from zero to infinity, but practical limitations restrict the range so lenses usually zoom in a limited range of focal lengths such as 35mm to 70mm, 100mm to 200mm and 85mm to 300mm.

MACRO LENSES

Macro means photography at magnifications of 1.0 or greater. Close-up photography includes magnifications from 0.1 up to 1.0. The dividing point—a magnification of 1.0—is called *life-size*.

Conventional lenses are corrected for aberrations on the assumption that the subject distance will be considerably longer than the image distance. At magnifications greater than 1.0, image distance is longer than subject distance. Conventional lenses work better if physically reversed on the camera to keep the long dimension on the same side of the lens even though that long dimension becomes image distance.

Canon supplies reverse-mounting rings to attach lenses backward. The loss of camera automation when this is done is usually not a major problem.

Because of increasing interest in close-up and macro photography, Canon has developed special lenses for this purpose, described in Chapter 14.

MIRROR LENSES

Mirror lenses have curved mirrors inside to reflect light rays. Because of the mirrors, light travels in two directions inside the lens to reduce the physical length of the tube. Mirror lenses are normally made only in long focal lengths.

Mirror lenses are sometimes called *reflex* lenses to imply reflection inside the lens. Lenses using

both mirror surfaces and glass elements are called *catadioptric*.

The catadioptric design produces a very compact and lightweight lens in long focal lengths with two disadvantages. Out-of-focus bright points in the scene appear as circles with a dark center. These "doughnuts" are characteristic of mirror lenses. The other disadvantage is that the lenses have fixed aperture. Exposure control is done by choosing shutter speed and film speed. If necessary, neutral-density filters are also used to control exposure.

The Canon Reflex 500mm *f*-8 is a catadioptric lens. It is only about half the length and one-fourth the weight of a conventional 500mm lens of similar aperture.

TILT AND SHIFT LENS

The Canon TS 35mm *f*-2.8 S.S.C lens is a very unusual design for 35mm cameras. TS means Tilt and Shift, language borrowed from view cameras.

These adjustments are useful for photographing architecture and to maintain good focus along a subject, such as a wall, that angles in respect to the film plane. The lens can be moved up and down, or sideways, while remaining parallel to the film. This is called *shift*. It can also be *tilted* so it is no longer parallel to the film plane.

To do these tricks, the image circle made at the film plane must be considerably larger than the frame on the film.

Any lens for a 35mm camera has to cover a 43mm circle—the diagonal of the film frame—with good focus and even illumination. The TS lens makes an image circle about 1/3 larger, covering 58mm in diameter.

This is good news and bad news. The bad news is that you can't get all of that image on the film. The good news is: You can get any part of it you want, within limits. This allows photographing tall buildings without the building seeming to get narrower as it gets higher. You get rid of the illusion that it is falling over backward.

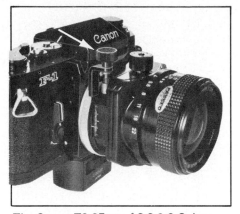

The Canon TS 35mm *f*-2.8 S.S.C. lens solves a lot of photographic problems. It is shifted by the screw adjuster (arrow) and the amount of shift is indicated by the scale on the side.

The unique Canon TS lens also tilts so the lens points off-axis. Knob at the center (arrow) does the tilting as indicated by the adjacent scale. The tilt adjustment is locked by a knob on the bottom of the lens.

To photograph buildings without the perspective-effect of falling over backward, you must keep the plane of the film parallel with the face of the building. A good way to judge this is to compare the lines made by the sides of a building with the lines made by the sides of the viewfinder. If they are parallel, the building will record on film with uniform width from top to bottom.

With an ordinary camera used at ground level and not aimed upward, the tall building looks fine but you only get the lower few floors and most of the parking lot. You can move back to get more building in the picture, but you also get more parking lot.

Figure 10-7 is a drawing to show how shifting the lens helps. Notice that the film is parallel to the build-

Here's one of the problems the TS lens can solve. If you point the camera upward to get all of the building, it seems to be leaning backward. Sometimes the effect is subtle.

Hold the camera so the film is parallel to the building, shift the TS lens upward, and you get the shot without the peculiar "leaning backward" effect.

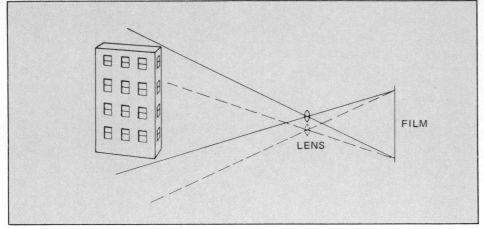

Figure 10-7/Shifting the lens upward changes the part of the scene which falls on the film.

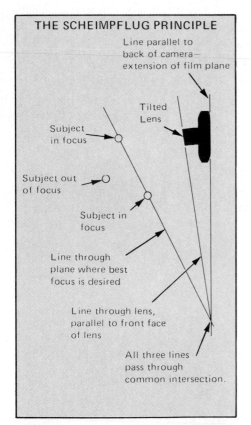

THE SCHEIMPFLUG PRINCIPLE

Line parallel to back of camera—extension of film plane

Tilted Lens

Subject in focus

Subject out of focus

Subject in focus

Line through plane where best focus is desired

Line through lens, parallel to front face of lens

All three lines pass through common intersection.

Figure 10-8/To figure which way to tilt, imagine you are looking from above at the camera and scene. Imagine a line extending from the film plane, a line through the lens parallel to the front face, and a third line through the scene which passes along the plane where best focus is desired. Arrange camera position and lens tilt so all three of these lines intersect at the same point. Make final adjustments by looking through the viewfinder.

ing. With the TS lens in normal position on the camera, the view is shown by dotted lines—part of the building and some of the parking lot.

To include the top of the building in the photo, the lens is moved upward as shown by the solid lines in the drawing. Now the photo includes the top of the building and less foreground.

The TS lens has a screw adjustment to allow shifting the lens so you can hold the film plane parallel to buildings and also control the amount of building in the picture.

The TS lens rotates in its mount so you can tilt and shift vertically, horizontally, or any angle in between. Knob visible on bottom is tilt adjuster lock.

The entire lens can be rotated in its mount to allow shifting vertically, horizontally, or any direction in between.

In addition to the shift feature, you can also tilt the lens in respect to the film plane. If the lens is positioned so the shift movement is vertical, then the tilt movement is side-to-side, or left-to-right.

The purpose of tilting a lens is to hold focus on a surface—such as a wall—at an angle to the film. Because of the angle between wall and film, the distance to different parts of the wall is not the same. With an ordinary lens, the only thing that helps keep all parts of the wall in focus is depth of field. If depth of field isn't enough, some of the wall goes out of focus.

Tilting the lens in respect to the film improves focus along an angled wall or fence by using Scheimpflug principle, illustrated in Figure 10-8. This drawing shows how to achieve the desired result with a tilting lens.

Canon TS lenses can be shifted and tilted simultaneously, with separate controls for each. When looking through the viewfinder, the effect of shift is obvious and easy to see—the whole scene moves in the viewfinder. The effect of tilt is more subtle and often much more apparent in the developed slide or print. The best way to become familiar with lens-tilt effects is to shoot some pictures and examine the results.

HYPERFOCAL DISTANCE

Just as the discovery of our friend Scheimpflug leads to practical information you can use, so also does the optical designer's term *hyperfocal distance*.

If you focus a lens at infinity, it has some depth of field in both directions from the focused distance. However, the part that extends beyond infinity is wasted because nobody lives there.

When focused at the hyperfocal distance, the lens has more total depth of field than at any other setting of the focus control. Therefore, focusing at the hyperfocal dis-

tance is a good way to set the camera when you are carrying it around. Then, if something happens suddenly and you want to shoot as fast as possible, you have a very good chance of getting the picture without fooling around with focus.

Finding the hyperfocal distance is easy because it is just the near limit of depth of field, when the lens is set for infinity. You read it off the lens. It will vary with *f*-stop, but the depth of field indicator on the lens takes care of that problem.

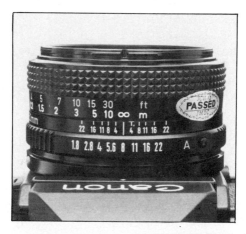

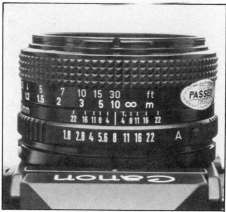

Top lens is focused at infinity and set at *f*-8. Depth of field starts at *10 meters* and goes beyond infinity. Refocus the lens to 10 meters which is the hyperfocal distance (H) for *f*-8.

In the bottom picture, depth of field now extends from 5 meters to infinity and none is wasted. When focused at H, near limit of depth of field is always half H. Far limit is always infinity. This setting always gives maximum depth of field for any *f*-stop.

Set the lens to infinity and notice the near limit of depth of field, at the aperture you intend to use. Then refocus to that distance.

HOW FD LENS AND CAMERA WORK TOGETHER

As you remember, the FD lens has pins and levers to allow full-aperture viewing, full-aperture metering and automatic aperture operation by the camera. It also works with automatic cameras so the camera can set lens aperture.

In the accompanying photo, you see the front of the camera body and the back of an FD lens. Three signaling devices affect stopping down and metering:

The Automatic-Aperture Feature —When a lens is mounted on the camera, the Automatic Aperture Lever on the lens is just left of the Stopped-Down Coupling Lever on the camera. When you depress the shutter button on the camera, the Stopped-Down Coupling Lever moves to the left (in the photo) and pushes the Automatic Aperture Lever on the lens along a curved slot. This causes the lens aperture to stop down to the *f*-number selected on the lens. Then the shut-

ter opens to make the exposure.

Some cameras have a control called *Stop-Down Lever* or *Stop-Down Slide* that you use for two purposes: to meter stopped-down, and to view depth of field with the lens stopped down. The Stop-Down Lever on the camera moves the Automatic Aperture Lever on the lens to stop down the aperture. There are some special procedures in using the Stop-Down Lever. See Chapter 18.

To Disable Automatic Aperture—When an FD lens is mounted on the front of *non-automatic* accessories such as a bellows, it is necessary to operate the lens with *manual control* of aperture. Remove the lens and use your finger to push the Automatic Aperture Lever fully to the right. The lever must be held in that position. Most old-style FD lenses have a

LENS	CAMERA
Aperture Signal Lever	Aperture Signal Coupling Lever
Full Aperture Signal Pin	Full Aperture Adjustment Pin
Automatic Aperture Lever	Stopped-Down Coupling Lever

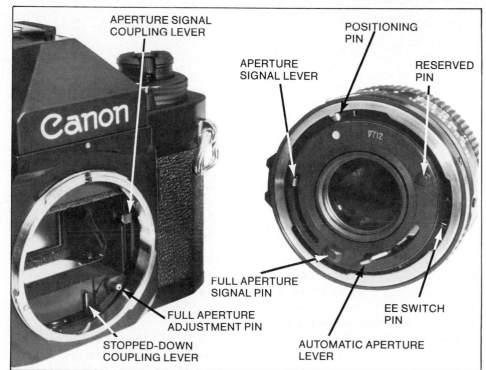

Pins and levers on camera body and lens work together to provide the automatic features of an FD lens.

detent that holds the lever in that position.

Most New FD lenses use an accessory Manual Diaphragm Adapter that fits into the slot to hold the lever fully to the right. Then the aperture will change size as you rotate the aperture ring on the lens. *Never* set a lens this way and then mount it directly on an automatic camera or on the front of automatic accessories.

To put the lens back on automatic aperture, return the Automatic Aperture Lever to the left in its slot.

Full-Aperture Metering—To meter at full aperture, the camera must "know" two things: the maximum aperture size of the lens and how many steps you have rotated the aperture ring away from its maximum-aperture setting.

The Full Aperture Signal Pin on the lens presses against the Full Aperture Adjustment Pin in the camera. The pin on the lens is a different length for different maximum aperture values. It "tells" the camera the maximum aperture of the lens you have installed.

When you rotate the aperture ring on the lens, the Aperture Signal Lever on the back of the lens moves up and down to signal how many steps the setting is away from full aperture. The camera receives this signal because the Aperture Signal Coupling Lever on the camera fits just beneath the Aperture Signal Lever on the Lens—so they move up and down together.

Lenses and accessories that provide this information to the camera meter are sometimes called *meter-coupled*.

Setting an FD Lens for Automatic Exposure—For most Canon SLR cameras, the control that selects automatic is the aperture ring on the lens. At the right end of the scale on the aperture ring is a green letter A, for Automatic. On older lenses, it's a green O. To select automatic operation, rotate the aperture ring until the A or O is opposite the index mark.

An exception is the aperture-priority automatic mode of the F-1.

In this mode, you must choose an aperture on the lens, using the aperture ring; therefore, it cannot be set on A. Automatic operation is selected by turning the shutter-speed dial to A.

FD lenses have a pushbutton near the aperture scale called AE Lock Pin. You must depress this pin to set the lens to A or turn it away from A so you can select aperture manually.

When set to automatic, a tiny metal EE Switch Pin projects from the back of the lens. Cameras with automatic-exposure have a matching hole in the lens mount; non-automatic cameras do not have the hole. If the lens is set to A, the pin projects and you can mount the lens only on automatic cameras. If the lens is not set to A, the pin does not

project and you can mount the lens on any Canon SLR. Once the lens is mounted, you can turn the lens to A only if it is mounted on an automatic camera with the hole for the EE Switch Pin.

Controlling Lens Aperture Automatically—When the aperture ring on an FD lens is set to A, the function of the Aperture Signal Lever changes.

With manual aperture control, this lever moves up and down as you rotate the lens aperture ring to *tell the camera what lens aperture has been selected*.

When the lens is set to A, the Aperture Signal Lever on the lens is mechanically disconnected from the aperture ring. The camera then controls the position of the lever and thereby controls aperture size.

To set an FD lens so the camera can select lens aperture automatically, rotate the aperture ring to place the green letter A opposite the index mark as shown. Current FD lenses have a small pushbutton adjacent to the A that you must press to select A or move the control away from A.

VIEWING AND FOCUSING

When hand-holding the camera, take a relaxed, stable position. Grip the camera firmly, pressing it against your cheek and forehead. Stop breathing while you smoothly squeeze the shutter button.

To hold the camera vertically, most photographers put the shutter button at the top. Left-eyed people encounter nose interference and may need the thickness of a thumb between camera and forehead. It's a good idea to support the lens with your left hand.

Some photographers prefer to make a vertical shot this way, using the thumb to operate the shutter button. However you do it, learn to minimize camera motion during exposure.

In an SLR camera, one purpose of viewing the image from the lens is to see if it is in good focus. This is done by examining a ground-glass *focusing screen* above the mirror with the mirror angled so it intercepts light rays from the lens. The irregular surface of the ground-glass screen is called a *matte* surface. Each small point on the screen receives light from the lens and becomes luminous. Each point retransmits light rays toward the eye of the photographer. What you see is the image on the screen, whether it is in focus or not.

The camera is designed so the distance from lens to film is the same as the distance from lens to focusing screen by way of the mirror. Therefore, if the image is in focus on the focusing screen, it will also be in focus on the film when the mirror is moved out of the way. When you make focus adjustments, you are using the focusing screen as a substitute for the surface of the film.

Because this screen is used both to view the scene and to check focus, it has two common names: *focusing screen* and *viewing screen*.

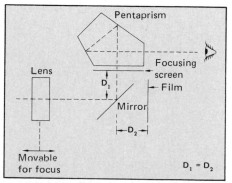

Distance from lens to focusing screen by way of mirror must be identical to distance from lens to film when mirror is raised. Judging focus by looking at the screen is equivalent to examining the image on the film.

FOCUSING SCREEN BRIGHTNESS

A rough matte surface on a focusing screen causes some lost light and reduced image brightness. Recent Canon models, identified in Chapter 18, use improved screens, called Laser Matte screens. They have a finer

Figure 11-1/Most focusing screens use an irregular *matte* surface, similar to ground glass, to intercept the image and make it visible. Without optical correction, some of the light at the edges of the screen goes out of the observer's field of view, so the edges appear darker than the center.

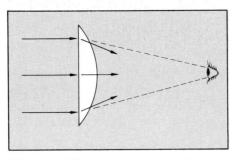

Figure 11-2/Correction of uneven illumination of a focusing screen is made by a *field lens,* which bends the outside light rays toward the viewer's eye.

Figure 11-3/To save weight and space, a converging lens can be "flattened" by removing circular segments of material from the inside. This is a Fresnel lens. When viewed from the front, faint circles may be visible.

and smoother texture and are 50% brighter than old-style screens.

A further improvement, available in some focusing screens, is called Bright Laser Matte. The contours of the irregularities that form the matte surface are even smoother; therefore, the image is brighter.

A matte screen works fine as a way of locating a plane on which to judge image focus. It will be brighter in the center than the edges unless the brightness is corrected by another lens.

As shown in Figure 11-1, each point of the matte screen, when acting as a light source, sends light rays forward in all possible directions. Away from the center of the screen, some of the rays are not directed toward the observer's eye, so the screen appears dark around the edges.

More uniform brightness is obtained by use of a converging *field lens,* which bends the rays from the edges of the screen toward center, as shown in Figure 11-2.

A field lens to improve screen brightness tends to be thick and heavy. It is possible, for special applications, to remove material from inside the lens without changing the contour or shape of the surface. Visualize the result, a *Fresnel lens,* by looking at Figure 11-3. The lens is divided into a series of concentric rings by slices through the lens.

Each concentric ring can be made thinner by removing material from the inside without changing the shape of either top or bottom surface. The Fresnel lens works the same as a conventional lens except that the vertical faces between the circular segments of the lens may appear as circular lines in the image. For use in a camera viewfinder, the circles are not objectionable.

Sometimes, more than one converging lens is used to perform the ray-bending needed to correct focusing screen brightness. Canon focusing screens have a Fresnel field lens on the bottom surface

Figure 11-4/A biprism is two wedges of glass, tapering in opposite directions. Normally made to fit a circular area in the center of the viewing screen.

and also a curved top surface that acts as a conventional field lens.

FOCUSING AIDS

Judging focus by looking at the image on a matte screen depends a lot on how good your eyesight is. Even with good vision it may be inferior to other methods, called *focusing aids.*

A split-image focusing aid is two small prisms with their faces angled in opposite directions as shown in Figure 11-4. The outer edges of the prisms are trimmed to form a circle. It is called a *biprism,* although Canon literature refers to it as a *rangefinder.*

Each of the two prism faces bends light rays that pass through it. If the image from the lens is brought to focus *in front of* the focusing screen, rather than at the screen, the two halves of the image appear misaligned as shown in Figure 11-5.

If the image comes to focus on the viewer's side of the screen, the effect is reversed and the image is misaligned in the opposite direction. At the point of best focus, the two halves of the image are not displaced in respect to each other.

Imagine that your eye is looking out at the scene through the biprism and the lens. Your line of sight will be displaced in one direction by one prism and in the other direction by the other prism.

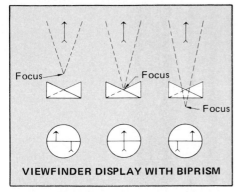

Figure 11-5/A biprism visually separates lines into two displaced segments when the image is not in focus.

Figure 11-6/A Canon improvement to the conventional biprism is the New Split focusing aid. It produces a split image, similar to a biprism, but does it in a new way.

Even though the prism angles allow you to look through the lens at full aperture, a smaller aperture may block your line of sight so you look at the back of the aperture diaphragm. This is common with focusing aids of this type and the biprism will seem to go black on one side or the other.

The side that goes black depends on where your eye is. Move your head one way or the other and the opposite side of the biprism will go black.

Large prism angles cause large image displacements when the image is not in focus, and therefore give a good indication of focus. However, the larger the angle, the sooner the focusing aid blacks out when you stop down the lens. If the *maximum* aperture of a lens is smaller than the size that causes blackout, the focusing aid can not be used with that lens.

Standard lenses start to black out the biprism focusing aid at about *f*-4. At *f*-5.6 and smaller

apertures, the focusing aid does not work.

Canon developed a new type of focusing aid called the New Split rangefinder. Instead of two prisms as shown in Figure 11-4, each prism is replaced by *a group of tiny individual prisms* in a row as shown in Figure 11-6. There are two groups facing in opposite directions so they work collectively as a biprism. The sloping surface of each tiny prism has two different angles. The smaller angle, at the top, works with smaller apertures; the larger angle, at the bottom of each prism, works with larger apertures.

This focusing aid works at apertures from *f*-1.2 to about *f*-5.6. At smaller apertures, it does not function as a focusing aid but it doesn't black out totally. Therefore, it is not as distracting to the viewer.

Both the biprism and the New Split focusing aids split vertical lines when the camera is held with the long dimension of the frame horizontal. If the scene does not have definite vertical lines, rotate the camera 90 degrees while focusing and the focusing aid will split horizontal lines.

Another screen, the Cross Split-Image, is a combination of two New Split aids.

It appears as a cross in the center of the viewfinder. The vertical line splits horizontal lines in the image. The horizontal line in the viewfinder splits vertical lines in the image. This allows you to focus on either vertical or horizontal lines without rotating the camera.

A focusing aid that is useful on scenes without strong geometric lines is a *microprism,* shown in Figure 11-7.

It is an array of many small pyramids whose intersections work in a way similar to the biprism. Visually, the microprism displaces small segments of an out-of-focus image causing it to "break up" and have an overall fuzzy appearance. When focus is reached, the image seems to "snap" into focus.

Figure 11-7/A microprism is an array of small pyramids whose intersections work like little biprisms. Microprisms work well on any subject with surface details.

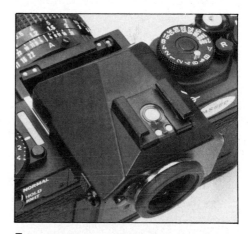

To remove the viewfinder of an F-1, squeeze the two buttons on each side and slide the finder backward. To install, slide the finder forward until it clicks into place.

A microprism is even more helpful when hand-holding the camera. You can jiggle the camera—on purpose or because you can't help it—and the image will seem to scintillate when it is out of focus.

Because operation of the microprism is similar to the biprism, it has the same problem with blackout at reduced apertures. Blackout at around *f*-5.6 is also usual with microprisms.

The Canon F-1 has a removable viewfinder to allow the user to interchange focusing screens as shown in Chapter 18.

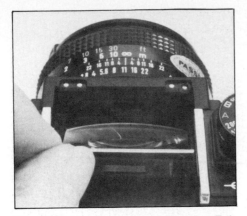

To change the focusing screen in an F-1, remove the viewfinder. Then lift up the rear edge of the screen until it clears the back of the camera. Lift the screen out. Be careful not to touch or scrape either surface of the screen. The bottom surface is precision-molded plastic and is especially vulnerable. To install another screen, reverse the procedure. Focusing screens for the New F-1 are not interchangeable with screens from the "old" F-1.

Some Canon cameras have rectangular viewing windows, some round. Dioptric Adjustment Lenses are made to fit either shape, identified as S and R for square and round. To put your eyeglass prescription into the viewing optics so you can shoot without wearing your glasses, order the Dioptric Adjustment Lens nearest to your distant-vision eye correction. For example if your eye correction is +1.5 diopters and your camera has a square (rectangular) viewing window, order S +1.5.

The A-1 also uses interchangeable screens, shown in Chapter 18, but they are not user interchangeable. They can be changed at Canon Service Centers.

The AE-1 PROGRAM camera accepts screens that are user-interchangeable. They are changed by removing the lens and using a special tool to reach into the camera body, as shown in Chapter 18.

Combined Focusing Aids—Some focusing screens have two focusing aids. A split-image surrounded by a microprism gives you a choice without having to exchange focusing screens.

VIEWING AIDS

Accessories are available that attach to the viewing eyepiece of all camera models. Dioptric Adjustment Lenses allow you to put your eyeglass prescription into the viewing lens.

A rubber eyecup excludes stray light while you are looking into the viewfinder. It makes viewing more comfortable for some people and prevents reflections from the glass surface of the view-finder window, which can be distracting and prevent a good view of the screen.

The normal viewing arrangement through the window on the back of the camera is called eye-level viewing and is convenient for most shooting. If you have the camera at ground level, it is inconvenient to get your eye where it needs to be to look through the finder window.

Two Angle Finders, B and A2, mount on the viewing window and can be positioned so you view from the top of the camera. The angle finders can also be rotated to allow other ways to view. They have their own adjustments to fit your eyesight.

Angle Finder B gives a correct image, left to right and top to bottom, meaning there is no reversal of the image. Angle Finder A2 is a simplified type that reverses the image from left to right, but not vertically.

Rubber eyecups are comfortable and exclude stray light which can make viewing difficult and may influence the exposure meter reading by coming into the "back door" of the camera. They are made to fit square and round viewing windows.

Magnifier attaches to viewing window and magnifies part of the focusing screen so you can judge precise focus. It also flips up for normal viewing. Useful for copying and high-magnification photography.

For critical focusing, a Magnifier can be attached to the viewfinder. Magnifying the image on the focusing screen helps focus accurately, but you can't see the entire screen. For composing, move the magnifier up out of the way.

PENTAPRISM

The image placed on film by a lens is upside down and reversed left-to-right. A mirror is used to intercept this image and reflect it upward into the camera viewing system.

Angle Finder B snaps in place and allows viewing from the top or at an angle.

The F-1 uses windows to admit light to illuminate the exposure displays. The window on the camera top is used with all viewfinders to illuminate the display on manual or shutter priority. AE Finder FN provides an additional mode, aperture priority. The display for this mode is illuminated by light from the window on the front of this finder.

Each reflection from a flat surface reverses an image, either left-to-right or top-to-bottom, depending on how the image strikes the reflecting surface. In an SLR camera, the mirror reflection reverses the image top-to-bottom. At the focusing screen, it has correct orientation top-to-bottom, but is still reversed left-to-right.

A *pentaprism* is used in most viewfinders to show correct orientation in both directions. This is a piece of glass with several inclined surfaces that produce a series of reflections. It is the angled surfaces of the pentaprism that give most viewfinder housings their unusual shapes—like the pitched roof of a house.

INTERCHANGEABLE VIEWFINDERS FOR THE F-1

You can select from five interchangeable finders for the F-1, shown in the accompanying photo. To remove a finder on the camera, depress the two small release buttons near the back of the finder and draw the finder

back until you can lift it off. To install a finder, place it on the metal rails on the top of the F-1 body and slide it forward until it clicks in place. The focusing screen is in the body below the viewfinder.

In addition to providing different ways to view the focusing screen, the choice of finder and motor drive or power winder affects the available operating modes of the camera as described in Chapter 18.

Five interchangeable viewfinders are available for the F-1. Finder FN is standard. It's an eye-level viewfinder, which means you hold the camera to your eye. AE Finder FN is also used at eye level but provides the additional capability of shutter-priority automatic exposure. For the maximum capabilities of an F-1, use AE Finder FN with a motor drive or power winder attached to the camera. The two waist-level finders are for special purposes. The viewing window of Speed Finder FN can be rotated so you can use it either at eye level or waist level. This finder shows you the complete image without requiring your eye to be pressed against the eyepiece. This is an advantage for wearers of eyeglasses, for sports and action photography, and other purposes.

SPEED FINDER FN

WAIST-LEVEL FINDER FN-6X

WAIST-LEVEL FINDER FN

EYE-LEVEL FINDER FN

AE FINDER FN

12
EXPOSURE METERING

Through-The-Lens metering means the camera meter measures light after it has come through the lens. Measuring the light after it has come through the lens and any accessories such as filters is an advantage because what the internal light meter "sees" is the light that will expose the film.

Canon uses two types of light sensors: Cadmium-sulfide, which has been virtually standard in the past, and silicon, which is more sensitive and requires more electronics in the camera.

Light measurement alone is not enough. Some sort of exposure calculation must also take into account the amount of exposure the film needs and the length of time the shutter will be open.

The output of the light-measuring sensor in the camera is fed into a calculator along with ASA film speed and the camera control settings. The camera operates an exposure display in the viewfinder to tell you if the camera settings are correct for an average scene.

A basic design feature of an SLR is that the image reflected onto the focusing screen is the same as the image that will later fall on the film. The focusing screen can be used as a substitute location *to measure light* just as it is a substitute location to judge focus and composition of the picture.

It would be convenient to place the sensor on the focusing screen itself, except that it would block that part of the image from your view. An alternate approach is to locate the sensor elsewhere but cause it to receive light from the image so it can measure image brightness. Canon uses two sensor locations, depending on the model. These will be discussed later in this chapter.

METERING PATTERNS

The simplest metering pattern is to have the light sensor respond equally to all parts of the frame, sometimes called *full-frame averaging*. This has proven difficult to use because the subject of interest is usually placed in the center of the frame and is surrounded by background. If the background is unusually bright or dark, and is seen by the meter, it will cause bad exposure of the subject.

Several metering patterns have been developed to reduce the sensitivity of the meter to areas near the edges of the frame but retain normal sensitivity at the center. One such pattern is called *center-weighted averaging* because more weight, or importance, is attached to the light reading at the center. Starting at the center of the frame, the meter sensitivity is gradually reduced toward the edges. This pattern is one of three that are used in the F-1.

F-1 METERING PATTERNS

The F-1 sensor is in the back of the camera body, behind the focusing screen. The focusing screen has several layers. The center layer has an array of tiny, angled surfaces called a Micro Beam Splitter. The beam splitter reflects part of the light toward the back of the camera and transmits the rest of the light upward to the pentaprism for viewing. Light from the beam splitter emerges through a window in the back of the focusing screen frame. Then it strikes the surface of the light sensor and is measured.

Canon manufactures focusing screens with three different metering patterns, by controlling the shape of the beamsplitter in the focusing screen, the angles and reflectivities of its surfaces.

CENTER-WEIGHTED AVERAGE METERING

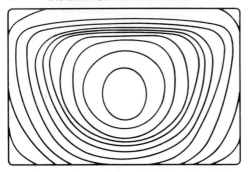

The F-1 Center-Weighted metering pattern has maximum sensitivity in the center. In the zones away from center, sensitivity is progressively less. This pattern tends to ignore bright areas at the edges of the scene.

SELECTIVE-AREA METERING

The F-1 Selective-Area metering pattern has maximum sensitivity in the rectangle near the center of the screen. Outside of the rectangle, light from the scene has no effect on the meter and is not measured.

SPOT METERING

The F-1 Spot metering pattern is similar except it has sensitivity only in the small circle at the center of the screen. You can use this spot as a probe, to measure brightness of very small areas in the scene.

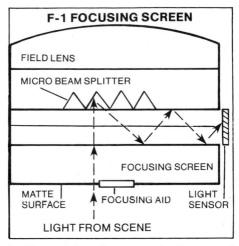

F-1 FOCUSING SCREEN

FIELD LENS

MICRO BEAM SPLITTER

FOCUSING SCREEN

MATTE SURFACE — FOCUSING AID — LIGHT SENSOR

LIGHT FROM SCENE

Inside each focusing screen for the current F-1 model is an array of tiny, angled surfaces that reflect part of the light to the sensor at the back of the camera. The metering pattern is determined by the shape of this array.

Center-Weighted Average—The letter A, for Average, identifies these screens. The area of maximum sensitivity is approximately the same in height as in width. If you rotate the camera to make a vertical-format shot, the meter will read virtually the same portion of the overall scene as it would if the camera were horizontal. Recommended for manual or automatic exposure.

Selective-Area Metering—Meters only in a rectangle in the center of the screen, occupying 12% of the total frame area. If you look closely, you can see the metering rectangle. Used to meter precisely defined areas, such as only in the shadows or only in sunlight. Recommended for manual exposure control but can be used on automatic if subject is entirely within the metering rectangle. The letter P, for Partial, is used to identify these screens.

Spot Metering—Meters only in a circle at the center of the screen, occupying 3% of the frame area. Metering spot is visible in viewfinder. Useful to meter a specific small area of a subject or a distant subject against an unusually light or dark background, such as a spotlit performer on stage. Recommended for manual exposure control only. Identified by the letter S.

By control of exposure, you control the brightness of each part of the scene as it appears in the photograph. In a way, it's like painting with light.

The small window in the back of an F-1 focusing screen transmits light from the Micro Beam Splitter to the light sensor in the camera body.

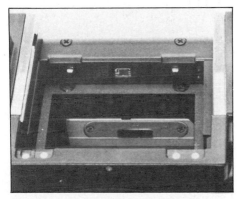

The tiny rectangle in the F-1 body, in the back of the focusing-screen cavity, is a silicon light sensor. It receives and measures light from the Micro Beam Splitter in the focusing screen.

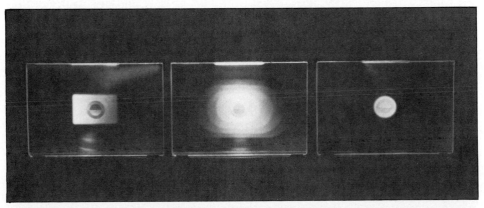

By sending light backward through F-1 focusing screens, the Micro Beam Splitters become visible. Here you see one of each type. The Selective-Area Pattern is actually rectangular. It appears as shown because the screen is angled. In the center of each screen, you can also see a focusing aid. Each of these is a biprism surrounded by a microprism.

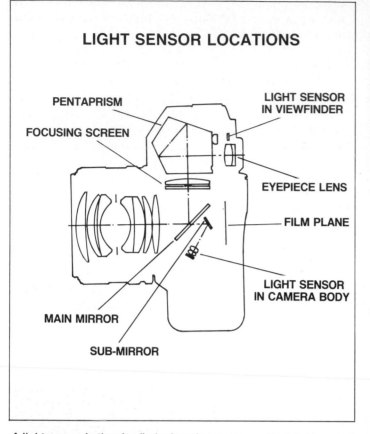

LIGHT SENSOR LOCATIONS

PENTAPRISM

FOCUSING SCREEN

LIGHT SENSOR IN VIEWFINDER

EYEPIECE LENS

FILM PLANE

LIGHT SENSOR IN CAMERA BODY

MAIN MIRROR

SUB-MIRROR

A light sensor in the viewfinder housing measures the brightness of the image on the focusing screen. This sensor can provide more than one metering pattern, depending on the camera model. The T90 has a second light sensor in the bottom of the camera that provides a spot metering pattern. The camera-body sensor is also used to control flash exposure automatically by measuring light on the surface of the film.

Average outdoor scenes include some sky, foliage, dirt and people, but not close-up portraits. All average scenes reflect 18% of the light averaged over the entire frame, whether photographed in color or b&w.

AN AVERAGE SCENE

In the discussion of over- and underexposure, I pointed out that film has a limited range of density between fully clear and fully black. An important idea of exposure is to cause the various light values from a scene to produce densities within the range of the film. The safest thing to do is put the middle light value of the scene right on the middle density of the film density scale. Then higher and lower light values from the scene "have a place to go" on the film.

By measurement of many typical scenes, it has been found that most outdoor scenes and many shots in a man-made environment have the same average amount of light coming from the entire scene. Some parts are brighter and some are darker but they average out, or integrate, to the amount of light that would come from a certain shade of gray. This gray shade is called 18% gray because it reflects 18% of the light.

Camera stores sell cards that are 18% gray on one side and 90% white on the other. These cards are bound into some reference books sold at camera shops.

The inside covers of HPBooks' *SLR Photographers Handbook* are approximately 18% gray so you can use them as a metering aid. The idea is that you can meter on a average scene, or meter on an 18% gray card in the same light, and the exposure meter in your camera will give the same settings.

The percent of incident light reflected by a surface is called the reflectance of that surface. Average scenes have 18% reflectance overall, and the middle tone of an average scene has 18% reflectance and looks the same as the gray card—at least to the camera light meter.

The middle density of the range of densities that film can produce corresponds to the same 18% gray. Which says, again, that the middle tone of a typical scene should record as the middle tone on the film. You cause that to happen by adjusting the exposure controls on your camera.

The value 18% may not seem

like the middle or average of anything, but remember we are considering human vision.

Black velvet reflects about 3.5%—about as black as you will find except for a hole where light goes in and nothing comes out. White paper is about 90%.

There sits 18%, smugly in the middle between black velvet and white paper—*the middle tone,* as seen by our eyes.

There are about 5 exposure steps between white and black when the scene is uniformly illuminated, so 18% gray is about 2.5 steps below white and 2.5 steps above black.

HOW TO INTERPRET EXPOSURE READINGS

If you decide to go around photographing 18% gray cards, I guarantee every exposure will be a whopping success. It's built into the system. The exposure called for by film-speed ratings will put an 18% gray card right in the middle of the density scale of the film.

It takes good photographic judgment to look at a real-world scene and decide if it will average out to 18% gray. If so, you can shoot it just as you would a gray card— follow the advice of the camera exposure meter. Most outdoor scenes have sky, people, dirt, rocks, foliage and maybe a distant building. This is average. If your scene is mainly sky, that is not an average scene. But the exposure meter in your camera doesn't know the difference.

The exposure meter, unless you override it with your own good judgment, will place the average brightness or tone of every scene at the middle density of the film. If the scene is mainly sky, sky will be rendered middle gray on the print and faces of people against the sky will be too dark.

Here's a way to waste two frames of film in the interest of science: Photograph a piece of white paper on one frame of film and a piece of black paper on the next frame. Use either b&w or color-slide film. Adjust the camera

controls to satisfy the exposure display each time. After development, examine the b&w negative or the slide. The two frames should be the same shade of gray—18%.

You can only believe your exposure meter when it is looking at an average scene. If you shoot a bird on a snow bank, the camera will think the snow bank is a gray card in very bright light. It will stop down so the white snow appears gray on the negative. If faithfully printed, it will also appear gray on the print.

If you shoot a coin on black velvet, the camera will think the gray card is in very poor light and open up the lens until the black velvet registers middle gray on the film.

The clue is the amount and brightness of the background. If the subject is small and the background large, worry. If the background is significantly brighter than middle gray, you know the camera will want to stop down on account of the bright background and underexpose your subject. You have to give more exposure than the exposure meter will suggest.

If the background is significantly darker than average and your main interest is the subject against that background, you have to give less exposure than the meter suggests to avoid overexposing the subject.

Another situation where an exposure meter may give an unsatisfactory reading is when every-

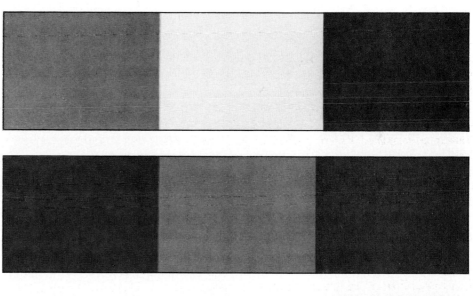

This exciting panorama shows the importance of metering. In real life, this was medium gray on the left, white in the center, black at right. In the top photo, meter reading was taken from the gray surface. All three tones reproduced properly. In the middle, metering was done on the white surface. White became gray, gray became black, black couldn't get any blacker. At bottom, metering was done on the black surface which became middle gray on the negative. Gray became white and white couldn't get any whiter. Depending on how you meter, you can shift all tones toward white or toward black.

thing in the scene is unusually light or dark. If you photograph a marshmallow on a white table cloth, the exposure meter will suggest camera settings that make everything middle gray on the negative. If printed that way, the result is a gray marshmallow on a gray table cloth—probably not your intention.

To make marshmallow and cloth both appear white on the negative, you probably need about two more steps of exposure than the meter will suggest.

Similarly, a dark subject against a dark background will both be changed to a medium gray by the unthinking exposure meter if you allow it to happen. For realism, you probably want both subject and background to appear dark on the print. You probably need one or two steps less than the meter will suggest.

With an automatic camera, the exposure-measuring system does more than suggest exposures. It adjusts the camera and takes the picture the way it thinks is right. I'll tell you in a minute how to prevent an automatic camera from making an incorrect exposure of a non-average scene.

SUBSTITUTE METERING

This is a way to solve some difficult exposure problems. Suppose you are shooting a scene with no middle tone. Everything is very bright or very dark. If areas of bright and dark are about equal and the exposure meter includes an equal amount of each, the meter itself will average light and dark and give an exposure as though it were examining the middle tone of the scene. For example, a checkerboard with black and white squares will affect a meter as though it were a uniform gray color.

This requires some judgment on your part as to how bright and how dark the two extremes are and whether they appear in equal amounts to the meter.

You can sidestep the problem by placing an 18% gray card in the scene, so it receives the same

amount of light as the rest of the scene. Meter on the card and shoot at the exposure setting that results. The picture will show the 18% gray card as a middle tone with the bright and dark areas appropriately lighter and darker than middle gray.

If you remove the 18% gray card after taking the reading but before exposing the film, the picture will be the same as before, except the card won't be there. Bright and dark areas will reproduce properly.

If it is not convenient to place the 18% gray card at the scene— perhaps because the scene is on the other side of a chasm or river—you can meter on the card anywhere as long as it is in the same light as the scene. If you are shooting in sunlight, for example, you can assume it has the same brightness everywhere as long as it falls on the scene or subject at the same angle. Hold the gray card near the camera in the same light as the scene and meter on the gray card.

Metering on a substitute surface instead of the scene itself is called *substitute metering*. Many photographers carry an 18% gray card for this purpose.

In dim light, a gray card may not reflect enough light to allow metering. Some gray cards are 90% white on the reverse side and white paper is about the same. If you meter on 90% white instead of 18% gray, the white card will reflect five times as much light into the exposure meter as the gray card would, because

90% / 18% = 5.

Because the exposure meter assumes everything out there is

A handy substitute metering surface you are not likely to leave behind is your handsome palm. Most palms reflect about 36% of the light. Meter on your palm in the same light as the scene, open up one stop and shoot.

Substitute metering can be done on an 18% gray card in the same light as the scene. Set the camera exposure controls according to light reflected from the gray card and then shoot the scene. Of course it doesn't matter if you remove the card when taking the picture. Tones in the scene will be recorded correctly on film—color or b&w.

18% gray, it attributes the high value of light to brighter illumination rather than more reflectance of the surface. Therefore, it will recommend an exposure only 1/5 as much as it would if you were actually metering on 18% gray. Because you know that, you compensate by increasing exposure by 5 times over the exposure meter reading.

To make the correction, multiply the indicated shutter-opening time by 5 and select the nearest standard number. If the exposure meter says shoot at 1/60 second, you will want to shoot at 5/60 second, which reduces to 1/12 second. The nearest standard speed is 1/15 second.

You can also correct by changing aperture. Opening up by 2 stops is an increase of 4 times. Opening up aperture by 2-1/2 stops increases exposure 5.6 times. The click stops or detents between the numbered settings of the aperture ring are half-stops.

A very handy substitute metering surface is the palm of your hand. You should check your own palm, but light skin typically reflects about one stop more light than an 18% gray card. If so, you can hold your palm in front of the camera—in the same light as the subject or scene—meter on your palm and then open up one stop. If your palm reflects only a halfstop more, obviously that's how much to open before shooting.

You will find that dirt, grass, weeds, foliage and other common things have a suprisingly uniform reflectance. You can learn to use them in a hurry as substitute metering surfaces to set your camera for a quick shot of some unusual scene such as a flying saucer passing by. An advantage of using your exposure meter to measure the reflectance of common objects is that it helps you learn to distinguish non-average scenes from average scenes.

EXPOSURE COMPENSATION

Making a deliberate change in exposure to compensate for an unusually bright or dark background

Canon A-1 has two pushbuttons on left side of lens mount. Top button, called Exposure Memory Switch, turns on viewfinder display and locks exposure at whatever *exposure value* the camera light meter is reading at the instant you depress the button.

Lower button with chrome ring around it is the Exposure Preview Switch. Depress this button when you want to see exposure-control settings in the viewfinder readout. The Exposure Preview Switch does the same thing as depressing the shutter button partway to turn on the display but it gives you a choice of doing it with your left hand.

is called *exposure compensation*. With a non-automatic camera, do it by changing either aperture or shutter speed. With any camera you can do it by changing the film-speed setting. Some Canon automatic cameras have special controls for this purpose.

Backlight Control Switch— The AE-1 has this control. It's a pushbutton on the camera body, near the lens mount, convenient to use with the forefinger or thumb of your left hand.

When depressed, it causes the camera to give 1-1/2 steps more exposure than the camera would give normally on automatic.

This is convenient for backlit situations such as a portrait against the sky. One-and-a-half steps is a compromise and doesn't suit every backlit situation. After using it a few times, you'll become familiar

with this control and find it handy.

Because the AE-1 has shutter priority, this control increases exposure by opening aperture. You can see the viewfinder exposure display change when you use the Backlight Control Switch.

The A-1 and F-1 Exposure Compensation Dial—This is a special control that is part of the ASA dial surrounding the Film-Rewind Knob. At most film speeds, this control has a range of two exposure steps in each direction.

The dial is marked with numbers that are exposure multipliers: 1/4, 1/2, 1, 2, 4. The normal setting is 1, which means the control multiplies exposure by 1, therefore it doesn't change it. Multiplying exposure by 1/2 reduces it one exposure step; 1/4 is two steps less. Multiplying by 2 is one step more exposure; 4 is two steps more.

To use the control, depress the adjacent Exposure Compensation Lock Button and turn the film-speed dial until the desired amount of exposure compensation is shown opposite the index mark. What this really does is change film speed so the camera gives more or less exposure. However, by making the change on a special scale, it is easy to remember that you did it and you don't have to change the actual setting on the Film-Speed Dial.

Because the film-speed dial is subdivided into third-steps, the exposure compensation dial is also marked off in third-steps. You must set either dial exactly on one of the marks.

In the F-1, the meter needle moves to show the setting of the Exposure Compensation Dial. The digital display in the A-1 camera reads in half-steps, so what you see may not exactly agree with what you are doing. The exposure compensation you set on the dial is what you will get on the film.

When you are not using exposure compensation, be sure to set the dial to 1. If you forget and leave it set for some amount of compensation, it will affect all subsequent exposures until you change the setting back to 1.

APPROXIMATE EXPOSURE COMPENSATION FOR SMALL SUBJECT AGAINST VARIOUS BACKGROUNDS		
Background	Exposure Change	Dial Reading
Black	2 steps less	1/4
Dark	1 step less	1/2
Average	no change	1
Light	1 step more	2
White	2 steps more	4

The Main Switch of the T70 can be set to LOCK, for locking the camera. It can also be set to select either of two metering patterns, or to set the SELF-TIMER for a ten-second count down. The AVERAGE setting is for center-weighted averaging metering. The PARTIAL(AE L) setting is selective-area metering in the 11% circle at the center of the frame. Exposure can be locked at this setting while the composition is changed. The adjacent pushbuttons check the battery, set ISO/ASA film speed and set the operating mode of the camera.

Spot, selective-area, or central-emphasis metering will read exposure from the subject in this photo, ignoring foreground and background brightness.

so the main subject fills the 11% circle at the center of the frame. Lock and hold the exposure setting while changing the composition as you choose. Then press the shutter button to make the exposure. The same technique can be used for substitute metering.

With either metering pattern, exposure is locked when the self-timer is started. Exposure may be altered for one or more shots by changing the film-speed setting.

T90—The T90 has three metering patterns: center-weighted averaging, partial-area and spot. When using partial or spot metering, automatic exposure can be locked by pressing the shutter button partway or by pressing the Exposure Preview Button.

SPOT READINGS
WITH THE T90

The T90 has a special Spot Metering Button near the shutter button. When the spot button is pressed, the camera takes a spot reading at the center of the frame and holds the resulting shutter-speed and aperture settings for 30 seconds even if you remove your finger from the spot button.

Single Spot Readings—You can use a spot meter to select a single small area in the scene that you wish to record as a medium tone, ignoring the background. An example is a person in a spotlight on an otherwise dark stage. Press the spot button to make the measurement, then press the shutter button to make the exposure.

Two Spot Readings—For a scene with light and dark but no middle

tone, such as a checkerboard, you can make a spot reading of the light tone and the dark tone. The average will be halfway between, representing a middle tone that doesn't actually exist in the scene. Shooting with the averaged exposure should produce good exposure.

Averaging Spot Readings—If more than one spot reading is taken, the T90 will automatically

f-number	shutter speed	EV number
16	2,000	19
16	1,000	18
16	500	17
16	250	16
16	125	15
16	60	14
16	30	13
16	15	12
16	8	11
16	4	10
16	2	9
16	1 second	8
11	1 second	7
8	1 second	6
5.6	1 second	5
4	1 second	4
2.8	1 second	3
2	1 second	2
1.4	1 second	1

average them—up to a maximum of 8 readings—and hold the result for 30 seconds. Each reading appears in a viewfinder display at the right of the image area, as shown in Chapter 18.

Use of multiple readings is more art than science. Suppose a subject is in shadow, surrounded by a bright area. One reading of the subject and another of the bright area will provide a starting point that balances exposure between the two. The subject will probably be underexposed. A second spot reading of the subject, averaged with the first two readings, will bias the resulting exposure to bring the subject toward a middle tone on the film. In the resulting average, the spot reading of the subject will have twice the weight as the spot reading of the background.

EXPOSURE STEPS
AND METERING RANGE

The number of exposure steps that a camera can make depends both on the camera and the lens in use. Suppose you are using a camera with a shutter-speed range of 1 to 1/2000 second and the lens has an aperture range of f-1.4 to f-16.

Suppose we set the lens to its smallest aperture and the shutter to its fastest speed. Then move the shutter to slower speeds until we use them all up. Then, at the slowest shutter speed, continue to increase exposure a step at a time by opening the lens until it is fully open. Count the steps. Each space between lines in the accompanying table is an exposure step. I make it 18 steps.

You should recognize that each of the exposure settings in the list is a definite amount of exposure—different by a factor of two from the one above or below.

Canon specifies the working range of the exposure-measuring system in EV numbers. The range of the exposure system in the F-1 camera is from EV −1 to EV 20—a total of 21 exposure steps.

Let's keep separate the exposure steps you can make by different camera control settings and the EV range of the exposure metering system because they are not necessarily the same. If the exposure meter can see 15 steps, but the camera can make 18, the exposure meter cannot work at all camera settings.

It is unusual but not impossible for film to need an exposure that the camera cannot provide. This will never happen due to decreased light because you can always set the camera on B and expose for two or three weeks if necessary.

It may happen when using fast film in a bright light. You will look for a way to reduce the amount of light coming in the lens. When you find it, it will be called a neutral-density filter in Chapter 15.

COUPLING RANGE OF THE EXPOSURE METER

This gets complicated, but all you really need to understand is the general idea.

These are the basic limits in an exposure-measuring system: When setting exposure or helping you do it, the system cannot use any settings that aren't possible, for example *f*-64 and 1/4000. Also, the light-measuring sensor cannot be expected to read light levels beyond its range. There is a limit in both directions. The light can be too dim for an accurate reading, or it can be too bright.

Canon publishes tables to show the operating range of the built-in meter. They are called Meter Coupling Range or something similar. For automatic cameras, the meter coupling range limits the *operating range* of the camera because the meter makes exposure settings. If the meter is operating beyond its range, the meter reading will not be accurate and automatic exposure settings will also be inaccurate.

For some cameras, Canon publishes a graph such as the accompanying one for the F-1.

In general, you don't have to worry about finding light so bright the camera can't measure it accurately. If the light is too dim, each camera warns you, as shown in Chapter 18.

The meter-coupling limits are not limits on the camera control settings. You can set the camera any way you wish, but if you operate outside the range of the meter, you are on your own as far as exposure is concerned. All Canon SLR cameras work this way, but the meter-coupling limits vary among different models.

USING EV NUMBERS TO SPECIFY EXPOSURE-METER RANGE

We encounter a minor complication here. EV numbers basically represent combinations of shutter speed and aperture. But there are two additional factors that affect exposure on film: the amount of light from the scene and the film speed. Four things affect exposure and an EV number expresses two.

When we use an EV number to specify the operating range of an exposure meter, we really mean to specify the upper and lower limits of light coming from the scene into the lens. If the light is within those limits, the exposure meter reads

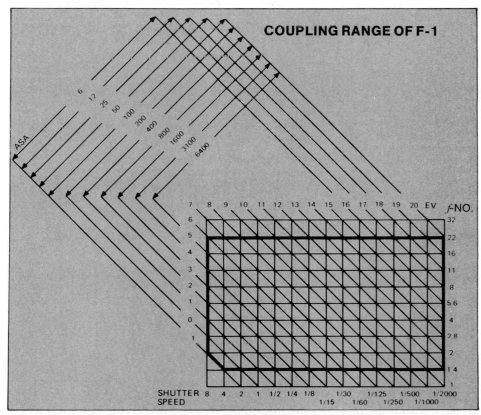

F-1 coupling range is shown by this graph. With ASA 100 film, it is from EV −1 to EV 20. EV −1 is *f*-2 at 8 seconds or *f*-1.4 at 4 seconds. EV 20 is *f*-22 at 1/2000. With ASA 400, the range is EV 1 to EV 20. EV 1 can be set several ways, such as *f*-2.8 at 4 seconds.

accurately. If the light is outside of those limits—too bright or too dim—the meter will not read accurately although it may give you a reading.

To state a metering range, camera makers give EV numbers and also specify maximum aperture of the lens and the film speed. When this is done, the EV range becomes the light-measuring range. Here's how all four of the things that affect exposure are handled:

Because modern SLRs meter at maximum aperture, it is assumed that the lens is always set at maximum aperture.

With aperture identified, the EV number itself identifies a shutter speed.

Film speed is stated as part of the metering-range specification—usually ASA 100.

Light from the scene is the only factor left, so it is identified by stating the other three factors and making one more assumption. We assume that the amount of light gives correct exposure of the film.

Let's do it once with numbers. The meter-coupling range of the A-1 camera is EV −2 to EV 18 with an f-1.4 lens and ASA 100 film. Let's examine the lower metering limit. We can find shutter speed at f-1.4 and ASA 100 for EV −2 in the EV table at the beginning of Chapter 8. It's 8 seconds.

The lowest light level at which the camera can meter is the amount of light from the scene that gives correct exposure to ASA 100 film with an f-1.4 lens wide open and a shutter speed of 8 seconds.

In the earlier discussion of programmed automatic exposure, I said the A-1 program can't use exposures longer than 8 seconds with ASA 100 and f-1.4. That's because the meter doesn't work accurately below EV −2.

What About Different Lenses and Film Speeds?—A metering range is usually given for f-1.4 and ASA 100. But you are using an f-2 lens with ASA 200 film. How do you figure the correct metering

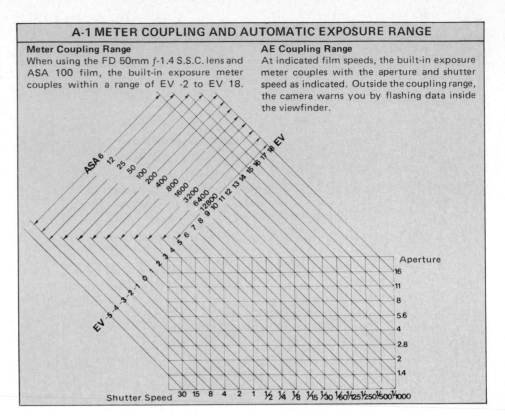

A-1 METER COUPLING AND AUTOMATIC EXPOSURE RANGE

Meter Coupling Range
When using the FD 50mm f-1.4 S.S.C. lens and ASA 100 film, the built-in exposure meter couples within a range of EV -2 to EV 18.

AE Coupling Range
At indicated film speeds, the built-in exposure meter couples with the aperture and shutter speed as indicated. Outside the coupling range, the camera warns you by flashing data inside the viewfinder.

range? Let's consider the changes one at a time.

An f-2 lens can't open up as much as an f-1.4. The camera compensates by using one step slower shutter speed, so the EV limit remains at EV −2 as long as the camera has slower shutter speeds. When the slowest speed has been used, then the lower limit goes up step by step as the aperture is made smaller.

The next part requires some tricky reasoning. If the amount of light specified by the EV numbers gives correct exposure with ASA 100 film, what will it do with ASA 200 film—which needs one step less exposure? Suppose you have the camera set for correct exposure and then you change the film from ASA 100 to ASA 200, and change nothing else. Obviously the ASA 200 film will be overexposed by one step. To make the light right for ASA 200, you must either close aperture one step or switch to a shutter speed that is one step faster. It doesn't matter which you do, as long as you do only one. The resulting EV number goes up one step.

The limits of the EV metering range go up step by step with film speed increases, remembering that doubling film speed is one step.

This discussion of how metering limits move up and down with film speed is theoretical and also practical within limits. In an actual camera, the lower EV limit won't go down indefinitely with lower film speeds and the upper limit won't go above EV 18 with higher film speeds. This is because the light sensor in the camera has limits and you can't work beyond those. You can see these absolute limits in the accompanying AE Coupling Range graph for the A-1.

FILM SPEED AS AN EXPOSURE CONTROL
Film speed is a message from the film manufacturer to the exposure calculator in your camera, requesting a certain amount of exposure. With a non-automatic camera, the film receives that amount of exposure if you set the controls according to viewfinder display. With an automatic camera, the film gets that exposure if you stand back and let

Double exposures are fun. This shot brought back the essence of our family vacation on a Colorado ranch.

the camera do it.

You don't have to use the speed number as an input to the camera—you can use whatever you choose. If you dial in a higher or lower speed number, then you are not using the official film speed but you are using your own *exposure index* to guide the camera.

If you have selected 32 at the camera when the film is ISO/ASA 64, the camera is set to give one step more exposure than it would if you dialed in 64.

This is not necessarily a wrong exposure. Suppose you have performed substitute metering using your precision palm, which reflects 36% of the light. To use your palm instead of a gray card, meter on it and open up one step.

There are three ways to change the camera settings so the film will get one step more exposure: increase aperture, decrease shutter speed, decrease the film-speed number.

Film speed is an exposure *control* only if the camera exposure is set according to the film speed you have dialed in. An automatic camera responds automatically to a changed film speed, so it is a control. A manual camera responds to a changed film speed only if you set exposure according to the exposure display for the new speed.

Another use of film speed is to deliberately underexpose or overexpose an entire roll and compensate by special development. It is common to shoot with a higher than ISO/ASA film speed set into the camera. This amounts to de-

liberate underexposure but many photographers don't think of it that way. They say, "I am rating this film at a higher speed, so I can use it in dim light." Even so, it's still underexposed.

When you shoot any part of a roll with a higher speed number, you should expose the entire roll that way. Remember to mark that cartridge for special development so it won't get mixed up with the rest of your film.

DOUBLE AND MULTIPLE EXPOSURES

If a subject against a dark background is photographed with normal exposure, the film frame can be considered as two distinct areas. The area of the subject is normally exposed. The dark background

caused little or no exposure on the film.

A second subject against the dark background can be photographed on the same frame, also with normal exposure, provided the areas on the film occupied by the two subjects do not overlap.

Now the film frame can be considered as three areas. One for each subject and some still unexposed or underexposed background. Obviously, a third subject could be placed in the unused dark background area and normal exposure could be given to the third subject.

The rule for multiple exposures against a dark background where the subjects do not overlap is to give normal exposure to each shot.

When subjects do overlap, the situation is different. Normal exposure of two subjects occupying the same area on film amounts to twice as much exposure as that area needs—one step too much. Three overlapping exposures give three times as much total exposure as the film needs, and so forth.

With overlapping subjects, the rule is to give the correct total amount of exposure to the film, allowing each individual shot to contribute only a part of the total. If there are two overlapping images, each should receive one-half the normal exposure. Three overlapping images should each receive one-third the normal exposure, and so forth.

This is done by dividing the nor-

Operating the Stop-Down Slide or Lever causes the Stopped-Down Coupling Lever in the camera to move to the position shown here, exposing a red warning dot. *Don't install a lens if you see the red dot.* If you do, the camera cannot stop down the lens to shooting aperture when making an exposure. Exposures will be incorrect.

mal amount of exposure for each shot by the total number of exposures to be made. Please notice: This does not require each exposure to be the same. Measure for each exposure, divide by the number of exposures to be made, and give the resulting amount— whether or not it is the same as some other subject requires.

This procedure tends to give normal exposure to the combined image on the film, but each individual image is less bright according to how many shots there are. If you

make more than three exposures, each individual image becomes pretty dim, but the effect is sometimes pleasing anyway. Also, even though the background is dark, it will get lighter and lighter with successive exposures.

RULES FOR MULTIPLE EXPOSURES

Dark uncluttered backgrounds are preferable.

The background gets lighter with each exposure.

If there is no image overlap, give normal exposure to each shot.

If there is image overlap, divide the normal exposure for each shot by the total number of shots to be made.

A handy way to adjust exposure is to multiply film speed by the planned number of shots and set the nearest available speed on the camera dial. Then use the camera normally for each shot.

Don't forget to reset film speed afterward.

You can also adjust exposure by changing shutter speed or aperture.

OPERATING THE CAMERA FOR MULTIPLE EXPOSURES

Cameras prevent accidental double exposures by a mechanical interlock that requires advancing the film before each shutter operation.

The procedure for deliberately making multiple exposures varies among cameras and is described for each model in Chapter 18.

13
CLOSE-UP AND MACRO PHOTOGRAPHY

Two different types of accessory items are used in close-up and macro photography. They will be discussed separately with the simple theory of how they work. After that, application is easy.

MAGNIFICATION OF A STANDARD LENS

A 50mm lens used by itself on the camera has greatest magnification when focused on the closest possible subject. Closest focus with the 50mm *f*-1.8 lens is a little less than 0.6 meters, which is the closest marked distance on the focusing ring. This distance is measured from the film-plane in the camera or the film-plane indicator mark on top of the camera body.

To change focus from infinity to the closest distance, the focus control moves the 50mm lens outward about 5mm, so the distance from lens node to film becomes about 55mm.

Under these conditions, magnification is approximately 0.11—the image on the negative is about 11% as tall as the subject.

CLOSE-UP PHOTOGRAPHY

Close-up photography begins where standard lenses leave off. Close-up photography starts at a magnification of about 0.1 and extends up to a magnification of 1.0, which is *life-size*. Macro takes over from there and gives larger-than-life images on the negative.

Close-Up Lenses—These clear accessories increase magnification. They look like filters and attach

This attractive bug was photographed with a 50mm lens at maximum magnification —as close as the lens would focus—which is about 0.11. Not enough, obviously. Entire frame is not reproduced here.

A simple and handy way to get more magnification is use of close-up lens attachments.

67

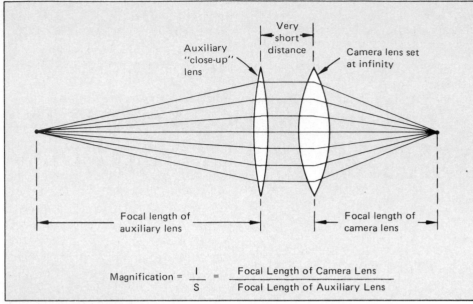

Figure 13-1/With auxiliary close-up lenses, magnification is easy to calculate.

$$\text{Magnification} = \frac{I}{S} = \frac{\text{Focal Length of Camera Lens}}{\text{Focal Length of Auxiliary Lens}}$$

(labels in figure: Very short distance; Auxiliary "close-up" lens; Camera lens set at infinity; Focal length of auxiliary lens; Focal length of camera lens)

Close-up lenses screw into the filter threads on the front of a camera lens. They should be kept clean and treated with the same care as other lenses.

the same way. They work by playing a little optical trick on the camera lens, illustrated in Figure 13-1.

If the camera lens is focused at infinity, so it is "expecting" parallel rays from the scene, it will bring them to focus at its own focal length. With a close-up lens attached, the subject is placed in front of the lens at a distance equal to the focal length *of the close-up lens.* Light rays from every point of the subject enter the close-up lens and emerge as parallel rays that immediately enter the camera

lens and are brought to focus on the film.

In this situation, magnification is easy to figure because the image distance is the focal length of the camera lens and subject distance is the focal length of the close-up lens. When these distances are known, magnification is simply I/S—Image distance divided by Subject distance.

Accessory close-up lenses are available at most camera shops in diameters to fit the filter threads of common lenses. If your lens uses filters with a 55mm thread diameter, get close-up lenses with the same thread diameter. Accessory close-up lenses often come in sets of three, identified as **1, 2** and **3,** sometimes **1, 2** and **4.** Some makers offer a **10** lens also. The focal length of the lens is implied by its identification number.

These numbers are properly called *diopters,* a measure of lens power. Eyeglass prescriptions are written in diopters. The diopter rating of a lens is the reciprocal of its focal length—when focal length is expressed in meters rather than millimeters or any other unit. To find the diopter rating of a 500mm lens:

$$\frac{1}{0.5 \text{ meters}} = 2 \text{ diopters}$$

That's a **2** close-up lens.

To figure magnification with one of these lenses, you need to work that problem backward because you already know the diopter rating—it's marked on the lens. Focal length in meters is the reciprocal of the diopter rating.

$$\frac{1}{2 \text{ diopters}} = 0.5 \text{ meter or } 500\text{mm}$$

If you are using a **2** close-up lens with a 50mm camera lens set at infinity, magnification is **50/500 = 0.1.** *Only when the camera is focused at infinity.*

Focus the camera lens closer and two things happen. Image distance gets longer because the focusing mount moves the lens farther from the film. Subject distance gets shorter.

Therefore, when you focus the camera lens closer than infinity with a close-up lens attached, magnification increases. Greatest magnification occurs with the camera lens focused at its shortest distance, but it isn't simple to calculate.

Figure 13-2 does the arithmetic for you. Based on a camera lens with focal length of 50mm, it gives minimum and maximum distances at which the subject can be focused, and it gives the range of magnifications obtainable over the focusing range of the lens. The numbers are approximate, but probably close enough.

Here's how to use the table. First, figure the amount of magnification you need. You can compare the height of a 35mm frame with the height of your subject, or compare widths. The height is 24mm, a little less than one inch. For most purposes, assume it is an inch.

If the subject is 3 inches tall and you want it to fill the frame vertically, you want a magnification of approximately 1/3, or 0.33. The table shows a magnification range of 0.20 to 0.33 if you stack a **3** with a **1** lens, or use a **4** lens. With this

68

Figure 13-2
MAGNIFICATION WITH ACCESSORY CLOSE-UP LENSES

Camera Lens	Close-Up Lens	Maximum Subject Distance		Minimum Subject Distance		Magnification	
		MM	IN	MM	IN	MIN	MAX
50mm	1	1000	40	333	13	0.05	0.17
	2	500	20	250	10	0.10	0.22
	3	333	13	200	7.9	0.15	0.28
	3+1	250	10	167	6.2	0.20	0.33
	3+2	200	7.9	143	5.6	0.25	0.39
	3+2+1	167	6.2	125	4.9	0.30	0.45
	10	100	3.9	83	3.3	0.5	0.67

Figure 13-2/Approximate range of magnifications with commonly-available accessory close-up lenses used with a 50mm camera lens. For each case, maximum magnification occurs at minimum subject distance.

Figure 13-3
MAGNIFICATION WITH CANON CLOSE-UP LENSES

Camera Lens	Close-Up Lens	Maximum Subject Distance		Minimum Subject Distance		Magnification	
		MM	IN	MM	IN	MIN	MAX
50mm	450	450	18	237	9.3	0.11	0.23
	240	240	9.5	162	6.4	0.21	0.34
	450+240	156	6.1	118	4.6	0.32	0.47
100mm	450	450	18	300	12	0.22	0.37
	240	240	9.5	189	7.5	0.41	0.60
	450+240	156	6.1	133	5.3	0.64	0.84
200mm	450	450	18	379	15	0.44	0.57
	240	240	9.5	218	8.6	0.83	1.0
	450+240	156	6.1	146	5.8	1.3	1.5

Figure 13-3/Approximate magnification range of Canon close-up lenses used with 50mm, 100mm and 200mm camera lenses.

Canon offers sets of two close-up lenses which give the same range of magnifications as a set of three ordinary accessory lenses

combination, you will get the desired magnification with the camera lens focused at its closest distance. If you have the camera on a copy stand or tripod, you can set it so the front of the lens is about 6 inches from the subject and then find focus by looking.

This table is for a 50mm lens. If you use a 100mm lens, all magnifications in the minimum magnification column will double. Maximum values will not double, for a complicated reason.

Please notice the amount of overlap between the magnification ranges. For example, a 1 has magnifications from 0.05 to 0.17. The 2 "backs up" and starts at 0.10, with a maximum magnification of 0.22. A 3 starts at 0.15, and so forth.

Canon Close-Up Lenses—Canon offers two close-up lenses identified as 450 and 240. These numbers are the *focal lengths* in millimeters, not diopters.

Figure 13-3 shows what these two close-up lenses will do individually and in combination. Notice the overlaps of magnification when used with a 50mm lens. The 450 goes from 0.11 to 0.23. The 240 only backs up to 0.21 and goes to 0.34. The two in combination start at 0.32 and go to 0.47.

With only two Canon close-up lenses, you can get every magnification possible with three accessory lenses: 1, 2 and 3. Until I did the arithmetic, I thought it was odd to offer 450 and 240 close-up lenses.

Canon recommends use of close-up attachments only with lenses from 35mm to 135mm because image quality will deteriorate with longer and shorter lenses. Most people say using close-up lenses for magnifications higher than about 0.5 causes noticeable reduction in image quality and recommend extension tubes instead—discussed in the following section.

However, you are the judge of image quality for your purpose and there is no harm in trying other combinations. Figure 13-3 shows magnifications for 50mm, 100mm and 200mm lenses. I have found a 200mm lens useful with close-up attachments and you may also if you don't expect too much.

The loss of image quality when using close-up lenses at higher magnifications is a lack of sharpness and other symptoms of lens aberrations. This deterioration has two causes. One is the close-up lens itself. These are often single pieces of glass—called *singlet*—and, therefore, uncorrected

Same insect as before, photographed with 50mm camera lens using Close-up Lens 450 (left), Close-up Lens 240 (center), and both lenses stacked.

lenses. To correct a lens for aberrations requires at least two pieces of glass of different optical properties. If there are only two glass elements, it's called a *doublet* lens.

The other cause is the fact that a close-up lens is added on. The camera lens used alone will make a very good picture because all of the glass elements work together to form an image and correct aberrations. When an accessory piece of glass is put in the same optical path, the lens corrections don't work as well because they were not calculated for a close-up attachment hanging out in front.

Canon offers close-up attachments in four diameters: 48, 52, 55 and 58mm. At each focal length, both singlet and doublet lenses are available. Doublets cost more. If you want the best image with close-up lenses, use the 55mm Canon doublets.

When using close-up lenses, magnification increases in direct proportion to focal length of the camera lens. Here a Canon 200mm *f*-4 lens was used with the Close-up 240 lens to get a magnification of about 0.8 on the negative—enlarged more to make this print. Depth of field is reduced at higher magnifications. Notice legs nearest camera.

USING CLOSE-UP LENSES

As with any other high-magnification photography, the camera should be on a tripod or solid mount. If you are a solid mount, you can try hand-holding. Use a lens hood to exclude stray light from the surface of the lens.

These lenses are normally screw-in type with the thread pattern repeated on the outside of each lens to allow stacking. Put the highest diopter lens nearest the camera.

These lenses do not interfere with camera automation, so you can meter and set exposure as you normally do. With selective-area 12% metering or spot 3% metering in the F-1 camera, pay attention to what part of the subject you are metering on. Don't hesitate to use an 18% gray card for substitute metering.

Depth of field is usually a major problem in close-up and macro photography because it is seldom enough. About the only thing you can do is use small aperture. In the high-magnification domain, closing aperture is not as effective as in normal photography, but it will help some.

You may end up looking for more light and shooting at long exposure times so you can use a small aperture.

As a rule of thumb, doubling camera-lens focal length doubles magnification with the same close-up lens. Don't use two or three close-up lenses stacked if you can avoid it because every surface reflects light. I think it's better to use only one close-up lens with longer camera lenses to get more magnification.

Changing focus with any lens changes magnification, but when subject distance and image distance are about the same, focusing the lens causes large magnification changes. When you are trying to control image size in the frame and also find focus, it can be frustrating. A technique you will quickly discover is to set the focus control for magnification, then

Photographed with 200mm camera lens and a 3 diopter accessory close-up lens, using flash. This is a good combination for stalking insects because you can take the picture with the front of the lens about 8 to 12 inches away. Flash stops motion. Magnification on the slide is about 0.7.

move the entire camera back and forth to find focus.

A good way to get acquainted with a new set of close-up lenses is to try different combinations while focusing on a yardstick.

MACRO PHOTOGRAPHY

Another way to increase magnification of a lens without adding any additional lenses in the optical path, is to locate the lens farther from the film. This increases image distance and therefore increases magnification.

This can be done by spacer rings inserted between lens and camera body—usually called *extension rings* or *extension tubes*. It can also be done by a bellows between lens and camera body, which has the advantage of continuous lens positioning at any distance between the maximum and minimum *extension* or *draw* of the bellows.

Magnification obtained by increasing the distance between lens and camera is calculated approximately by the formula

$$M = X/F$$

where M is magnification, X is the added distance or extension of the lens, and F is the focal length of the lens being used. When X and F are equal, magnification is 1.0, as would be the case with a 50mm lens and 50mm of added extension with the lens set at infinity.

From the amount of magnification calculated, magnification can be increased by focusing the lens to shorter distances because that

Detail of postage stamp shot using extension tubes at a magnification of about 5. Lens correction for flatness of field is very important in this type of photography.

Toy paint bucket tragedy photographed with 50mm camera lens and Canon 240 close-up lens. Top photo with lens at minimum aperture for best depth of field —perhaps 1.5 inches. Bottom photo with lens wide open. Depth of field is best seen by texture of background. At higher magnifications, using smaller aperture won't help this much.

decreases subject distance and simultaneously adds image distance.

The same formula can be rearranged to figure the lens extension needed for a desired amount of magnification:

$$X = F \times M$$

where the symbols mean the same as before. Suppose you are using a 50mm lens and need a magnification of 0.8:

$$50mm \times 0.8 = 40mm$$

This 40mm is added extension. Using bellows or extension tubes, move the lens that far from its normal position and the magnification will be approximately 0.8 with the lens set at infinity.

Canon Extension Tubes—There are three types of extension tubes that fit between lens and camera body. Extension Tube M set has breech-lock fittings that fit the camera mount at one end and the lens mount at the other. These are handy because they match the existing camera and lens mounts, but the size range is limited.

Extension Tube M set consists of four tubes:

 One 5mm tube
 One 10mm tube
 Two 20mm tubes

The shortest extension is with the 5mm tube between camera and lens. With a 50mm lens, the magnification is 5/50 = 0.1. You can get any magnification with lens extensions that you can with close-up lenses. But with lens extension, magnification can be a lot higher—into the macro range—with less image degradation.

All of the tubes in the M set connected together add up to 55mm. With a 50mm lens, this gives a magnification of about 1.1—slightly more than life size.

You can use extension tubes with lenses of any focal length, but magnification is greater with shorter lenses.

Another set of extension tubes was originally designed for Canon rangefinder cameras with screw-type lens mounts. These have male threads at one end and female on the other for connecting end-to-end. The series is:

 Tube A—6mm
 Tube B—9mm
 Tube C—12mm

Plus numbered extension tubes identified by their length in millimeters: 25, 50, 75, 100, 150 and 200.

Extension Tube M set uses standard Canon breech-lock mounts to fit camera on one side and lens on the other. These can be stacked for more extension. Nomenclature is engraved on the items.

For longer extensions, use screw-type tubes available in lengths from 6mm to 200mm. Tubes screw together as desired, require Lens Mount Converters A and B to adapt the threaded ends to Canon mounts.

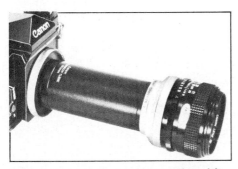

100mm screw-type extension tube with Lens Mount Converter A at camera end, converter B at lens. With 50mm lens, this gives magnification of 2. For best picture quality, lens should be reversed.

Screw-type extension tubes require adapters on both ends to fit breech-lock mounts on Canon SLR lenses and camera bodies. Lens Mount Converter A fits on the camera body and accepts the screw-in extension tubes. This converter itself adds 2.8mm of extension.

At the front end of screw-type extension tubes, use Lens Mount Converter B to accept Canon FD and FL lenses. This converter adds 13.2mm of extension to the end of the tube. Thus, Lens Mount Converters A and B together add 16mm to the extension total, in addition to whatever the tubes themselves contribute. Take this into account when figuring magnification.

There is no theoretical limit to the amount of extension you can use. Image quality and depth of field are reduced as magnification is increased. If one each of the screw-type extensions together with adapters A and B were all connected together, the total extension would be 643mm. With a 50mm lens, this gives 12.8 magnification! Canon recommends using extension tubes up to magnifications of 8.

None of the extension tubes discussed so far provide for meter coupling between lens and camera or for automatic aperture control. You operate the aperture manually by rotating the aperture ring on the lens. To set old FD lenses for manual operation of the aperture, move the Automatic Aperture lever on the back of the lens to the Manual setting (counterclockwise movement) and lock it in position. Most New FD lenses require a special adapter to hold the Automatic Aperture Lens counterclockwise. Do this before mounting the lens on the extension tube.

Because these extension tubes do not couple a full-aperture signal back to the camera, you cannot use full-aperture metering, even with an FD lens. Therefore, you meter stopped-down. You can view and focus at full aperture by

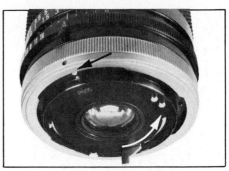

When an old FD lens is mounted backwards, these pins and levers become the "front" of the lens. Aperture control is manual. To set lens for manual control of aperture, do two things: Move Automatic Aperture (white arrow) lever counterclockwise to the end of its slot. Rotate the knurled Breech-Lock Ring as though the lens was being mounted on the camera. This unlocks the internal mechanism of the lens. If lens is equipped with a Mount Lock Pin (black arrow) it must be depressed to rotate Breech-Lock Ring.

To set up most New FD lenses for manual aperture control, use the accessory Manual Diaphragm Adapter to hold the Automatic Aperture Lever fully counterclockwise.

manually opening the lens. Then manually set the lens to the aperture for shooting and set exposure while holding or locking the stop-down control in the stopped-down position.

Another series of extension tubes, identified as the FL type, come in two lengths: FL15 and FL25—the number is the length in millimeters. These were designed for use with FL lenses, which have full-aperture viewing but not full-aperture metering. Metering is done stopped-down.

Extension Tubes FL25 and FL15 preserve automatic aperture operation—the camera stops down the lens at the moment of exposure. Using these stacked together to get 40mm of extension is not recommended because of added friction and play in the linkage.

Extension Tube FD25-U preserves all automatic features of FD lenses. When used with the 50mm macro lens, magnification is from 0.5 to 1. A similar extension tube, FD50-U, is 50mm long and gives the same range of magnification with the 100mm macro lens.

FL extension tubes are equipped with breech-lock fittings and require no lens-mount converters.

FD extension tubes have the same pins and levers as an FD lens and preserve all automatic features of lens and camera. Extension Tube FD-50-U provides 50mm of extension and is normally used with the 100mm macro lens to increase the magnification range from 0.5 to 1. FD-25-U provides 25mm of extension and is normally used with the 50mm macro lens for the same purpose. FD-15-U provides 15mm of extension. All of these tubes can be used with any FD lens.

With a lens mounted normally on the front of one or more extension tubes of fixed length, the lens focusing movement provides an additional, variable amount of extension. Even so, there may be occasions when a certain exact magnification can not be provided because the exact amount of extension is not possible.

This problem can be solved by using a Canon Vari-Extension Tube, which has variable length. The M15-25 has a minimum length of 15mm and extends to 25mm. The M30-55 extends from 30mm to 55mm. Both are manual, used like Extension Tube M set, already discussed.

Macrophoto Coupler—At magnifications greater than 1.0, image quality is improved by reversing most lenses so the longer distance is on the same side as the designer intended—even though it becomes image distance rather than subject distance.

When mounted backwards, a lens is attached using its filter threads. These are screwed onto a gadget usually called a reversing ring, but Canon calls it a Macrophoto Coupler. There are two types, each in four thread diameters—48mm, 52mm, 55mm and 58mm. When using these couplers, you must operate the lens manually and meter stopped-down.

Macrophoto Coupler 48, 52, 55, or 58 is a simple reversing attachment. It is used with Lens Mount Converter A between coupler and camera body, or coupler and bellows, or coupler and extension tubes.

Macrophoto Coupler FL accepts lenses mounted backwards and provides variable lens extension up to 13mm with a built-in helicoid focusing mechanism.

Both Macrophoto Couplers have threads on the forward side to match filter-ring threads on the lens. The FL coupler breech-lock fitting fits any suitable extension

Vari-Extension Tubes M15-25 and M30-55 can be combined with fixed-length tubes and used to adjust magnification by changing the total extension. This is the M30-55.

tube or mount converter, and also fits the lens mount on the camera body. It can be used without any other extension between camera and a reversed 50mm lens to give magnifications from about 0.5 to 0.75.

In addition to variable extension, the FL coupler has a fixed extension:

Macrophoto Coupler	Fixed Extension	Variable Extension
FL48	24mm	0-13mm
FL52	20mm	0-13mm
FL55	20mm	0-13mm
FL58	20mm	0-13mm

Reversing the 50mm Macro and using the Macrophoto Coupler FL to fit on the camera allows magnifications from 1.2 to 1.4.

When the lens is reversed, the distance between the filter mounting ring where the Macrophoto coupler is attached and the lens itself is additional extension. This distance is 41.2mm. In other words, just reversing the 50mm Macro lens adds an additional 41.2mm to the extension of the lens. To figure magnification, this should be added to any other extension being used.

MacroHood—With the lens reversed, you have to use stopped-down metering and control aperture by rotating the aperture ring on the lens.

Canon 50mm Macro lens with FD-25U gives magnifications from 0.5 up to 1.0 and is handy for stalking nature.

Setting the lens for manual aperture control depends on the lens type. With most old FD lenses, you merely push the lever fully counterclockwise where it is held by a detent. With a few old FD lenses, there is a separate lock lever to hold the Automatic Aperture Lever clockwise.

With New FD lenses, except 50mm and 100mm macro lenses, use the accessory Manual Diaphragm Adapter to hold the Automatic Aperture Lever in the clockwise position. Then install the MacroHood onto the breech-lock mount of the lens. The aperture will respond and change size immediately when you rotate the aperture ring on the lens.

Alternate Method—Another way you can set up a lens for manual aperture control is to use the Macro Auto Ring and Double Cable Release as shown on the following page. This method can be used with the lens reversed on a bellows or extension tube, or with the lens mounted normally on a bellows or non-meter-coupled extension tubes.

If you buy an FL Macrophoto Coupler, a MacroHood is included in the package.

BELLOWS

Canon bellows use breech-lock mounts at both ends and fit between lens and camera. The theory of extension by bellows is the same as by fixed tubes.

Bellows M has no automatic features. It accepts lenses directly or reversed with either of the Macrophoto Couplers. A rack-and-pinion gear extends the bellows from 33mm to 145mm. Read the extension directly from a scale on the extension rod below the bellows.

Bellows M has a tripod socket on the bellows, and the combined camera with bellows balances bet-ter on a tripod or copy stand if the bellows socket is used instead of the camera socket. This bellows has only one adjusting screw to move the lens in relation to the camera.

Bellows FL allows automatic aperture operation by the stopped-down lever on the camera and also during shooting.

Bellows FL adjusts from 34.5mm to 142.5mm extension. The bellows scale reads extension distance and reproduction ratio or magnification. Automatic-aperture control is by rods that run the length of the bellows. A lever on

Macrophoto coupler FL has a built-in helicoid that moves the camera lens through a 13mm range. When used between a reversed 50mm Macro lens and a camera body, the combination gives magnifications from 1.2 to 1.4.

Auto Bellows has three adjusting knobs. Adjuster at front moves lens independent of camera. Adjuster at rear moves camera independent of lens. Adjuster in middle moves camera and lens together, toward or away from subject, which changes focus without affecting magnification.

Auto Bellows with 50mm Macro Lens mounted conventionally on front, F-1 camera on rear. Double Cable Release allows automatic diaphragm operation, stopping down lens before tripping shutter in camera.

Automatic diaphragm operation of a reversed FD or FL lens can be done using the Macro Auto Ring on the breechlock end of the lens and the Double Cable Release. From left to right: camera, extension tube. Macrophoto Coupler, 50mm lens, Macro Auto Ring, Macrophoto Hood.

the side should be depressed before mounting FL or FD lenses to couple the aperture-control system to the aperture lever on the back of the lens. The lens should be set for automatic operation of the aperture.

A special bracing strut extending from the front of the FL bellows can be used as a steady-rest when pointing downward by extending the strut until it contacts the table top or copy-stand base and locking the strut in that position.

The latest design is the Canon Auto Bellows. It accepts Canon cameras equipped with motor drive or power winders. The camera can be rotated 90° for vertical-format shots.

This bellows has three independent adjustments: front standard, rear standard, and a third knob that moves the entire bellows forward or backward without changing the spacing between front and rear standards.

When a Canon FD or FL lens is mounted on the bellows front standard, not reversed, automatic diaphragm operation is possible using a special Double Cable Release. One branch of the cable release screws into the front stan-

dard of the bellows; the other branch screws into the shutter-release button on the camera. Operation of the plunger in the handle of the cable release first causes the lens to stop down to aperture size selected on the lens. Then the shutter button on the camera is depressed by the other branch of the cable.

The front standard can be removed from the bellows rail and installed backward. A lens mounted in the normal way on the front standard then becomes reversed and fits between the front standard and the forward end of the flexible bellows fabric. Automatic diaphragm operation with FD and FL lenses remains possible using the Double Cable Release.

Still another way to reverse the lens is to leave the front standard installed in the normal way and reverse the lens on the front standard using any of the reversing rings mentioned earlier. This allows full use of the bellows extension but does not allow automatic diaphragm operation with the Double Cable Release screwed into the front standard.

To solve this problem, the Macro Auto Ring fits on the

breechlock mount of most FD or FL lenses and can be used between lens and camera mount, lens and bellows mount, or between the lens and any standard Canon mount. If the lens is reversed so the mount is the forward end of the optical system, you can still install the Macro Auto Ring on the lens. One branch of the Double Cable Release is then connected to the Macro Auto Ring and automatic operation of the lens diaphragm is provided.

The Macro Auto Ring will not work with these FL lenses: FL 19mm f-3.5; FL 35mm f-2.5; FL 50mm f-1.8 Type 1; FL 58mm f-1.2.

Extension of the Auto Bellows is from 39mm to 175mm. Scales on the bellows show extension and magnification for 50mm lenses mounted both conventionally and reversed.

Accessories for the Auto Bellows—A Macro Stage screws onto the forward end of the bellows rail and serves as a platform that supports the bellows in a vertical position. The Macro Stage has a translucent insert plate so the subject being photographed can be illuminated from below if desired.

For convenient high-magnification photography, the Macro Stage attaches to the front of the Auto Bellows rail. Mounted on the bellows is one of the special Macro Photo Lenses.

It is equipped with spring clips to hold specimen slides as you can see in the accompanying photo.

Duplicator 35 fits on the forward end of a bellows-mounted 50mm lens to allow copying 35mm slides. Duplicator 16 and Duplicator 8 are used with the special 35mm and 20mm Macro Photo lenses. These duplicators allow copying single frames of 16mm and 8mm film onto 35mm film in the camera.

EXPOSURE MEASUREMENT WITH BELLOWS

All Canon bellows require exposure measurement with the lens stopped down. If the lens is reversed, aperture adjustment is fully manual.

With a standard FD or FL lens not reversed, exposure measurement depends on which bellows you use. With Bellows M, aperture adjustment is fully manual. Open the lens to focus, manually stop down for exposure measurement and take the picture.

Bellows FL and the Auto Bellows both have an automatic diaphragm feature—the FL uses rods on the bellows itself and the Auto Bellows uses the Double Cable Release. Either way, this feature closes down the lens as part of the exposure sequence. You must measure the light and set the exposure controls beforehand.

With Bellows FL, stopping down the lens for exposure measurement is done using the stop-down control on the camera body. With the Auto Bellows, this is done by partially depressing the plunger in the handle of the Double Cable Release. This plunger has a locking ring to hold it partially depressed for metering or fully depressed for a time exposure.

As you will see later in this chapter, there are two special lenses for use on the front of a bellows: Macro Photo 35mm *f*-2.8 and Macro Photo 20mm *f*-3.5. They have no automatic features. Aperture control is fully manual at all times.

EXPOSURE CORRECTION FACTORS FOR 50MM LENS

Magnification	Exposure Factor	Aperture Adjustment (*f*-stop)	Magnification	Exposure Factor	Aperture Adjustment (*f*-stop)	Magnification	Exposure Factor	Aperture Adjustment (*f*-stop)
0.1	1.21	0.28	3.2	17.64	4.14	6.8	60.84	5.93
0.2	1.44	0.53	3.4	19.36	4.28	7.0	64.00	6.00
0.3	1.69	0.76	3.5	20.25	4.34	7.2	67.24	6.07
0.4	1.96	0.97	3.6	21.16	4.40	7.4	70.56	6.14
0.5	2.25	1.17	3.8	23.04	4.53	7.5	72.25	6.18
0.6	2.56	1.36	4.0	25.00	4.64	7.6	73.96	6.21
0.7	2.89	1.53	4.2	27.04	4.76	7.8	77.44	6.28
0.8	3.24	1.70	4.4	29.16	4.87	8.0	81.00	6.34
0.9	3.61	1.85	4.5	30.25	4.92	8.2	84.64	6.40
1.0	4.00	2.00	4.6	31.36	4.97	8.4	88.36	6.47
1.22	4.84	2.27	4.8	33.64	5.07	8.5	90.25	6.50
1.4	5.76	2.53	5.0	36.00	5.17	8.6	92.16	6.53
1.5	6.25	2.64	5.2	38.44	5.27	8.8	96.04	6.59
1.6	6.76	2.76	5.4	40.96	5.37	9.0	100.00	6.64
1.8	7.84	2.97	5.5	42.25	5.40	9.2	104.04	6.70
2.0	9.00	3.17	5.6	43.56	5.45	9.4	108.16	6.76
2.2	10.24	3.36	5.8	46.24	5.53	9.5	110.25	6.78
2.4	11.56	3.53	6.0	49.00	5.62	9.6	112.36	6.81
2.5	12.25	3.63	6.2	51.84	5.70	9.8	116.64	6.87
2.6	12.96	3.70	6.4	54.76	5.78	10.0	121.00	6.92
2.8	14.44	3.85	6.5	56.25	5.81			
3.0	16.00	4.00	6.6	57.76	5.85			

Exposure Factor is $(1+M)^2$ where M is magnification. When you *don't* use meter in camera reading through extension devices, measure light and figure indicated exposure as though no extensions were to be used. Then correct exposure according to the magnification. To correct by changing shutter speed, multiply indicated speed by the Exposure Factor and take the nearest available setting. To correct by changing aperture, make aperture larger by indicated *f*-stop adjustment. You can make part of the correction in shutter speed and the rest in aperture if desired.

LIGHT PROBLEMS
WITH LENS EXTENSION

From the film's point of view, light comes from the back end of the lens as an expanding cone making a circle at the film plane.

Light sources that produce diverging rays are subject to the *inverse-square law*. The law says the amount of light changes inversely with the distance from the light source. The farther away from the source, the dimmer the light is.

When you use extension rings or a bellows to put extra distance between lens and film, the effect is noticeable.

The light loss due to adding lens extension is seen by the metering in the camera, so correction is automatic so long as you set exposure controls *after* you set lens extension. There can be cases where the light is so low that the camera exposure meter doesn't read accurately.

If all else fails, you meter the subject as though you were going to shoot it without any extra lens extension, then calculate the loss of light due to the lens extension you plan to use. Then correct the exposure settings to compensate for the light loss.

There are several ways to meter the subject without lens extension. You can remove the extension tubes or bellows from your camera, meter the subject, then reinstall the extension devices. If you have two cameras, you can use one without extension to meter the subject. Or you can use a separate exposure meter.

To calculate approximately the light loss due to extension, use this formula:

Exposure Correction Factor =
$(1 + M)^2$

in which M is the magnification you will get from the additional extension.

Suppose your equipment is set up to give a magnification of 2. The correction factor is:

$$(1 + 2)^2 = 9.$$

The Speed Finder is a very handy accessory for copy stand use.

If you meter the subject directly rather than through the extension, you need about 9 times as much exposure. Get it by multiplying exposure time by 9, or by opening aperture to let 9 times as much light through—which is a little more than 3 steps—or any combination of the two.

The shutter speed you end up using may be in the range that indicates reciprocity failure. Check the film data sheet.

Whenever there is technical uncertainty including reciprocity failure, and when it is important that you get a good exposure, bracketing is a good idea.

The formula and example just given for exposure correction apply to lenses near 50mm focal length. Exposure correction for telephoto and retrofocus lenses mounted both normally and reversed is more complicated and there are several more formulas. If you are interested in this subject, I cover it thoroughly in *SLR Photographers Handbook*, also published by HPBooks.

SPECIAL LENSES FOR
MACRO PHOTOGRAPHY

Some zoom lenses listed in the next chapter have a special "macro" setting that positions the lens elements for short subject distances. These lenses are not intended for table-top macro photography such as copying or pho-

tographing flat subjects such as a stamp collection. They are not as fully corrected for flat subjects as the Canon Macro lenses.

The special focusing feature of these zoom lenses should properly be called "close focusing" rather than "macro" because magnification is only about 0.2. It's handy to have this extra magnification when photographing nature.

The FD 50mm *f*-3.5 Macro lens is intended for general outdoor photography and also at magnifications up to about 2, including flat subjects. It can be used on the camera, on extension tubes, or on a bellows.

The FD 100mm *f*-4 Macro and the FD 200mm *f*-4 Macro have the same application as the 50mm with more distance between lens and subject. Doubling focal length approximately doubles shooting distance at the same magnification. This makes it easier to get light on a subject and, if you are photographing a wary insect, may persuade it to continue posing rather than fly or flee.

You should get satisfactory image quality at magnifications from 1 to 2 when reversing standard macro lenses. Beyond that, image quality deteriorates significantly and you should consider using bellows-mounted Macro Photo Lenses.

CANON MACRO
PHOTO LENSES

Two special Canon lenses are *specifically* designed to work at high magnifications on a bellows without being reversed. They are the Macro Photo Lenses with 35mm and 20mm focal lengths. These are manual lenses with no focusing mechanism. They have threads on the back side that screw into an adapter plate called Macro Photo Lens Adapter. The back side of the adapter has the standard Canon breech-lock mount so it can be attached to the front of a bellows.

With the Auto Bellows, the Macro Photo 35mm lens gives magnifications from about 1.8 to

For best image quality at magnifications from about 2 to 10, use Macro Photo Lens 35mm *f*-2.8, shown at left, or Macro Photo Lens 20mm *f*-3.5, at right. Each is shown mounted on the Macro Photo Lens Adapter that is required to attach the lens to a bellows. The adapter is also shown separately. Handles on the aperture rings aid in setting apertures.

Camera Holder F is useful to hold the camera on a tripod or copy stand. Particularly with long lenses or lens extension, it adds rigidity to the set up.

EXTENSION LENGTH OF ACCESSORIES	
ITEM	EXTENSION (mm)
Auto Bellows	39 to 175
Bellows FL	34.5 to 142.5
Bellows M	33 to 145
Extension Tube M5 M10 M20	5 10 20
Macrophoto Coupler FL55, FL58	20 to 33
Lens Mount Converter A	2.8
Lens Mount Converter B	13.2
Screw-type Extension Tube 6mm 9mm 12mm 25mm 50mm 75mm 100mm 150mm 170mm 200mm	 6 9 12 25 50 75 100 150 170 200
Vari-Extension Tube M15-25	15-25
Vari-Extension Tube M30-55	30-55
Extension Tube FL15 FL25	15 25
Extension Tube FD25	25
Extension due to reversing 50mm Macro	41.2
Extension Tube FD50	50
Extension due to reversing 100mm Macro	55.1

To figure magnification, use the formula $M = X \div F$, where M is magnification, X is total lens extension and F is focal length of lens being used.

5. Using the Macro Photo 20mm gives magnifications from about 4 to 10. For best image quality in these ranges, use the appropriate Macro Photo lens. With Bellows M or Bellows FL, maximum magnification is about 15% less because these bellows have less extension.

For magnifications larger than 10, mount the camera body on a microscope as discussed later in this chapter.

USING CLOSE-UP AND MACRO PHOTO EQUIPMENT

In high-magnification photography, take all possible measures to guard against camera vibration. If possible, lock up the mirror after focusing and before shooting. Use a cable release or the self-timer on the camera to trip the shutter.

Depth of field is often a major problem except for flat subjects. To get reasonable depth of field requires shooting at small aperture, which in turn may complicate lighting for exposure. When the camera lens is close to the subject, it is sometimes difficult to get enough light. This is largely a

matter of technique and the lighting equipment you have available.

Often it is necessary to experiment with lighting to bring out the details you want to show, particularly with limited depth of field. Sometimes, side lighting gives good modeling and puts shadows where the depth of field is poor anyway. If you cannot provide sufficient depth of field to include all of the subject or surface variations

Handy Stand F is lightweight and useful to copy documents. Extension Tube M5, supplied with the stand, allows a 50mm lens to focus at the table top.

Copy Stand 4 has a flat base for the material to be photographed and a movable arm to support the camera or a bellows with camera attached. Shown here with a camera on the movable arm.

Duplicator 35 mounted on the Auto Bellows with the accessory Roll Film Stage attached. This duplicator can be shifted 8mm vertically and 12mm horizontally to improve composition by cropping when using magnifications greater than 1.

you are photographing, it is usually best to put good focus near the front of the object.

When lenses are not reversed, you can use the lens focusing mechanism to change magnification and focus. If the two are in conflict, use the focus control to set magnification and move the entire camera to find focus.

When lenses are reversed, the focus control doesn't have any effect with lenses of conventional design. When the lens is attached by its front ring, the focus control moves the back mounting fixture in and out, but doesn't change the location of the lens itself. Some lenses use internal focusing, which is changed by rotation of the focus control no matter which way the lens is mounted.

When using 75mm or longer tube extensions on the camera, the Macrophoto Strut clamps onto the lower part of the extension tube. Place its rubber tip against the copy-stand base to reduce vibration.

A convenient small copy stand for use on a desk or table with camera and extension tubes is the Handy Stand F. It is a four-legged "tripod" with marks on the legs so all can be extended the same amount to keep the camera parallel with the table top. It includes one Extension Tube M5 and an F ring to fit the lens filter ring and thus support the camera.

Viewing aids described earlier are useful on a copy stand to make viewing and composing easier. These include the Speed Finder and the Waist Level Finders for the F-1, and Angle Finders A2 and B. Magnifier R with the normal Eye-level Finder helps get good focus under difficult circumstances when you don't have any excess depth of field anyway.

DUPLICATING SLIDES

A slide holder is used to hold a slide in front of a bellows-mounted lens so the slide can be copied. The slide holder has its own bellows that attaches to the lens and

keeps light out of the optical path between slide and lens. Variable extension of the main bellows and variable extension of the slide-holder bellows are used together to establish magnification of the slide. To copy a 35mm slide, magnification should never be less than 1. Often an improvement results from using magnification larger than 1 because that crops the edges of the picture and a tighter composition results.

Depending on the holder used, you can crop asymmetrically by shifting the slide up and down, or laterally, in the holder.

Bellows FL is used with Slide Holder FL. Duplicator 35 is used with the Auto Bellows. They are not interchangeable but they have the same basic functions.

Mounted slides can be inserted in the slide holder. Unmounted slides can also be duplicated by opening up the holder and placing the sprocket holes of the unmounted slide over pins inside the unit.

The slide should be inserted with the emulsion side toward the light—that is, away from the camera. Slides can be duplicated the other way around if you need to reverse the image left-to-right for some reason. Be sure the camera is focused on the image in the emulsion.

On the back side of the slide, meaning the side away from the camera lens, is a frosted glass pane to give uniform illumination across the slide.

Exposure can be read directly from the camera metering, and it is normally possible to shoot at ordinary speeds such as between 1/30 and 1/500. You can do this simply by controlling the amount of light entering the slide holder through the frosted glass pane.

For the most realistic color rendition, the light used should agree with the film in the camera—daylight for daylight film, and so forth. It is possible to use filters over the lens to correct color quality of the light or for special effects.

Duplicating a slide onto slide film is a positive-to-positive process and the colors of the duplicate slide will not usually be exact duplicates of the original. This is often not noticed or the effect is small enough to be tolerated. Also, an increase in contrast is common when duplicating slide-to-slide.

If you just want one or a few copies of a slide and you don't need duplicates very often, you are probably better off having your duplicates made by a commercial lab.

Slide-duplicating equipment is a good purchase for the ordinary photographer only if he intends to make duplicates in volume, or create new images by sandwiching existing slides and photographing the result and perhaps change colors by using filters. If you know you will need several exact duplicates of a slide, expose more originals.

Two special duplicators are available to copy single frames of

Duplicator 8, mounted on Macro Photo Lens 20mm *f*-3.5, on Auto Bellows, being used to copy frames of 8mm film onto 35mm film in the camera.

8mm or 16mm film using the two special Macro Photo lenses. The cone-shaped ring on the front of the lens is unscrewed and the special duplicator is screwed on in its place.

Duplicator 8, for 8mm film, is used with the 20mm Macro Photo Lens. Duplicator 16 is used with the 35mm lens. The combination can be installed on the front of any Canon bellows, although this equipment is listed as accessory to the Auto Bellows. Use the same precautions and procedures mentioned earlier for duplicating 35mm slides.

MICROPHOTOGRAPHY

This is photographing through a microscope to get magnifications larger than the 8 or 10 normally practical with extension tubes or bellows. Magnifications up to 2000 are possible with the right microscope.

Because the microscope replaces the camera lens, there is no camera *f*-stop to be concerned with. Exposure is arrived at using whatever light comes into the camera and an appropriately long

exposure time. This makes lighting of the subject critical and sometimes difficult. The technique of using microscopes and illuminating the subject is beyond the scope of this book, but can be found in books on microscopes.

Two accessories allow optically and mechanically connecting a camera to a microscope.

Canon Photomicro Unit F has an outer tube that replaces the camera lens. It attaches to the front of the camera the same way lenses do. There are no optics in the tube. At the opposite end are fittings that adapt to the top tube of the microscope and hold the top lens of the microscope—called the eyepiece of the microscope.

Photomicro Unit F has sufficient mechanical strength and rigidity to support the camera on top of the microscope.

The Canon Microphoto Hood is a telescoping light-tight tube. It is not intended to support the camera, so a copy stand is required. The copy stand supports camera and bellows in the normal way. The microscope sits on the base of the copy stand and the Microphoto Hood fits between bellows and microscope.

Focusing is possible with the microscope focus control or by changing bellows extension at the camera. Changing bellows extension is aided by the telescoping feature of the Microphoto Hood, and of course different extensions give different magnifications.

Using Microphoto Equipment—Precautions about preventing vibration are more important with increasing magnification. Use a cable shutter release. Shutter speeds between 1/2 and 1/30 cause the least camera shake, so stay in that range if possible. Canon recommends using rubber pads, 3/4 to 1-inch thick, underneath the equipment set-up and between table or bench and the floor. These isolate the equipment from earth-borne vibrations or those transmitted through the structure of a building.

HOW TO INCREASE MAGNIFICATION BY LENS EXTENSION

This table does not include all possible combinations. For example, extension tubes can be used in place of bellows. Lenses with different focal lengths can be used in a similar way.

Longer focal lengths require proportionately more extension to give the same magnification. For example, a 100mm lens requires twice as much extension as a 50mm. Shorter focal lengths require proportionately less extension.

Longer focal lengths give more working distance between lens and subject which is often desirable for lighting the subject.

1 Lens	5 Macrophoto Coupler FL 55mm	8 Lens Mount Converter A
2 Camera	6 Lens Mount Converter B	9 Macrophoto Coupler 55mm
3 Extension Tube FD25	7 Extension Tube	10 Macrohood
4 Bellows		

Lens	Approximate Magnification	Approximate Distance between Subject and Film Plane (mm)	Approximate Lens Extension (mm)	Equipment Needed
50mm Macro with Extension Tube FD25	0.5 to 1	232 to 205	25 to 50	1 3 2
50mm Macro with Bellows	0.67 to 2.76	263 to 214	35 to 175	1 2 4
50mm Macro reversed with Macrophoto Coupler FL	1.2 to 1.4	212 to 207	61 to 74	10 1 5 2
50mm Macro reversed on Bellows with added extension	2.3 to 8.4	541 to 238	118 to 433	10 1 5 6 7 8 2 4 or 10 1 9 7 8 2 4

To show what to expect from simple slide copying, I used a slide holder attachment with ordinary daylight slide film and diffused daylight as the illuminant. Original on left, copy on right. Notice slight enlargement, increased contrast and color change. Color change can be reduced by testing and use of filters.

14

AVAILABLE CANON LENSES

Newcomers to SLR photography sometimes become too interested in the camera body because that's where most of the gadgets are. It's the lens that makes the picture. All the body does is hold the film.

If economy is a consideration, buy a less expensive camera body rather than less expensive lenses. Buying an SLR camera with only one lens is a waste! If you intend to do that, I strongly suggest that you buy a cheaper camera with a fixed, non-interchangeable lens.

When you are no longer a newcomer, you take great pleasure and satisfaction in the versatility that you get with several lenses of different focal length—perhaps some of the zooms. You will choose lens focal length for the desired effect when you make pictures of various scenes and subjects. Lenses become the central part of your photographic equipment and everything else exists to help the lenses do their job.

In the early 1970s Canon replaced FL lenses with FD lenses. The meter-coupled FD series offers full-aperture metering, and can be used with shutter-priority and aperture-priority automatic exposure.

Aside from these operational advantages, additional design improvements to individual lenses produced better image quality. These include the Floating System that changes spacing between lens elements to reduce spherical aberration at close subject distances, aspheric elements, fluorite elements, ultralow dispersion glass

It's the lens that makes the picture. The camera holds the film flat and the photographer helps as much as possible but, fundamentally, lens quality determines picture quality. Shot with the Canon 200mm f-4 lens on an A-1 camera using shutter-priority AE.

and multicoating. All contribute to improved image quality.

As these lens improvements were adopted, some were used in combinations that made lens nomenclature increasingly complex. To regain simplicity, Canon adopted the symbol L to identify lenses with special design features that give exceptional image quality rather than stating each of the individual measures used.

New FD lenses replaced old-style FD lenses during 1979 and 1980. New FD lenses, where possible, have smaller minimum apertures, larger maximum apertures, optical design improvements, and multi-coating on all except the 50mm f-1.8 lens. In addition, new FD lenses are

smaller, lighter and easier to mount on the camera.

The lens table in this chapter shows available lenses and a few scheduled for announcement shortly after printing this book.

New FD lenses and old FD lenses are mechanically interchangeable. They are all breech-lock lenses and all have the same levers and pins to work with the camera body. Both types of lenses are shown in this book.

LENS CATEGORIES

Most photographers think of lenses in categories such as telephoto or wide-angle. The paragraph titles that follow are Canon nomenclature for lens types and categories.

The 7.5mm Fish-Eye takes a 180° view in all directions. A lens hood or even a filter ring will intrude into the picture area and reduce the angle of view.

CIRCULAR FISH-EYE

The Fish-Eye 7.5mm f-5.6 lens has an angle of view of 180°—90° each side of the lens axis. It distorts visibly, causing vertical and horizontal lines to curve and similarly distorts natural objects such as trees and people. The distortion of natural objects may not be as noticeable.

Shorter focal lengths have greater depth of field. At 7.5mm focal length, this lens has depth of field from very near the lens all the way to infinity, so there is no need for a focus control. It is a fixed-focus lens, set at the hyperfocal distance.

Because of the 180° field of view, any forward projection around the lens, such as a lens hood, will vignette the image. No lens hood is used. Because filters mounted at the front of the lens would also vignette, six internal filters are built into the lens on a turret. By an external control you can select from Sky, Y3, 01, R1, CCA4 or CCB4. These are Canon filter designations—see Chapter 15. Canon service facilities can change these filters to other types, but designations engraved on the control will stay the same.

To make an image with 180° coverage in all directions, the image must be circular. The 23mm circular image made by this lens fits inside the rectangular 35mm film frame. Outside of the circle, the film is unexposed.

Both the 7.5mm Fish-Eye and the 15mm Fish-Eye discussed below are retrofocus designs. They install on the camera without interfering with normal mirror operation and viewing.

Aperture control of the 7.5mm Fish-Eye is completely manual. It is not stopped down by the camera mechanism at the instant of exposure. Stopped-down metering is used.

FULL-FRAME FISH-EYE

The FD 15mm f-2.8 Fish-Eye lens also has a 180° angle of view, but the image circle at the film plane completely fills the frame. The sides, top and bottom of the image circle are cut off and the 180° field of view exists only on the diagonal of the frame.

A shaped, attached lens hood shades the lens on the sides, top and bottom, but the hood is cut away at the corners so it doesn't obstruct the 180° viewing angle. This lens has four built-in filters: Sky, Y3, 01 and R1. These can also be changed, but the control markings cannot.

Because it fills the frame, it doesn't call attention to the fact that it is a fish-eye as much as the 7.5mm lens, although the same type of image distortion exists. Interesting and unusual wide-angle views result from use of this lens and it is generally more useful than the circular fish-eye. Even though it has a maximum aperture of f-2.8, this is one of the smallest fish-eye lenses available and it has many uses. Controls and operation are the same as for any other FD lens.

SUPER-WIDE-ANGLE LENSES

Canon offers a series of lenses covering angles of view from 104° to 64° in steps of approximately 10°. Super-wide-angle lenses are the FD 17mm, 20mm and 24mm with angles of 104°, 94° and 84°.

These lenses do not have fish-eye distortion and are useful for

The 15mm Fish-Eye makes a rectangular image. It has a built-in lens hood that is cut away at the corners where the angle of view is 180 degrees.

shooting in limited space, photographing groups of people, interiors, buildings, and for the special impact of wide-angle scenic views and nature. Incidentally, lenses that do not cause straight lines to curve are called *rectilinear*.

WIDE-ANGLE LENSES

Two focal lengths, 28mm and 35mm, have viewing angles of 75° and 63°. Because of their inherently large depth of field, lenses in these focal lengths are good for candid and snapshot photography in addition to interiors and general use. Because photos made with 35mm focal length are not extremely wide-angle, many photographers use a 35mm lens as the standard camera lens.

TILT AND SHIFT

Some features of the TS 35mm f-2.8 S.S.C. were described in Chapter 10. This lens tilts in one direction and swings at right angles to the tilt direction—that is, if it tilts vertically it swings horizontally. The entire lens rotates on its mount so it can be set to swing and tilt in any orientation. If you need it to tilt and swing both in the same direction, it can be modified by Canon Authorized Service Facilities.

The lens mounts in the normal way on the camera, but a tripod may limit the range of tilt or swing

CANON INTERCHANGEABLE LENSES

Lens	Type	Diag. Angle of View (deg)	Min Aperture	Min Focus Dist. (m)	Filter Diam (mm)	Length (mm)	Weight (g)
7.5mm f-5.6	Circular Fisheye	180	f-22	—	*	62	365
FD 15mm f-2.8	Full-frame Fisheye	180	f-22	0.2	*	61	460
FD 14mm f-2.8L	Super Wide	114	f-22	0.25	*	84	500
FD 17mm f-4	Super Wide	104	f-22	0.25	72	56	360
FD 20mm f-2.8	Super Wide	94	f-22	0.25	72	58	305
FD 24mm f-1.4L	Wide	84	f-16	0.3	72	68	430
FD 24mm f-2	Wide	84	f-22	0.3	52	51	285
FD 24mm f-2.8	Wide	84	f-22	0.3	52	43	240
FD 28mm f-2	Wide	75	f-22	0.3	52	47	265
FD 28mm f-2.8	Wide	75	f-22	0.3	52	40	170
FD 35mm f-2	Wide	63	f-22	0.3	52	46	245
FD 35mm f-2.8	Wide	63	f-22	0.35	52	40	165
FD 50mm f-1.2L	Standard	46	f-16	0.5	52	51	380
FD 50mm f-1.2	Standard	46	f-16	0.5	52	46	315
FD 50mm f-1.4	Standard	46	f-22	0.45	52	41	235
FD 50mm f-1.8	Standard	46	f-22	0.6	52	35	170
FD 85mm f-1.2L	Telephoto	29	f-16	0.9	72	71	680
FD 85mm f-1.8	Telephoto	29	f-22	0.85	52	54	345
FD 100mm f-2	Telephoto	24	f-32	1	52	70	445
FD 100mm f-2.8	Telephoto	24	f-32	1	52	54	270
FD 135mm f-2	Telephoto	18	f-32	1.3	72	90	660
FD 135mm f-2.8	Telephoto	18	f-32	1.3	52	78	395
FD 135mm f-3.5	Telephoto	18	f-32	1.3	52	85	325
FD 200mm f-2.8	Telephoto	12	f-32	1.5	72	134	735
FD 200mm f-4	Telephoto	12	f-32	1.5	52	122	440
FD 300mm f-2.8	Telephoto	8.3	f-32	3	48**	245	2345
FD 300mm f-4L	Telephoto	8.3	f-32	3	34**	207	1070
FD 300mm f-4	Telephoto	8.3	f-32	3	34**	204	945
FD 300mm f-5.6	Telephoto	8.3	f-32	3	58	199	635
FD 400mm f-2.8L	Super Tele	6.2	f-32	4	48**	348	5395
FD 400mm f-4.5	Super Tele	6.2	f-32	4	34**	288	1280
FD 500mm f-4.5L	Super Tele	5	f-32	5	48**	395	2610
Reflex 500mm f-8	Super Tele	5	f-8	4	34**	146	710
FD 600mm f-4.5	Super Tele	4.2	f-32	8	48**	462	3800
FD 800mm f-5.6L	Super Tele	3.1	f-32	14	48**	577	4270
FD 20-35mm f-3.5L	Zoom	94-63	f-22	0.5	72	84	470
FD 28-55mm f-3.5-4.5	Zoom #	75-43	f-22	0.4	52	61	220
F 28-85mm f-4	Zoom	75-29	f-22	0.9	72	104	485
FD 35-70mm f-2.8-3.5	Zoom #	63-34	f-22	1	58	120	545
FD 35-70mm f-3.5-4.5	Zoom #	63-34	f-22	0.5	52	61	200
FD 35-105mm f-3.5-4.5	Zoom #	63-24	f-22	1.2	58	84	345
FD 50-135mm f-3.5	Zoom #	46-18	f-32	1.5	58	125	650
FD 50-300mm f-4.5L	Zoom	46-8.3	f-32	2.5	34**	250	1820
FD 70-210mm f-4	Zoom #	34-12	f-32	1.2	58	151	645
FD 75-200mm f-4.5	Zoom	32-12	f-32	1.8	52	123	510
FD 80-200 f-4L	Zoom	30-12	f-32	1.2	58	153	675
FD 85-300mm f-4.5	Zoom	29-8.3	f-32	2.5	***	247	1630
FD 100-300mm f-5.6L	Zoom	24-8.3	f-32	2	58	172	710
FD 100-300mm f-5.6	Zoom	24-8.3	f-32	2	58	173	830
FD 150-600mm f-5.6L	Zoom	16-4.2	f-32	3	34**	468	4260
FD 50mm f-3.5	Macro	46	f-32	0.23	52	57	235
FD 100mm f-4	Macro	24	f-32	0.45	52	95	455
FD 200mm f-4	Macro	12	f-32	0.58	58	182	780
FD 35-70mm f-4AF	Autofocus	63-34	f-22	0.5	52	85	645
FD 85mm f-2.8	Soft focus	28.5	f-22	0.8	58	70	375
TS 35mm f-2.8	Tilt/Shift	63	f-22	0.3	58	75	550
20mm f-3.5	Macrophoto		f-22			20	30
35mm f-2.8	Macrophoto		f-22			23	56

NOTES:
Zoom lens with close-focusing "macro" capability
* Built-in filter turret
** Drop in filters in holder
*** Series IX filter

Shift lenses are fairly common for 35mm cameras. A lens that *shifts and tilts* is unusual. This is the Canon TS 35mm *f*-2.8 S.S.C. mounted on an F-1.

Sometimes, if your shadow or reflection is in the picture, you can use the TS lens to shift yourself out. Camera was moved and lens shifted for the right photo but the two pictures are essentially the same—except for the reflection.

Fish-eye lenses cause straight lines to curve outward from the center, unless a line passes through the center of the lens. In these rectangular fish-eye shots, the horizon was placed above center, on center, below center.

movement. A Tripod Adapter furnished with the lens fits between camera and tripod to give adequate clearance.

Mechanically this is a complicated lens with movement in two directions plus rotation, so aperture control is manual. Use it with stopped-down metering.

The TS lens makes a large image circle and when either or both of the adjustments are used, the result is a picture made with light from the edge of the image circle rather than the center. Because the light falls off more rapidly at greater distances from center, uneven illumination may be visible in the photo. Shooting at small aperture will help some, but nothing can entirely eliminate the effect. Because of light variation across the frame, exposure metering is not as precise as with other lenses, which may require bracketing exposures, testing to find correct settings, and good photographic judgment on your part.

Because biprism and microprism focusing aids depend on ray angles, they may not work properly when using the TS lens. Observe the entire image on the focusing screen to judge focus and composition.

Use of this lens to correct architectural views is important, but don't think of it as a lens exclusively for that purpose. Instead of using the tilt feature to improve focus of an angled surface or row of objects, it can be used the other way to cause dramatic out-of-focus effects for everything except the subject of main interest in the photo.

STANDARD LENSES

Lenses with 50mm focal length are standard for Canon 35mm cameras, meaning they give a view we accept as normal or usual. One of these lenses is supplied with a camera unless the buyer makes other arrangements.

The main differences among standard lenses are aperture and optical quality. The FD 50mm *f*-1.8 is lowest-priced. It will give complete satisfaction to many camera users. The 50mm *f*-1.4 is nearly as popular because of its better light-gathering capability. If you often shoot in dim light, one of the larger-maximum-aperture lenses may be worth the extra cost and weight—such as the 50mm *f*-1.2.

The star performer in this category is the FD 50mm *f*-1.2L,

Important lens accessories: Lens hood, lens cap and rear cover. Rear cover is different for New FD lenses. Lens hood nomenclature is BW, BS or BT, followed by lens accessory thread diameter—such as BS 55 for a lens that uses 55mm filters. W is for wide-angle lenses, 35mm and shorter. S is for standard lenses, 50 and 55mm. T is for telephoto lenses, 85mm and longer. These hoods use a bayonet twist-to-lock mount on the outside of the lens and do not interfere with use of filters or other screw-in accessories. Some lenses have permanently-attached hoods.

which is an aspheric lens. It is an outstanding lens in every respect with suppressed spherical aberration, unusually large aperture and superb image quality.

When selecting the lens for your new camera, you should first decide if you want a 50mm focal length. If so, you have several to choose from and the choice may be difficult. Don't buy less lens than you need, but don't waste money by purchasing more than you need. If you are sure you will use the larger aperture or better performance of the more expensive standard lenses, get the better lens when you buy the camera. Lenses with better light-gathering

capability weigh more.

You can buy a camera body with any of the standard lenses by specifying the lens you want. Or, you can buy a camera body only—without lens—then choose whatever lenses you want.

As a standard lens, you should consider the 50mm Macro. Because I enjoy high-magnification photography and do some close-up product photography for publication, I have switched to the 50mm Macro and have another 50mm lens I don't use much anymore.

MACRO LENSES

With the new FD 50mm f-3.5 Macro lens, you have about two

steps less light-gathering ability than the f-1.8 and about three steps less than the f-1.2 lens.

Obviously this can be a handicap when shooting action in dim light, but otherwise it is not a problem. Most photography is done at apertures smaller than f-3.5.

When using this lens for high-magnification, you will probably use artificial lighting anyway to get more light on the subject and to control shadows and modeling of surface features. Try to get enough light to use f-8 or f-11 for best image quality.

An advantage of this lens is a magnification of 0.5 with no accessories and no time spent fiddling. Turn the long-travel focus control out to full extension and you get an image on the film that is 50% as large as real life.

Extension Tube FD25-U is packaged with the 50mm macro lens and provides an additional 25mm of extension. It is an automatic extension tube, meaning that it preserves the mechanical linkages between lens and camera. You operate the camera the same way with or without the extension tube, which is very convenient.

Because the focus control moves the lens, it also affects magnification. Therefore, this lens shows magnification by a separate set of numbers engraved on the

When Extension Tube FD25-U is used with the 50mm Macro lens, read magnification from a scale on the lens barrel. This scale is gradually exposed as the lens is cranked out for nearer subjects. The scale shows a magnification range from 0.5 to 1.0. This is the New FD lens.

Canon Macro FD 100mm f-4 has the same basic features as the 50mm Macro. For the same magnification, this lens gives more distance between lens and subject than the 50mm Macro. Extension Tube FD50-U gives life-size images and preserves all automation. This lens will be replaced by the New FD 100mm f-4 Macro.

The New FD 200mm *f*-4 Macro lens has a useful focal length together with macro capability. It gives magnifications up to 1.0 without an extension tube.

Still another macro lens is the New FD 200mm *f*-4 Macro, which gives even more lens-to subject distance. At a magnification of 1, the subject is 12.2 inches (0.31 meters) in front of the lens! The focus adjustment in the lens provides magnifications up to 1.0 *without an extension tube* between lens and camera. This is a handy focal length for many kinds of sports, travel, nature and general use. The close focusing capability makes it excellent for nature photos.

The 200mm macro has a detachable tripod mount that clamps on the lens barrel and can be loosened to allow rotating lens and camera together to make a vertical format shot. Use the mount on the lens rather than the tripod socket on the camera.

As you can see in the lens table earlier in this chapter, the 200mm macro is about 75% longer and heavier than the New FD 200mm *f*-4 lens without the macro capability. The macro lens gives you a lot more capability for the additional size and should be considered if you are shopping for a 200mm lens.

These three lenses are "true" macros—they produce life-size images in the camera and they are corrected for good image quality including flatness of field so you can copy documents and photograph such things as stamps without the edges going out of focus.

BELLOWS MACRO

Two bellows macro lenses are the special Macro Photo 20mm and 35mm lenses described in the preceding chapter. If you want best image quality with magnifications in the range of 2 to 10, use these lenses.

The T80 uses special AC-type lenses with built-in motors to provide automatic focus. It has a beeper that sounds when the image is in focus. FD lenses may also be used, but only with manual focus. With FD lenses, the beeper confirms good focus. A list of available AC lenses is in Chapter 18.

focus scale. Without Extension Tube FD25 the magnification scale reads from 1/10 to 2 according to where you have set focus. The whole numbers are denominators of fractions whose numerator is one. Magnification varies from 1/10 to 1/2 as you change focused distance.

The New FD 100mm *f*-4 Macro lens is similar except for focal length. It has a magnification range up to 0.5 when used alone and from 0.5 to 1.0 when used with its companion Extension Tube FD50-U, which is 50mm long. It also preserves the automatic features of the lens and camera, including full-aperture metering and automatic aperture. This lens can be used as a medium-telephoto for portraiture and general applications, and as a macro when that capability is needed. At every magnification, the lens-to subject distance is approximately double that of the 50mm macro.

CANON EXTENSION TUBES

Tube	Use With
FD 15-U	Any fixed-focal-length lens from 28mm to 200mm.*
FD 25-U	Any fixed-focal-length lens from 35mm to 200mm.*
FD 50-U	Any fixed-focal-length lens from 35mm to 200mm.*

* Not recommended for FD 85mm *f*-1.2L or *f*-1.2.

Canon rear-focusing telephoto lenses are very compact compared to earlier designs. As an example, this New FD 300mm ƒ-5.6 is only 7-7/8 inches long, and weighs only 1 lb., 8 oz. The New FD 300mm ƒ-4L also uses rear focusing.

Advantages of a 200mm lens for this photo include: The reduced depth of field helps put background out of focus, allowing the viewer to admire the subject without distraction. Also, longer focal length gives more distance between photographer and subject.

SHORT TELEPHOTO

These are the 85mm and 100mm focal lengths. Both are fine portrait lenses for two reasons. One is, you don't get as close to your subject as with the 50mm lens. This sometimes eases the tension of a portrait session and allows your subject to relax more.

The other reason relates to distortion of facial features by short subject distances. A very short lens, such as 17mm or 24mm, is often used to create a sort of caricature photo with an exaggerated nose or chin. We usually think these pictures are funny even if the subject doesn't.

A 50mm lens has the same effect in portraiture—but to a less noticeable amount. Nevertheless it is there if you look for it, particularly if you compare the shot to another taken with a long lens. Most photographers agree that an 85mm or 100mm lens makes a more pleasing and natural-looking portrait. These lenses are also useful in general photography including nature and scenic views.

TELEPHOTO

These are 135mm and longer lenses. The 135mm focal length is popular because it can also be used for portraiture, sports and other general telephoto applications.

Longer focal lengths give higher magnification without any accessories but as focal length is increased there are usually two penalties: the closest focusing distance of the lens gets farther away, and the maximum aperture size is reduced significantly.

For general photography including sports, nature and scenic views, you need telephoto focal lengths. I often use the 200mm lens.

In most focal lengths there is more than one lens design to choose from. Differences include maximum aperture, lens coating, optical design, mechanical design, size, weight and price. This allows the user to choose a lens best suited for his application whether the choice is based on technical reasons or budget.

A recent trend in telephoto lens design is focusing by moving rear elements of the lens inside the lens tube so the lens remains the same overall length at any focused distance. They focus with an internal cam rather than a screw thread. The cam gives quick focusing from near to far and also focuses more slowly at farther distances so the focusing control is not unduly sensitive for distant subjects. These lenses give the photographer more telephoto range in a smaller package. The focusing method is called *rear focusing*, *internal focusing*, and sometimes *internal rear focusing*. Current lenses with rear focusing are listed in the accompanying table.

SUPER TELEPHOTO

This is both a general and a specific designation for lenses with focal lengths of 400mm or longer. For example, the FD 400mm ƒ-4.5 is a super telephoto lens. The FD 400mm ƒ-2.8L is also in the general category of super telephoto, but in addition has unusually large maximum aperture, uses ultralow diffraction glass and has other design features that qualify it for the L designation.

FD lenses are available in focal

LENSES WITH REAR FOCUSING
FD 200mm *f*-4
FD 300mm *f*-4
FD 300mm *f*-2.8L
FD 300mm *f*-4L
FD 300mm *f*-5.6
FD 400mm *f*-4.5
FD 400mm *f*-2.8L
FD 500mm *f*-4.5L
FD 600mm *f*-4.5
FD 800mm *f*-5.6L

Canon lenses with focal lengths of 300mm and longer come with tripod mounts which support the lens near its balance point. Shown here are the FD 600mm *f*-4.5 and the FD 800mm *f*-5.6L. Both are super-telephoto lenses and both use internal rear focusing so overall length doesn't change.

lengths up to 800mm. For an even narrower angle of view, you may be able to find the FL 1200mm *f*-11 S.S.C. Super Telephoto Lens. This lens has two parts that fit together to make the complete lens. A Focusing Adapter fits on the camera body and contains the aperture and focusing mechanism. Because it's an FL type, there is a lever for automatic diaphragm operation. You attach the optical part of the lens to the front of the adapter when setting up to use the lens. This has the narrowest angle of view of any Canon lens: about 2.1°.

With very long focal lengths, you can get a full-frame image of a subject so far away that you have to worry about the amount of air between lens and subject. If the intervening air is turbulent or polluted, it can fuzz up the image. Even with clear air, a blue haze may appear in the photo.

FLUORITE TELEPHOTO

The FD 300mm *f*-2.8L and the FD 500mm *f*-4.5L telephoto lenses both use a fluorite element in the lens. The fluorite lens element is a man-made crystal with special optical qualities.

Canon specs say the secondary spectrum is eliminated and these lenses are *apochromatic*. You may want a translation: Chromatic aberration means all colors of light are not brought to focus at the same plane. This causes color images to have a fringe of colors around the edges, which you can see around the light spot made by any household magnifying glass. In b&w photos, chromatic aberration fuzzes up the image because some of the light is not in focus where it should be.

Conventional lens designs suppress chromatic aberration at two colors of the spectrum, meaning that both colors come to focus at the film. All other colors still exhibit some chromatic aberration and this is called the *secondary spectrum*. It has a bad effect on both color and b&w pictures. Through the unusual optical properties of fluorite, Canon is able to also suppress the secondary spectrum in these lenses to keep chromatic aberration im-

perceptible over the entire range of colors we can see.

Apochromatic means a sophisticated lens design in which chromatic aberration is brought near zero at three colors instead of two. There will still be a secondary spectrum at other colors unless it is suppressed.

What this means in practical terms is that these lenses make excellent pictures.

ZOOM LENSES

The two focal lengths in the lens specification such as 35-70mm are the shortest and longest focal lengths of the zoom range. *Zoom ratio* is the longest focal length divided by the shortest, so it is one indicator of the versatility and potential usefulness of the lens. With a zoom ratio of 2, you can make the image twice as large by using the full zoom.

There is a penalty in lens light-gathering ability with zoom lenses. In the data table at the beginning of this chapter, you can see the zoom lenses have smaller maximum apertures than most fixed-focal-length lenses in the same range.

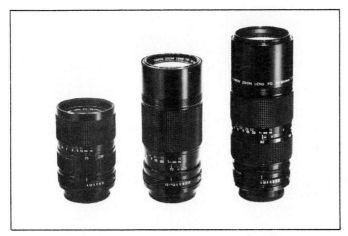

Canon zoom lenses operate in one of two ways. The New FD 35—70mm at left and 80—200mm at right both zoom by rotating the zoom control. The 70—150mm in the center zooms by sliding the front part of the lens forward and back. All have a scale to show focal length being used.

Zoom lenses are also heavier and usually longer.

Some photographers cling to fixed-focal-length lenses because of concern over image quality. For many years it was true that zoom lenses produced poorer image quality than fixed lenses. However recent advances in optical materials, lens design and lens coating have made zoom lenses virtually equal to fixed lenses in

Canon zoom lenses now cover every focal length from 24mm to 300mm. This is the FD 24-35mm ƒ-3.5 S.S.C.

image quality. In ordinary photography it is difficult or impossible to see any difference.

Canon offers high-quality zoom lenses with focal lengths to cover nearly every application as you can see in the lens table earlier in this chapter. With three zooms, for example, you can cover nearly every focal length from 24 to 300mm. The 35-70 zoom is referred to as a standard zoom because it includes the standard focal length of 50mm. This is an excellent general-purpose range with more flexibility than a fixed-focal-length lens.

Some of the zoom lenses have a control setting labeled **MACRO** that is actually a special close-focusing setting with a magnification of about 0.2. This is useful for nature photography, such as flowers, and similar purposes. These lenses are indicated in the lens table by an asterisk.

Once you try a zoom lens, you'll probably agree they are so useful and such an aid to creative photography that you want some. If so, then you must decide how to intermingle zoom lenses and fixed-focal-length lenses. The main problem with zooms is relatively small maximum aperture and you will find some photo-

graphic situations where a zoom won't open up enough to do the job. One solution is to have a zoom lens for general use and one larger-aperture fixed lens with a focal length somewhere near the middle of the zoom range. That gives you one large-aperture lens you can use when you need to.

The 24-35mm ƒ-3.5 doesn't sound like it zooms very much until you realize that it covers three of the fixed focal lengths. Because these focal lengths are retrofocus lenses, wide-range zooming is technically difficult and good image quality requires special measures. Canon solved the image quality problem by using an aspheric element in the lens to reduce aberrations and maintain good image sharpness, contrast and color correction.

The FD 35-70mm ƒ-2.8-3.5 does not have constant aperture over the full zoom range. When set for 35mm focal length, the maximum aperture is ƒ-2.8. As you zoom to 70mm focal length, the maximum aperture will gradually decrease to ƒ-3.5—about half an exposure step. If the lens is used with a through-the-lens exposure measuring system and the exposure controls are set after zooming, the change in ƒ-stop is automatically compensated—also by the automatic cameras.

The FD 35-70 ƒ-4 zoom does not change aperture when it is zoomed and does not have a close-focusing setting. It has smaller maximum aperture, but it focuses closer, weighs less and is a little smaller.

AUTO FOCUS ZOOM

The New FD 35-70mm ƒ-4 AF is a zoom lens with self-contained automatic focus, independent of the camera. It uses optical range-finding to determine the distance to the dominant subject in the field of view and has an electric motor to focus the lens at that distance. When you press a button on the lens, the focusing mechanism operates and an audible beep tells

Josh Young zoomed during exposure of this night scene in Baltimore. Zoom effect shows more on bright lights so choose the scene carefully if you are going to do this.

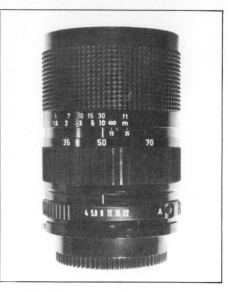

Two 35—70mm zoom lenses are available. The New FD 35—70 f-2.8—3.5 changes aperture from f-2.8 to f-3.5 as it is zoomed. This is New FD 35—70 f-4 which is a little more compact and maintains the set aperture during zooming.

you when the image is in focus. You can turn off the beeper if you wish. The motor is powered by two AA batteries housed in the lens.

Optical rangefinding requires viewing the subject from two locations and then using geometric triangulation to calculate distance. The viewing locations are the two windows in the autofocus housing. Inside, everything is electronic and automatic.

This lens is basically the standard New FD 35-70mm f-4 zoom with the auto focus electronics "wrapped around" it. The focusing action is fast: from infinity to 1 meter in about 1.4 seconds. To focus closer than 1 meter (3.3 feet), to the minimum of 0.5 meter (1.6 feet), focus manually.

CHOOSING A SET OF LENSES

There are no fixed guidelines and basically it's every photographer for himself, but here's a rule I think makes sense. When you add a new fixed-focal-length lens, either double or halve (approximately) the focal length of a lens you already own. If you own a 100mm and want a longer focal length, try a 200mm.

Using the rule of thumb, there are two possible sets of focal lengths in which each lens is approximately double the focal length of the next shorter: 17 or 20, 35, 85, 135, 300mm, and 24 or 28, 50, 100, 200, 400. Of course, zoom lenses can replace some of these focal lengths.

If you are an active photographer with a variety of photographic interests, you need more than one lens.

Some Canon lenses with longer focal lengths use 34mm or 48mm filters in drop-in holders (arrow). This is New FD 300mm f-4 which uses 34mm filters.

The Canon FD 300mm *f*-4L has a design improvement indicated by the letter L and a red ring around the front of the lens. This lens has a removable tripod, and uses rear focusing. It has a slot near the back of the lens for 34mm drop-in filters and it can also use screw-in filters at the front.

With a Canon camera on automatic and this New FD 35-75mm *f*-4 Auto Focus Zoom lens, you can just point and shoot. The lens has an optical rangefinder and built-in motor to set focus for you. The camera sets exposure.

For travel and general photography, this New FD 35-105mm *f*-3.5 Zoom lens offers a bagful of useful focal lengths plus close-focusing "macro," which is useful for close-ups of flowers and similar small objects.

15
LIGHT, FILTERS AND FILMS

Several characteristics of light affect equipment and technique when you take pictures.

COLOR OF LIGHT

We call direct light from the sun *white*. It is composed of all the colors in the visible spectrum. Light appears to travel in waves, similar to waves in water, which have different wavelengths. Different wavelengths appear as different colors in human vision.

The drawing in Figure 15-1 shows colors of light and their approximate wavelengths. Human vision does not respond to all colors of light. We see only three colors: red at the long-wavelength end of the spectrum, green in the middle, and blue at the short-wavelength end. The sensation of other colors is produced in the mind by noting the relative proportions or the mix of these three *primary colors.*

Beyond the visible blues in the spectrum are shorter wavelengths called *ultraviolet,* abbreviated UV.

When white sunlight is separated into its components by a prism or rainbow, we see the colors of the visible spectrum.

Figure 15-1/The difference between one color and another is wavelength. Long waves cause the sensation of red; short waves cause blue; green is in the middle.

Figure 15-2/Incandescent objects radiate light because they are hot. Low color temperatures mean long wavelengths and reddish light. High color temperatures result in bluish light.

We can't see UV, but film can and most types of film will be exposed by UV. When you expose ordinary film in your camera—color or b&w—some exposure results from light you can see and some from UV wavelengths you can't see. At times this is a technical problem and there are technical solutions.

Most films do not respond to wavelengths longer than visible red, called *infrared* or IR, but some special films do. You have probably seen photos taken with IR-sensitive film and noticed that natural objects such as water and foliage do not photograph the same in IR as in visible light.

LIGHT SOURCES

Not all light sources produce the entire spectrum of light. There are two main categories of light sources. Those that produce light due to being heated are called *incandescent*. Light sources that use a heated filament—such as a household light bulb—are called *tungsten* sources because the filament is made of tungsten.

The other category of light sources does not depend on temperature to make light. These are sources such as fluorescent lamps and the yellowish sodium-vapor lamps used to illuminate highways and streets. The quality of light from non-incandescent sources is often a problem with color film.

COLOR TEMPERATURE

The color of light produced by an *incandescent source*—including the sun—depends on its temperature. By stating the temperature of the source, the color of the light is implied. When so used, the temperature is stated in degrees Kelvin (K) and we refer to it as *color temperature.*

We can also perceive light coming from apparent sources such as a mirror or the sky. The actual source is something else, perhaps the sun. We use color temperature to state the color of light received indirectly.

Figure 15-2 is the spectrum of several color temperatures. Notice that low temperatures produce mainly long wavelengths of light, which we see as red, orange and yellow. As color temperature increases, the amount of long-wavelength light increases a small amount but the amount of short-wavelength light increases a much larger amount. At a high color temperature, the light appears to be more blue than red. The blue light from the sky is a very high color temperature.

So far, this is all technical and not very practical. However, in practical photography, you worry about color temperature in one of two ways. For ordinary photography, you think of it in general terms: Is the light warm-looking and made up of red and yellow colors or is it cold-looking and bluish? Are you shooting outdoors under the blue sky, or indoors with warm tungsten illumination?

If you do technical photography where exact color rendition is important, you worry in more detail and use color temperatures to make technical choices. A discussion of this is in my book *SLR Photographers Handbook.*

Color temperatures are labels to indicate the color quality of light. You can talk about the warm color of candle light or a color temperature of 1800K. If you say 3200K or 3400K, you are talking about the light produced by the two types of tungsten lamps used in photography. They have a higher color temperature than ordinary room lamps.

Sunlight alone is about 5000K, but the cold-looking blue light from the sky may be around 12,000K. Therefore, combinations of sunlight, light from the blue sky and a few puffy white clouds is between those two color temperatures. Standard "photographic daylight" is 5500K. Light from an electronic flash simulates daylight.

A subject in the shade of a tree is illuminated only by the blue light from the sky without the "warming" benefit of direct sunlight. We think the light is cold-looking and too blue.

APPROXIMATE COLOR TEMPERATURES OF COMMON LIGHT SOURCES
(degrees Kelvin)

Setting sun	1,000K approx.
Burning candle	1,800K
Household incandescent lamps	2,500 to 3,000K
Professional photo lamps	3,200 and 3,400K
Clear flash bulbs	4,000K
Direct sunlight at mid-day	4,500K
Commercial theater motion picture projector lamps	5,000K
Average daylight (sun, sky, and random clouds)	5,500 to 6,000K
Electronic flash	6,000K
Sun and blue sky	6,500 to 7,000K
Blue sky only (no direct sunlight)	8,000 to 20,000K or more

THE COLORS OF THINGS

A white piece of paper reflects whatever color of light falls on it. If illuminated by white light, it looks white. If illuminated by red light, it looks red.

Things may owe their color to the light that is illuminating them, or to a property known as *selective reflection*. That means they do not reflect all wavelengths of light uniformly. A blue cloth in white light looks blue because it reflects mainly blue wavelengths. The other wavelengths of white light are absorbed by the cloth.

The color of transparent things such as glass is determined by *selective transmission*. Blue glass looks blue because it transmits mainly blue wavelengths. If illuminated by white light, blue wavelengths pass through the glass to your eye. The other wavelengths are either absorbed by the glass or reflected from its surface—back toward the source.

In general, the color of an object is determined both by the color of the light that illuminates it and the selective transmission or reflection of the object.

THE VISUAL COLOR OF FILTERS

If you hold a color filter between your eye and white light, you see the colors that are *transmitted* or passed by the filter.

Because human vision responds only to red, green and blue, it is only these three colors and their combinations that you have to worry about.

If a filter blocks all three primary colors completely, it looks black. If it reduces light transmission but equal amounts of the three primary colors still come through, the filter appears gray.

If a filter blocks red, then it transmits both blue and green. To the eye, light coming through the filter appears bluish green—a color photographers call *cyan*. We say cyan is the *complementary* color to red because you get cyan if you block red but transmit blue and green. Each of the three primary colors has a complement, according to this table.

Primary Color	Complementary Color
Red	Cyan (Blue-Green)
Green	Magenta (Red-Blue)
Blue	Yellow (Red-Green)

In printing color films, laboratories use complementary-colored filters. The words cyan, magenta and yellow are part of the language of photography and you should know what they mean.

ADAPTATIONS OF THE EYE

There are three kinds of human visual adaptation that are important in photography. One relates to the brightness of light. We can be visually comfortable in outdoor sunlight. On entering a building, we have the sensation that it is darker for only a few seconds and then we adapt to the lower level of Illumination and don't notice it any more. On returning outdoors, we again adapt to the higher brightness in a short time.

Because of adaptation, people are very poor judges of the amount of light and should rely on exposure meters that don't have this adaptability problem.

We adapt to color of light in the same way. If you are reading at night using a tungsten reading lamp, you adapt to the yellowish color and don't even notice it. The paper in this book looks white to your mind. Go outside and look at your window. It will be obvious that you are reading in light that has a definite yellow cast.

Another adaptation results from your feeling of participation in a real-life situation. This turns up in several ways that often make a photo look ridiculous.

You can pose somebody in front of a tree and think it's a fine shot. When you look at the print, a tree limb seems to be growing out of your model's ear, which seems absurd in the picture even though it didn't bother you at all when it was real life.

When you look at a person in side-lighting, half of the face is in deep shadow but you think nothing of it. You know the person has a complete face with the two sides similar to each other. Take the picture and it will look different. Without being there, you are not nearly so charitable and when looking at the picture you ask,

55mm filters fit many old-type FD lenses. You can use them with most New FD lenses, which have 52mm filter threads, by screwing a 52→55mm Step-Up Ring into the front of the lens.

Color filters change the color of light by transmitting some wavelengths and blocking others.

Atmospheric scattering of light is caused by the air itself, plus dust and smog. If the air is clean, haze looks blue. It gives a perspective effect in photographs, calling attention to the fact that distant objects are distant.

"Where is the other side of that guy's face?"

You Have Just Been Unadapted—These adaptations can be reduced or even reversed by thinking. As soon as you know about the difference in color of tungsten light compared to daylight, you no longer fall victim to that visual adaptation. In that sense, you no longer have it.

THE EFFECTS OF ATMOSPHERE

The sun flings energy toward the earth over a extremely wide spectrum, part of which is visible. The atmosphere acts as a *filter* to block transmission of some wavelengths and allow transmission of others, including all visible wavelengths.

The atmosphere also has an effect on light rays that is called *scattering*. Instead of coming straight-arrow through the air, some light rays are diverted from the straight path and bounce around in the atmosphere. The last bounce, for light that reaches the earth, is toward the earth. This is light from the sky as opposed to light directly from the sun.

The atmosphere scatters short wavelengths much more than long wavelengths. Therefore, blue light is extracted from the direct rays of the sun and scattered all over the sky. That's why the sky is blue.

On a nice clear day, the sky is blue except near the horizon where it often looks white. This is another form of scattering caused by dust and smoke particles that are large enough to reflect most

Atmospheric scattering extracts blue light waves from sunlight and scatters them all over the sky which makes the sky look blue. Without the blue component, sunlight looks more red-colored. At sunrise and sunset, sunlight travels through more atmosphere, more blue light is scattered, so morning and evening sunlight is more red-colored.

Top photo at left made with panchromatic b&w film and no filter. Distant valley is obscured by haze. You can see successive improvements in haze-cutting by a yellow filter, and, at bottom, a red filter. As filter color becomes more red, it excludes more of the scattered blue light.

Photo at right made with blue filter which transmits haze and blocks longer wavelengths which carry picture detail.

wavelengths of the visible spectrum. They scatter all of the light from the sun and the lower atmosphere appears to be white.

If you look from here over to that distant mountain, you are looking through a lot of lower atmosphere with both white-light scattering and blue-light scattering. The light rays coming to your eye from trees and rocks on the mountain are diverted from straight paths, details are obscured and the image looks hazy. We call that *atmospheric haze*. Fog is water droplets in the air and is worse than dust and smoke as a light scatterer and image obscurer.

The air itself scatters blue light, and other particles in the air tend to scatter all colors of light. Therefore, even from point to point in the lower atmosphere, blue light is scattered more than any other wavelength.

If you take a picture without using the blue light rays to expose the film, there will be less atmospheric haze in your picture.

Details of a distant scene will be more distinct. You can do that by putting a color filter that excludes blue light over the lens. It must therefore pass both green and red light. If you hold such a filter against white light and look "through" it, it will look yellow, because the combination of red and green makes the sensation of yellow light.

It is common to use a yellow-colored filter over the lens to cut atmospheric haze. This works fine on b&w film, but on color film it will make a yellow-colored picture.

If your picture on b&w film is still too hazy with a yellow filter, remember that short wavelengths of light are scattered more than long wavelengths. If excluding short wavelength blue won't do the job, try also leaving out medium-wavelength green. The filter now transmits red only, but image detail is greatly improved.

What if you exclude blue, green and also red? That will use still less scattered light to make the picture. A filter that excludes all three primary colors will look black because no visible wavelengths get through. Invisible IR wavelengths can come through a very dark-looking IR filter and expose IR film. That's the best haze cutter of them all.

Another effect of light scattering between your camera and the scene is reduced contrast of the image on the film. Light rays coming from bright parts of the scene are diverted by scattering so they land on the film at the wrong places. Some will land where it should be dark and that will make the dark places lighter.

You can see this when outdoors on a sunny day. Notice the contrast in brightness between sunlight and shadow near where you are. Then look as far away as you can and compare the brightness of sunlight and shadowed areas over there. The shadows will appear much lighter than those nearby. This is due to atmospheric scattering.

Any filter that blocks scattered rays will improve contrast and sharpness of the image on the film.

COLOR-SENSITIVITY OF B&W FILM

Even black-and-white film is color sensitive. The early b&w emulsions were sensitive mainly to blue and UV light. Photos of women with red lipstick caused the lipstick to appear black because the film did not respond to red.

An improved film, called *orthochromatic,* was still deficient in red response.

Current b&w films, called *panchromatic,* are said to be responsive to all visible wavelengths and as a practical matter, they are. There is still a slight deficiency in red response and too much sensitivity to blue, but it is usually not noticeable.

COLOR FILTERS WITH B&W FILM

Because the result of exposing b&w film to light of various colors is always shades of gray between black and white, we tend to think b&w film is colorblind.

It is difficult to relate the color response of b&w film to human vision, which notices both color and brightness. Technically, they are tied together by saying that the brightness of an object in b&w, even though it is gray, should correspond to the brightness of that object in the original scene as viewed by people, never mind what color it is.

I think it is more important to recognize that the major problem of b&w film is just that—it records in shades of gray. The print does not show colors that help to distinguish a red apple from green leaves or a yellow skirt from a blue sweater. If the skirt and sweater happen to cause the same shade of gray on the film, they will look the same in b&w.

Usually a b&w picture is improved if objects of different color record as different tones or shades of gray because the viewer of the print expects to see some difference between a necktie and jacket, or a rose and foliage.

You can use color filters on your camera to change brightnesses on a b&w print so there is a visual difference between adjacent objects of different colors, as you can see in the accompanying photos.

The rule when using color filters with b&w film is: A filter lightens its own color. This applies to the final print, not the negative, but it is the print you are concerned about. A corollary is: A color filter used with b&w film darkens every color except its own.

It is common with b&w film to use filters to make clouds stand out against a blue sky. With no filter, clouds in the sky are sometimes nearly invisible and the entire sky is light-colored in the print. It is much more dramatic to have a dark sky with white clouds.

White clouds reflect all colors of light, but the sky is blue. Suppress blue with a filter and the sky darkens. The clouds darken, too, but not as much. Because you are using b&w film, you can go as wild as you wish with filter colors and only different shades of gray will result. Sky-darkening filters for b&w film range from yellow to light red to dark red with more effect as you use darker reds.

Naturally the effect of a red filter appears on everything in the scene. If you include a model with red lipstick, the filter lightens its own color and your model's lips will be lighter in tone.

A compromise filter often used for outdoor b&w portraits is a shade of green. This suppresses blue to darken the sky some but also holds back red so makeup and skin tones are not affected as much as with a red filter.

HOW COLOR FILMS WORK

Color film and the color printing process used in books and magazines are possible only because human color vision is based on the three primary colors. A color picture needs only these three

With color film objects are visually separated by different colors even though they may be the same brightness.

With black-and-white film, there are only shades of gray to distinguish one object from another. Without a filter, there's not much visual difference between a red tomato and a green pepper.

Used with b&w film, a color filter lightens its own color. Here a yellow filter was used. It lightened the lemon. Tomato and pepper are still distinguishable from one another mainly by shape.

Green filter blocks red light from tomato to make it appear darker. Slight lightening of pepper, not much effect on lemon.

Red filter lightens its own color and also lightens lemon because yellow wavelengths are close to red. Darkens pepper slightly. Use of color filters to improve contrast in b&w is generally predictable but sometimes there are surprises.

colors mixed in proper proportions to do a very good job of presenting all colors we can see.

Color film does this with three different layers of emulsion coated on a base. The main difference between a color slide and a color print is that the base of the print is opaque white paper.

The trick of color film is to use one layer to record the amount of each primary color at every point in the scene. When viewing a color slide by transmitted light, or a print by reflected light, each layer controls the amount of light at its own primary color. The light we see from the combination of all three layers causes our vision to see the colors of the original scene.

Naturally the colors we see when viewing a slide or print are affected by the color of the light or room illumination where we view the picture.

NEGATIVE-POSITIVE COLOR

Color prints are obtained from color negatives in a two-step procedure. A comparison to b&w will be useful. In b&w negatives, the shades of gray are reversed from the original scene. A white shirt appears black in the negative.

In color-negative film, after development, each layer transmits a reversed density of that particular color. If the subject is strongly red, the color-negative layer will be strongly not-red, meaning cyan colored. A color print made from the negative reverses the color densities again with the result that a strong red in the scene becomes a strong red on the print.

You have probably noticed an overall orange color of color negatives. Even the clear parts have an orange cast. The dyes used in color films are as good as each film manufacturer can make them, but not as good as the manufacturer would like them to be. These slight deficiencies in the color dyes are corrected by a complicated procedure called *color masking*. Evidence of masking is the orange color. It is removed when the print is made.

Because of color masking, the colors in a negative-positive process can be more true-to-life.

If a color print is made and the colors don't look quite right, it can be fixed by making another print. Color filters are used to change the color of the printing light and thereby make small corrections in color balance of the final print.

If you miss exposure a step or two when using color-negative film, it is usually possible to make a correction during printing, so the print is properly exposed and not too dark or too light.

Color-negative film allows the camera operator to make small mistakes, or be less precise about his work, and still end up with an acceptable print.

COLOR-SLIDE FILM

A color slide or transparency is the same piece of film you originally exposed in the camera. It is developed and chemically processed to make a positive image directly. This procedure is called *reversal processing* because it makes a positive out of a negative. There is no color masking because there is no opportunity to remove the orange color when making a print. The color balance of slide film is theoretically inferior to that of a good color negative-positive procedure but in practice, it's hard to see any difference.

Because there is no separate printing step to make a color slide, there is no opportunity to correct a bad exposure and no way to change the color balance of the positive. This makes exposure more critical, both in the amount of light on the film and its color.

Color-slide film will often make a perfectly good image when under- or overexposed a small amount, but it won't look right when projected on a screen. It will be too light or too dark overall, particularly when viewed in succession with other slides that were properly exposed. For this reason, we say that color slides should be correctly exposed—within half a step either way.

When any color film—negative or reversal—is seriously under- or overexposed, two effects may result. One is comparable to under- or overexposing b&w film.

The second effect is peculiar to color film and is caused by reciprocity failure of the three layers, acting individually. Because the three layers are different emulsions, they usually don't go into reciprocity failure simultaneously and when they do, they don't react in exactly the same way.

A typical result of serious exposure error with color film is that one layer goes into reciprocity failure and needs more exposure but doesn't get it. Therefore, that layer is effectively underexposed and does not properly control its color when developed. The end result is an overall color cast, such as pink or blue, which affects the entire picture.

This can be corrected during printing in a negative-positive process if the color change is not too severe. With color-slide film, correction must be made during the original exposure. The correction often requires both additional exposure and a color filter over the camera lens.

Making Tests—When you are making tests of equipment or your skill, it's important to see what you actually put on the film. Most film laboratories will automatically make corrections when printing b&w or color negatives to compensate for apparent errors in exposure or color balance. If you are testing exposures and deliberately shoot some frames under- or overexposed, you don't want the lab to correct your shots.

Color-slide film is the best way to make tests. What you get is what you shot, without any corrections by the film lab.

FILTERS FOR COLOR FILM

There are three types of color film. Two are manufactured so they make a good color image with tungsten illumination.

If you use tungsten film in tungsten light, the manufacturer has already solved the problem for you and you don't have to use a filter to change the color balance of the light that gets on the film.

If there is not enough room light to shoot with, you can add light by using special photo lamps, commonly called photofloods. There are two types. Some operate at 3400K to get more light output but with shorter life. Some operate at 3200K, which is closer to normal room lighting.

Type B tungsten film is intended for use with 3200K. If you use 3400K lamps with Type B film, you should use a filter over the camera lens.

Type A color film is designed for use with 3400K lighting. If you use it with 3200K lamps or ordinary room lighting, you should use a filter over the camera lens to compensate.

A table later in this chapter gives filter recommendations for various types of films and lighting.

Daylight color film is balanced for daylight, but you may need to use a filter anyway.

Ultraviolet light is reduced by the atmosphere but present in some amount everywhere. The higher you are in altitude, the more UV there is to expose your film. You can't see it and your exposure meter probably ignores it, but the film will be exposed by UV.

UV filters reduce transmission of UV. They are clear because they don't stop any visible wavelengths. They are recommended for use where the air is clear, such as on or near large bodies of water and in rural areas. Also, in the mountains where the air is both clear and thin.

If atmospheric haze is a problem, you want to exclude short wave-lengths. With color film, you can't use a strongly colored filter unless you want the picture to have that color. *Haze filters* for color film cut UV and also cut some of the barely visible blue wavelengths—the shortest. A haze filter for use with color film

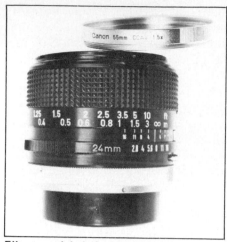

Filters are labeled with thread diameter, identification and filter factor. In this case the filter factor is 1.5X, meaning multiply exposure by 1.5 to compensate for light loss in the filter. If you use internal camera metering, disregard filter factors.

is practically clear. If you use one, you don't need a UV filter because it will do both jobs.

A subject in shade outdoors is illuminated by skylight, which has more blue in it than average daylight or direct sunlight. With color film, the effect is usually noticeable as an overall blue cast to the picture and bluish skin tones on people. *Skylight filters* for use with color film block some of the blue light to give a more warm-looking picture. Some photographers like the effect even in daylight or direct sunlight, so they put a skylight filter on the lens and use it all the time with color film outdoors. It also blocks UV.

Some photographers use a skylight, haze or UV filter on the lens at all times, both as a filter and to protect the lens.

There are filters that allow you to use tungsten film in daylight, and daylight film in indoor illumination.

To use tungsten film in daylight, the filter has to alter the daylight. The filter will reduce the amount of blue and green so what comes through has a color balance similar to tungsten light. Such filters have a yellow-orange appearance when viewed in white light.

To use daylight film indoors, it depends on what kind of illumination is being used inside the building. If it is tungsten light, the filter must change it so it appears to be daylight as far as the film is concerned.

The filter will block a lot of red and will look bluish or blue-green in white light.

If the indoor illumination is fluorescent lamps, it is difficult to filter. Some look bluish and some are designed to look like daylight to humans. Daylight fluorescent light sources do not look like daylight to film. Filter manufacturers offer filters for use with fluorescent lighting and the best guide to their use is the maker's instructions.

I have done some experimenting with color filters for special effects with color film and enjoy doing it. I suggest you try it.

MIXED LIGHTING

A problem always results from using color film with more than one type of lighting. If you are photographing a person under room lighting but near a window that allows some daylight to fall on the model's face, what do you do? If you use tungsten film, the daylight will give a blue cast to skin. If you use daylight film, the skin will have a warmer tone. Most people greatly prefer warm tones to cold bluish tones, so the choice should be daylight film.

Mixed lighting is a problem solved best by avoiding it. If you must shoot with such light, experiment with different filters until you find something that is acceptable.

FILTER FACTORS

Most filters reduce light at visible wavelengths. They reduce it more at some wavelengths than others, but the net result is still less light on the film. This does not apply to visually-clear filters such as UV and some haze filters for color film.

Filter manufacturers normally state the amount of light loss as it affects the film exposure by a number known as the *filter factor*. This number is used to multiply the camera exposure that would be used without the filter to get the correct exposure with the filter. The symbol X is included in a filter factor to remind us that it is used as a multiplier.

Some examples will clarify this. A 2X filter must be compensated by two times as much exposure, which is one more exposure step. Use the next smaller *f*-number or the next longer shutter speed. A 4X filter requires two exposure steps. An 8X filter needs three exposure steps.

Canon cameras meter behind the lens and the camera exposure meter automatically compensates for the effect of a filter on the lens. That is a great convenience. You don't have to worry about filter factors or making exposure corrections for them.

You are not getting filtering free. Even though it is simple and uncomplicated to set exposure with a filter on the lens, the filter must have the effect of increased aperture or exposure time.

If you are shooting action in poor light and decide to pop on a red filter with a filter factor of 8X so the sky will be dramatic, you may also have a dramatic shooting problem called *you can't do it!* With action, you probably can't slow down the shutter by three steps. If you were already shooting in poor light, you probably can't open up by three *f*-stops and even if you can, depth of field may disappear.

Filter factors are also a guide in purchasing a filter because they tell you how strong the color will be. Higher filter factors mean deeper colors and more light loss.

Using daylight slide film with tungsten lighting makes scene appear orange. This is often acceptable unless there are people in the picture.

A light-conversion filter converts tungsten light to appear as daylight to daylight film by removing some of the red-orange. Skin tones improve.

Subject by window receives mixed lighting—warm-looking tungsten on one side, cold-looking daylight on the other because this was shot with tungsten film. A light-conversion filter makes day-light look OK to tungsten film by re-moving some of the blue. This also warms the tungsten light but the overall result is better.

Neutral-density filters screw into the filter-mounting threads in the front of the lens. They are gray, which means they reduce the light equally among all visible colors; therefore, the overall color balance of the photo does not change because of the ND filter.

While in Los Angeles, Josh Young became vexed at the freeway traffic and decided to eliminate all other drivers. Notice tree shadows on cars.

His secret weapon was a Kodak Wratten gelatin neutral density filter with a *density* of 4.0 (not filter factor) which allowed multiplying exposure time by 10,000 plus additional exposure for reciprocity failure. Filter factor is 10,000. He solved reciprocity failure problem by series of arbitrary longer exposure times. No moving vehicle remained in the frame long enough to have visible effect on film. Tree shadows are still there. Don't vex Josh!

NEUTRAL-DENSITY FILTERS

There are circumstances when you want to get less light into the camera so you can expose for a longer time or use smaller aperture.

Gray-colored filters, called *neutral density* (ND), reduce the amount of transmitted light uniformly across the visible spectrum, which is why they are called neutral.

These filters can be used with either color or b&w film because they have uniform color response. Because an ND filter has the effect of taking out only white light, some people say it does not change the color of the image. That is not true. If you look through an ND filter, all colors are different because they are less bright.

Some ND filters are rated the same way as color filters—by a filter factor. Commonly available ratings are 2X, 4X and 8X. You may have to stack filters, meaning put one in front of another, to get the required density. When stack-ing filters using filter-factor ratings, the combined rating is obtained by multiplying the individual ratings. A 2X filter and an 8X filter used together will have a rating of 16X.

Some ND filters are labeled with their *optical density* instead of a filter factor. The two ratings can be tied together by the fact that each increase in optical density of 0.3 is equal to a filter factor of 2X.

When filters rated by optical density are stacked, the densities add directly. An ND 0.3 filter plus a ND 0.3 filter make an ND 0.6 filter—with a filter factor of 4X.

Some technical filters are rated by *optical transmittance,* or the percentage of light transmitted through the filter. A transmittance of 100% implies no light loss at all.

One can strain the brain in this welter of different kinds of ratings, so I made this table to tie them all together.

Optical Density	Percent Transmission	Filter Factor	Equivalent *f*-Stops
0.1	80	1.25	1/3
0.2	63	1.5	2/3
0.3	50	2	1
0.6	25	4	2
0.9	12.5	8	3
1.0	10	10	3 1/3
1.2	6	16	4
1.6	3	32	5
1.9	1.5	64	6
2.0	1	100	6 2/3
3.0	0.1	1,000	10
4.0	0.01	10,000	13 1/3

You can use ND filters in ordinary photography when the film in the camera is too fast for the job at hand. If you have high-speed film already in the camera and you need to make a shot or two in bright sunlight, clip on an ND filter and effectively slow down the film.

The camera will behave as though the film speed is divided by the filter factor. If you have ASA 400 film in the camera and put on an ND filter with a factor of **4X**, you will end up setting aperture and shutter speed as if the film had a rating of ASA 100.

Does this mean you should change the film-speed dial of the camera from 400 to 100? No, even though some instructions seem to say that.

POLARIZING FILTERS

Still another property of light waves is responsible for *polarization,* the direction of movement or vibration of the light waves. Water waves again serve as a good analogy. Water particles in a water wave move up and down, so the wave is vertically polarized. Light can be vertically polarized, horizontally polarized, or polarized in all directions at once, which is called

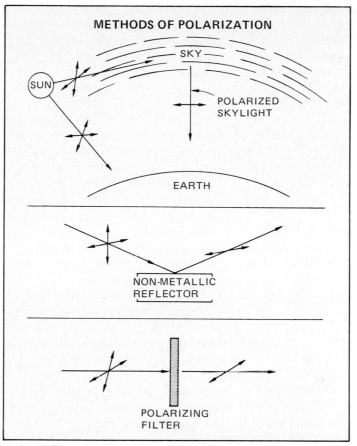

METHODS OF POLARIZATION

Light from the sky is polarized when viewed at a right angle to the sun. In this drawing, crossed arrows indicate unpolarized light, single arrow perpendicular to ray path indicates polarized light. Light reflected from a non-metallic surface is polarized in the plane of the reflecting surface. Light passing through a polarizing filter emerges polarized, according to rotation angle of filter.

random polarization. Direct sunlight is randomly polarized.

Some materials have the ability to transmit waves with only a single direction of polarization. These materials are made into *polarizing filters,* sometimes called *polarizing screens.* A polarizing filter that transmits vertically polarized light will not transmit horizontally polarized light, and the reverse.

If randomly-polarized light arrives at a polarizing filter oriented to pass vertical polarization, the horizontally polarized component will be blocked by the filter. If the filter were perfect, this would block exactly half of the total light in a randomly-polarized beam and

the filter would have a filter factor of 2X or a density of 0.3. Practical filters vary from around 2.5X to 4X. They don't block all light of the wrong polarization, but the filter material is gray-colored so it also absorbs some light of all polarizations just because of the gray color.

Unpolarized light becomes polarized by reflection from smooth surfaces—except unpainted metal. Where such reflections occur, we see the reflection as glare, such as in a store window or glass display case, and on the surface of varnished wood furniture. When a polarizing filter is used to block such reflections, the improvement is sometimes dramatic. When un-

polarized light is reflected from a surface, vibrations in the light that are parallel to the surface are reflected and those that are perpendicular are suppressed. For example, unpolarized light reflecting from a horizontal surface will become polarized horizontally.

Polarizing filters are mounted in front of a lens in such a way that they can be rotated to block light of a certain polarization. While looking at the viewfinder image, rotate the polarizer for the desired effect.
Removing Glare—Reflection from a window can cause glare, obscuring the view through the window. Reflection from a surface such as varnished wood can obscure the wood grain.

Light reflected from most surfaces becomes at least partially polarized and can therefore be subdued or blocked by a polarizing filter. That allows you to remove glare from windows, furniture and similar surfaces. For maximum effect the line of sight of the lens should be at an angle of about 35 degrees with the reflecting surface.

Outdoors, light from the blue sky is reflected from the surfaces of foliage, flowers, terrain and water. We see the color of the natural objects mingled with reflected blue light from the sky. By removing the reflection with a polarizer, landscape colors often become more vivid.
Darkening Blue Sky—A clear blue sky is polarized over a wide band, at a right angle to the direction of sunlight reaching you. For example, at noon the sky near the horizon is polarized.

If you are making a photo that includes a polarized area of the sky, you can use a polarizing filter to make that part of the sky much darker. This is a practical way to darken skies with color film and make white clouds stand out more clearly.

A polarizing filter does not absorb selectively individual colors of the spectrum and, therefore, does not affect the basic color balance of a photo.

EXPOSURE METERING WITH POLARIZERS

It is usually satisfactory to rotate a polarizer for the desired effect, then meter and make the exposure. However, a special polarizer is required with certain camera models, as shown in the accompanying table. These models use optical devices such as beam splitters in the light path for metering—devices that themselves polarize light.

The problem occurs when the polarized light from the lens-mounted polarizer is partially or totally blocked by the polarizing device in the camera. Incorrect exposure metering results.
Ordinary (Linear) Polarizers—Cameras without beam splitters in the metering path can use ordinary, *linear* polarizers. These block light of one polarization, such as vertical, and transmit the rest of the light from the scene.
Circular Polarizers—Circular polarizers are required with cameras that use beam splitters in the metering path. These polarizers also block light of one polarization and transmit the rest of the light from the scene but the camera metering system works normally.

FILTER MOUNTING

There are about as many ways to mount filters on cameras as human ingenuity can achieve. Canon uses the screw-type filter that screws into the threaded accessory-mounting ring on the front of most lenses. Each filter repeats the lens thread on the outer edge of the filter, so a second filter can be screwed into the first. As many filters as desired can be stacked by screwing them into one another.

A problem results from lenses with different screw-thread diameters at the front. If you have a filter that fits a small-diameter lens, it will be too small for larger-diameter lenses and you may end up buying the same filter type in two diameters.

With screw-in filters, the lens-size problem can be solved by purchasing filters to fit the lens of

Filters of different thread diameter than the lens can be used with step-up or step-down rings between filter and lens. Here a 55 to 52mm step-down ring is used to mount a 52mm filter on a lens with 55mm threads. When using smaller filters than normal size, image may vignette, particularly with wide-angle lenses.

largest diameter in your set. Adapter rings to mount a large filter on a smaller lens are available at most camera shops. These are usually called *step-up rings*. The step-down type adapts a smaller filter to a larger lens, which may cause vignetting of the image by blocking some of the light around the edges of the frame. Using a filter larger than the lens rarely causes any problem unless several are stacked.

IMAGE DEGRADATION DUE TO FILTERS

Besides vignetting due to stacking filters, image quality may deteriorate when several filters are used together. The image will normally show no visible effect from a single filter—except the desired

POLARIZING FILTERS FOR CANON CAMERAS	
Camera	Polarizing Filter
A-1, AE-1, AE-1PROGRAM, T50, T70, T80	Linear
F-1, T90	Circular

Filters can serve more than one purpose. Photo of corral taken with daylight film in early-morning sunlight, didn't amount to much. A minute or two later, using an orange 85-B filter and shooting into the sun, I got a golden sunrise even if I had to help it a little. The "official" purpose of an 85-B filter is to shoot tungsten film outdoors.

Polarizing filters can remove window reflections and darken blue skies. The polarizer angle which darkens blue sky is not the same as the angle which removes window reflections.

effect. You can normally use two without worrying. When using three or more, test first to be sure you don't have problems with an important shot.

The light reflects back and forth between glass surfaces of a stack of filters, just the same as in a lens. Most good-quality modern filters are coated to reduce reflections.

Filters have least effect on the image when they are mounted close to the front of the lens. Stacking and use of step-up rings puts some of the glass far enough from the lens to make aberrations and defects more apparent. Naturally, dirt, scratches or fingerprints on a filter surface will scatter the light and reduce contrast of the image, the same as dirt does on the lens itself. Filters should receive the same care as lenses.

Filters may fade with age, particularly if exposed to bright light a lot of the time. This change is hard to detect because it is gradual, but it may not be important until you can detect it.

Front-mounting gelatin filter holders like this are available at your camera shop.

SOME COMMONLY USED COLOR FILTERS

Film Type	Light	Effect of Filter	Common Name	Visual Color
Any	Day	Reduce UV	UV or Haze	Clear
	Any	Reduce light 2 steps	ND 4X or ND 0.6	Gray
	Any	Reduce light 3 steps	ND 8X or ND 0.9	Gray
B&W	Day	Normal sky	8 or K2	Yellow
	Day	Darker sky	15 or G	Yellow
	Day	Very dark sky	25 or A	Red
	Day	Normal tones	8 or K2	Yellow
	Tungsten	Normal tones	11 or XI	Yellow-Green
Color Daylight	Day	Reduce blue skylight	IA or Skylight	Light Pink
	Day	Warmer image	81C	Orange
	Day	Less red with low sun	82C	Light Blue
	3400K	Normal colors	80B	Blue
	3200K	Normal colors	80A	Dark Blue
	Fluoresc.	Normal colors	FLD	Purple
Color tungsten	Day	Normal colors at morn or late aft	85C	Amber
	Fluoresc.	Normal colors	FLB	Orange
3400K	Day	Normal colors	85	Amber
3400K	3200K	Normal colors	82A	Blue
3200K	Day	Normal colors	85B	Amber
3200K	3400K	Normal colors	81A	Amber

ELECTRONIC FLASH

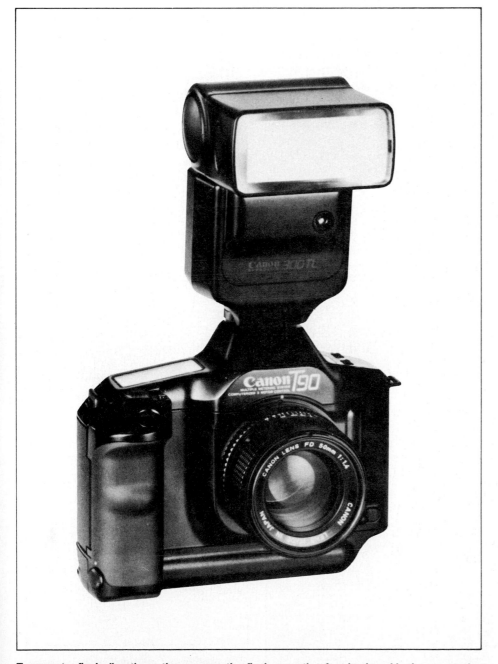

To mount a flash directly on the camera, the flash mounting foot is placed in the camera hot shoe. Electrical connections are made in the hot shoe so the flash and camera can cooperate to provide automatic operating features.

Current Canon electronic flash units have automatic features to make flash convenient and easy to use. This chapter begins with a discussion of non-automatic flash units and then shows how the automatic features work.

HOW A NON-AUTOMATIC ELECTRONIC FLASH WORKS

You don't have to be an electronic whiz to understand the basic operation of an electronic flash. Figure 16-1 shows a power source feeding a voltage converter. The power source is usually batteries, but for some equipment it is AC power from a wall socket.

Either way, the electrical voltage needed to operate the flash tube is higher than the supply or source voltage, so a special circuit converts the source voltage to a higher voltage. This high voltage is accumulated in a storage *capacitor*.

An electrical capacitor behaves very much like a rechargeable battery. The storage capacitor charges up to the high voltage from the voltage converter, then suddenly dumps its charge into the flash tube to make the bright light. A signal is required to tell the capacitor to dump its charge and cause the flash. This signal comes from the X-sync contacts in the camera. The signal wire in the drawing is shown connected to the flash tube itself, and you can think of it as turning on the flash. The flash turns itself off when the storage capacitor has discharged.

Once the flash has been fired, it

cannot be operated again for a short period of time needed to charge up the capacitor again, called the *recycle time*.

With rechargeable batteries, longer recycle time tells you the batteries need charging. The specs on most flash units give you an idea of the time needed to put enough charge back into the batteries to expose another roll of film. If your flash uses flashlight-type non-rechargeable batteries, use alkaline cells. They will give a lot more flashes than the common variety, before recycle time becomes excessively long or the unit won't recycle at all.

The type of capacitor used in electronic flash units may deteriorate if left a long time without an electrical charge. Just before you put the flash away after shooting, it's a good idea to let it recycle so it is ready to shoot, but don't fire the flash. That allows you to store it in a charged condition. In long storage it is beneficial to turn on the flash unit and recharge the capacitor about once a month, returning it to storage in a charged condition.

Most electronic flash units have a signal light, or ready light, which glows when the capacitor has enough charge to operate the flash. Except where mentioned in following discussions, this indication does not represent full charge. By waiting an additional time interval approximately equal to the recycle time, the capacitor will be fully charged. It will make about 1/2 step more light when fully charged; however, this is significant only when the flash is switched to non-automatic operation. If you are using the flash as a non-auto unit, you will get more uniform lighting if you always trigger the flash when the lamp first turns on, or else always wait for full charge. An automatic flash gives correct exposure no matter how bright the flash is.

GUIDE NUMBERS

Guide numbers are a guide to exposure using non-automatic electronic flash units. Higher guide numbers indicate more light from

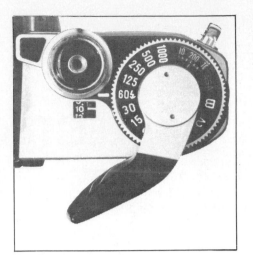

A lightning symbol signifies electronic flash. The shutter-speed control on this camera is set to the correct speed for electronic flash, 1/60 second. Other camera models may have different shutter speeds for electronic flash.

the flash.

Assume that a flash makes sufficient light for correct exposure at a certain distance. If the distance is doubled, the aperture change to get the same exposure as before should be opening up two steps.

Now let's use some numbers to illustrate that. Suppose the light is 5 feet from the subject and a suitable aperture is *f*-16. Please notice that the distance in feet multiplied by the *f*-number is: 5 x 16 = 80.

Double the distance, to 10 feet, and open up the aperture two steps, to *f*-8. The product of distance times *f*-number is still 80.

All combinations of distance and *f*-number that produce the same exposure with that flash will have the

same product—80 or whatever it turns out to be. That number is called a *guide number*.

A non-automatic electronic flash may have a guide number of 60 feet for ISO 25. Here's how to use a guide number (GN) to find the *f*-stop you should use:

$$f\text{-number} = GN/Distance$$

If the guide number is 60 feet, and you are shooting at a distance of 15 feet from the subject, the *f*-number you should use is

$$60/15 = f\text{-}4$$

If you move closer, say 7.5 feet to keep the arithmetic simple, the new aperture is

$$60/7.5 = f\text{-}8$$

Notice that a guide number includes distance between light source and subject. If the distance is measured in feet, a certain guide number results. If measured in meters, a different guide number results. Unless you know if the number is based on feet or meters, you can miss exposure by using the wrong aperture.

Sometimes guide numbers are specified only for one film speed. If you decide to shoot with film of a different speed, you should know how to convert the guide number. Let's use the terms *New GN* and *New ISO* to mean the GN and film speed you intend to use. *Old GN* and *Old ISO* will mean the published guide number.

NON-AUTOMATIC ELECTRONIC FLASH

Turn-on signal from camera X-contact

Power Source | Voltage Converter | Storage Capacitor | Flash Tube

Figure 16-1/When using a non-automatic electronic flash, camera-generated signal turns it on. Flash tube makes light until storage capacitor discharges to the point where flash tube extinguishes.

THE INVERSE SQUARE LAW

A small light source produces an expanding beam of light. When such a beam travels twice as far, it illuminates a surface that is twice as tall and twice as wide. That's four times as much area. If the same light covers four times the area, its brightness on the surface is reduced to one-quarter. If a beam travels three times as far, brightness at the subject is reduced to one-ninth, and so forth. The light always falls off as the square of the distance. That's the *Inverse Square Law.*

$$\text{New GN} = \text{Old GN} \times \sqrt{\frac{\text{New ISO}}{\text{Old ISO}}}$$

Sometimes the film speeds make the calculation easy. Suppose the guide number as stated in the specs is 60 feet with ISO 100 film. You intend to shoot with ISO 400 film.

$$\text{New GN} = 60 \text{ feet} \times \sqrt{\frac{400}{100}}$$

$$= 60 \text{ feet} \times 4$$

$$= 60 \text{ feet} \times 2$$

$$= 120 \text{ feet}$$

Indoors you can use direct flash as at left, bounce it off the ceiling as above, or from a wall. Be wary of bouncing light off a colored surface because it colors the reflected light. Shot with a Canon 199A flash on an A-1 camera in the Electronic Flash AE mode.

If you switch to ISO 400 film instead of ISO 100 film, you can place the flash at double the distance or close down the aperture by two steps.

Guide numbers for electronic flash units are quoted at ISO 25 or ISO 100 or some other film speed. The flash unit "looks better" when a higher film speed is used as the base—because the guide number is higher. If you are shopping for an electronic flash, compare guide numbers based on the same film speed.

Guide numbers are just that—a guide. They are based on photographing people indoors because more flash is used for that purpose than any other. Some of the light from the flash bounces off ceiling and walls and then illuminates the subject while the shutter is still open. If you use flash outdoors you will lose the light that would otherwise bounce off ceiling and walls and the picture may be underexposed. Try figuring *f*-stop with the guide number and then opening up one-half step or more for outdoor locations.

ESTABLISHING YOUR OWN GUIDE NUMBERS

Because guide numbers are based on average conditions, the published guide number for your flash may not work well under your shooting conditions—such as a room with a high dark ceiling.

You can figure and assign your own guide number to your equipment and shooting environment by testing—remember that a guide number is just the product of distance and *f*-stop that gives a good exposure at a specified shutter speed.

A handy shooting distance for the test is 10 feet from the subject. Use several different *f*-stops above and below the one suggested by the published guide number. Make notes or have the subject hold a card showing the *f*-stop for each exposure. After processing, pick the one you like best. The guide number for that situation is the *f*-stop used

multiplied by the distance used. If you liked *f*-8 best, and you were testing at 10 feet, the guide number is 80 feet. Use color-slide film for the test.

FLASH WITH A FOCAL-PLANE SHUTTER

Here is a reminder of how a focal-plane operates:

The first curtain is released to make an exposure, and the second curtain follows behind at a time interval equal to the desired length of exposure. When the first curtain reaches the end of its travel, the film frame is uncovered as far as the first curtain is concerned, so it closes electrical contacts and fires the flash.

If the second curtain is following closely behind the first, at 1/500 second for example, part of the frame will already have been covered up by the second curtain at the instant of the flash. The only part of the frame that could be exposed is the narrow slit between the two curtains.

To use electronic flash with a focal-plane shutter, a shutter speed must be selected so the first curtain reaches the end of its travel and then a brief instant passes before the second curtain begins its journey across the frame. During that brief instant, all of the frame is open to light and the flash occurs.

This means the exposure time on the shutter-speed dial must be slightly longer than the time required for the first curtain to travel across the frame. At slower shutter speeds, the second curtain waits even longer before starting across the frame, so electronic flash works OK.

FLASH SYNCHRONIZATION

The *fastest* shutter speed at which electronic flash can be used is called the X-sync speed. The X-sync speed depends on the velocity of the curtain and its direction of travel. For the same velocity, it takes longer to travel horizontally across the long dimension of the frame than vertically across the short dimension.

The accompanying table shows X-sync speeds for current Canon cameras and the direction of shutter-curtain travel.

GHOST IMAGES

Electronic flash with a focal-plane shutter requires exposure at X-sync, or slower. But the actual time of exposure *due to the bright light of the flash* is very much shorter—1/500 second down to as little as 1/50,000 second or less in some cases.

If there is enough illumination on the scene from sources other than the flash—called *ambient* light—to cause some exposure during the full time the shutter is open, then there are two exposures: one short-time exposure due to the flash and another longer-time exposure due to the ambient light on the scene.

If the subject moves during the time the shutter is open, or the camera moves, the image due to ambient light will not be in register with the image due to flash. This can cause a blur or a faint "echo" of the subject on the film.

With a motionless subject, the cure is to hold the camera still during the entire period of exposure. With a moving subject, there isn't much you can do about it except try to shoot so the flash is the dominant light and the other light on the subject is too dim to make a visible image on the print, or else pan with the subject.

LIGHTING RATIO

A thing to worry about with artificial lighting, and sometimes outdoors, is the difference in the amount of light on the best-lit areas of the subject and the amount in the worst-lit areas.

Direct sunlight from above or the side can spoil a portrait by casting deep and well-defined shadows of facial features. This can be reduced by using reflectors to cast some light into the shadows, or using flash to fill shadowed areas with more light, which is called *fill lighting*.

If you are using more than one source of light, you can usually control some or all of them to adjust both the amount of light and the directions of illumination on the subject. In portraiture and other kinds of photography, arrangement of lighting is important for artistic effect.

For a portrait, suppose there are two light sources, such as flood lamps or flash. With the subject looking straight ahead, one light source is to the left at an angle of 45 degrees. Let's say this source puts 4 units of light on the subject.

Another source, at a 45 degree angle on the opposite side, puts only one unit of light on the subject. This gives a lighting ratio of 4 to 1—which is simply the ratio of the two amounts of light.

On the subject, there are three values of light. Where illumination is only from the brighter source, the amount of light is 4 units. Where it is only from the less-bright source, which will be in the shadows cast by the brighter source, the illumination is 1 unit. Where both lights overlap and both illuminate the subject, the total light is 5 units. The brightness ratio is 5 to 1 because the brightest part is five times as bright as the darkest part.

In photographic exposure steps, a brightness ratio of 5 to 1 is only a fraction more than two steps, usually no problem for b&w film. It is often recommended as the upper limit for brightness variation in color photography because of the nature of color film.

X-SYNC SPEEDS		
Camera	X-Sync Speed	Focal-Plane Shutter
A-series	1/60	Horizontal
F-1	1/90	Horizontal
T50	1/60	Vertical
T70	1/90	Vertical
T80	1/90	Vertical
T90	1/250	Vertical

Color film has two jobs to do. It must record differences in scene brightness, just as b&w film records the different brightnesses along the gray scale. In addition, it has to record color information.

A simple way to think about that is to remember that the brightness information gets on the film first. After that, color is introduced by chemical processing. When there is conflict between brightness information and color, color loses. By restricting the lighting ratio to about 4 to 1, giving a brightness ratio of 5 to 1 as measured by the exposure meter in your camera, you allow "room" on the film for both brightness and color variations. If the colors in the scene are very bold and vivid, you may need to hold the lighting ratio to 2:1. With color, the colors themselves produce visual differences between objects in the scene, so we don't have to rely as much on brightness differences.

HOW TO CONTROL LIGHTING RATIO

If the lights are floods or flash, you can control the brightness of each source by selecting sources of different light output and you can control the amount of light from any source by adjusting the distance from source to scene. Sometimes this is more difficult in the real world than on paper.

A reasonable guide to incandescent-lamp light output is the wattage rating. You can confirm lighting ratio by measuring at the scene with a hand-held meter, or by moving the camera up close so it only "sees" parts of the scene. Measure the brightest part and the darkest part of interest.

With lights of the same intensity, control lighting ratio by moving one farther back. If they are located so they put the same amount of light on the scene, and then one is moved back to double the distance, the light from that one drops to one-fourth its former value due to the inverse-square law.

Using Flash for Fill Lighting—

When using flash, you have to predict the amount of light on the scene when the flash happens. A simple way is to use the guide number to figure f-stop and then consider the f-stop as an indicator of the amount of light. If you are using two flash units to make a portrait, one is located so it requires f-4 and the other requires f-8 to produce full exposure; you will get a 4 to 1 lighting ratio by setting the camera at f-8.

Two flash units can be triggered by the camera—one in the hot shoe and another connected to the flash terminal on the camera body. You can also use flash units that are triggered by light. One flash is operated by the camera. One or more additional flash units are equipped with an accessory light sensor that "sees" the light from the main flash and triggers the other flash units. When so arranged, the additional flash units are called *slaves*.

If you have the lighting set for a 4 to 1 ratio, use the f-stop associated with the brighter light. This is generally true of fill lighting whether by continuous light or flash.

USING FLASH IN SUNLIGHT

A special case of fill lighting with flash is when the main light is the sun.

The T90 camera and the 300TL flash unit provide flash fill in daylight automatically, as described in Chapter 18. You can control flash fill "manually" with most flash units by following this procedure.

With the shutter at the speed required for flash, and sunlight on the subject at an angle that makes shadows, the camera exposure setting should be for the main light source—the sun. Then locate the flash at the right distance from the subject so it gives the desired lighting ratio.

1. Set the camera shutter speed for use with flash—X-sync.
2. Focus, meter the subject and set aperture for normal exposure using sunlight. Notice the distance from the camera location to the subject, either by reading the distance scale on the lens or actual measurement.
3. Using the guide number of the flash for the film speed you are using, calculate the flash f-stop for the distance between camera and subject. For a 4-to-1 lighting ratio, that f-stop as calculated should be two stops larger than the camera setting.
4. If it is not 2 stops larger, use the guide number to figure distance between flash and subject that will give the desired aperture.
5. Put the flash at that distance. Remember about flash outdoors being less effective than flash indoors where ceiling and wall reflections help. Fudge the flash forward a little ways to compensate. That's not scientific but it's practical.
6. Shoot at the camera setting you made for sunlight, not the larger aperture you calculated for normal exposure with the flash.

There is a handy mathematical coincidence that is useful when moving a flash or flood light to change the amount of light. Doubling distance reduces the amount of light on the subject by a factor of 4. Doubling the f-number at the camera also reduces the amount of exposure of the film by a factor of 4. The mathematical series used for f-numbers also applies to distances between light and subject.

If you have the type of flash that connects to the camera by a PC cord, you can locate the flash away from the camera by using PC cord extensions.

If you cannot remove the flash from the camera because it is a hot-shoe type, then you can't use a different distance for flash and camera. It is always possible to find some distance that will give the lighting ratio you want, but that may not give good composition of the picture.

When your calculation indicates that the flash should be moved back to reduce its light, but you can't

Outdoors, you can use flash to fill shadows caused by direct sunlight.
Photos by Josh Young.

LOCATING FLASH OR FLOOD LAMPS	
To Decrease Illumination By:	Multiply Distance By:
Zero	1
1 stop	1.4
2 stops	2
3 stops	2.8
4 stops	4
5 stops	5.6
6 stops	8

move it back independent of the camera, you can reduce the amount of light coming from the flash.

With electronic flash, which doesn't get hot, you can cover about half of the window that lets light out and about half of the light will come out—a reduction of one step. One thickness of pocket handkerchief over an electronic flash cuts the light by one step. Two thicknesses—two steps. Don't do this with flashbulbs.

Some electronic flash units come with neutral-density filters that fit over the window. 2X is one step, 4X is 2 steps.

PROBLEMS WITH FLASH

Flash has several kinds of problems.

Flash on camera, very close to the axis of the lens can cause "red eye" when using color film. Light rays from the flash enter the subject's eyes and reflect from the retina of the eye. The light will be colored red from the blood vessels in the eye. SLR cameras mount a flash high enough to avoid this problem, but it is possible. Corrections include holding the flash high or to one side, having the subject not look directly into the lens, and using brighter room lighting so the pupils of the subject's eyes are

small.

Flash on camera produces "flat" lighting because it is usually aimed straight at the face, eliminating all shadows. The exception of course is when the flash is used for fill lighting.

When people stand close to a wall while being photographed with flash on camera, there are often sharp shadows of the people visible on the wall behind them.

Mounting a flash on the camera is convenient because it is all one unit, but has those disadvantages. If the flash connects to the camera with a PC cord, and the cord is long enough, hold the flash high and to one side. This casts shadows similar to those caused by normal overhead lighting and the effect is more realistic. Also, a flash held high tends to move shadows on the wall downward and they may not be visible in close "head shots" of people.

Light from a single flash falls off drastically with increasing distance. If you photograph a group of people at different distances from the flash, and make a guide number calculation for the middle of the group, people nearest the camera will be overexposed, those in the center will be OK and those in the background will be underexposed.

Using guide numbers to find *f*-

stop is a bother, particularly when you are shooting in a hurry.

BOUNCE FLASH

A technique used to avoid flat lighting and harsh shadows from a single flash is to aim it at the ceiling. With a flash detached from the camera, just point it at an angle toward the ceiling so the bounced light will illuminate your subject.

Some flash units intended for hot-shoe mounting have a swivel head so the light can be bounced. This has all the advantages of holding the flash unit high plus the added diffusion of the light from a broad area of the ceiling. If the ceiling is colored, it will also color the reflected light and change skintones in a color photograph.

To bounce with non-automatic flash, the distance to use in the guide-number calculation is the distance from flash to ceiling and then from ceiling to subject. With a little practice and a tape measure if necessary, you can learn to estimate this distance fairly well. You must also allow for light absorption by the ceiling, which can require opening up one or two stops larger than the guide-number calculation suggests. A flash must be more powerful—meaning make more light—to be used this way, but it is a much-improved method of taking flash pictures indoors.

AUTOMATIC ELECTRONIC FLASH

Automatic electronic flash units measure the amount of light reflected from the subject and automatically turn off the flash when the desired amount of light has been measured. No guide-number calculation is necessary.

How Light-Sensing Automatic Flash Works—The light-measuring sensor of most automatic flash units is mounted in the housing, so it is pointed toward the subject. A turn-on signal comes to the flash tube from the camera. The light sensor measures exposure and at a standard amount of exposure it turns the flash off. It is possible to work at a shorter distance by closing down aperture so the camera accepts less light, and it is also possible to work at different film speeds by changing aperture of the lens. Shutter speeds slower than X-sync can be used, but not faster. Slower shutter speeds will not gather more light from the flash but will produce more exposure by ambient light.

You set film speed into your camera and also into the calculator on the automatic flash. Then the calculator on the flash unit displays an *f*-stop for the camera along with a maximum shooting distance. There is also a minimum shooting distance—sometimes it is in the instruction booklet but not on the calculator.

If you set the lens for the indicated *f*-stop, you can shoot automatically anywhere within the specified distance range without changing *f*-stop of the lens.

Suppose the distance range is 2 to 18 feet. If the subject is at the maximum distance in that range, the automatic flash will operate as long as it can. If you shoot at a shorter distance, the sensor on the flash receives more light reflected back from the nearer subject and decides that exposure is correct with a shorter time duration of the flash. It turns off sooner. At the shortest distance, the unit turns on

and then turns back off again as fast as possible.

The sensor in the flash unit measures exposure on behalf of the camera. When the sensor on the flash receives what it "thinks" is correct exposure, the actual exposure on film in the camera should be correct.

Some automatic flash units allow you to choose from two or more *f*-stops at the camera and make an adjustment to the sensor. This adjustment changes the sensitivity of the sensor so it still gives correct exposure. Choice of *f*-stop gives you some control over depth of field.

Some automatic flash units are built with swivel heads to allow bouncing the light off the ceiling. The sensor does not swivel but continues to look where the camera does—assuming the flash is mounted on the camera. Thus, the flash also compensates automatically for light loss due to bouncing and will not shut off until the proper amount of exposure is received. Naturally the flash must have enough power to bounce light off the ceiling.

Some automatic flashes are detachable from the camera but have a small light sensor that mounts on the camera. This allows you to

point the flash in any direction and hold it anywhere. Meanwhile, the sensor mounted on the camera still does its job of keeping the flash on until it thinks the film got enough exposure.

Automatic flash units with a sensor-sensitivity control normally have one position of the control that allows the flash to run for maximum time duration at every firing. It puts the automatic flash on non-automatic or manual operation. Then you use it with its guide number just like any other non-auto flash.

TTL AUTO FLASH

Another way to automatically control flash exposure is to measure light reaching the film during the actual exposure. This method uses a light sensor in the bottom of the camera, looking backward toward the film surface, as shown in Chapter 12. When the light sensor has measured sufficient exposure, the camera sends a turn-off signal to the flash unit. Because this method uses light that has come Through The Lens, it is called TTL automatic flash. Canon uses this method of flash control in the T90 camera.

FULLY AUTOMATIC FLASH

Fully automatic means that the

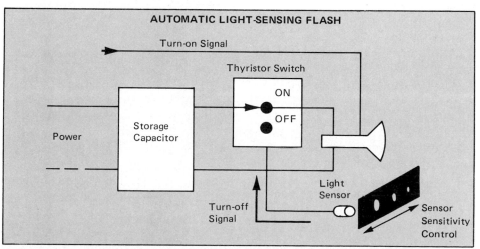

Light-sensing auto-flash units are turned on by X contact in the camera. Light sensor controls *time duration* of flash, turns off flash unit at standard amount of exposure. Sensitivity control determines the *f*-stop that should be set at the camera.

camera sets both aperture and shutter speed automatically.

A-Series Cameras—With A-series cameras and flash, fully automatic is called *Electronic Flash AE* (Automatic Exposure). When the flash is charged and ready to fire, shutter speed is set to X-sync.

The user selects a desired operating distance range, such as 1 to 9 meters, by moving a switch on the flash. The camera then sets lens aperture to provide that operating range with the film speed in use. For different film speeds, aperture size is different but the operating distance range is the same.

T-series Cameras—With T-series cameras and flash units, fully automatic operation is labeled PRO-GRAM. When the flash is charged and ready to fire, shutter speed is set automatically to X-sync.

When you press the shutter button partway, the flash emits a dark-red burst of light from a red lens on the flash body—called a *pre-flash*. This light is reflected by the subject being photographed. A light sensor on the flash measures the reflected pre-flash. For an average subject, the amount of reflected light is directly related to subject distance.

Using a built-in program, the camera calculates correct aperture size for the subject distance and the film speed being used. It sets aperture automatically.

If insufficient light is measured after the pre-flash, the camera warns you that the subject is too far away. If there is no warning, press the shutter button fully to fire the main flash and make the exposure.

SLOW-SYNC FLASH

This means using a shutter speed that is slower than X-sync. When flash is used in bright ambient light, some of the exposure is caused by the flash and some by the ambient light.

Because light from a flash behaves according to the inverse square law, it diminishes rapidly with increasing distance. Usually, the subject of a photograph is illu-

TELL-TALE SIGNS OF FLASH

The more you use flash, the more you will appreciate how helpful it can be. You will use it often to solve many kinds of problems and sometimes for the effect of flash itself. Also, as you gain competence in using flash, you will become more sensitive to the photographic indications that show flash was used.

Flash on camera, aimed directly at your subjects, gives photos a newspaper-like appearance—or sometimes the look of having been taken by a *papparazzi* springing out of hiding to snap shots of celebrities.

Direct flash with the subject near a wall casts sharp well-defined shadows and makes reflecting highlights on faces.

Flash with a distant background in dim light is a very easy way to get a solid black background in your photo.

By now you recognize flash fill in sunlight. Notice both the lightening of shadows and the pin-points of flash light reflected in subjects eyes. When using flash fill, be careful not to eliminate facial shadows entirely.

A-SERIES CAMERAS WITH CANON FLASH UNITS ON AUTOMATIC			
FLASH	**A-1**	**AE-1** PROGRAM	**AE-1**
199A 577G 533G	Shutter speed and aperture set automatically. The viewfinder shows flash ready. Special procedure allows use of 1/30 to 30-second exposures with automatic features.	Shutter speed and aperture set automatically.	Shutter speed and aperture set automatically.
188A 166A	Shutter speed and aperture set automatically. The viewfinder shows flash ready.	Shutter speed and aperture set automatically. Viewfinder indicator shows flash ready and correct exposure.	Shutter speed and aperture set automatically.

minated mainly by flash but the background is illuminated mainly by ambient light.

Exposure due to flash is not affected by shutter speed because the flash duration is much shorter than any allowable shutter speed. For example, the flash may occur in 1/20,000 second while the shutter is open for 1/60 second.

Exposure due to ambient light is affected by shutter speed. If you use 1/30 second instead of 1/60

second, exposure due to ambient light will be doubled while exposure due to the flash does not change.

Using a shutter speed slower than X-sync gives a brighter background due to ambient light without much change in exposure of the subject.

SECOND-CURTAIN SYNC

Most cameras fire the flash at the instant the first shutter curtain becomes fully open, as described earlier. Sometimes this causes a peculiar effect with a moving subject.

After the flash exposure, a second dim image is formed by ambient light. Because the subject is moving, the dim image is "stretched" across the frame in the direction the subject was moving and therefore extends in front of the sharp image made by the flash.

We expect the dim image to trail behind a moving subject, rather than precede it, so the image looks odd.

The T90 camera can fire the 300TL flash with second-curtain sync—just before the second curtain begins to close. Thus, the ambient-light exposure of a moving

In addition to flash units that mount in the hot shoe on top of the camera, Canon offers powerful flash units that can be held away from the camera or mounted on a bracket which also holds the camera.

subject occurs first, then the sharp image caused by the flash. The dim image caused by ambient light will trail the moving subject, as we would expect it to.

FLASH BEAM ANGLE

The beam of light produced by electronic flash units is approximately rectangular, with about the same shape as the film frame. That prevents wasting light on an area of the scene that will not be imaged on film.

The light pattern should be large enough to illuminate the area of the scene that is within the angle of view of the lens and recorded on film—which depends on lens focal length. This is referred to as the "coverage" of the flash.

Most flash units cover the angle of view of a 35mm lens and therefore provide more than enough coverage for all longer focal lengths. Flash specifications will tell you the beam width or coverage.

If a wide-angle lens is used, with a focal length shorter than 35mm, then the flash beam must be made wider also in order to cover the wider angle of view.

Wide Adapters—These are clip-on lenses that fit over the flash window to provide a wider beam. Because the light is spread over a larger area, it is less bright. The distance range of the flash is reduced.

Tele Adapters—Some flash units are provided with clip-on adapters

to narrow the beam when telephoto lenses are used. These extend the operating range of the flash.

Zoom Heads—Some flash units, such as the 299T, have a permanently attached lens in front of the flash that can be moved in and out to change the flash beam width. The zoom head on the 299T has three settings: 28mm, 35mm and 85mm. These values are lens focal lengths. At each setting, the beam angle is slightly wider than the angle of view at that focal length.

DEDICATED FLASH

Simple flash units can be used with virtually any camera because all they do is flash when triggered by the camera and perhaps use a light sensor on the flash body to turn themselves off.

The trend in flash and camera design has been to make both more automatic, with fewer controls for the user to set—or possibly forget to set. Flash units may set both shutter speed and aperture at the camera, operate a flash ready-light in the viewfinder, and provide other automatic features. This requires electronic cooperation between flash and camera, which must be designed into both units.

Flash that has special operating features with one or more specified camera models is called *dedicated* flash. It is dedicated to those models. Usually a dedicated flash can be used with other camera models of the same brand also, but with fewer of the automatic features.

ON-OFF switch of 199A flash unit is at left, by my index finger. Opposite is the Aperture Selector control which has three automatic settings indicated by letter A and appropriate color in adjacent window, and one manual setting indicated by M. Here set to yellow automatic operating range. PILOT lamp at lower right glows when flash is ready to fire. Depress PILOT Lamp and it serves as TEST button, firing the flash. If flash sensor measures enough reflected light from subject, AUTO CHECK lamp at lower left glows green. Depress AUTO CHECK lamp and it illuminates calculator dial so you can see it in dim light.

FLASH CONNECTIONS

The hot shoe on Canon cameras has a central contact called the X-contact. It fires the flash. Additional contacts are used to provide additional features, such as a display in the viewfinder. When a flash is mounted in the hot shoe, all necessary connections are made automatically.

Canon also manufactures larger, more powerful flash units that are not mounted in the camera hot shoe. They can be held separately in your hand or attached to the camera with a bracket. These are called *handle-mount* or *bracket-mount* flash units. Special connecting cords are used to provide flash sync and automatic or dedicated features. One end of the cord plugs

into the hot shoe and the other end into the flash.

Some camera models have a flash connector on the body with only a single contact. This is called a *PC socket*. A PC cord is used to connect a flash to the PC socket. The camera can fire the flash through the PC cord but no dedicated features are available.

FLASH DESCRIPTIONS

A-type flash units, such as Speedlite 199A, are discussed in this chapter. They are for general use with the A-series cameras discussed in this book, such as the A-1, and earlier A-series cameras that are no longer manufactured.

G-type flash units, such as Speedlite 577G, are handle-mount units and intended for general use with A-series cameras. They are also discussed in this chapter.

The F-1 camera uses A-type and G-type flash, but there are some differences compared to other camera models. The F-1 is described in Chapter 18, including flash procedures.

As the new T-series cameras were introduced, companion T-type flash units were announced. The T-type flashes have more dedicated features than earlier flash models and work more closely with T-series cameras.

Some T-type flash units are for use with only one camera model. For that reason, T-type flash units are discussed in Chapter 18, along with the T-series cameras.

Mounting foot of Speedlite 188A has three electrical contact-pins. One is for normal X-sync to fire the flash, the other two are for dedicated functions.

Controls are simple and easy to use.

Speedlite 188A was introduced with the AE-1 PROGRAM.

Speedlite 199A—The 199A can be shoe-mounted or cord-connected to a camera flash terminal using optional Synchro Cord A. Its special dedicated features work only when the flash is mounted in the hot shoe. The flash head can be rotated upward for bounce flash. The light sensor is in the body of the flash and remains pointed straight ahead.

Controls are: An ON-OFF switch. A color-coded Aperture Selector used to select any of three apertures for auto operation or M for manual. A calculator dial used to set in film speed and read operating distances for automatic. A PILOT lamp that also serves as a TEST button to fire the flash independent of the camera. And an AUTO CHECK lamp that glows green to indicate that the flash made sufficient light for correct exposure. You can use the AUTO CHECK feature with the TEST button before exposure or after an exposure is made. Depressing the AUTO CHECK lamp illuminates the calculator dial.

When the 199A is installed, turned on and ready to fire, the flash pilot lamp glows and the flash takes control of the camera. It sets both shutter speed and aperture, or

shutter speed only, depending on which camera is being used and how the controls are set as shown in the accompanying table.

The pilot lamp is off during initial charge and recharge. While off, the camera operates as though the flash were not installed. If you leave the flash on the camera, but turn the Main Switch off, the camera operates as though the flash were not installed.

When the flash sets shutter speed automatically, it selects X-sync.

There is an exception: When installed on an A-1 or F-1 camera, a special AUTO-MANU. 1/60-30S switch lets you use shutter speeds of 1/30 or slower while retaining all automatic features of the flash. This procedure is described in Chapter 18. With all other cameras, the setting of this special switch doesn't matter.

To operate, turn the Transistor Pack on. Turn the ASA dial so the index mark aligns with the film speed you are using. The three usable *f*-stops change when you change the film-speed setting. Use the Aperture Selector Switch to choose one of the three operating ranges.

The main subject should be kept within the selected operating range

when shooting.

Specific control settings are in the table at the end of this chapter.

Speedlite 188A—The 188A is shoe-mounted. There is no socket on the flash for a sync cord. The light sensor is on the front of the flash.

This flash was introduced along with the AE-1 PROGRAM camera. The 188A has operating features that vary depending on camera model.

The AE-1 PROGRAM has a lightning symbol at the bottom of the aperture scale in the viewfinder. When an A-series or G-series flash is in the hot shoe or connected to the hot shoe and the flash is ready to fire, this symbol glows steadily.

If the flash is the 188A and both camera and flash are on automatic, the lightning symbol will blink on and off for about two seconds after each flash exposure, if there was sufficient light for correct exposure of an average scene.

There are only three controls on the 188A, all on the back panel: a Main Switch, a color-coded Aperture/Manu. selector and a sliding Film Speed selector that you use to set in film speed.

A red pilot lamp on the back panel of the 188A glows when the flash

Controls are simple and easy to use.

The light sensor is in the window below the model designation.

The 166A is a dedicated flash with special functions when used with Canon SLR cameras.

is ready to fire and also serves as a test button to fire the flash independent of the camera. When the pilot lamp glows, the flash takes control of the camera. It sets both shutter speed and aperture, or shutter speed only, depending on which camera is being used and how the controls are set as shown in the table at the end of this chapter.

There is no indicator on the 188A to show that there was sufficient light for correct exposure. The sufficient-light indicator in the AE-1 PROGRAM viewfinder does not operate when you use the flash TEST button to fire the flash. Therefore, there is no way to test before making an exposure.

The pilot lamp is off during initial charge and recharge. While off, the camera operates as though the flash were not installed.

If you leave the flash on the camera, but turn it off, the camera operates as though the flash were not installed.

When the flash sets shutter speed automatically, it selects X-sync.

The Aperture/Manu. Selector has one setting for non-automatic guide-number operation, and two for light-sensing automatic operation, identified by a red or green bar visible through an adjacent window. Selecting one of these colors

also selects the aperture size for the camera, which appears in a window above the color bar. The color bars indicate operating range, read from adjacent scales in meters or feet. These ranges are 3.3 to 30 feet (1 to 9 meters) on red and 1.6 to 15 feet (0.4 to 4.5 meters) on green.

These operating ranges are the same at all film speeds. The aperture settings required for each range vary with your choice of film speed.

To operate on automatic, turn the Main Switch ON. Use the Film Speed selector to set the film speed you are using. Choose one of the two operating ranges.

If the 188A is setting aperture automatically, it will set the camera to the aperture indicated on the flash. If you are setting aperture manually, use the indicated *f*-number. Camera settings are in the table at the end of this chapter.

Wide Adapter 188A clips over the flash window and widens the beam to cover the field of view of a 28mm lens. The reduced operating range is shown by a black line on each of the the colored bars.

Speedlite 166A—The 166A is shoe-mounted. There is no socket on the flash for a sync cord. The light sensor is on the front of the flash. It is energy saving on auto-

matic. The 166A has features that vary depending on camera model.

The AE-1 PROGRAM has a lightning symbol at the bottom of the aperture scale in the viewfinder. When an A-series or G-series flash is in the hot shoe or connected to the hot shoe and the flash is ready to fire, this symbol glows steadily. If the flash is the 166A and both camera and flash are on automatic, the symbol will blink on and off for about two seconds after each flash exposure, if there was sufficient light for correct exposure of an average scene.

There are only three controls on the 166A, all on the back panel: a Main Switch, an Aperture/Manu. Selector with a color-coded distance scale and a sliding ASA Film Speed selector that you use to set in film speed.

A red pilot lamp on the back panel of the 166A glows when the flash is ready to fire and also serves as a test button to fire the flash independent of the camera. When the pilot lamp glows, the flash takes control of the camera. It sets both shutter speed and aperture, or shutter speed only, depending on which camera is being used and how the controls are set as shown in the table presented earlier in this chapter.

There is no indicator on the 166A to show that there was sufficient light for correct exposure. The sufficient-light indicator in the AE-1 PROGRAM viewfinder does not operate when you use the flash TEST button to fire the flash. Therefore, there is no way to test before making an exposure.

The pilot lamp is off during initial charge and recharge. While off, the camera operates as though the flash were not installed. If you leave the flash on the camera, but turn it off, the camera operates as though the flash were not installed.

When the flash sets shutter speed automatically, it selects X-sync.

The Aperture/Manu. Selector has one setting for non-automatic guide-number operation, labeled MANU., and two for light-sensing automatic operation, identified by a red or green bar visible through an adjacent window. Selecting one of these colors display the required aperture size in a window above the color bar.

The color bars indicate operating range, read from adjacent scales in meters or feet. These ranges are 3.3 to 22 feet (1 to 7 meters) on red and 1.6 to 11 feet (0.5 to 3.5 meters) on green.

These operating ranges are the same at all film speeds. The aperture settings required for each range vary with your choice of film speed.

To operate on automatic, turn the Main Switch ON. Use the Film Speed selector to set the film speed you are using. Choose one of the two operating ranges.

If the 166A is setting aperture automatically, it will set the camera to the aperture indicated on the flash. If you are setting aperture manually, use the indicahted f-number. Camera settings are in the table at the end of this chapter.

To operate the flash manually, turn the Main Switch ON. Use the ASA Film Speed selector to set the film speed you are using. Move the Aperture-Manu. Selector so the window above the color bars shows MANU. Use the flash guide number

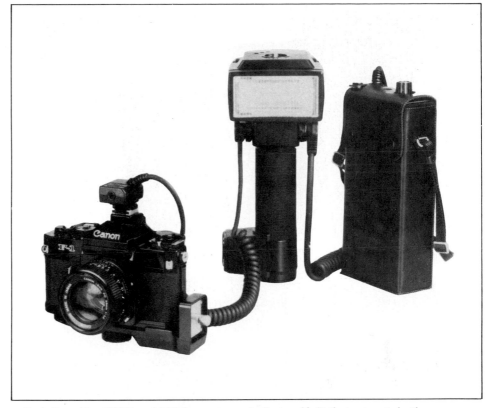

Both Speedlite 577G and 533G use a remote Sensor Unit that mounts in the camera hot shoe and connects to the flash with an electrical cord. Speedlite 577G is shown here removed from its bracket so you can hold flash and camera apart and point the flash in any direction you choose. For this purpose, an accessory light sensor with a one-meter-long coiled cord is used. Power for the 577G is derived from the separate Transistor Pack G, also connected to the flash with a coiled cord.

to calculate aperture size and set that value on the lens. When the ready-light glows, the camera is set automatically to X-sync shutter speed.

Speedlite 577G—The 577G is a handle-mount flash sold with a bracket to mount flash and camera together as a single unit. The bracket also mounts a camera with motor drive or auto winder. The light sensor, Sensor Unit G20, is separate from the flash and is intended to mount in the camera hot shoe. The G20 has an attached electrical cord that plugs into the flash and carries all electrical signals from camera hot shoe to flash. The 577G can set shutter speed and aperture automatically, depending on the camera used and control settings as shown in the accompanying table.

The unit can work as a light-sensing automatic flash or manual flash with any camera that provides X sync, but not with the special features.

To use as an automatic flash, install the Sensor Unit in the camera hot shoe. If the camera doesn't have a hot shoe but does have a flash terminal on the camera body, connect the Sensor Unit to the flash terminal using a Canon Synchro Cord A. The special features work only when the Sensor Unit is mounted in the hot shoe.

To use as a manual non-auto flash, set the AUTO-MANU. switch on the back of the flash to MANU. and install the Sensor Unit in the camera hot shoe. If there is no hot shoe, connect the Sensor Unit to the camera flash terminal using Syn-

nect the Sensor Unit to the flash terminal using Canon Synchro Cord A. The special features work only when the Sensor Unit is mounted in the hot shoe.

To use as a manual flash, disconnect the Sensor Unit and connect the camera flash terminal to the PC terminal on the flash using a standard accessory PC cord. Two flash units can be fired simultaneously on manual using an accessory "Y" PC cord feeding both flash units from the camera flash terminal. To fire additional units simultaneously, use accessory optical slave units rather than cord connections.

The flash head can be rotated upward and horizontally for bounce flash while the flash is mounted in the bracket. The flash can quickly be removed from the bracket so you can hand-hold it and point it in any direction. For this purpose, a special Sensor Unit 100 with a one-meter connecting cord is available.

There are two ways to supply power. A battery holder in the handle can be loaded with six AA-size alkaline or Ni-Cd cells. This power source is controlled by the ON-OFF switch on the flash. The alternate source is the separate Transistor Pack G, which is supplied with a shoulder strap and belt loop. This unit has an ON-OFF switch and built-in regulator. The Transistor

Controls on Speedlite 533G are similar to 577G. There is no switch to select manual operation of the flash. To operate on manual, disconnect the Sensor Unit. There is an ON-OFF switch on the 533G to control power from batteries in the flash handle.

Pack is loaded with either six C-size alkaline batteries or a special rechargeable Ni-Cd Pack TP, which is supplied with its own recharger unit. To use power from Transistor Pack G, both ON-OFF switches must be turned on. It's OK, but not necessary, to have batteries installed in the handle of the flash.

The pilot lamp is not a two-stage indicator. On manual operation, Canon recommends waiting for full charge. If you shoot when the light first turns on, add about one stop more exposure.

When the 533G is connected, turned on and ready to fire, the pilot lamp glows and the flash takes control of the camera. It sets both shutter speed and aperture, or shutter speed only, depending on which camera is being used and how the controls are set as shown in the accompanying table.

The pilot lamp is off during initial charge and recharge. While off, the camera operates as though the flash were not installed. If you leave the flash on the camera but turn off the Main Switch, the

Special adapters clip on the front of Canon flash units to change beam width. The 577G and 533G use both beam-widening and beam-narrowing adapters, shown here.

CANON A-TYPE AND G-TYPE FLASH COMPARISON TABLE

Model	199A	188A	166A	577G	533G
Mount	Hot Shoe	Hot Shoe	Hot Shoe	Hot Shoe	Hot Shoe
ASA 100 Guide Number ft. (m)	100 (30)	85 (25)	22 (20)	157 (48)	118 (36)
Aperture Choices on Auto ASA 25 ASA 100 ASA 400	f-1.4, f-2.8, f-5.6 f-2.8, f-5.6, f-11 f-5.6, f-11, f-22	f-1.4, f-2.8 f-2.8, f-5.6 f-5.6, f-11	f-1.4, f-2.8 f-2.8, f-5.6 f-5.6, f-11	f-1.4, f-2.8, f-5.6 f-2.8, f-5.6, f-11 f-5.6, f-11, f-22	f-1.4, f-2.8, f-5.6 f-2.8, f-5.6, f-11 f-5.6, f-11, f-22
Auto Ranges ft. (m) Red Green Yellow	4.9 to 35 (1.5 to 10.6) 3.3 to 17 (1.0 to 5.3) 1.6 to 8.5 (0.5 to 2.6)	3.3 to 30 (1 to 9) 1.6 to 15 (0.5 to 4.5) —	3.3 to 22 (1 to 7) 1.6 to 11 (0.5 to 3.5) 	8.2 to 56 (2.5 to 17) 4.9 to 27.9 (1.5 to 8.5) 3.3 to 14 (1 to 4.3)	8.2 to 42 (2.5 to 12.8) 4.9 to 21 (1.5 to 6.4) 3.3 to 10.5 (1 to 3.2)
Switchable to Manual	Yes	Yes	Yes	Yes	Yes
Widest lens covered No Adapter Wide Adapter Tele Adapter	35mm 24mm —	35mm 28mm —	35mm — 	35mm 24mm or 20mm 100mm	35mm 24mm or 20mm 100mm
Viewfinder Flash-Ready Indication	A-1, New F-1 and AE-1 PROGRAM only	A-1, New F-1 and AE-1 PROGRAM only	A-1, New F-1 and AE-1 PROGRAM only	A-1, New F-1 and AE-1 PROGRAM only	A-1, New F-1 and AE-1 PROGRAM only
Viewfinder Sufficient-Exposure Indication	No	AE-1 PROGRAM only	AE-1 PROGRAM only	No	No
Bounce Capability	Yes	No	No	Yes	Yes
Batteries	4 AA size Alkaline or Ni-Cd	4 AA size Alkaline or Ni-Cd	4 AA size Alkaline or Ni-Cd	6 C size Alkaline or Ni-Cd Pack TP	6 AA Alk. or Ni-Cd, 6 C Alk, or Ni-Cd Pack TP
Number of Flashes Automatic: AA Alkaline AA Ni-Cd C Alkaline C Ni-Cd Ni-Cd Pack TP Manual: AA Alkaline AA Ni-Cd C Alkaline C Ni-Cd Ni-Cd Pack TP	100 to 1000 50 to 500 — — — 100 + 50 + — — —	200 to 2000 70 to 700 — — — 200 + 70 + — — —	250 to 2500 80 to 800 — — — 250 + 80 + — — —	— — 120 to 1200 100 to 1000 75 to 750 — — 120 100 75	120 to 1200 55 to 555 220 to 2200 180 to 1800 110 to 1100 120 55 220 180 110
ASA Film-Speed Range of Flash Control Settings	25 to 800	25 to 800	25 to 800	25 to 800	25 to 800
Aperture Range of Flash Control Settings	f-1 to f-32	f-1.4 to f-16	f-1.4 to f-16	f-1.4 to f-32	f-1.4 to f-32
Dimensions (WxDxH)	3-1/8x3-1/4x4-9/16" 79 x 83 x 116mm	2-11/16x2-1/16x4-1/16" 68 x 52 x 103mm	2-5/8x1-15/16x3-7/8" 66 x 49.5 x 98mm	2-7/8x4-1/4x9-5/8" 99 x 107 x 245mm	3-11/16x4-1/8x9-3/4" 93 x 104 x 248mm
Weight	490g, 17.2 oz. with batteries	290g, 10-1/4 oz. with batteries	260g, 9-3/16 oz. with batteries	600g, 21.1 oz. with batteries	605g, 21.1 oz. with batteries

camera operates as though the flash were not installed.

When the flash sets shutter speed automatically, it selects X-sync. There is an exception: When installed on an A-1 or F-1, there is a special **AUTO-MANU. 1/60-30S** switch on the front of the flash that lets you use shutter speeds of 1/30 or slower while retaining all automatic features of the flash. This procedure is described in Chapter 18. With all other cameras, the setting of this special switch doesn't matter.

To operate, select the power source. Turn the film-speed dial so the index mark aligns with the film speed you are using. The three usable f-stops change when you change the film-speed setting. Use the Aperture Selector Switch to choose one of the three operating ranges. The main subject should be

FLASH PHOTOGRAPHY WITH AE-1 PROGRAM AND AE-1

Flash Type	Method of Operation	Flash Control Settings	Camera Control Settings AE-1 PROGRAM & AE-1	Exposure Control
199A 188A 177A 166A 155A 133A 011A 577G 533G	ELECTRONIC FLASH AE Flash sets camera to 1/60 and aperture called for by Aperture Selector on flash.	199A, 577G, 533G: Aperture Selector to red, green or yellow. AUTO-MANU. 1/60h30S to either setting. 188A, 177A, 166A, 155A, 133A: Aperture Selector to red or green.	FD lens to A or O. Shutter speed not on B.	Light sensor in flash.
199A 188A 177A 166A 155A 133A 011A 577G 533G	AUTOMATIC FLASH with manual aperture control. Camera automatically set to 1/60. You set aperture manually to agree with aperture called for by setting of Aperture Selector on flash.	199A, 577G, 533G: Aperture Selector to red, green or yellow. AUTO-MANU. 1/6030S to either setting. 188A, 177A, 166A, 155A, 133A: Aperture Selector to red or green.	FD lens not on A or O, or FD lens with non-meter-coupled accessories, or FL lens. Shutter speed not on B. You set aperture to agree with flash.	Light sensor in flash.
199A 188A 177A 166A 155A 577G 533G	NON-AUTOMATIC FLASH with manual aperture control. Camera automatically set to 1/60. You control exposure by setting aperture.	199A, 577G, 533G: Aperture Selector to M. AUTO-MANU. 1/60-30S switch to either setting. Disconnect 533G Sensor Unit. 188A, 177A, 166A, 155A: Aperture Selector to MANU. or M.	FD lens not on A or O, or FD lens with non-meter-coupled accessories, or FL lens. Shutter speed not on B. You set aperture.	Camera operator.
199A 188A 177A 166A 155A 133A 011A 577G 533G	SHUTTER ON B, AE Flash automatically sets camera aperture to value called for by setting of Aperture Selector on flash.	199A, 577G, 533G: Aperture Selector to red, green or yellow. AUTO-MANU. 1/6030S switch in either position. 188A, 177A, 166A, 155A, 133A: Aperture Selector to red or green.	FD lens to A or O. Shutter speed to B.	Flash exposure by sensor in flash. Ambient light exposure controlled by camera operator.
199A 188A 177A 166A 155A 133A 011A 577G 533G	SHUTTER ON B. AUTOMATIC FLASH with manual aperture control. You set lens aperture manually to agree with aperture called for by Aperture Selector on flash.	199A, 577G 533G: Aperture Selector to red, green or yellow AUTO-MANU. 1/60h30S switch in either position. 188A, 177A, 166A, 155A, 133A: Aperture Selector to red or green.	FD lens not on A or O, or FD lens with non-meter-coupled accessories or FL lens. Shutter speed to B.	FD lens not on A or O, or FD lens with non-meter-coupled accessories, or FL lens. Selector Dial set to A.
199A 188A 177A 166A 155A 577G 533G	SHUTTER ON B, NON-AUTO FLASH Flash does not control exposure or make camera settings. Make flash guide-number calculation or use flash calculator dial for reference.	199A, 577G, 533G: Aperture Selector to M. AUTO-MANU. 1/60-30S switch in either position. Disconnect 533G Sensor Unit. 188A, 177A, 166A, 155A: Aperture Selector to MANU. or M.	FD lens not on A or O, or FD lens with non-meter-coupled accessories, or FL lens. Shutter speed to B.	Camera operator.

kept within the selected operating range when shooting.

Specific control settings are in the table at the end of this chapter. **Macrolite ML-1**—A special flash for close-up and macro photography, the ML-1 mounts on the forward end of the lens and provides automatic exposure with choice of three apertures and manual. It sets shutter speed automatically, but not aperture. There are two flash units, on opposite sides, which can be rotated for best illumination of the subject. One of the flash units can be turned off to provide less uniform illumination. Guide number is 16 meters with ISO 100.

This flash is recommended for use with the 50mm and 100mm macro lenses and also with the FD 80-200mm *f*-4 zoom using Close-Up Lens 500T on the zoom lens.

This combination serves well for medical and dental photography and similar uses. The combination of zoom lens and close-up provide both flexibility and a relatively long working distance between lens and subject.

HOW TO CARE FOR YOUR CAMERA

by John Wall, Canon Representative

The best care you can give your camera is to use it regularly. Keep it clean and protected from dirt, water or mechanical damage. Inspect and test it occasionally to be sure it is functioning properly.

Before leaving on the once-in-a-lifetime trip, have it checked at a service center. Then shoot a test roll to be sure you will get good pictures.

TESTING YOUR CAMERA

Without film in the camera, operate the film-advance lever and press the shutter button several times at different shutter speeds. Listen to the sound and check the feel of the mechanism. You can hear a difference in shutter operation at speeds slower than 1/60. Sometimes, it's helpful to compare the sound of one camera to another of the same model.

Look into the viewfinder. If you see dirt particles in sharp focus, they are on the focusing screen. Blurry smudges are on the lens, mirror or the surface of the viewing eyepiece. Remove the lens and look to see which.

Dirt on the lens will affect the picture. Dirt on the mirror or in the viewing system is visible to your eye but not to the film. Cleaning methods are discussed later.

Open the back of the camera and operate it at different shutter speeds and aperture settings. You can see the focal-plane shutter work. Don't touch it. Through the open shutter, and through the front of the lens, you can see the

lens aperture. It should change size when you change control settings or point an automatic camera at scenes with different brightness.

EXPOSURE TESTS

Test metering accuracy by pointing the camera at an average scene in direct sunlight. With aperture at *f*-16, the indicated shutter-speed number should be approximately the same as the film-speed setting. The T50 does not display shutter speeds.

With film in the camera, test exposure accuracy by photographing an 18% gray card or any similar surface. Use slide film. Compare the projected slide to the original subject.

Photograph the same scene at different shutter speeds and aperture settings, if possible. All of the resulting slides should be similar and have good exposure.

KEEP IT CLEAN

You need some way to make a jet of air to blow dirt particles off the surface of the lens and from inaccessible places in the camera. You can use pressurized cans of air, rubber squeeze-bulbs or blower brushes.

To clean the camera body and lens bodies, use a soft cloth and a brush. To clean lens surfaces, use another soft brush. Do not use the same brush on the camera body and on glass surfaces.

Get a pack of *lens-cleaning* tissue. Don't use any other kind. Get a bottle of lens-cleaning fluid at your camera shop. Cotton swabs on a stick are useful, too.

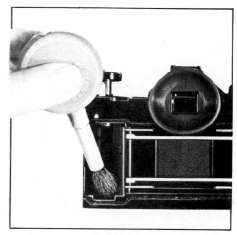

Blower brushes dislodge dirt particles two ways. Try a squirt of air first. Don't use the same brush to clean camera body and lens surface.

A cotton swab moistened with lens-cleaning fluid is a good way to get the viewing window clean.

Assemble a cleaning kit to carry with you. You need two brushes—one for glass the other for camera and lens bodies—plus lens-cleaning fluid and lens-cleaning paper.

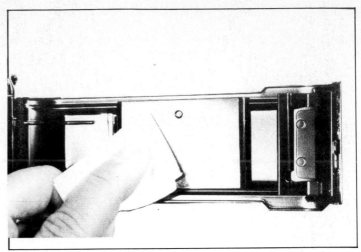

Use lens tissue or a clean soft cloth to remove dirt from pressure plate, rollers and film-guiding rails.

CLEANING THE CAMERA BODY

Use a soft cloth or brush to clean the exterior. Use a brush to clean the interior, aided by a squirt of air if needed. Occasionally, dampen a lens tissue or cotton swab with lens-cleaning fluid and clean the film-guide rails, rollers and the pressure plate on the back cover.

Do not touch the mirror. If there is dust on it, it's OK to blow it off or brush it away gently, using your lens-cleaning brush. If that doesn't work, have it cleaned by a camera repairman.

Don't touch the bottom of the focusing screen. You can blow away dust particles, or use a soft brush very gently. You can clean the top side of removable focusing screens as you would clean a lens.

Don't touch the focal-plane shutter. Don't direct a strong blast of air at it—you may blow it out of its guides.

The viewing eyepiece will get dirty more often than other optics. Blow away dirt particles. Then use a lens-cleaning tissue or cotton swab moistened with lens-cleaning fluid to gently clean the glass surface.

CLEANING LENSES

Clean the lens barrel and exterior parts with a cloth and brush.

The front and back glass surfaces should be cleaned infrequently and with great care to avoid scratching. First, blow away all dirt particles. Then, blow them away again. If the surface looks clean, stop right there. If not, use your glass-cleaning brush to gently *lift* the dirt off the surface.

If visible smears remain, moisten a piece of lens tissue with cleaning fluid, using only one or two drops. Start at the center of the lens and work to the edge with circular motions and without applying pressure to the surface.

Never apply lens-cleaning fluid directly to the surface of a lens. It may seep into the interior.

The rear element should need cleaning much less often than the front. On lenses with a movable rear element, set the lens to infinity. This moves the element to the back of the lens so it will be easier to reach.

STORING YOUR CAMERA

Store camera equipment in a clean, dry area that doesn't get hot or cold. If you will not be using the equipment for a few weeks, remove the batteries and store them separately. If you will not be using it for a few months, package the equipment in dust-proof cases or plastic bags, along with packets of desiccant to keep it dry.

REPAIR FACILITIES

Your dealer can assist you in determining if your camera needs service or repair. He can refer you to authorized repair agencies.

There are two types: Canon Factory Service Centers are part of the Canon organization, operated by Canon employees. Canon Authorized Service Facilities are independent repair shops that are qualified to work on Canon equipment.

This chapter has descriptions of current cameras and accessories. Some operational procedures not covered earlier are also included.

THE T50 CAMERA

The T50 is the simplest to operate among current Canon SLRs. All you do is focus and press the shutter button. It has programmed automatic exposure, automatic film loading and automatic film advance, using a built-in motor.

With the companion 244T or 277T flash unit, it offers automatic "focus-and-shoot" flash photography. Canon A-type or G-type flash units may also be used.

POWER SOURCE

Install two AA-size 1.5V alkaline or carbon-zinc batteries in the battery chamber, observing polarity as marked on the cover. Ni-Cd (Nicad) batteries should not be used.

LENSES

Use FD lenses. Programmed automatic exposure is possible only when the lens is set to A.

SELECTOR DIAL

The Selector Dial has four settings. At L, the camera is turned off. PROGRAM is the normal setting for programmed automatic exposure. SELF enables the self-timer. B.C. checks the batteries.

BATTERY CHECK

Rotate the Selector Dial to B.C. If battery power is sufficient, a beeper in the camera will beep rapidly.

SETTING FILM SPEED

The film speed scale is visible in a window at the back of the Rewind Knob. While depressing the adjacent Lock Release Button, move the Film-Speed Lever to set the film-speed number opposite the index mark.

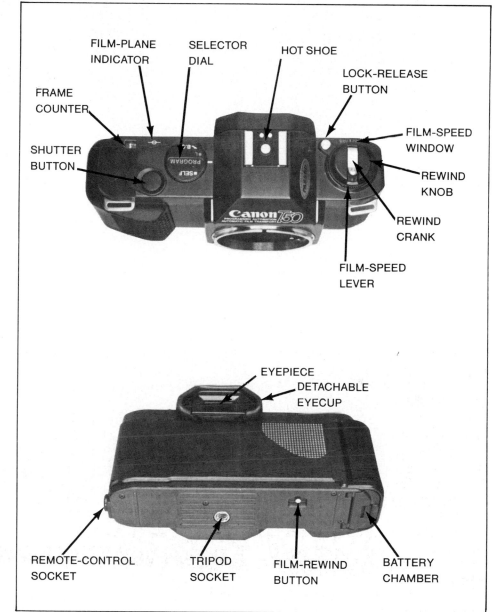

SHUTTER BUTTON

When partially depressed, the camera is turned on—if the Selector Dial is not set to L—exposure is set and the LED displays in the viewfinder operate. Depressing the button fully causes the shutter to operate.

To expose a single frame, press the button and release it immediately. If you hold it down, the camera will advance film and expose frames continuously.

LOADING FILM

After you position the end of the film leader, the camera completes the loading procedure automatically. Begin by setting film speed. Shield the film from bright light while loading it. Leave it in the factory package until you are ready to load it.

The T50 is the first of the new Canon T-series and offers simplicity of operation. It has programmed automatic exposure, automatic film loading and automatic film advance, using a built-in motor.

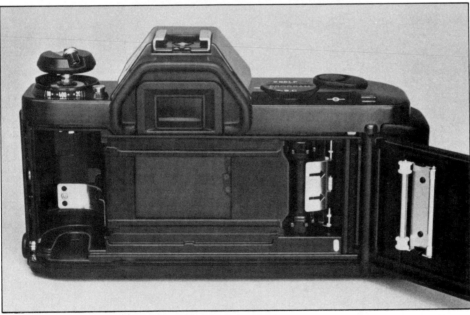

The T50 uses a vertical, metal, focal-plane shutter. At the right end of the body is the takeup spool and an automatic film-loading mechanism that seizes the film leader and winds it onto the takeup spool automatically.

Tip up the Rewind Crank and use it to pull up the Rewind Knob. This opens the back of the camera. Pull the Rewind Knob all the way up while placing the film cartridge into the chamber on the left. Press the knob down to its normal position, turning it if necessary.

Turn the Rewind Crank clockwise until some of the film is drawn back into the cartridge and the leader does not reach the takeup sprocket. Use your left thumb to rotate the film cartridge clockwise, so the film lies flat across the back of the camera. Grasp the end of the film, *without* *touching the focal-plane shutter,* and pull it to the right.

Align the film end with the orange mark at the right. Place the nearest sprocket hole over a tooth on the takeup sprocket. Close the camera back. Fold down the Rewind Crank. Turn the Selector Dial to PROGRAM.

Look at the Rewind Knob and press and release the shutter button. The built-in motor will run. If the Rewind Knob turns, the film is advancing. If not, repeat this procedure. Press the shutter button again until the frame counter is at 1. The motor stops automatically. The camera is ready to use.

EXPOSURE CONTROL

Metering is center weighted. Exposure is set when the shutter button is partially depressed—to the point where resistance is felt. The camera sets both aperture and shutter speed automatically, following a built-in program shown in the accompanying graph.

VIEWFINDER

The focusing screen has a New Split biprism surrounded by a microprism ring. At the right are LED symbols.

When loading film, draw the leader across and place the end opposite the orange mark. Then place a sprocket hole over a tooth of the takeup sprocket. Close the back and use the built-in motor to advance the film.

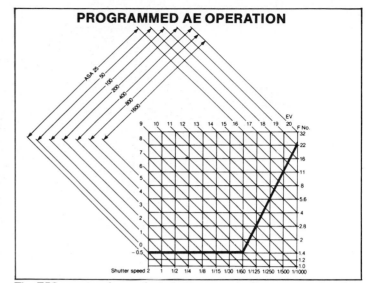

PROGRAMMED AE OPERATION

The T50 program favors fast shutter speeds. It opens aperture by two steps while increasing shutter speed by only one step.

With the lens set to **A**, the green **P** will glow steadily if exposure will be correct for an average scene. If it blinks slowly, two times per second, shutter speed will be 1/30 or slower. This suggests using a tripod or firm camera support to prevent image blur due to camera shake.

If the P symbol blinks rapidly, eight times per second, there is not enough light. Use flash, faster film, or put more light on the scene.

If the lens is not set to A, a red M symbol blinks in the viewfinder. The camera can not set exposure automatically. If an exposure is made, it will be at 1/60 and the aperture set on the lens.

SELF-TIMER

When set to **SELF**, the camera delays exposure for 10 seconds after the shutter button is pressed. Exposure is set and the timer is started when the shutter button is depressed.

If your eye is not at the viewfinder when you press the shutter button, cover it with your hand to avoid incorrect exposure due to light entering through the eyepiece. Don't stand in front of the camera when you start the self-timer.

During timer operation, the camera beeps slowly for eight seconds, then rapidly for the last two seconds. During countdown, the self-timer can be turned off by rotating the Selector Dial to **PROGRAM** or **L**.

SHOOTING CONTINUOUSLY

Holding the shutter button down exposes frames continuously, at rates up to 1.4 frames per second. Long exposure times cause slower rates. The viewfinder display does not operate after the first exposure, but exposure is set automatically for each frame.

END OF FILM

When the last frame has been exposed, the motor stops. The beeper sounds rapidly for four seconds. Depress the Film-Rewind Button. Turn the Rewind Crank clockwise to rewind the film.

REMOTE CONTROL

Use Remote Switch 60 T3. It has a 60 cm cable that is plugged into the T50 Remote Control Socket. Extension Cord 1000 T3 adds another 1000 cm. When the Remote Switch is connected, the camera shutter button still operates, so you can use either one.

The viewfinder display uses only three symbols. M indicates that the lens is not set to A. P indicates programmed automatic. The "lightning" symbol is used with flash.

HIGH MAGNIFICATION AND MACRO PHOTOGRAPHY

Close-up lenses can be used. Only automatic extension devices can be used between lens and camera—FD-type extension tubes.

FLASH

If the light is too dim for correct exposure without flash, the P symbol in the viewfinder blinks rapidly. Canon A-type, G-type or T-type flash can be used in the hot shoe. There is no camera-body sync connector. To use flash, set the T50 Selector Dial to **PROGRAM** or **SELF** and the lens to A.

T50 SPECIFICATIONS

Type: 35mm SLR with programmed automatic exposure, automatic film loading and film advance.

Usable Lenses: FD series only.

Viewfinder Image: 92% vertical and 93% horizontal coverage of frame. 0.87 magnification with 50mm lens.

Viewfinder Information: New Split biprism and microprism focusing aids. LED indicators at right of frame.

Selector Dial: Settings for programmed automatic, self-timer, battery check and off.

Metering: Center-weighted with silicon cell. EV 1 to EV 18 with f-1.4 and ASA 100. Stopped-down metering not possible.

Focal-Plane Shutter: 1/1000 to 2 seconds, stepless. Vertical travel. Electronically controlled.

Film-Speed Range: ISO 25 to 1600.

Shutter Button: Two stage. First stage turns on electronics. Second stage operates shutter.

Self-Timer: Electronic with beeper. Ten-secon delay.

Flash: X-sync at 1/60. Hot shoe only. Uses Canon A-type, G-type and dedicated T-type flash.

Remote Control: Remote Switch 60 T3 with optional Extension Cord 1000 T3. Uses Wireless Controller LC-1 or Interval Timer TM-1 Quartz with Remote Switch Adapter T3.

Batteries: Two AA-size, 1.5V, alkaline or carbon zinc. Ni-Cd cannot be used.

Dimensions: Body only: 150.2mm x 87mm x 48.4mm. (5-15/16" x 1-15/16").

Weight: Body only: 490g (1.09lbs).

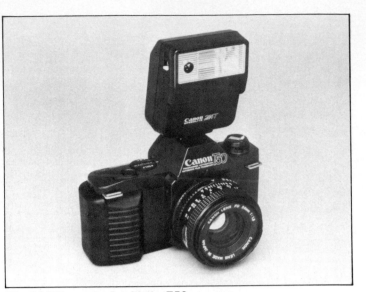

The 244T is used only with the T50.

244T FLASH SPECIFICATIONS

Type: Energy-saving, light-sensing automatic. Used with T50 only. Produces dark-red preflash used to set f-2.8, f-4 to f-5.6 automatically on T50 lens.

Guide Number: 16 meters at ISO 100 with full charge.

Film Speeds: 100 or 400 only.

Coverage: 35mm lens angle of view.

Range: With ISO 100, 0.5 to 5.7m (1.6 to 18.7 ft). With ISO 400, 1 to 11.4m (3.3 to 37.4 ft).

Warning Signal: Flashes P symbol in viewfinder if subject too far away. No warning for subject too close.

Flash-Sync Connector: Hot shoe only.

Power: Two AA-size, 1.5V alkaline or Ni-Cd batteries.

Dimensions: 63 x 86 x 41.5mm (2-1/2" x 3-3/8" x 1-5/8").

Weight: 140g (4-15/16oz) without batteries.

LENSES THAT CANNOT BE USED WITH T50

FL lenses	TX 35mm f-2.8
Fisheye 7.5mm f-3.6	Reflex 500mm f-8
Macrophoto 20mm f-3	Macrophoto 20mm f-3

MAJOR ACCESSORIES

The T50 can use most Canon FD lenses, accessories on the front of the lens, automatic extension tubes, accessories on the viewfinder eyepiece, Remote Switch 60 T3, and Wireless Controller LC-1 or Interval Timer TM-1 connected through Remote Switch Adapter T3.

WITH A-TYPE OR G-TYPE FLASH

Set film speed on the flash and choose one of the *automatic* settings of the flash Aperture Selector. Turn the flash on. When the flash is charged, the "lightning" symbol glows in the viewfinder. The flash automatically sets shutter speed to 1/60 and lens aperture to the correct value. Focus and shoot.

THE 244T FLASH

The 244T is a light-sensing automatic flash for the T50. It sets shutter speed and aperture automatically. Set film speed on the flash. Only ISO 100 or ISO 400 can be used. Turn the flash on. When the flash is charged, the "lightning" symbol glows in the viewfinder and shutter speed is automatically set to 1/60.

Press the shutter button partway. This causes the flash to emit a dark-red burst of light, which is reflected from the subject and sensed by the flash. The flash sets the lens aperture to f-2.8, f-4 or f-5.6.

In dim light, if the subject is too far away, the P symbol blinks rapidly. Remove your finger from the shutter button, move closer, and try again.

When the P symbol does not

blink, the subject is not too far. It may be too close—see the specification table. If the subject is within range, focus and shoot. Wait for the charge indication before exposing the next frame.

THE T70 CAMERA

The T70 is a multimode, programmed automatic camera with built-in motor drive. It has eight exposure modes, plus *Bulb,* three automatic exposure programs, and two metering patterns.

Film loading is automatic. The film is automatically advanced to the first frame, automatically advanced after each exposure, and automatically rewound. By holding down the shutter button, a continuous sequence of exposures can be made.

There is no manual film-advance lever or film-rewind crank. The camera is operated by pushbuttons, rather than knobs and dials and relies on advanced built-in electronics.

Flash exposure is fully automatic with T-type flash units such as the 277T and other Canon automatic flash units.

The accessory Command Back 70 can be used to print data on each frame, for unmanned photography, and as a timer for very long exposures.

DISPLAYS

Operating data and camera settings are shown by two electronic displays—an LED display in the viewfinder and an LCD display panel on top of the camera.

POWER SOURCE

Install two AA-size 1.5V batteries in the battery compartment on the bottom of the camera, observing polarity as marked on the underside of the cover. Alkaline batteries are standard but NiCad or ordinary carbon-zinc cells can also be used.

BACKUP BATTERY

A built-in lithium battery prevents the camera from "forgetting" current settings—such as mode, frame count and film speed—while the main AA batteries are being replaced. The backup battery has an expected life of 5 years and can be replaced at any Canon service facility.

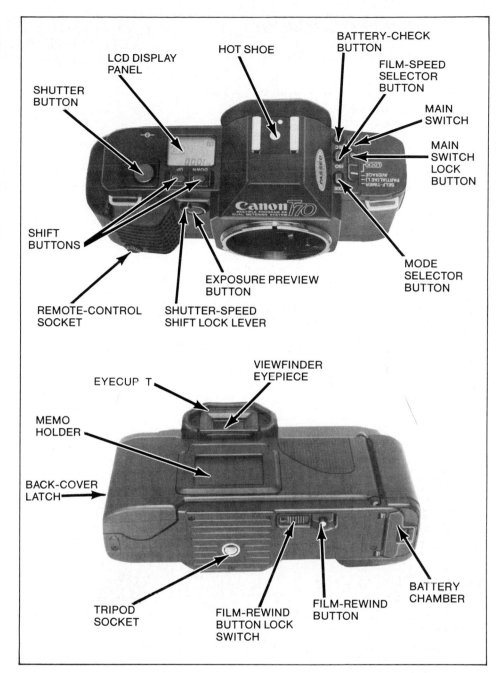

LENSES

Canon FD lenses provide full-aperture metering. Non-FD lenses may also be used, but only with stop-down metering.

MAIN SWITCH

The Main Switch has four settings. Depress the lock button in the center of the switch and slide it to the desired setting.

At the **LOCK** setting, the camera is turned off and cannot be operated. The **AVERAGE** setting selects center-weighted averaging metering.

The PARTIAL(AEL) setting is used for selective-area metering. Metering is in the visible circle at the center of the focusing screen, which contains 11% of the image area. The (AEL) symbol indicates that the automatic exposure setting may be locked by pressing the Shutter Button partway or holding in the Exposure Preview Button.

The SELF-TIMER position sets the camera self-timer for a ten-second countdown after the shutter button is pressed.

SHUTTER BUTTON

Depressing the Shutter Button partway, until slight resistance is felt, turns on the camera metering system and the displays. Depressing it fully makes an exposure. When the shutter closes, the built-in motor automatically advances film to the next frame.

To make a single exposure, remove your finger from the Shutter Button as soon as the shutter operates.

EXPOSURE PREVIEW BUTTON

Depressing the Exposure Preview Button, on the front of the camera, also turns on the exposure meter and the displays. This button cannot be used to make an exposure.

SHIFT BUTTONS

Two Shift Buttons are above the LCD display panel on the right side of the camera top surface. One is labeled DOWN, the other UP. They are used for several purposes, including setting film speed, selecting the exposure mode and changing shutter speed.

BATTERY CHECK

With the camera turned on, press the BC button, to the right of the Main Switch. This tests the two AA-size batteries in the bat-

SHOOTING CAPACITY WITH FRESH BATTERIES in 36/24 exposure rolls			
TEMPERATURE	ALKALINE	CARBON-ZINC	NICAD
68F (20C)	40/60	13/20	20/30
14F (–10C)	4/7	0 to 1	10/15

tery compartment. The LCD panel will show three or two horizontal lines if battery power is sufficient. Discharged batteries are indicated by one blinking horizontal line or no display at all.

Because NiCad batteries have lower voltage than the other types, the above procedure may indicate that NiCad cells are discharged even when they are fully charged. With any type of battery, you may continue to use the camera as long as the shutter operates and exposure will be correct. When the shutter no longer operates, the batteries must be replaced.

The built-in lithium backup battery is not tested by this procedure. After approximately five years of use, the symbol ISO 100 will blink in the LCD display panel to indicate that the backup battery should be replaced.

The camera will not operate with completely discharged AA-size batteries. It will operate when the backup battery is discharged.

LOADING FILM

Turn off the camera. Open the back cover by holding in the Back Cover Latch Safety Lock Button while sliding the Back Cover Latch downward.

Hold the cartridge of film to be loaded in your left hand. With your right hand, turn the projection at the bottom counterclockwise until a small amount of film has been drawn into the cartridge.

Move the cartridge upward while sliding it into the compartment, so the round hole in the top of the film cartridge fits over the projecting fork in the top of the film compartment.

A film-cartridge symbol will appear in the panel display to show that film is in the camera, even if

the camera is turned off.

With your left thumb, rotate the film cartridge to the right, as far as it will go, so the film leader lies flat across the back of the camera. Pull the end of the film across the camera so the end aligns with the orange mark near the back-cover hinge. Be careful not to touch the focal-plane shutter.

Make certain that the film lies flat across the camera and the perforations in the film leader fit over the lower sprocket teeth on the right side of the camera. Close the camera back.

While watching the LCD display panel, turn on the camera. The motor will operate to advance film automatically to the first frame. *If film is loaded correctly and being advanced,* three horizontal lines will appear in sequence on the panel display. The lines begin at the film cartridge symbol and move from left to right, indicating that film is moving across the camera. Be sure to observe this indicator. It is the only way to know for sure that film is loaded correctly and the automatic film-advance mechanism is working.

While film is being advanced, the ASA/ISO film-speed setting of

the camera is displayed in the panel, so you can see what it is. When film has been advanced to frame 1, the number 1 appears in the frame-counter rectangle in the display panel. The film-speed setting is no longer displayed. The exposure mode setting is displayed, along with the "film-in-camera" symbol and the frame counter.

Permanent Displays—With the Main Switch turned off, the "film-in-camera" display and the frame counter appear in the display panel.

SETTING FILM SPEED

With the T70 turned on, pressing the ISO button near the Main Switch changes the panel display to show a film-speed number and an ISO symbol. The film-speed number is the first value of the ISO designation, which is the same as the ASA film-speed rating.

If the setting is not correct for the film that is loaded, hold down the ISO button while pressing one of the Shift Buttons above the display panel. Pressing the **UP** button changes to higher film speeds. Pressing the **DOWN** button selects lower film speeds.

Film-Speed Range—Film speeds may be set from ASA 12 to 1600 in standard steps.

MODE SELECTION

Available exposure modes are shown in the accompanying table. With the camera turned on, the operating mode is selected by holding down the **MODE** button adjacent to the Main Switch while pressing either of the Shift Buttons above the LCD display panel. The LCD display cycles through the available mode settings until the Shift Button is released. The selected mode is displayed in the

T70 EXPOSURE MODES	
MODE	**CAMERA OPERATION**
Program	Camera sets both shutter speed and aperture using the standard program.
Wide Program	To get increased depth of field with wide-angle lenses, a smaller aperture is used than the standard program provides, with correspondingly slower shutter speed.
Tele Program	To minimize image blur with telephoto or other lenses, a faster shutter speed is used than the standard program provides, with correspondingly larger lens aperture.
Shutter-Priority AE	You set shutter speed, the camera sets aperture automatically. Used to stop subject motion or deliberately blur the image. An automatic *Safety Shift* will change shutter speed to give correct exposure if necessary.
Stopped-Down AE	Automatic exposure with non-FD lenses and non-automatic macro equipment. Indicated by aperture symbol on display panel.
Manual	You set both shutter speed and aperture. Camera exposure meter displays recommended aperture for set shutter speed with over- and under-exposure warnings.
Bulb	Shutter remains open as long as you hold shutter button down. LCD display panel serves as reference timer, counting to 120 seconds.
Programmed Flash	With a T-type flash unit, subject distance is measured by the flash, aperture and shutter speed are set automatically. Focus and shoot.
Automatic Flash AE	With the 277T, the F.NO. SET option allows selecting any aperture from *f*-2 to *f*-22 by a control on the flash with automatic exposure at that aperture setting. Other Canon flash units have a similar mode.

LCD panel by mode symbols shown in the accompanying table.

If the Shutter Button is pressed partway, or the Exposure Preview Button is pressed, the panel display also shows the shutter speed to be used.

METERING PATTERNS

Two of the four settings of the Main Switch select metering patterns and also turn the camera on. Either of the two metering patterns can be used with any mode selection.

Center-Weighted Averaging— The usual Main Switch setting is AVERAGE, which selects the center-weighted averaging pattern shown in the accompanying drawing.

This pattern should be used to photograph average scenes, such as landscapes.

Selective-Area Metering—When the Main Switch is set to PARTIAL(AEL), metering is mainly in the circle at the center of the frame, as shown in the accompanying drawing. The circle is usually visible and includes 11% of the image area.

When this metering pattern is being used, the metered exposure setting can be locked by pressing the Shutter Button partway or by pressing the Exposure Preview Button on the front of the camera.

If the subject is unusually light or dark, additional exposure adjustment may be necessary. This can be done by temporarily changing the film-speed setting or by substitute metering as discussed in Chapter 12.

VIEWFINDER

The focusing aids are a New Split biprism surrounded by a microprism ring. Surrounding the focusing aids is a circle that shows the metering area used for selective-area metering. At the right of the image area is an LED display.

VIEWFINDER DISPLAY

All of the symbols used in the LED viewfinder display are shown

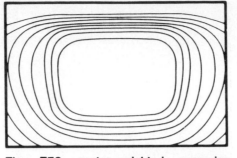

The T70 center-weighted averaging metering pattern has maximum sensitivity in the central area of the frame. Sensitivity diminishes toward the edges. The pattern is not symmetrical. It takes more of the reading from the lower part of the frame than from the top. Minimum sensitivity is at the top, which is often sky. If the camera is rotated to shoot a vertical frame, minimum sensitivity will be at the side.

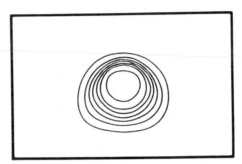

The T70 selective-area metering pattern has maximum sensitivity in a circular area at the center of the frame. The circle is visible in the viewfinder. There is some sensitivity below the circle, but none at the edges of the frame.

Viewfinder LED displays are at the right, outside the image area.

in the accompanying drawing although not all are used simultaneously. The brightness of the LED symbols is changed automatically, according to the scene brightness.

The red M symbol blinks when the camera is in the Manual mode. The green P symbol glows when any of the three programmed automatic modes has been selected. If shutter speed is slow enough that camera shake may blur the photo, the P symbol blinks.

The red asterisk glows when selective-area metering is being used. The green "lightning" symbol glows when a Canon flash is being used and the flash is charged, ready to fire.

The red numerals at the bottom normally show the f-number that will be used to make the exposure. In the shutter-priority automatic mode, it shows shutter speed. In the manual mode, it shows the *recommended* aperture for the set shutter speed, but you can *use* any aperture setting.

Locked Exposure—The only way to turn on the viewfinder and panel displays is to depress the Shutter Button partway or depress the Exposure Preview Button. If selective-area metering is in use, pressing either button locks the exposure settings. If you point the camera at areas of different brightness in the scene, the exposure and the display readings cannot change unless you release the Shutter Button or Exposure Preview Button momentarily to allow the values to change.

AUTOMATIC EXPOSURE PROGRAMS

Any of the three programmed automatic modes may be selected by depressing the MODE button while pressing either of the Shift Buttons. The selected mode is shown in the LCD display panel.

The three programs are shown in Figure 18-1, along with a graph of the Safety Shift function used with Shutter-Priority automatic exposure, discussed later.

These programs provide correct exposure from EV 1 to EV 19 with ASA 100 film and a lens with an aperture range of *f*-1.4 to *f*-22. The brightest scene that can be correctly exposed causes the aperture to be set at *f*-22 and a shutter speed of 1/1000 second.

Standard Program—If the scene becomes less bright, and the standard PROGRAM mode has been selected, aperture opens gradually to *f*-16 while shutter speed remains at 1/1000. If the scene becomes still darker, the program changes both aperture and shutter speed in equal amounts—one step larger aperture and one step slower shutter speed.

When maximum aperture has been reached, *f*-1.4 in this example, shutter speed continues to change with decreasing scene brightness until the slowest shutter speed is reached. Scenes darker than that cannot be correctly exposed.

Tele Program—To minimize the chance of image blur, the tele program uses faster shutter speeds with correspondingly larger aperture settings.

Wide Program—For increased depth of field, the wide program uses smaller aperture settings with correspondingly slower shutter speeds.

USING THE PROGRAMMED EXPOSURE MODES

Use an FD lens set to A. Use the Main Switch to select one of the two metering patterns. Hold down the **MODE** button while pressing either of the Shift Buttons to select PROGRAM, PROGRAM WIDE, or PROGRAM TELE. The selected mode will appear in the LCD display panel. Focus and compose the scene.

Depress the Shutter Button partway or depress the Exposure Preview Button. The P symbol glows in the viewfinder to indicate that you are using one of the programmed modes. The red numeral at the bottom of the viewfinder display is the aperture that will be

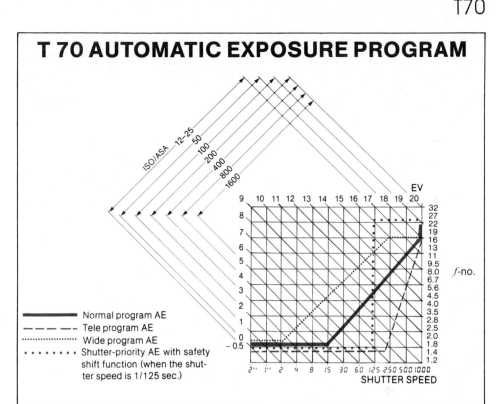

T 70 AUTOMATIC EXPOSURE PROGRAM

—— Normal program AE
– – – – Tele program AE
· · · · · Wide program AE
· · · · · · · Shutter-priority AE with safety shift function (when the shutter speed is 1/125 sec.)

Figure 18-1/This graph shows the three exposure programs and the Safety Shift function used in the shutter-priority automatic mode. These curves are for a 50mm *f*-1.4 lens. The operating range (meter-coupling range) varies with film speed. The programs will be different for a lens with different maximum or minimum aperture, but the idea is the same.

used. To see shutter speed, hold the camera pointed at the scene and look at the display panel on top of the camera. The number at the top of the panel is shutter speed.

Overexposure Warning—In the viewfinder display, if the *f*-number blinks, overexposure may be indicated. If the blinking *f*-number represents a smaller aperture than the minimum aperture of the lens, overexposure is indicated.

When the f-number in the viewfinder blinks, the fastest shutter speed also blinks in the LCD display panel.

Underexposure Warning—If the scene is too dark, the P symbol in the viewfinder blinks slowly. The maximum aperture of the lens is

displayed in the viewfinder, blinking rapidly. The slowest shutter speed—two seconds—is displayed in the LCD display panel, blinking slowly.

Camera-Shake Warning—The P symbol in the viewfinder display blinks slowly to suggest the selected shutter speed may be too slow

MODE	CAMERA-SHAKE WARNING
Tele Program	1/125 second or slower
Standard Program	1/60 second or slower
Wide Program	1/30 second or slower

to handhold the camera. The shutter speed that causes this warning depends on which of the programmed modes has been selected:

USING THE SHUTTER-PRIORITY AE MODE

You set shutter speed. The camera sets aperture for correct exposure of an average scene.

When this mode is first

selected, shutter speed is set automatically to 1/125 second. You can change it to whatever you wish.

Set the FD lens to A. Use the Main Switch to select either of the metering patterns. Hold down the MODE button while pressing either of the Shift Buttons until the Tv (Time Value) symbol appears at top left in the LCD display panel. When you release the MODE button, the display panel will show a shutter speed of 1/125 second. Shutter speed may be changed by pressing either of the Shift Buttons. Pressing the UP button shifts to faster speeds. Pressing DOWN selects slower speeds.

Focus and compose the scene. To see the displays, press the Shutter Button partway or press the Exposure Preview Button. The aperture to be used at the set shutter speed appears at the bottom of the viewfinder display. If you prefer not to use that aperture, change shutter speed. Aperture will change accordingly.

The Safety Shift Function—In bright light, it is possible to set a shutter speed such that correct exposure cannot be made even at minimum aperture. If that happens, shutter speed is automatically increased (shifted) to provide correct exposure at minimum aperture, if possible.

The Safety-Shift function is shown on the graph of Figure 18-1 for a shutter-speed setting of 1/125. At EV 16, the exposure settings are f-22 and 1/125. If the scene becomes brighter, shutter speed is gradually increased up to the fastest possible speed of 1/1000. If the scene is still brighter, correct exposure cannot be made.

Similarly, in dim light, it is possible to select a shutter speed such that correct exposure cannot be made even at maximum aperture. Shutter speed is automatically shifted to slower values until the slowest possible speed is reached, using the maximum aperture of the lens. If the scene is still darker, correct exposure cannot be made.

Overexposure Warnings—Two levels of warning may be indicated. One shows that the Safety Shift function is operating. The other shows that correct exposure cannot be made, even with Safety Shift.

The shutter speed to be used is shown in the LCD display panel. As scene brightness increases, the aperture shown in the viewfinder display becomes smaller until minimum aperture is reached.

If the scene becomes still brighter, the minimum-aperture f-number in the viewfinder flashes slowly to warn that the Safety Shift function has operated to increase shutter speed. Correct exposure of an average scene should result. When the Safety Shift function operates, the displayed shutter speed changes in the LCD display panel.

If the scene becomes still brighter, overexposure may be indicated by a *rapidly* flashing f-number in the viewfinder that represents a smaller aperture than the minimum aperture of the lens. In this condition, the LCD display panel shows maximum shutter speed, with the number blinking.

Underexposure Warnings—Two levels of warning may be indicated. One shows that the Safety Shift function is operating. The other shows that correct exposure cannot be made, even with Safety Shift.

The shutter speed to be used is shown in the LCD display panel. As scene brightness decreases, the aperture shown in the viewfinder display becomes larger until maximum aperture is reached.

If the scene becomes still darker, the maximum-aperture f-number in the viewfinder flashes slowly to warn that the Safety Shift function has operated to decrease shutter speed. Correct exposure of an average scene should result. When the Safety Shift function operates, the displayed shutter speed changes in the LCD display panel.

If the scene becomes still darker, overexposure is indicated by a *rapid* flashing of the f-number representing maximum aperture in the viewfinder. In this condition, the LCD display panel shows the slowest shutter speed, with the number blinking.

USING THE MANUAL MODE

You set both aperture and shutter speed, using the viewfinder exposure display as a guide. The Safety Shift function does not operate in this mode.

Set the camera to Shutter-Priority automatic as described in the preceding section. Turn the FD lens aperture ring away from the A setting to any f-number engraved on the ring. An M symbol will appear in the lower left corner of the LCD display panel.

Focus and compose the scene. Press the Shutter Button partway or press the Exposure Preview Button to turn on the viewfinder display. The red M symbol blinks to indicate that the camera is on manual. An f-number appears at the bottom of the display. This is the "recommended" aperture setting for correct exposure of an average scene at the set shutter speed.

Warnings—Underexposure and overexposure warnings in this mode are the same as in the shutter-priority mode. However, the warnings assume that the lens is set to the f-number shown in the viewfinder display.

USING THE STOPPED-DOWN AE MODE

You set aperture. The camera sets exposure automatically by choosing a shutter speed for correct exposure of an average scene. This mode is necessary when using non-FD lenses such as reflex lenses or FL lenses. It is necessary when using non-automatic close-up or macro accessories, such as Bellows FL. It cannot be used with an FD lens mounted directly on the camera.

T70 SPECIFICATIONS

Type: 35mm SLR with three programmed and a total of 8 exposure modes, automatic film loading, film advance and rewind by built-in motor.

Usable Lenses: Canon FD and most other Canon lenses with stop-down metering.

Viewfinder Image: Vertical and horizontal coverage of the frame is 92%. Magnification at infinity with a 50mm lens is 0.85. Eyepiece is -1 diopter. Dioptric adjustment lenses available.

Viewfinder Information: New split biprism and microprism focusing aids. Visible circle shows selective-area metering zone. LED indicators at right are M for manual mode, P for program mode, ˙ symbol for selective-area metering, flash-charge indicator, and numerals for aperture or shutter speed. Symbols also used for exposure warnings.

LCD Display Panel: This display is on top of camera and supplements viewfinder display. Shows mode, shutter speed, film speed, frame counter, self-timer countdown, reference timer for bulb exposures, battery check, and other information.

Metering: Full-aperture, center-weighted or selective-area. Selective-area uses 11% circular area in center of frame. Silicon photocell in viewfinder. EV 1 to EV 19 with f-1.4 and ASA 100. Stopped-down metering possible.

Focal-Plane Shutter: Metal, vertical travel, 1/1000 to 2 seconds, stepless on automatic. Electronically controlled. Film-Speed Range is ISO 12 to 1600.

Shutter Button: Two stage. First stage turns on electronic systems. Second stage operates shutter.

Self Timer: Electronic with beeper and countdown shown in display panel. Ten-second delay.

Flash: X-sync at 1/90 second. Hot shoe only. Uses Canon T-type, A-type and G-type flash units.

Remote Control: Uses Remote Switch 60 T3, Wireless Controller LC-1 or Interval Timer TM-1 with Remote Switch Adapter T3.

Batteries: Two AA-size alkaline, carbon-zinc or NiCad. Built-in lithium backup battery with five-year life.

Back Cover: Removable for accessory Command Back 70. Has safety latch and memo holder.

Dimensions: Body only—151mm x 89.2mm x 48.4mm (5-15/16 x 3-1/2 x 1-7/8 inches).

Weight: Body only—530g (1.12 lbs).

Use the Main Switch to select one of the metering patterns. While holding down the **MODE** button, press either of the Shift Buttons until an aperture symbol appears near the top left corner of the LCD display panel.

Compose and focus. Set the desired aperture on the lens. Press the Shutter Button partway or press the Exposure Preview Button to turn on the displays. The camera-selected shutter speed is shown in the LCD panel display.

Because the numerals at the bottom of the viewfinder display are normally used to display f-numbers, there are only two digits. Therefore, all shutter speeds cannot be displayed as they are on the LCD display panel.

If the shutter speed is 1/90 second or slower, it is indicated by two numerals in the viewfinder. If the shutter speed is faster than 1/90 second, it is indicated by two letters which define a range of shutter speeds. Because these speeds are all higher than 1/90, you can think of them as *high* speeds. There are two ranges. H.L designates the Low end of the High range: 1/125 through 1/350. H.H designates the High end of the High range: 1/500 to 1/1000.

Warnings—Overexposure is indicated by a blinking H.H symbol in the viewfinder and blinking **1000** in the panel display. Underexposure is indicated by a blinking 2" in both displays.

USING THE BULB SETTING

At this setting, the shutter will remain open as long as you depress the Shutter Button.

Set the camera for manual operation as described earlier. Press the **DOWN** Shift Button until the word **bulb** appears in the LCD display panel. This is the next step "slower" than two seconds.

Set lens aperture manually. Press the Shutter Button for the desired exposure time.

Reference Timer—When the shutter opens, the three horizontal bars extending from the film-cartridge symbol disappear from the display panel. They are used to assist in timing exposures up to two minutes.

A 30-second timer appears in the area of the display panel normally used to display the frame counter. It counts from 1 to 30. Then, one of the three horizontal bars appears, indicating that 30 seconds have passed. The 30-second timer starts over again at 1 second. Two bars indicate that 60 seconds have passed. When all three bars appear and the 30-second timer reaches 30, a total of 120 seconds have elapsed.

SHUTTER-SPEED SHIFT LOCK LEVER

This control is a ring surrounding the Exposure Preview Button. When the ring is rotated so the L symbol on the ring aligns with the dot on the camera body, shutter speed cannot be changed by depressing the Shift Buttons.

This is to prevent changing shutter speed by accident in the shutter-priority automatic, manual and stop-down AE modes.

SELF TIMER

Moving the Main Switch to the SELF-TIMER position sets the timer for a 10-second countdown. When the Shutter Button is pressed, exposure is metered at that instant using the center-weighted averaging pattern. Exposure is locked at that value and the timer starts counting.

To avoid incorrect exposure, be sure your eye is at the viewfinder when you press the shutter button or cover the viewfinder eyepiece with the Eyepiece Cover. The cover clips into the shoulder pad of the carrying strap when not in use.

Because exposure is locked when the Shutter Button is pressed, be sure the camera is viewing the scene to be photographed.

The camera beeps slowly for the first eight seconds, then beeps rapidly for the last two seconds. Countdown is displayed in the LCD display panel, in the area normally used for the frame counter.

To Cancel—To stop and reset the timer, press the battery-check button. To stop and cancel the self-timer selection, move the Main Switch away from the SELF-TIMER setting.

SEQUENTIAL EXPOSURES

If you hold down the Shutter Button, the camera will make a sequence of exposures at approximately one per second, advancing the film automatically after each exposure.

When center-weighted averaging is being used, exposure settings will change from frame to frame if scene brightness changes. When using selective-area metering, exposure is locked by depressing the shutter button. Exposure settings will not change from frame to frame if scene brightness changes.

END OF ROLL SIGNAL

When the last frame has been exposed, the camera beeps rapidly for about four seconds. On the display panel, the frame-counter number and the three horizontal lines representing film blink rapidly.

REWINDING FILM

To rewind, slide the Rewind Button Unlock switch toward the Rewind Button and hold it in that position while depressing the Rewind Button until it locks. During rewind, the frame counter counts backward and the horizontal bars representing film move in sequence from right to left, to simulate rewinding. The built-in motor rewinds the film fully into the cartridge.

When rewind is complete, the motor stops and the film-cartridge symbol blinks in the display panel. Open the back cover and remove the film. The camera is ready for reloading.

The mirror may remain up after rewinding. If that happens, slide the Rewind Button Unlock switch toward the Rewind Button and hold it in that position while depressing the Rewind Button again. The mirror should return to its normal position.

DEPTH OF FIELD

The T70 does not have a depth-of-field preview button.

REMOTE CONTROL

Use Remote Switch 60 T3 by attaching it to the Remote Control Socket on the camera. This is a switch at the far end of a 60 cm cable. Extension Cord 1000 T3 may be used to add another 10 meters. When the Remote Switch is connected, the camera Shutter Button can also be used.

FLASH

Canon T-type, A-type or G-type flash units can be used. There is no camera-body sync connector. The 277T and 299T have more dedicated features with the T70 than other flash models. See the descriptions, later in this chapter.

X-Sync Shutter Speed—The X-sync shutter speed is 1/90 second. The camera is automatically set to it by a Canon dedicated flash when the flash is turned on, charged, and ready to fire. Flash charge indication is the lightning symbol in the viewfinder display.

MAJOR ACCESSORIES

The T70 uses Canon FD and most other Canon lenses, lens accessories, close-up and macro accessories, viewfinder-eyepiece accessories, including S-type Dioptric Adjustment Lenses, Command Back 70, Canon flash units, Remote Switch 60 T3, Wireless Controller LC-1 and Interval Timer TM-1 connected through Remote Switch Adapter T3.

LENS RESTRICTIONS WITH THE T70

LENS	COMMENT
FL 19mm f-3.5	Cannot be mounted
FL 58mm f-1.2	Cannot be mounted
FL 19mm f-3.5 Retrofocus	Camera metering inoperative. Use separate accessory meter.
FL 50mm f-1.8	Camera metering inoperative. Use separate accessory meter.
FL 35mm f-2.5	Camera metering inoperative. Use separate accessory meter.

COMMAND BACKS 70 AND 80

Command Back 70 replaces the standard back cover of the T70. Command Back 80 is used with the T80. There are only minor differences between the two. The command back can be set to imprint date, time or other data on the lower right corner of the film frame.

It can also be used as a timer for intervals up to 23 hours, 59 minutes and 59 seconds. The timer function can be used as long-duration self-timer to make a single exposure after a preset time interval. It can be used as an interval timer to make a series of exposures with a preset delay between the exposures. It can also be used as an exposure timer on bulb to close the shutter after a very long exposure.

The imprinting and timer functions can be used simultaneously.

INSTALLATION

To install the Command Back, first remove the standard back cover from the camera. Press down on the hinge-release pin, shown in the accompanying photo, and tip the back out of the camera. Install the Command Back by reversing the procedure.

BATTERY

Power is supplied by a 3-volt lithium battery behind a cover on the inside of the Command Back. Battery life is about 4 years.

CONTROLS

The controls are pushbuttons behind a cover on the Command Back, shown in the accompanying photo. To use the buttons, fold down the cover. Functions are set by pressing the buttons and referring to a LCD display panel on the Command Back in a way similar to setting functions on a digital wristwatch.

FUNCTIONS

The Command Back has a data imprinting function with several modes and a timer function with several modes. Because the timer function may control operation of

Command Backs 70 and 80 can be used to imprint several kinds of data on the lower right corner of the film frame. They can also be used as timers for a variety of purposes.

To remove the standard back cover, press downward on the projecting hinge-release pin near the top of the back-cover hinge (arrow). Tip the cover outward, and lift it out of the camera. Install a Command Back by reversing the procedure. Be sure film is not loaded when interchanging camera backs.

the camera, it is also referred to as the *command* function—which is why this accessory is called the Command Back. The two functions can be used simultaneously.

COMMAND BACK DISPLAY PANEL

The display panel on the Command Back uses the symbols shown in the accompanying drawing. They are not all used simultaneously. When you are setting the controls on the Command Back, the display panel is used as a guide. When data is being imprinted on the film, the panel shows what is being imprinted.

The low-battery indicator is independent of the rest of the display. If it appears, the battery in the back should be replaced.

If data is being imprinted on the film, the exposure confirmation indicator at top right is visible for a second or two after each exposure to confirm that the data was actually recorded.

Function Indicator—The triangular function indicator can be at only one of five locations: at lower left or at one of the four locations shown along the top of the panel. This indicator is used when *setting* the Command Back. It shows the function that can be set, using the pushbuttons.

The position of the function indicator is interpreted by reference to markings on the Command Back, adjacent to the display panel. You can see the markings in the photo at the beginning of this discussion.

If the function indicator is at lower left, any mode of the DATA imprinting function can be set. Selecting which mode to set is discussed later.

If the function indicator is in one of the four positions at the top, that mode of the TIMER function can be set. In the photo, the indicator shows that the FRAMES mode can be set.

SETTING FILM SPEED

When no other function is being set, film speed can be set by pressing the ISO button. Only three settings are possible—25, 100 and 400. What this setting actually does is control the brightness of the exposure lamp in the Command Back. At the 400-speed setting, the amount of exposure on film is less than at the 25-speed setting. Set film speed on the Command Back to the value closest to the actual film speed being used.

For best visibility of imprinted data, arrange the scene so the lower right corner in the picture will be relatively dark.

SETTING DATA MODES

To set the Command Back to imprint data, press the FUNCT button to place the triangular function indicator at lower left in the display panel, pointing to the adjacent DATA symbol. Pressing the MODE button will then select modes of the data function.

Off—A good reference point is the OFF setting, which means that no data will be imprinted. Press the MODE button repeatedly until OFF appears in the display panel.

Year, Month, Day—Pressing MODE again switches the mode and the display to Year, Month, Day, such as '84 12 31. The year numerals are preceded by an apostrophe. Three orders are

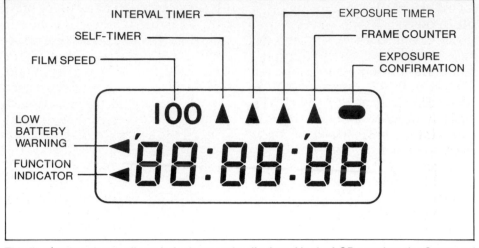

This illustration shows all symbols that may be displayed in the LCD panel on the Command Back. Not all are used simultaneously. The numerals represented by the 8 may be replaced by letters.

available: Y M D, D M Y, and M D Y. You can usually tell which order is being used by the numbers displayed. To change the order, hold down the SET button while pressing the MODE button.

When the order is as desired, you can change the values in three steps. Press the SELECT button. The year value will blink, no matter where it is in the order of the display. To change the year, press the SET button. If the year is not to be changed, just press SELECT again. The month value will blink. Change it, if desired, by pressing SET. When the month value is correct, press SELECT again and set the date. End the operation by pressing SELECT again. The display stops blinking. It shows what will be imprinted on the film at the next exposure—provided you do not change the mode setting.

Automatic Update—The Command Back has a built-in electronic calendar and clock. As time passes, the display is automatically updated so it shows the correct date. If time is being displayed, it is always correct, once set.

Resetting to Standard Values—In each mode, there are standard values for each quantity being

displayed, such as 0 or 1. When you are setting any value, pressing the button labeled START STOP-C resets to the standard value for that item. This is referred to as Clear on the Command Back. The -C stands for Clear.

Date, Hour, Minute—If Year, Month, Day is being displayed, pressing MODE switches to Date, Hour, Minute—in that order—with a colon between Hour and Minute. Date will be the same as previously set. Hours are shown as 0 to 23, using the 24-hour clock.

To change the time setting, press SELECT. The colon will blink. Press SET. The display does not change, but the internal clock is "zeroed" so it will take a full 60 seconds to advance the minute value—whatever is shown.

Use the SELECT and SET buttons to change minute and hour as desired. End the operation by pressing SELECT. The time display will automatically be updated. The time that is displayed will be imprinted on the film at the next exposure—provided you do not change the mode setting.

or letters from A to F in any of the three positions. This mode is used to label frames with any code that you set. The code will not change from frame to frame unless you change it. Change the display using the SELECT and SET buttons as already described.

Imprinting Sequential Numbers—Pressing MODE again changes the display to show Fc followed by four numbers. Using the procedure already described, the starting value can be set to any number from 0000 to 9999. After being set, the number will increase by 1 after each exposure. After 9999 has been imprinted, counting starts again at 0000. This will continue, from roll to roll, unless the starting value is changed.

SETTING TIMER MODES

When any timer mode has been set, operation is started by pressing the START button on the Command Back, not the Shutter Button on the camera. To use a timer mode, the camera must be turned on and not have any control settings that conflict with the desired timer mode.

Pressing the Shutter Button causes the camera to operate normally, disregarding the Command Back.

To stop operation in any timer mode, press the START STOP-C button on the Command Back.

To set a timer mode, press the FUNCT button to cause the function indicator to move to any position along the top of the display panel. The four timer modes are marked on the Command Back. To set one of the modes, press the MODE button until the function indicator points to the desired mode.

Frames—This mode sets the number of frames that will be exposed by any other timer mode. By pressing MODE, move the function indicator opposite FRAMES at the top of the display panel. Using SELECT and SET, set the number of frames to be exposed, keeping in mind the number of available frames in the camera. Settings of 00 and 01 both produce a single exposure.

Self-Timer—Move the function indicator to SELF and set the desired time interval. Set the camera Main Switch to either of the metering patterns, but not SELF-TIMER. Press the START button on the Command Back.

The panel display will immediately change to show what will be imprinted. The function indicator opposite SELF will blink. If any other timer mode has been set, a function indicator appears opposite that mode but will not blink.

After the set time interval has passed, the camera will make an exposure. It will also imprint the film unless the data function is set to OFF. If the FRAMES value is set greater than 1, the set number of exposures will be made with no delay between exposures.

To disable the self-timer, set the time value to 00 00 00. Otherwise, the set self-timer interval will always precede any other action by another timer mode.

Interval Timer—Select this mode to set a time interval between sequential exposures. Set the desired total number of exposures in the FRAMES mode. Press the START button on the Command Back.

If the self-timer mode is set, that time interval will pass first. Then, the desired number of exposures will be made with the desired time interval between them. If the data function is not turned off, the set data will be imprinted on each frame.

Timer for Bulb Exposures—This mode will time an exposure up to 23 hours, 59 minutes and 59 seconds. The camera must be set to BULB. Move the function indicator to the EXP(BULB) position. Set the desired exposure time. Press the START button. If the self-timer mode has a value other than 00 00 00, that time delay will be executed first. Then, the shutter will open for the set time.

If a number of frames greater than one has been set in the FRAMES mode, but the interval timer is set to zero, only one exposure will be made. If the interval timer is set to a value other than zero, the set number of bulb exposures will be made, with the set time interval between them.

Bulb Timer with the T80—Use of Command Back 80 to time bulb exposures with the T80 camera depends on which lens type is installed. This function requires the camera to be set to bulb.

With an AC (autofocus) lens installed, the T80 cannot be set to bulb and therefore the bulb timer function cannot be used. With an FD lens installed, the camera can be set to bulb and the bulb timer function of Command Back 80 can be used.

Using More than One Timer Mode—If more than one timer mode has been set, they will operate in sequence, starting with the self-timer delay. The function indicator opposite the mode that is operating will blink. Non-blinking function indicators will appear opposite the other timer modes that have been set.

COMMAND BACK 90

The standard back cover of the T90 camera can be replaced with Command Back 90. There are only minor differences between Command Backs 70, 80 and 90. Operating procedures for Command Back 90 are essentially identical to those for Command Back 70 and 80. The minor differences are discussed here.

Data Exposure Level—It is not necessary to set film speed on Command Back 90 because it receives that information automatically from the T90 camera. Therefore the film-speed control on Command Backs 70 and 80 does not appear on Command Back 90. Instead, a control is provided on Command Back 90 to allow you to "fine tune" the amount of exposure used to imprint data on the film.

Notice, in the accompanying photo, that the word LEVEL appears on Command Back 90 at the locations where ISO appears on the other backs—above the LCD display panel and on one of the control buttons. In the accompanying drawing of the LCD panel, the symbols + 1 + 2 + 3 appear in the area used to display film speeds in the other backs.

To adjust the amount of exposure used to imprint data with Command Back 90, press the LEVEL button. Each time the button is pressed, the LCD display will change, rotating among blank, + 1, + 2, and + 3. If the display is blank, no additional

The Command Back 90 is used with the T90 camera.

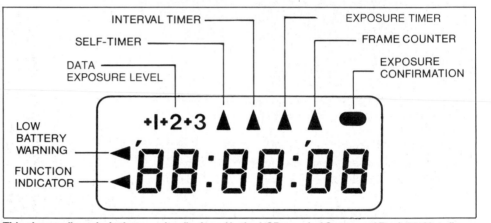

This shows all symbols that may be displayed in the LCD panel of Command Back 90. Not all are used simultaneously. The numerals, represented here by 8, may be replaced by letters.

exposure will be used. The symbol + 1 means one more step of exposure, and so forth.

With film in the range of ISO 80-160, exposure can be increased a maximum of 2 steps. With film in the range of ISO 25-64, exposure can be increased only one step.

You can increase the data-imprint exposure with any film if experience suggests the need. The accompanying table shows some films and recommended exposure increases.

Multiple Exposures—The T90 can be set to make a specified number of multiple exposures on the same frame. After the last multiple exposure, film is advanced to the next frame.

When using this feature under control of the timer function of Command Back 90, set the

FRAMES indicator on the command back to 02. The digits 01 will be used to make the multiple exposures on a single frame. The digits 02 will be used to advance the film to the next unexposed frame.

Controlling Flash—Electronic flash units designed for use with the T90 camera, such as the 300TL, have an SE (Save Energy) setting of the main switch. If the flash is not used for 5 minutes, it turns itself off to save energy.

The camera and flash can be controlled by the self-timer and interval timer function of Command Back 90. If the flash is set to SE and the interval timer is set longer than 5 minutes, power to the flash will be turned off until 1 minute before shooting. At that point, power is turned on so the flash can charge and become ready to fire.

RECOMMENDED EXPOSURE INCREASES WITH COMMAND BACK 90	
Film	Exposure Increase
Agfa ISO 100	1 step
Agfa ISO 400	1 step
Agfachrome ISO 1000	1 step
Agfachrome RS Professional, ISO 100	1 step
Agfachrome RS Professional, ISO 200	2 steps
Agfachrome RS Professional, ISO 1000	1 step
Sakura SR Series, ISO 100	1 step
Sakura SR Series, ISO 200	2 steps
Sakura SR Series, ISO 400	1 step
Sakura SR Series, ISO 1600	1 step

THE 277T FLASH

The 277T flash was introduced with the T70. It is an energy-saving, light-sensing, programmed automatic flash that can also be used on the T50 and other Canon cameras. An unusually wide choice of eight aperture settings, from *f*-2 to *f*-22, can be made. The following discussion applies to the T70. Use with other cameras is discussed in the 277T instruction booklet.

When the flash is charged and ready to fire, the Pilot Lamp on the flash glows and a flash-ready indication appears in the viewfinder—the lightning symbol. The camera is automatically switched to X-sync shutter speed in any camera mode except bulb. When the flash-ready indicator does not glow, when the flash is turned off or during recharge after a flash, the camera operates as though the flash were not attached.

The 277T has two modes. Both measure light returned from the subject and automatically turn off the flash when sufficient light has been measured.

In the PROGRAM mode, the flash sets lens aperture automatically according to a built-in program. In the F.NO. SET mode, you set the desired *f*-number on the flash. The flash then sets the lens to that *f*-number automatically.

To use, install batteries in the flash and mount in the camera hot shoe. Turn on the camera and select the PROGRAM mode. Be sure the FD lens aperture ring is set to A. Set the film-speed on the flash to the same value as on the camera, using the flash Film-Speed Selector.

PROGRAM MODE

Turn on the flash and slide the flash Main Switch o the PROGRAM setting. ompose and focus with the subject at the center of the frame.

Press the Shutter Button halfway. When the flash is charged, it emits a dark-red burst of light—called *preflash*—which reflects off

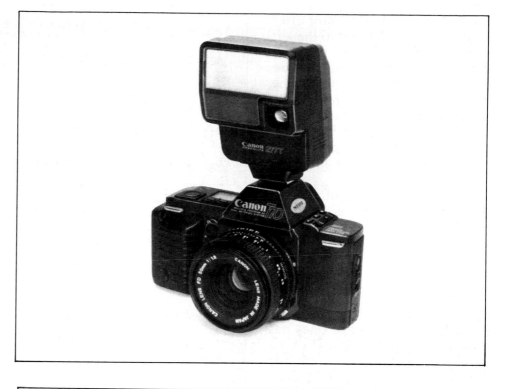

277T SPECIFICATIONS

Type: Energy-saving, light-sensing automatic with PROGRAM mode to set aperture. A second F.NO SET mode sets lens aperture to manually selected *f*-number on flash. Sets shutter speed automatically to X sync when flash-ready indicator glows.

Aperture Range: In either mode, eight aperture settings may be used, from *f*-2 to *f*-22.

Guide Number: With flash fully charged—82 feet (25 meters) at ISO 100; 41 feet (12.5 meters) at ISO 25. With Wide Adapter 277T, 52 feet (16 meters) at ISO 100; 26 feet (8 meters) at ISO 25.

Film-Speed Range: ISO 25 to 400.

Beam Angle: Covers angle of view of 35mm lens. With Wide Adapter 277T, covers 28mm lens.

Operating Range: See accompanying graph.

Warning Signals: In PROGRAM mode, underexposure indicated in viewfinder. Red dot on flash aperture scale glows. Warning does not operate in ambient light exceeding EV 8.

Flash-Sync Connector: Hot shoe only.

Pilot Lamp: Glows when minimum charge for flash operation is reached.

Test Button: Press Pilot Lamp lens to fire flash.

Power: Four AA-size alkaline or NiCad batteries.

Dimensions: 66mm x 97mm x 64.5mm (2-5/8 x 3-13/16 x 2-9/16 inches).

Weight: 180g (6-3/8 oz) without batteries.

the subject. The reflected light, plus ambient light from the scene, is measured by the light sensor on the front of the flash and used to select aperture according to a built-in flash program. Exposure is locked as long as the shutter button is not released.

The aperture to be used is displayed in the viewfinder. The same *f*-number glows on the aperture scale on the back of the flash. If there is no exposure warning, press

the Shutter Button to make the shot. You may recompose so the subject is off center, if you wish, as long as you keep the Shutter Button depressed partway after lens aperture has been established.

Operating range depends on film speed and the aperture used, as shown in the accompanying graph. If the camera-to-subject distance is not within the operating range, incorrect exposure will result.

Warnings—If insufficient light is

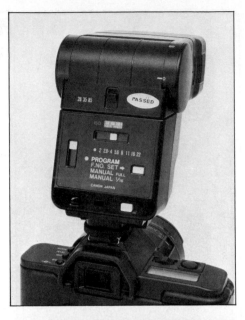

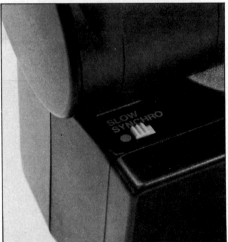

SPEEDLITE 299T SPECIFICATIONS

Type: Energy-saving, light-sensing hot-shoe flash with PROGRAM and F.NO. SET automatic modes, plus manual. Sets shutter speed automatically to X-sync. Has zoom beam-angle control and can be used for bounce flash.
Aperture Range: *f*-2 to *f*-22 in either auto mode.
Guide Number: Nominal 30 (meters) at ISO 100. See table.
Film-Speed Range: ISO 25-1000
Beam Angle: Variable by zoom control, with settings to cover angle of view of 28mm, 35mm or 85mm lens.
Operating Range: See table.
Warning Signals: In auto modes, underexposure indicated in viewfinder and on flash.
Sync Connection: Hot shoe or Synchro Cord A.
Pilot Lamp: Glows when minimum charge for flash operation is reached. If pressed, the Pilot Lamp fires the flash independently of the camera.
Auto-Flash Confirmation Lamp: In F.NO. SET mode, press Pilot Lamp to fire flash. If flash sensor measures sufficient exposure, confirmation lamp will glow briefly.
Power: Four AA alkaline or NiCad batteries.
Dimensions: 82mm x 131.4mm x 117.5mm (3-1/4 x 5-3/16 x 4-5/8 inches).
Weight: 435g (15-3/8 oz.) without batteries.

In bright ambient light this warning is not given and is not necessary because correct exposure can be made with ambient light.

If the subject is too far away *and* the ambient light is too dim for correct exposure, the underexposure warning appears in the viewfinder and a red dot at the left of the aperture scale on the flash will glow.

If the flash is too close to the subject, overexposure will result. There is no warning of overexposure. Minimum distances for various zoom settings and film speeds appear in the accompanying table.

The PROGRAM mode should not be used for bounce flash. Underexposure will result. In this mode, aperture is set by the pre-flash light source and sensor on the front of the flash body, which do not measure along the bounce path and do not perceive light lost at the bounce surface. If you tilt or rotate the flash head in this mode, a red light at the left of the PROGRAM setting on the flash blinks as a warning.

F.NO. SET

Shutter speed is set automatically. You set aperture using a control on the flash. Use the Mode Selector on the flash to select F.NO. SET. Then press the Aperture Selector button on the flash to select the desired aperture size, which will be displayed on the aperture scale on the back of the flash.

Set the aperture ring of an FD lens to A. AC lenses don't have an aperture ring but will operate in this mode. The camera can be in any mode except bulb.

Compose and focus the image. Press the shutter button partway to turn on the display. When the flash is charged, the Pilot Lamp on the flash and the ready-light symbol in the camera both turn on. The camera is set automatically to X-sync.

The pre-flash does not operate in this mode because aperture is not being set automatically. To test for good exposure before making the shot, press the Pilot Lamp on the flash. The flash will fire independent of the camera and the light sensor on the flash will measure light reflected from the scene. If exposure was sufficient, the green Auto Flash Confirmation Lamp on the back of the flash will glow briefly. If the lamp does not glow, select a larger aperture or move closer and try again.

With the Pilot Lamp and camera ready-light indicator on, depress the shutter button fully to make the exposure.

Bounce Flash—The F.NO SET mode is convenient for automatic bounce flash. Point the flash head at the bounce surface. To rotate the head, move the Horizontal Bounce Latch upward. When tilting, set the head on a detent at 60, 75 or 90 degrees.

To test exposure, press the Pilot Lamp and observe the Auto Flash Confirmation Lamp. If it doesn't glow, set a larger aperture and try again.

Warnings—If you select an aper-

SPEEDLITE 299T GUIDE NUMBERS ON MANUAL-FULL (meters)

Zoom Head ISO Film Speed

	25	50	64	100	200	400	1000
28mm	12.5	17.5	20	25	35	50	79
35mm	15	21	24	30	42	60	94
85mm	20	28	32	40	56	80	126

NOTES: Guide Numbers for MANUAL 1/16 mode are these values divided by 4. To convert to feet, multiply meters by 3.3.

ture size on the flash that is larger than the maximum aperture of the lens underexposure will result. T-series cameras warn of this by blinking the maximum aperture value of the lens in the viewfinder, or by a blinking P symbol, depending on the camera model.

If you set a smaller aperture on the flash than the minimum aperture on the lens, overexposure will result. There is no warning.

If the flash is closer to the subject than the minimum operating distance, overexposure will result. There is no warning. Operating distances are shown in the accompanying table.

MANUAL FLASH MODES

Shutter speed is set automatically. Exposure control is not automatic. You set aperture manually on the lens. Use the Mode Selector on the flash to select either MANUAL FULL or MANUAL 1/16. Turn the aperture ring of an FD lens away from the A symbol.

Compose and focus. Determine subject distance by reading the focused-distance scale on the lens or by measurement. To choose an aperture size, make a guide number calculation. Guide numbers for various film speeds and flash-head zoom settings are shown in the accompanying table. Set the desired aperture value manually on the lens.

Depress the shutter button partway to turn on the viewfinder display. When the Pilot Lamp and ready-light symbols glow, shutter speed will automatically be set to X-sync. An M symbol will appear in the viewfinder as a reminder that lens aperture and exposure are controlled manually. Depress the shutter button fully to make the exposure.

Pilot Lamp—When the Pilot Lamp first glows, the flash is not yet at full charge. To fire at that instant, use an aperture about one-half step larger than calculated. If it took 5 seconds of charging to turn on the Pilot Lamp, then an additional 5 seconds or so will bring the flash up to full charge.

Power Levels—There are two power levels. At MANUAL FULL, the flash operates at full power, with the guide numbers in the accompanying table. At MANUAL 1/16, the light output is 1/16 as much and the guide number is 1/4 as much.

Full power is used when the flash is the main source of light. Reduced power can be used for fill flash. Although not recommended by Canon, reduced power can be used as a repeating flash to make a *few* exposures with motor drive. If you make too many repeating exposures, the flash will overheat and may be damaged.

SLOW-SYNC FLASH

Shutter speeds slower than X-sync can be used with the A-1, F-1 and T90 to provide more background exposure from ambient light. To use slow sync, rotate the 299T flash head to reveal the SLOW SYNCHRO switch and move the switch to the dot symbol. Set the 299T to F.NO. SET for automatic exposure or to a MANUAL mode. Set the camera to the desired shutter speed.

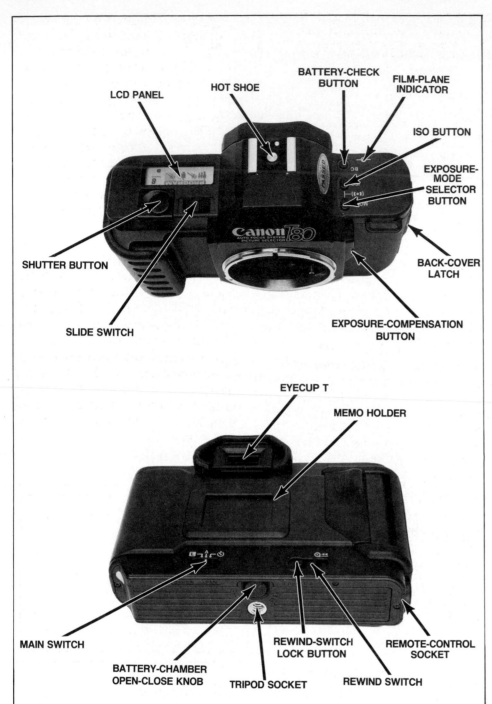

LCD PANEL · HOT SHOE · BATTERY-CHECK BUTTON · FILM-PLANE INDICATOR · ISO BUTTON · EXPOSURE-MODE SELECTOR BUTTON · BACK-COVER LATCH · SHUTTER BUTTON · SLIDE SWITCH · EXPOSURE-COMPENSATION BUTTON

EYECUP T · MEMO HOLDER · MAIN SWITCH · BATTERY-CHAMBER OPEN-CLOSE KNOB · TRIPOD SOCKET · REWIND-SWITCH LOCK BUTTON · REWIND SWITCH · REMOTE-CONTROL SOCKET

THE T80 CAMERA

The T80 is a simplified camera with automatic exposure and automatic focus using special Canon AC lenses. It has five programmed automatic-exposure modes. Film loading, film advance and rewind are performed automatically by a motor in the camera.

DISPLAYS

Operating data and camera settings are shown by an LED display in the viewfinder and an LCD Display Panel on top of the camera.

LENSES

The T80 provides automatic focusing with special Canon AC (Automatic Control) lenses, each of which has a built-in focusing motor. FD lenses may be used with manual focus. AC and FD lenses provide full-aperture metering. Non-FD lenses may be used with stop-down metering.

MAIN SWITCH

At L, the camera is turned off and the shutter locked. At A, the camera can be operated. The third setting is a clock symbol, used to set the self-timer.

POWER

Install four AAA-size 1.5-volt alkaline or carbon-zinc batteries in the chamber at the bottom of the camera. The camera will not operate if the batteries are missing or discharged.

A backup lithium battery preserves camera settings while the main batteries are being changed. It lasts about 5 years and can be replaced at a Canon service facility.

Battery Check—With the camera turned on, press the BC button. Three horizontal dashes at the bottom of the LCD Display Panel indicate sufficient power. Two blinking dashes indicate weak batteries. One blinking dash, or no dash at all, means the batteries need replacement. No matter what the display shows, if the camera operates, exposure will be correct.

CANON AC LENSES FOR T80

Lens	Auto Focus Range (m)	Diag. Angle of View (deg)	Macro Mag-nification	Filter Diam (mm)	Length (mm)	Weight (g)
AC 50mm *f*-1.8	0.6-∞	46		52	74	210
AC 35-70mm *f*-3.5—4.5	0.5-∞ Macro: 0.39	63-34	0.11	52	76	285
AC 75-200mm *f*-4.5	1.8-∞ Macro: 0.55	32-12	0.2	58	83	585

LOADING FILM

Open the back cover by depressing the Lock Button while sliding the Back Cover Latch downward. Tilt the film cartridge so you can insert it top end first. Pull the film leader across the back so the tip aligns with the orange index mark and a sprocket hole fits over one of the sprocket teeth.

Close the back cover. Turn the camera on, if it is off. Film will be advanced automatically to frame 1.

When film is in the camera, a film-cartridge symbol appears in the lower left corner of the LCD panel. During film advance, three bars extend sequentially to the right of the cartridge symbol, indicating film motion across the camera. When film has been advanced to frame 1, the three bars are stationary and the number 1 appears in the frame counter area at top right in the LCD panel.

Warning—If the film end is not captured by the film-loading mechanism, it will not be advanced. The camera will operate as though advancing film and stop with frame number 1 displayed. However, the three bars will not appear in the LCD display. If the three bars are not visible, open the camera back and start over.

FILM SPEED

Film speed is set manually. When loading film, the previously set ISO film-speed number is displayed at top right in the LCD panel. If it does not agree with the film speed being loaded, change it.

To set film speed, press the ISO button. The set speed will be displayed in the LCD panel. Moving the Slide Switch to the left or right changes the setting.

SHUTTER BUTTON

Pressing the shutter button partway turns on the camera metering system, the viewfinder display, and the autofocus system. Pressing the button fully makes an exposure. If you hold down the shutter button, the camera will expose frames continuously at rates up to about 1 per

Symbols in the LCD Panel indicate which program is being used. The selected symbol becomes darker than the others. This illustration shows the camera set to use the standard PROGRAM.

second, depending on shutter speed.

FRAME COUNTER

The frame counter in the top right corner of the LCD panel shows the number of the next frame to be exposed.

AE MODE SELECTOR

To use automatic exposure with an FD lens, the lens aperture ring must be set to A. AC lenses don't have an aperture ring. They are designed for automatic aperture control by the camera.

There are five programmed automatic-exposure modes: a standard program and four alternate programs that provide special photographic effects such as increased depth of field. Each is indicated by a symbol in the LCD Display Panel. The selected symbol becomes visibly darker than the others. To choose, hold down the MODE button while moving the Slide Switch to select the desired mode.

PROGRAM **Standard Program**—Indicated by PROGRAM in the LCD display, this program favors neither aperture nor shutter speed.

Deep Program—Provides increased depth of field by using smaller aperture than the standard program. Shutter speed will be slower to maintain correct exposure.

Stop Action Program—Shutter speed will be faster than standard program to reduce blur of a moving subject.

Shallow Program—Aperture will be larger than standard program to provide reduced depth of field. Shutter speed will be faster.

Flowing Program—Shutter speed is slower than standard program so image of moving subject will be deliberately blurred. If you move (pan) the camera with the moving subject while making the exposure, background will be blurred.

After this program has been selected, release the MODE button. Then move the Slide Switch to set shutter speed. You can choose 1/15, 1/30, 1/60 or 1/125 second. The selected speed is displayed below the flowing program symbol.

Exposure Compensation—For backlit subjects, press the Exposure Compensation Button while making the exposure. Shutter speed is reduced by 1.5 steps to give more exposure.

VIEWFINDER

The M symbol blinks when manual exposure control is necessary. P indicates programmed automatic exposure. If P glows steadily, exposure will be correct. It blinks to provide warnings.

The diamond symbol is a mode warning used with the four special-effect programs but not the standard program. The "lightning" symbol is a flash-ready indicator.

Warnings—If P blinks rapidly, eight times per second, correct exposure is not possible because the light is too bright or too dim.

At slow shutter speeds, P blinks slowly—one or two times a second—as a camera-shake warning. To avoid image blur, put the camera on a tripod or other firm support.

If the diamond symbol appears, the selected special-effect program cannot provide the desired photographic effect. Suppose you are using the *flowing* program and have chosen a shutter speed of 1/15 second. If the scene is brightly illuminated, the camera cannot use 1/15 second even at the smallest aperture of the lens because overexposure will result. It is necessary to use a faster speed, such as 1/250, which the camera will do if you make the shot.

If you shoot with the mode-warning symbol glowing, and the P symbol is glowing steadily, exposure will be correct but the desired special effect will be less than expected.

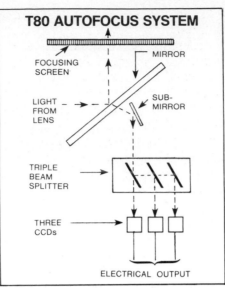

T80 AUTOFOCUS SYSTEM

To provide automatic focus, some light from the scene passes through the main mirror and is reflected downward by a sub-mirror to the focus detector. Using Charge-Coupled Devices (CCDs), the detector checks focus at three optical locations. The center location is equivalent to the film plane. If the image is not in focus at the film, the camera "tells" the focusing motor in the lens which way to turn.

This is the AC 35-70mm f-3.5—4.5 zoom lens. The Manual Focusing Ring is at the front. The focused-distance scale is near the front. The Focus-Mode Selector is at left, set to ONE SHOT. The zoom control is at right. Between is the Focus-Range Limit control, set to allow focusing from the macro range (M) to infinity.

MANUAL EXPOSURE CONTROL

This mode can be used in three ways. An AC lens cannot be used. With a flash operating on manual, aperture is set manually on an FD lens. The X-sync shutter speed of 1/90 will be set automatically.

For manual operation without flash, turn the FD lens aperture ring away from A to select an aperture. Only two shutter speeds are available—1/60 second or bulb. The symbol 60 or B will appear in the lower right corner of the LCD panel. To switch symbols, press the MODE button and operate the Slide Switch.

For bulb, select the B symbol. Exposure time is controlled manually by holding down the shutter button or using a Remote Switch plugged into the camera Remote Control Socket. Elapsed time is shown by a numeral in the upper right corner of the LCD panel that counts from 1 to 60 seconds. If you hold the shutter open longer than 60 seconds, the display continues to show 60.

OPTICAL FOCUSING AID

The T80 uses a Cross-Split focusing aid that splits the image both horizontally and vertically when it is out of focus. Focus can also be judged visually by looking at the matte surface of the focusing screen.

AUTOFOCUS

Pressing the shutter button partway causes the autofocus system in the camera to check focus at the center of the frame, along the horizontal line in the optical focusing aid. If focus is satisfactory, the camera makes a *beep-beep* sound.

With an AC lens, there are three focus modes, selected by a switch on the lens. In any mode, an exposure will be made when you press the shutter button, whether the image is in focus or not.

One Shot—The camera will focus the lens on the subject at the center of the frame and lock focus at that distance as long as the shutter button is held partway down. You can recompose to place the focused subject at the side of the frame if you wish. Press the shutter button fully to make the exposure.

For rapidly moving subjects, use this mode to focus at a location where the subject will appear. When the subject arrives at that location, make the shot.

Servo—When the shutter button is held partway down, the camera focuses the lens continuously, beeping each time focus is accomplished. Press the shutter button fully to make an exposure. This mode is suitable to follow a slowly moving subject, maintaining focus as the subject moves.

If you hold down the shutter button to make a continuous series of exposures, focus is locked at the distance used for the first frame of the series.

Manual Focus—When autofocus cannot function, or if you prefer to focus manually, use this mode. Focus by turning the Manual Focusing Ring on the lens. With an FD lens, manual focus is necessary.

Focus Beeper—Good focus is in-

dicated by two beeps. You can prevent focusing beeps by pressing the MODE and ISO buttons simultaneously until the sound-wave symbol disappears from the lower right corner of the LCD panel. To restore the beeper, press the buttons again until the symbol reappears.
Focus-Range Limit—The AC 35-70mm *f*-3.5-4.5 zoom lens has a mechanical control on the lens body to limit the focusing range—which will prevent the camera from "looking" outside of that range to find focus. There are three zones: M (Macro) to 0.8 meter; 1 meter to infinity; and M to infinity.

To select either of the smaller zones, manually focus the lens to a distance within that zone, then move the Focus Range Selector on the lens fully forward.

AUTOFOCUS LIMITATIONS
The autofocus system in the T80 measures subject contrast or sharpness to judge focus. When using autofocus, it helps to place the horizontal line in the viewfinder optical focusing aid across a *vertical* line or edge in the scene that is sharply defined.

There are some situations where autofocus cannot function and manual focus must be used. This occurs in dim light and with low-contrast subjects such as a blank wall or a landscape in fog. It also occurs with scenes that have horizontal lines but not vertical lines. Rotate the camera, and such scenes can be focused.

SELF-TIMER
Set the Main Switch to the timer symbol. Compose and focus. Exposure is set when you press the shutter button. If your eye will not be at the viewfinder when you press the shutter button, cover the eyepiece with the viewfinder cover that is attached to the camera neckstrap. Otherwise, incorrect exposure may result.

When you press the shutter button, 10 seconds will elapse before the shutter opens. Numerals in the upper right corner of the LCD panel count down from 10 to 1 second. The beeper sounds during countdown—more rapidly during the last two seconds.

To cancel the self-timer during the countdown, move the Main Switch away from the timer symbol.

END OF ROLL
When the last frame has been exposed, the beeper will sound for about four seconds. The frame number and the three "film" bars in the LCD panel will blink.

REWINDING
While pressing the adjacent Lock Button, move the Rewind Switch to the right. Release the switch when rewind begins. During rewind, the frame counter counts backwards. The film end is drawn completely into the cartridge. When rewind is complete, the film-cartridge symbol in the LCD panel blinks. It is then safe to open the camera back and remove the cartridge of exposed film.

FLASH
Canon T-type, A-type or G-type flash can be used. There is no camera-body sync connector. X-sync is 1/90 second, set automatically by Canon dedicated flash units when the flash is charged and ready to fire. The flash-ready indicator is a lightning symbol in the viewfinder.

POLARIZERS
A circular polarizing filter is recommended. If you use a linear polarizer, exposure measurement will be OK, but the autofocus system may not work correctly. With a linear polarizer, focus manually.

MAJOR ACCESSORIES
The T80 uses Canon AC lenses, FD and earlier lenses without autofocus, lens accessories, Canon flash units, Command Back 80, Remote Switch 60T3, Wireless Controller LC-1, and Dioptric Adjustment Lenses S.

T80 SPECIFICATIONS

Type: 35mm SLR with five programmed auto exposure modes and autofocus with Canon AC lenses. Motorized automatic film loading, advance and rewind.
Usable Lenses: Canon AC for autofocus, FD and earlier types without autofocus.
Viewfinder: Focusing screen has Cross-Split focusing aid. Horizontal line in focusing aid indicates area used for autofocus. Magnification is 0.83 at infinity with a 50mm lens. Image coverage is 92% vertical and 93% horizontal.
Viewfinder Information: Manual indicator, program indicator, exposure and camera-shake warnings, mode warning, flash ready symbol.
Metering: Full aperture, center-weighted, by silicon sensor in viewfinder housing. Coupling range is EV 1 to EV 19 with ISO 100 and *f*-1.4 lens.
Exposure Modes: Five programmed modes with AC or FD lenses. Manual with FD and earlier lenses. Stopped-down AE.
Film Speed: ISO 12 to 1600, set manually.
Exposure Compensation: Plus 1.5 steps, by pressing button.
Autofocus: Sharpness-detecting type. One shot and continuous servo. Operating range is EV 4 to 18 with AC 50mm *f*-1.8 lens.
Shutter Speed: 1/1000 to 2 seconds, steplessly selected in auto modes. Manual—1/60 second and bulb. X-sync is 1/90 second.
Self-Timer: Electronic. 10 second delay. Cancellable.
Flash: Programmed automatic or automatic with manual aperture selection, using Canon dedicated flash units.
Remote Control: Connector provided for Remote Switch 60T3.
Back Cover: Removable.
Power Source: Four AAA alkaline or carbon zinc. Memory backup by lithium BR-1225 or CR-1220.
Dimensions: 141 x 102 x 54.7mm (5-9/15 x 4 x 2-1/8 inches), body only.
Weight: 555g (19-9/16 oz.), body only.

Error Display—If you push in the Stop-Down Lever with an FD lens set on **A**, the viewfinder exposure display will show EEEE EE, which is an error signal. To clear the error, either press the Stop-Down Lever again to release it or take the lens off the **A** setting.

SELF-TIMER

To set the self-timer, open the Palm Wing. At the bottom of the control panel is a black lever surrounding a tan pushbutton. Turn the lever to the timer symbol.

In the LCD panel, the pointer at right will move down to the numeral 10, indicating that the self-timer is set to provide 10 seconds delay. To change the delay, press the tan pushbutton. The pointer in the LCD panel will move back and forth between 2 seconds and 10 seconds.

Prepare the camera to make the shot. Press the shutter button to start the self-timer. A red light on the front of the camera will blink during the countdown, blinking faster during the last 2 seconds. A numeral in the frame-counter area of the LCD panel will count down, showing seconds remaining.

Exposure is set at the instant the shutter button is pressed. Don't stand in front of the lens while pressing the button.

Eyepiece Shutter—If your eye will not be at the viewfinder eyepiece when you press the shutter button, close the viewfinder shutter using the lever at the left of the eyepiece.

To Cancel—During countdown, self-timer operation may be canceled by pressing the battery-check button inside the Palm Wing or by turning the self-timer setting lever away from the timer symbol.

EXPOSURE COMPENSATION

This control affects exposure in all automatic modes and with all metering patterns. To set exposure compensation, press the EXP. COMP. button while turning the Input Dial. As shown in the accompanying illustration, the LCD panel display will change to

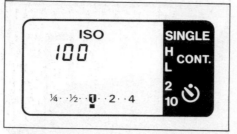

When setting exposure compensation, a scale and dot appear at the bottom of the LCD panel. The dot shows the amount of compensation being used. This camera is set at 1, which means that no compensation is being used. The ISO film speed setting is also displayed.

show ISO film speed plus an exposure-compensation scale. The rectangular dot below the scale shows the setting.

Warnings—When you release the EXP. COMP. button, the LCD display panel returns to whatever it was displaying before except that the exposure-compensation scale values remain visible just above the dashed line representing film. One of the dashes will blink on and off to show the amount of exposure compensation being used. For example, if the exposure-compensation setting is 2, a dash below 2 on the scale will blink.

In the viewfinder, a +/− symbol appears at far right, below the image, as a reminder that exposure compensation is being used.

MANUAL EXPOSURE MODES

These modes are used with an FD lens not on **A**, and with lenses or attachments that don't have signal pins.

Manual Override—Select Tv on the LCD panel. Set shutter speed using the Input Dial. The viewfinder display shows the set shutter speed and the camera-recommended aperture for correct exposure of an average scene. You can use that aperture value or any other that you wish. Set aperture manually on the lens.

Stopped-Down Automatic Exposure—Stopped-down metering is necessary when using lenses or attachments that don't provide full-

aperture metering, such as a bellows, Canon Reflex Lens, or Canon FL lenses.

Set the camera so the LCD panel displays Av, Program or P. Set the desired aperture manually on the lens. Push in the Stop-Down Lever. The camera will set shutter speed according to the aperture size that it "sees" when the stop-down lever is pushed in.

Stopped-Down Manual Exposure—Canon refers to this mode as Stopped-Down Fixed Index metering. It is used under the same conditions as stopped down automatic, but you set both shutter speed and aperture manually.

Set the camera LCD display to Tv. Set shutter speed by turning the Input Dial. Set aperture manually on the lens. Push in the Stop-Down Lever.

The viewfinder exposure display will show the set shutter speed with an exposure indicator in the space normally used to display *f*-number. CL means close the aperture to avoid overexposure. OP means open the aperture to avoid underexposure. Two small rectangles mean that exposure will be OK.

In the space to the right of the viewfinder image, a display appears that is similar to the spot metering display with a dot that moves as you change aperture. When the dot is aligned with the reference triangle, exposure is correct.

FRAME COUNTER

With DX film, there are two frame-count indications. The frame-counter area in the LCD Display Panel always counts up, starting at 1, to show the number of the next frame to be exposed. The display area at right in the viewfinder shows the number of frames *remaining* to be exposed—unless the display is being used for another purpose such as spot metering. The accompanying illustration shows the viewfinder counter.

With spot metering, or manual stopped-down fixed-index metering, this area in the viewfinder is

With DX-coded film, a frames-remaining counter appears at right in the viewfinder. Frames are represented by dots, as shown, with an F (Film) symbol at the bottom. When the number of frames remaining is less than 10, the F symbol changes to a number and counts down from 9 to 1.

used for a scale, but the bottom of the area still relates to film and frames remaining.

With DX film, the symbol F (Film is loaded) appears at the bottom of the display until the frames remaining become 9. Then the number counts down until all frames are exposed.

With non-DX film, the symbol F appears if film is loaded. There is no countdown below 9. Without film, no symbol appears.

EXPOSURE WARNINGS

Incorrect exposure is indicated by blinking the shutter-speed or aperture value in the viewfinder—or both. Values that blink depend on the lens in use, the film speed, the exposure mode, and whether the light is too bright or too dim.

If values blink in dim light, underexposure is indicated. If values blink in bright light, overexposure is indicated.

MULTIPLE EXPOSURES

You can preset the number of multiple exposures to be made on the same frame. Press the MODE and METERING/CLEAR buttons simultaneously. An ME symbol will appear in the LCD display along with the number 1. Rotate the Input Dial to change the value to the desired number of multiple exposures—up to a maximum of 9.

T90 INTERCHANGEABLE FOCUSING SCREENS

Type T90-A, Microprism—A matte screen with microprism focusing aid, suitable for use with apertures of ƒ-5.6 or larger.

Type T90-B, New Split—A matte screen with split-image (biprism) focusing aid, suitable for general photograpy with most lenses.

Type T90-C, All Matte—For use with macro and telephoto lenses, judging focus by the sharpness of the image.

Type T90-D, Matte/Section—An all-matte screen with a reference grid that is useful in architectural photograpy, copy work, and situations where accurate image placement is essential.

Type T90-E, New Split/Microprism—A matte screen with split-image (biprism) and microprism focusing aids. Useful for general photography with most lenses.

Type T90-H, Matte/Scale—A matte screen with horizontal and vertical scales marked in millimeters. Useful for macro photography, copy work and similar applications.

Type T90-I, Double Cross-Hair Reticle—A matte screen with clear center spot with cross-hairs.

Type T90-L, Cross Split-Image—A matte screen with crossed biprism focusing aids. Useful for general photography with most lenses.

Press the shutter button to make the exposures. Continuous film advance can be used. The LCD display counts down from the set number of multiple exposures. When the last exposure has been made, the ME symbol disappears and the film is advanced to the next frame. **To Change or Cancel**—Before shooting, repeat the setup procedure to select a different number of frames. If you select 1, the multiple-exposure operation is canceled.

During shooting, repeat the setup procedure to select a different number of frames, then continue shooting. If you select 0 (blank), the multiple-exposure operation stops.

FOCUSING SCREENS

User-interchangeable focusing screens are available as shown in the accompanying illustration. They are interchanged with a special tool, packaged with each screen.

VIEWFINDER DISPLAY SELECTOR

Under the Palm Wing, the top lever is labeled FINDER. It has three settings. The open circle turns off both viewfinder displays. The solid circle turns them on. The "light bulb" symbol illuminates both viewfinder displays.

REWINDING FILM

At the end of the roll, film is rewound automatically. The film end is drawn completely into the cartridge. The frame counter counts backward during rewind.

When rewind is complete, the film-cartridge symbol in the LCD display blinks. Open the back and remove the cartridge of exposed film.

To Rewind At Any Time—You can rewind at any time by pressing the button just below the rewind symbol inside the Palm Wing.

FLASH

Speedlite 300TL is the companion flash for the T90. Other Canon flash units may be used, with fewer automatic features. Using the 300TL is described later in this chapter.

HELP DISPLAY

If HELP appears in the LCD panel, there is a camera malfunction or operational error. If you know that the batteries are OK, remove the battery holder and then replace it. Press the shutter button one time. If the HELP display disappears, the camera is OK. If not, repeat this procedure. If the camera still wants help, take it to a Canon service facility.

MAJOR ACCESSORIES

The T90 uses Canon FD and earlier lenses, lens accessories, Canon flash units, Macro Ring Lite ML-2, multiple-flash connectors and accessories, Command Back 90, bellows and extension tubes, Remote Switch 60T3, Wireless Controller LC-2, and Dioptric Adjustment Lenses S.

Speedlite 300TL is designed for use with the T90 camera and provides many advanced features.

SPEEDLITE 300TL

The 300 TL is a technically advanced electronic flash designed for use with the T90 camera. It provides fully automatic and manual modes, automatic fill flash, and an FE Lock mode that locks flash exposure to allow recomposing to place the subject off center. The flash head tilts and swivels for bounce flash. It has a manually operated zoom lens to change the beam angle.

MODES

There are five operating modes, selected on the flash control panel. In each mode, when the flash is charged and ready to fire, shutter speed is set automatically.

Advanced TTL Mode—This mode controls flash exposure automatically, using the light sensor in the body of the T90 camera.

When the shutter button is pressed, a red lens on the body of the flash emits a dark red pre-flash. The pre-flash reflected by the subject is measured by a sensor on the body of the flash. The amount of reflected light is used to calculate subject distance and set lens aperture size automatically.

When aperture has been set, the main flash tube is fired. The sensor in the camera measures light on the film surface *during* exposure and turns off the flash when exposure is correct. Both light from the flash and ambient light are measured.

This method of flash control is called TTL (Through The Lens). The 300TL flash has advanced features, such as automatic flash fill, in this mode. Canon therefore refers to it as Advanced TTL (A-TTL).

Program or Full Auto Mode—For maximum simplicity, the flash can be set to P (Program) which automatically sets the camera to its Program mode and sets the flash to A-TTL. The result is fully automatic operation with a single control setting.

Flash-Exposure Lock (FEL) Mode—This mode allows you to set flash exposure for a subject at the center of the frame and then recompose with the subject off center but still correctly exposed. It also allows sophisticated fill flash and control of background exposure due to ambient light.

Manual High-Power Mode—The flash emits full light power each time it is fired. Aperture is set manually, based on a guide-number calculation.

Manual Low-Power Mode—The flash emits 1/16 of the full light output. Guide number is 1/4 that of the Manual Hi-Power Mode. Aperture is set manually, based on a guide-number calculation.

POWER SOURCE

The 300TL uses four AA-size alkaline or NiCad batteries.

MAIN SWITCH

The setting labeled 0 turns the flash off. To turn the flash on, move the switch to 1. If set to SE (Save Energy), the flash will turn itself off automatically if not used for 5 minutes. To turn it back on, press the camera shutter button

The 300TL flash head tilts and swivels. It also zooms to change beam angle. Controls are pushbuttons and switches.

partway or move the 300TL main switch to the 1 setting—and then back to SE, if you wish.

FLASH CHARGE

When the flash is charged and ready to fire, the flash-ready indicator appears in the camera viewfinder and the Pilot Lamp on the back of the flash glows.

Flash Test—Pressing the Pilot Lamp will fire the flash independently of the camera—to show that it is working.

SYNC POSITION SELECTOR

This switch is just above the 300TL Main Switch. When the Sync Position Selector is moved to the left, the flash fires when the first curtain of the T90 shutter is fully open. This is the normal setting.

When the sync selector is moved to the right, the flash is fired just before the second curtain begins to close, as discussed in Chapter 16.

Longer exposure times produce longer "trails" of moving subjects. Second-curtain sync may not be effective with the flash in the Full-

Auto (P) mode or the equivalent A-TTL mode with the camera on Program because exposure time may be too short. In these modes, the shutter speed is set automatically in the range of 1/60 to 1/250 second.

MODE SELECTOR

At the P setting, an adjacent red lamp glows. The flash is set to A-TTL and the camera is automatically set to Program. Operation with these flash and camera settings is described later.

At the MODE SET position, you choose one of four modes by pressing a Mode Set pushbutton. The pushbutton labels are A-TTL, FEL, M Hi and M Lo. When pressed, a confirmation lamp glows above the selected pushbutton.

A-TTL OPERATION

Set the FD lens to A. Set the flash to A-TTL. In this mode, the light sensor in the bottom of the camera measures light at the film surface during exposure and turns off the flash when exposure is sufficient. Shutter-speed and aperture values—or an exposure warning—are displayed in the viewfinder before making the exposure.

With T90 on Program AE—This is the same as the Full Auto (P) mode.

Set the T90 to Program. Compose and focus. Press the shutter button partway. When the flash-ready indicator glows, the 300TL emits a dark red pre-flash to determine subject distance. The camera sets shutter speed and aperture according to a built-in flash program, then fires the main flash. The sensor in the camera turns it off. The shutter-speed range in this mode is 1/60 to 1/250 second.

If the subject is too far away, both shutter speed and aperture will blink in the viewfinder display before you make the exposure. Remove your finger from the shutter button, move closer to the subject and try again.

With T90 on Shutter-Priority AE—Use the Input Dial of the T90 to select a shutter speed in the range of 30 to 1/250 second. This allows control of background exposure due to ambient light. Press the shutter button partway. When the flash-ready indicator glows, the 300TL emits a dark red pre-flash. The camera sets aperture, then fires the main flash.

If the aperture value blinks in the display, change shutter speed. If both shutter speed and aperture blink, move closer and start over.

With T90 on Aperture-Priority AE—Use the Input Dial of the T90 to set any aperture that is available on the lens. This allows controlling depth of field. Press the shutter button partway. When the flash-ready indicator glows, the 300TL emits a dark red pre-flash. The camera sets shutter speed in the range of 30 to 1/250 second.

If shutter speed blinks in the viewfinder display, change aperture. If both shutter speed and aperture blink, move closer and start over.

Flash Fill in A-TTL Mode—In the A-TTL mode, with the camera on Program or in the equivalent P mode, the T90 and 300TL automatically control flash fill and background exposure.

As the ambient light becomes brighter, flash duration is reduced. In daylight, the flash just fills the shadows.

To control exposure of the background due to ambient light, shutter speed is automatically changed from 1/60 second in dim light to 1/250 second in bright light.

FEL MODE

The FEL (Flash Exposure Lock) provides some novel and sophisticated operating features. In this mode, when the Spot Metering Button on the T90 is pressed, the camera measures ambient light on the scene using center-weighted metering, no matter which metering pattern is selected on the T90. Based on the ambient-light reading, the camera sets shutter speed, or aperture, or both, depending on the selected exposure mode.

Then, the flash emits a 1/20 power pulse from the main flash head as a test. Based on the reflected light, the flash duration needed at full power to correctly expose the subject is calculated and stored in the spot memory for 30 seconds. If the flash is fired within 30 seconds, its duration is the value stored in the spot memory. In the FEL mode, the light sensor in the bottom of the camera is not used to control flash duration.

Flash fill is automatic because shutter speed and aperture are set for correct exposure of the scene with ambient light. The flash duration stored in the spot memory will correctly expose the subject due both to ambient light and flash.

When using the FEL mode, you may occasionally want to clear the spot memory without waiting 30 seconds for it to clear itself. The spot memory is cleared when you press the shutter button to make an exposure and then release it. It is cleared when you press the METERING/CLEAR button on the T90. If you press the Spot Metering Button, and then press it again, the flash duration stored in the spot memory will change accordingly. To use this mode, be sure the FD lens is set to A.

With T90 on Program—Check the flash Pilot Lamp to be sure it is on. Place the spot-metering area over the subject and press the Spot Metering Button on the T90. Based on ambient light, a shutter speed in the range of 1/60 to 1/250 second and a suitable aperture are set automatically.

The pre-flash is emitted by the flash head of the 300TL, full-power flash duration is calculated and stored in the spot memory for 30 seconds.

A metering scale with a center reference triangle appears at the right of the image area in the viewfinder. Opposite the scale is a fixed dot that represents subject exposure due to the flash. If the fixed dot is not aligned with the reference triangle, exposure will be incorrect. Move closer and start over.

If an aperture value of *f*-27 or *f*-32 blinks, the combination of flash and ambient light is too bright and overexposure will result. Place a neutral-density (ND) filter over the lens and try again.

Before making the shot, you can recompose if you wish. When ready, press the shutter button.

With T90 on Shutter-Priority AE—Use the Input Dial to set a shutter speed in the range of 30 to 1/250 second. Be sure the Pilot Lamp on the 300TL is on.

Center the subject and press the Spot-Metering Button. Aperture is set automatically according to the ambient light. The pre-flash is emitted and the full-power flash duration for correct exposure of the subject is calculated and stored in the spot memory for 30 seconds.

A metering scale appears at the right of the image area in the viewfinder. A fixed dot represents subject exposure due to the flash. If the fixed dot is not aligned with the reference triangle, exposure will be incorrect. Move closer to the subject or change shutter speed and start over.

The spot-metering display also shows a moving "free" dot that represents scene brightness being measured by the exposure meter in the camera, using the selected metering pattern. With the camera set for center-weighted metering, the position of the free dot should agree with the position of the fixed dot. If you recompose before shooting, the fixed dot may move to show a different scene brightness but you can shoot anyway.

If an aperture value of *f*-27 or *f*-32 blinks, the combination of flash and ambient light is too bright and overexposure will result. Place a neutral-density (ND) filter over the lens and try again.

With T90 on Aperture-Priority AE—Using the Input Dial, set aperture to any value that is available on the lens. Be sure the flash Pilot Lamp is on. Center the subject and press the Spot Metering Button. A shutter speed in the range of 30 to 1/250 seconds is set auto-

matically, based on ambient light.

A pre-flash is emitted by the 300TL. The full-power flash duration for correct exposure of the subject is calculated and stored in the spot memory for 30 seconds.

A metering scale with a center reference triangle appears at the right of the image area in the viewfinder. A fixed dot represents exposure of the subject due to the flash. If the fixed dot is not aligned with the reference triangle, exposure will be incorrect.

The display also shows a moving "free" dot that represents scene brightness being measured by the exposure meter in the camera, using the selected metering pattern. It also should align with the reference triangle.

If you recompose before shooting, a different background with a different brightness may be included in the frame. Both the fixed dot and the free dot can be moved, if necessary. Turn the Input Dial on the T90 to move the fixed dot by changing aperture—which affects exposure of a nearby subject due to the flash. Press either the Highlight Control Button or the Shadow Control Button on the T90 to move the free dot by changing shutter speed—which affects exposure of the scene.

If a shutter speed of 1/250 blinks,

the combination of flash and ambient light is too bright and overexposure will result. Select a smaller aperture or place a neutral-density (ND) filter over the lens and try again.

MANUAL MODES

Shutter speed is set automatically. Exposure control is not automatic. You set aperture using the Input Dial of the T90.

Set the flash to M Hi or M Lo. Set the T90 to aperture-priority automatic. Be sure the aperture ring of the FD lens is set to A.

Compose and focus. Determine subject distance by reading the lens focused-distance scale or by measurement. To choose an aperture size, make a guide number calculation. Guide numbers for various film speeds and flash-head zoom settings are shown in the accompanying table. Set the desired aperture value using the Input Dial of the T90.

Depress the shutter button partway to turn on the viewfinder display. When the Pilot Lamp and ready-light symbols glow, shutter speed will automatically be set to the X-sync value of 1/250. An M symbol will appear in the viewfinder as a reminder that lens aperture and exposure are controlled manually. Depress the shutter button

300TL SPECIFICATIONS

Type: Designed for use with the T90 camera. Energy-saving automatic with pre-flash function, automatic flash duration control based on T90 spot metering, and automatic TTL exposure control by the T90.

Guide Number: 35 (meters) with ISO 100 and flash zoom head set to 50mm position. See table in this section.

Coverage: Flash zoom head settings to cover angle of view of 24mm lens, 35mm, 50mm and 85mm or longer.

Film Speed: Set automatically by camera.

Operating Distance Range with ISO 100:

Zoom Head Setting	Distance Range (meters)
24mm	0.5—12.5
35mm	0.5—15
50mm	0.5—17.5
85mm	0.5—20

Bounce Angles: Tilts up to 90 degrees. Swivels 180 degrees to left and 90 degrees to right.

Power: Four AA-size alkaline, manganese or NiCad batteries.

Dimensions: 81 x 119 x 94mm (3-3/16 x 4-11/16 x 3-11/16 in.)

Weight: 395g.(13-15/16 oz.) without batteries.

300TL GUIDE NUMBERS ON M Hi (meters)									
Zoom Head	ISO Film Speed								
	25	50	64	100	200	400	800	1000	1600
24mm	12.5	17.5	20	25	35	50	70	79	100
35mm	15	21	24	30	42	60	84	94	120
50mm	17.5	24	28	35	49	70	99	110	140
85mm	20	28	32	40	56	80	113	126	160

NOTES: Guide Numbers for M Lo mode are above values divided by 4. To convert to feet, multiply meters by 3.3.

fully to make the exposure.

Pilot Lamp—When the Pilot Lamp first glows, the flash is not yet at full charge. To fire at that instant, use an aperture about one-half step larger than calculated. If it took 5 seconds of charging to turn on the Pilot Lamp, then an additional 5 seconds or so will bring the flash up to full charge.

Power Levels—There are two power levels. At M Hi, the flash operates at full power with the guide numbers in the accompanying table. At M Lo, the light output is 1/16 as much and the guide number is 1/4 as much.

Full power is used when the flash is the main source of light. Reduced power can be used for fill flash. Although not recommended by Canon, reduced power can be used as a repeating flash to make a *few* exposures with motor drive. If you make too many repeating exposures, the flash will overheat and may be damaged.

ZOOM HEAD

The flash zoom head can be manually moved in or out to change beam angle. There are four settings: 24mm, 35mm, 50mm and 85mm. Use the setting that agrees with the focal length of the lens in use, or the nearest smaller setting.

BOUNCE FLASH

The T90 with the 300TL flash provide a simple way to use bounce flash with automatic exposure. Set the flash to P for fully automatic operation. Tilt and swivel the flash head so it illuminates the bounce surface. To swivel, lift up the latch on the back of the head. When the flash head is set for bounce, a "bounce" symbol glows on the back of the flash.

When the Pilot Lamp glows, press the shutter button fully to make the shot. As the shutter button passes the halfway point, the flash emits a 1/20 power pulse which travels along the bounce path and is reflected by the subject. The reflected light is measured and the camera calculates the flash duration at full power needed for correct exposure of the subject.

When the shutter button reaches the bottom of its travel, the flash emits a full-power pulse using the previously calculated duration.

USING MULTIPLE FLASH UNITS

Accessories are available to use up to four 300TL or Macro Ring Lite ML-2 flash units connected together and to the T90 camera, using Connecting Cords 60 and Connecting Cords 300. The numbers are lengths in centimeters. Connection diagrams and instructions are in the 300TL instruction booklet.

THE NEW F-1 CAMERA

Canon introduced a new F-1 camera in 1981 to replace the earlier version of the F-1. This discussion covers the New F-1. The "old" F-1 was discussed in earlier printings of this book. Accessories are not interchangeable between the two models, except for items that fit the lens mount, viewfinder eyepiece or hot shoe.

The F-1 is basically a durable and reliable mechanically operated camera that can be used with manual exposure control or several kinds of automatic operation. On manual, it uses match-needle metering. It uses interchangeable viewfinders and focusing screens. Your choice of finder, screen and motor drive or power winder determines both metering pattern and the available modes of automatic operation.

VIEWFINDERS

An assortment of interchangeable viewfinders is available, as shown in the accompanying photo. To remove a finder, press the two release buttons and slide the finder backward along the metal rails. To install, place the finder on the rails and slide it forward until it clicks into place. In addition to providing different ways to view, the finder in use affects the available operating modes.

LOADING AND REWINDING FILM

Loading and rewinding film is similar to the procedures shown in Chapter 7, with some minor differences.

The back cover is opened by lifting up the Rewind Knob, as usual. To prevent lifting the knob inadvertently, you must first depress the adjacent Safety Lock Button, which some literature calls a Safety Stopper.

The Film-Rewind Knob and the Film-Rewind Crank are mechanically connected to the spool inside the film cartridge only when the Film-Rewind Crank is unfolded to the position used for manual

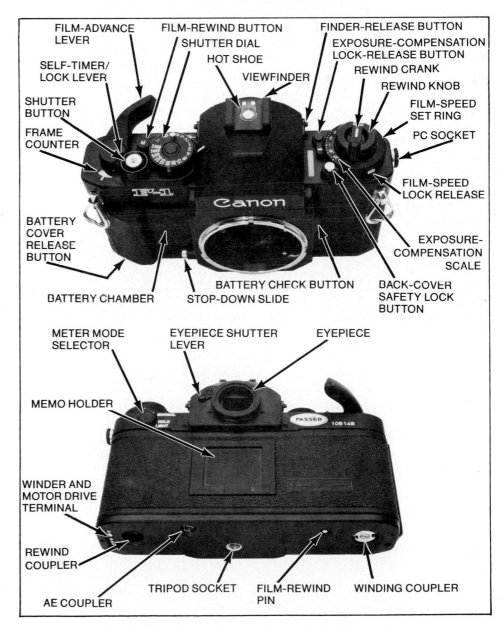

rewind. When the crank is folded into the rewind knob, both knob and crank are connected to the film spool through a slip clutch that will slip very easily.

This is because the F-1 is often used with a motor drive or power winder. With most cameras, when film is being advanced or rewound by a motor, the rewind knob rotates because of the motor. Some photographers get so close to the camera when shooting that the rotating knob can touch the photographer's face or forehead. With the F-1, a very light touch stops rotation of the knob.

Rotating the rewind knob to tension film in the camera may not work because the clutch will slip. To be sure, lift up the rewind crank and turn the crank. When rewinding manually, lift up the crank in the usual way and turn it in the direction of the arrow engraved on the crank.

Another difference is the location of the Film-Rewind Button. It's on top, near the shutter button, instead of on the bottom of the camera. To rewind film, first depress this button by turning it clockwise while pushing it down. It will lock in place. This disengages the takeup mechanism so film can be rewound. This control is also used in the multiple exposure procedure.

When the Film-Rewind Button is locked down, it will be released either by opening the back cover of the camera or depressing the shutter button halfway.

Rewinding can be done manually, using the Rewind Crank, or automatically by AE Motor Drive FN.

ON-OFF CONTROL

With a battery installed, depressing the shutter button partway, until slight resistance is felt, turns on the camera meter and electronics. There are two other controls that affect this operation:

Meter Mode Selector—When set to **NORMAL**, the meter and

By choosing one of these interchangeable viewfinders for the F-1, you can set up for virtually any need. AE Finder FN is recommended for aperture-priority automatic exposure and stopped-down automatic exposure. Without this finder installed, the camera will operate in these modes but there is no exposure display in the viewfinder.

camera electronics remain on only while you hold the shutter button down. Exceptions are the **B** and **A** settings on the Shutter Dial. The setting is 1/90 second, which is X-sync speed. None of these settings is metered.

When set to **HOLD**, you can release the shutter button and the camera remains on for about 16 seconds before automatically turning itself off. If you make an exposure before 16 seconds elapse, that turns the camera off. This setting can be canceled by pressing the Battery-Check Button.

The **LIGHT** setting causes a lamp to illuminate the viewfinder display for 16 seconds after the shutter button is depressed, or until an exposure is made, or until

the Battery-Check Button is pressed. You can turn off the light but keep the camera turned on until 16 seconds elapse by turning the control from **LIGHT** to **HOLD** or **NORMAL**. An exception is that there is no display illumination when the camera is set for aperture-priority or stopped-down automatic exposure.

SELF-TIMER/LOCK LEVER

This control surrounds the shutter button and has three settings. Set to **A**, the shutter button can be depressed and the camera operated in the normal way. Set to **S**, the electronic self-timer is set. The timer is started by depressing the shutter button all the way.

At **L**, the shutter button is

locked and cannot be depressed. This setting can also be used to hold the shutter open for a long time exposure by depressing the shutter button with the Shutter Dial set to B and the lock lever set to A. While holding the shutter button down, turn the lock lever to L. The shutter button will remain depressed and the shutter will remain open until you turn the lock lever back to A.

SHUTTER SPEEDS

If a battery is *not installed,* the camera will work at mechanically controlled shutter speeds of 1/90 (X-sync) to 1/2000, plus B. The shutter button operates mechanically to release the shutter, which also operates mechanically. The camera meter and electronics will not operate. Without a battery, if you set the Shutter Dial to 1/60 or any slower speed down to 8 seconds, the shutter will operate at 1/90 when you depress the shutter button.

With a charged battery installed, the meter operates and automatic operating modes can be used. Shutter speeds from 1/2000 to 1/90 continue to work mechanically but the shutter is *released* electrically. The shutter button requires less force from your finger. Also, the range of slower shutter speeds—1/60 to 8 seconds—is available. These are electronically controlled.

With a battery, the full range of shutter speeds is available—1/2000 to 8 seconds, plus B. The fastest shutter speed that can be selected automatically *by the camera* is 1/1000 second. When you choose shutter speed manually, 1/2000 can be used.

If a battery is installed, the camera requires battery power to operate. If the battery becomes discharged and you do not remove it, the camera will not operate. Removing the battery operates a switch in the battery compartment. This sets the camera to use the mechanical shutter speeds, operated mechanically by the shutter button.

F-1 SPECIFICATIONS

Type: 35mm SLR with metal focal-plane shutter.
Usable Lenses: FD lenses with full-aperture metering and automatic diaphragm. FL lenses with stopped-down metering.
Exposure Modes: Manual, stopped-down manual, aperture-priority automatic, stopped-down automatic, shutter-priority automatic, automatic with Canon flash.
Viewfinder: Interchangeable. Shows 97% of image vertically and horizontally. Has 0.8 magnification at infinity with standard 50mm lens. Eyepiece has −1 diopter. Accepts choice of 10 Dioptric Adjustment Lenses.
Aperture and shutter-speed displays can be illuminated on manual or shutter-priority automatic.
Viewfinder Information: Full information displayed in viewfinder outside of image area. See accompanying illustrations.
Focusing Screens: Interchangeable. Choice of focusing screen determines both screen type and metering pattern. See accompanying table.
Mirror: Instant return with shock absorber.
Shutter: Titanium, horizontal travel. Speed electronically controlled from 8 sec. to 1/60. Mechanical from 1/90 to 1/2000 plus B. Mechanical speeds operable with battery removed.
Shutter Dial: A, 8 seconds to 1/2000, special X-sync setting for mechanical operation at 1/90 second and B.
Self-Timer: Electronic. Audible beep-tone during ten-second delay.
Film-Speed Range: ASA 6 to ASA 6400.
Exposure Compensation: Plus or minus 2 steps in 1/3 steps.
Exposure Meter: Silicon photocell in camera body.
Metering Patterns: Center-weighted averaging, selective area or spot metering determined by choice of focusing screen.
Meter-Coupling Range: Aperture-priority automatic, EV −1 to EV 19. All other modes, EV −1 to EV 20. Based on *f*-1.4 and ASA 100.
Battery: One 6V lithium (PX28L), alkaline (A544) or silver-oxide (544), or equivalent.
Flash Synchronization: X-sync at 1/90 second or slower.
Film-Advance Lever: Single or multiple stroke. 30° standoff, 139° throw.
Film Rewind: Manual or by AE Motor Drive FN.
Multiple Exposure: With Rewind Button.
Back Cover: Removable to mount accessory data back or film chamber.
Dimensions: 146.7 x 48.3 x 96.6mm (5-11/16" x 1-15/16" x 3-13/16".
Weight: 795g (28-3/8 oz.) body only.

OPERATING MODES

There are six modes of operation, selected by your choice of accessory items and your settings of camera controls.

Manual Exposure Control— Available with any of the interchangeable viewfinders. Match the needles in the viewfinder exposure display for correct exposure of an average scene. To do this, set shutter-speed to any numbered setting on the dial; turn the lens aperture ring to any setting other than A.

You may prefer this mode when you want to use an exposure different than the camera meter suggests—perhaps because you are shooting a non-average scene or you wish to produce a special effect by over- or underexposing.

Stopped-Down Manual—Available with any of the viewfinders. This mode is referred to by Canon as stopped-down *fixed-index* metering.

It is used with lenses or lens accessories that do not allow full-aperture metering. Exposure is measured with the lens stopped down to shooting aperture. Release the Stop-Down Slide so lens stops down to the aperture set on the aperture ring. Select an aperture smaller than *f*-2.8. Turn the Shutter Dial so meter needle aligns with the Stopped-Down Metering Index adjacent to 5.6 in the viewfinder display.

Aperture-Priority AE—Only one of the interchangeable viewfinders provides this mode—AE Finder FN. AE signifies Automatic Exposure. Choose an aperture using the lens aperture ring. Set the Shutter Dial to A, which means the camera selects shutter speed automatically. The camera-selected shutter speed is indicated by a moving needle in the viewfinder display.

Stopped-Down AE—Requires AE Finder FN. Used with lenses or lens accessories that do not allow full-aperture metering. Set the Shutter Dial to A, which means the camera selects shutter speed automatically.

Release the Stop-Down Slide so lens stops down to the aperture set on the aperture ring. Set the lens to the desired shooting aperture. For metering accuracy, use an aperture smaller than *f*-2.8.

The camera will select a shutter speed automatically. Selected shutter speed is shown by moving needle display. This mode is especially useful in high-magnification photography such as through a bellows.

Shutter-Priority AE—This mode is available with any viewfinder. It requires either AE Power Winder FN or AE Motor Drive FN to be installed although not necessarily turned on. This is because the mechanical force to set aperture size is supplied by the motor attach-

On manual, match needles by placing straight meter needle through center of circular aperture needle. On stopped-down manual, aperture needle disappears. Align meter needle with fixed index at *f*-5.6. Shutter speed is in window below scale. Red zones at top indicate overexposure at three minimum apertures. Red zone at bottom indicate underexposure.

On shutter priority automatic, moving needle indicates aperture selected by camera. Shutter-speed setting appears in window. Red zones indicate over- or underexposure.

On aperture-priority automatic, moving needle shows shutter speed selected by camera. Aperture setting of New FD lens appears in window. Red zones indicate over- or underexposure. Stopped-down automatic display is similar except lens aperture not visible.

ment rather than the camera body.

Set the lens to A, which means the camera will set aperture automatically. Choose a numbered shutter speed on the Shutter Dial.

The viewfinder display shows the selected aperture.

If the lens aperture ring is set to A without a motor drive or power winder installed, the camera will not operate.

Electronic Flash AE—Fully automatic exposure using a Canon dedicated flash is provided when the camera is set for Shutter-Priority AE. When the flash ready-light goes on, the camera is automatically set to X-sync shutter speed and the correct aperture size. Other levels of automatic exposure are available with different accessory combinations as discussed later.

VIEWFINDER DISPLAYS

Displays with Eye-Level Finder FN or AE Finder FN are shown in the accompanying illustrations. On aperture-priority or stopped-down AE, a small lens on the front of the AE Finder FN views the aperture ring on a New FD lens and displays the setting in the viewfinder display. With an old-style FD lens or an extension tube between lens and camera, the aperture setting is not displayed.

With any of the other finders, the display is the same as with Eye-Level Finder FN. With both of the Waist-Level Finders, the display is on the left instead of the right.

CHOOSING A MODE

The accompanying table shows accessory combinations and camera control settings for the various modes.

A memory aid is to choose the A setting for the control to be set automatically by the camera. If you want lens aperture set automatically, set the lens Aperture Ring to A. If you want shutter speed set automatically, set the Shutter Dial to A.

Each of these settings is protected by a lock. To set the lens to A or away from A, you must depress the AE Lock Pin on the aperture ring. To turn the Shutter Dial to or away from its A setting, you must lift up the outer rim of the dial.

F-1 CONTROL SETTINGS AND ACCESSORY COMBINATIONS

Mode	Lens	Shutter Dial	Finder	Motor Drive or Power Winder
Manual	Not on A	Not on A	Any	Optional
Stopped-Down Manual	Not on A	Not on A	Any	Optional
Aperture-Priority AE	Not on A	A	AE Finder FN	Optional
Stopped-Down AE	Not on A	A	AE Finder FN	Optional
Shutter-Priority AE	A	Any Number	Any	Required
Electronic Flash AE	A	Not on B	Any	Required

Don't set both Aperture Ring and Shutter Dial to A at the same time. If you do, the aperture will close to its smallest value. The camera will set shutter speed automatically and give correct exposure if possible. Exposure time is likely to be long because of the small aperture. This applies with any finder installed.

To use aperture priority, install AE Finder FN. An extension arm from this finder projects over the camera Shutter Dial and works with a metal pin on top of the dial.

The correct procedure is to install the finder with the Shutter Dial not set to A, then turn the dial to A. This causes the pin to contact a movable tab on the bottom of the extension arm and move it toward the finder. This obscures the display at the right side of the focusing screen, which is used for shutter priority and manual operation. It exposes the display at the bottom of the screen, which is used for aperture priority.

If you set the Shutter Dial to A first, and then install AE Finder FN, the tab on the extension arm moves upward when it contacts the pin, instead of sideways. Neither of the displays is visible and the camera is not set to operate cor-

rectly. The remedy is to turn the Shutter Dial away from A and then reset it to A.

METERING

The meter does not operate if the Shutter Dial is set to A, B, or ⚡.

Metering Range—The metering range is from EV −1 to EV 20. The meter-coupling range defines the operating range of the camera. It varies with lens aperture and film speed as shown in the graph in Chapter 12.

Metering Method—Inside each focusing screen is a semi-reflecting layer, called a *micro beam splitter,* that reflects part of the light toward the back of the camera, through a rectangular window in the back of the focusing-screen frame. It falls on the silicon light sensor, which measures the amount of light. Three metering patterns are available, depending on your choice of focusing screen.

Metering Patterns—The micro beam splitter inside each focusing screen is a layer of tiny angled surfaces that reflect light to the silicon sensor at the back of the camera. The amount of light reflected by these angled surfaces and their locations in the focusing screen determine the metering pattern. Three metering patterns are available:

Center-Weighted Average Metering—Designated A, for *Average,* the area of maximum sensitivity near the center of the screen is symmetrical. This causes the meter to measure essentially the same area of the scene and give the same reading whether the camera is held for a horizontal or vertical format.

This pattern is recommended for use in general photography and automatic exposure (AE) photography.

Selective-Area Metering—Metering is only in a rectangle at the center of the screen, occupying 12% of the total frame area. Light outside this rectangle does not affect the reading. The metering rectangle is visible in the viewfinder because it is slightly darker than the surrounding area. This metering pattern is designated P for *Partial.*

This is a more precise measuring tool than center-weighted, but must be used thoughtfully. It is very useful to measure a small area of the scene, such as the shaded front wall of a backlit building. But, you must be aware of what you are measuring and the effect on overall exposure, if any, of measuring that part of the scene.

Manual exposure control is recommended with this metering pattern. Automatic exposure can be used, provided a representative area of the main subject is included in the metering area.

Spot Metering—Identified by the letter S, for *Spot,* this pattern measures light only in a circle at the center of the screen. It measures only 3% of the screen area. It is even more precise than selective-area metering and requires careful attention to the exact area being measured.

Recommended with a telephoto lens to meter faces of distant subjects, entertainers on stage, important subject areas in close-up photography, and similar applications. Normally used with manual exposure control rather than automatic.

171

FN-type focusing screens for New F-1 have two-letter identification. First letter is metering pattern. Second letter is screen type. This is a PE screen.

FOCUSING SCREENS

An assortment of interchangeable focusing screens is available, identified by a two-letter code. The first letter indicates the metering pattern. A is center-weighted average, P is selective area and S is spot metering. The second letter indicates the screen type, which states the basic features of each screen including focusing aids but not including metering pattern.

Some screens types are available with all three metering patterns, as you can see in the accompanying table.

Focusing screens for the New F-1 are Laser Matte except two, types J and K, which are the Bright Laser Matte type—approximately 20% brighter.

FILM SPEED

The ASA film-speed range is 6 to 6400. Film speed is set by pressing the Film-Speed Lock Release while turning the Film-Speed Set Ring, which surrounds the Film-Rewind Crank. An ASA Film-Speed Scale appears in a window at the back of the control. Set the desired film speed opposite an index mark at the top of the window.

Three metering patterns are available. A is center-weighted averaging, P is selective area, S is spot. Screen PE is standard with Eye-Level Finder FN. Screen AE is standard with AE Eye-Level Finder FN.

F-1 FOCUSING SCREENS

Type		Metering Pattern	
A Standard Microprism		A, P	Matte field surrounding microprism. For general use with all lenses. Also see types F and G.
B New Split		A, P, S	Matte field surrounding New Split focusing aid. Focusing aid does not darken at small apertures. For general use with all lenses.
C Overall Laser Matte		A, P, S	Overall matte field with no focusing aid in center. For macro and telephoto photography.
D Laser Matte with Grid		A, P	Matte field with 7mm grid. No focusing aid. Grid helps copy work and composition in architectural photography. Especially recommended with Tilt and Shift 35mm lens.
E New Split/ Microprism		A, P, S	Matte field with dual focusing aid: New Split rangefinder surrounded by microprism. Type E screen is standard for F-1.
F Microprism/Fast Lenses		A, P	Matte field surrounding microprism with prism angles that provide easier and more accurate focusing with fast lenses: f-1.2 to f-2.8.
G Microprism/Slow Lenses		A, P	Matte field surrounding microprism with prism angles suitable for slow lenses: f-3.5 to f-5.6. Microprism does not become dark.
H Laser Matte with Scale		A, P	Matte field with 1mm vertical and horizontal scales. No focusing aid. Used to set magnification precisely.
I Laster Matte with Reticle		A, P, S	Matte field with special focusing aid for high magnifications and astro photography. If cross hairs do not move across subject when you move your eye at eyepiece, image is in focus.
J Bright Laser Matte/Short Lenses		A, P, S	Very bright image on overall matte field. Effective in dim light with 50mm to 200mm lenses.
K Bright Laser Matte/Long Lenses		A, P, S	Very bright image on overall matte field. Suitable for 300mm lenses or longer, and high-magnification photography.
L Cross Split		A, P	Provides split-image focusing indication both vertically and horizontally. For use with all lenses.
M A/B Size Laser Matte		A, P	Overall matte field with special crop marks in corners. For use in publishing and advertising.

Normal setting for Exposure Compensation Dial is at 1.

EXPOSURE COMPENSATION

When photographing a non-average scene, the exposure-meter recommendation may not give good exposure. With the camera in any automatic mode, the best way to get more or less exposure than the camera would give automatically is to use exposure compensation.

Press the Exposure-Compensation Lock-Release Button while turning the Film-Speed Set Ring. Exposure compensation is indicated by a scale on the set ring. The numbers are factors or multipliers, from 1/4 to 4. This is a range of 2 steps under to 2 steps over.

In effect, this control changes the film-speed setting. When you don't want exposure compensation, return the control to 1. It's important to remember to do this because there is no signal in the viewfinder to indicate that you are using exposure compensation.

Because the intermediate steps on the film-speed scale are 1/3 steps, the subdivisions on the exposure-compensation scale are also 1/3 steps. The effect of changing the exposure-compensation setting appears in the viewfinder display as a changed reading.

The limits of the film-speed range also apply to the exposure-compensation control. If you have film speed set to ASA 6, you can't get two steps more exposure by using the exposure-compensation control. You can get two steps less exposure because that is the same as setting to ASA 25. Similarly, if ASA 6400 is set on the film-speed

scale, you can't use exposure compensation to get less exposure.

If you need more than two steps of exposure compensation, I suggest using the camera on manual and not matching the needles in the exposure display. Or, you can change the film-speed setting provided you remember to reset it to the correct value after the exposure.

INTERMEDIATE CONTROL SETTINGS

When on automatic, the camera can make intermediate settings of both shutter speed and aperture. When you are setting either of these controls manually, intermediate settings on the lens aperture ring are OK. Set the Shutter Dial exactly on a marked number. In-between settings cause no harm, but the camera will use the next higher or lower marked setting.

VIEWING DEPTH OF FIELD

The Stop-Down Slide is convenient to operate with the index finger of your left hand by reaching under the lens. When pushed in, it locks. This is the normal setting and the lens is not stopped down.

To stop down the lens, press and release the Stop-Down Slide. This allows the slide to move out. When fully extended, a red ring is visible at the base of the slide and the lens is stopped down to the aperture set on the aperture ring.

If the film is not advanced, you may not see correct depth of field. Always advance film before checking depth of field and you will never have this problem.

If the lens is not set to A, choose the aperture you will use for the next exposure. Release the Stop-Down Slide to see depth of field. If it is not what you want, change aperture as needed. Press in the Stop-Down Slide again. Adjust shutter speed if necessary for correct exposure. Make the shot.

If the lens is set to A, the camera is on automatic and the Stop-Down Slide cannot be operated. In the viewfinder display, notice the aper-

To use camera, set Self-Timer/Lock Lever to A.

ture that will be used to make the next exposure. Set the aperture ring to that f-number. Release the slide to view depth of field. If it is not what you want, change aperture as needed. Then push the Stop-Down Slide in again. Return the aperture ring to A. Change shutter speed if necessary so the display indicates the desired aperture size. Make the exposure.

SELF-TIMER/LOCK LEVER

A tab extending toward the front of the camera is used to turn a ring around the shutter button. It has three settings.

Shutter Lock—Turn the ring to L and the shutter button cannot be depressed. If you depress the shutter button on B, you can use this setting to hold it down for a time exposure.

Normal Operation—Set this control to A to unlock the shutter so you can use the camera in the normal way.

Self-Timer—At S, the electronic self-timer is set to operate, if a battery is installed in the camera. Start the timer by depressing the shutter button. After ten seconds delay, the shutter will operate. A beep tone sounds intermittently during the first eight seconds of delay, then speeds up for the final two seconds.

To cancel the self-timer before the shutter operates, press the Battery-Check Button. To prevent starting it again when you depress the shutter button for the next exposure, set the Self-Timer/Lock Lever to L or A.

With a motor drive or power winder installed and set to operate, use of the self-timer will cause a single frame to be exposed even if you have the motor drive or winder set to expose continuous frames.

The self-timer will not operate without a battery in the camera. If you set the self-timer anyway and depress the shutter button, the shutter operates immediately.

With the Shutter Dial set to **B**, the self-timer will count down and the shutter will open, but it will close again immediately. This is not correct operation for **B**.

Eyepiece Shutter Lever—If your eye will not be at the viewfinder eyepiece when you press the shutter button *and when the shutter operates,* move the Eyepiece Shutter Lever upward to expose a red dot. This closes an internal shutter and prevents light from entering the viewfinder through the eyepiece. The result could be underexposure.

On aperture-priority automatic and manual, exposure is set at the instant you press the shutter button. If you are using the self-timer, do not stand in front of the camera when pressing the shutter button because this may cause incorrect exposure.

On shutter-priority automatic, the camera sets exposure just before the shutter is released. If you are using the self-timer, this will be ten seconds after you press the shutter button.

FRAME COUNTER

The number **1** on the frame counter is colored red as an aid to loading film and setting to frame 1. The numbers **12, 20, 24** and **36** are also colored red as a reminder that you may be out of film. Some film cartridges have these numbers of frames. After frame 36, there are three dots, representing frames up to 39. If there is still film in the camera, the frame counter remains at the highest count but you can continue to advance and shoot film.

The frame counter is reset auto-matically to **S** any time the camera back cover is opened. It does not count backward when you rewind film.

MULTIPLE EXPOSURES

Before making the first exposure on the frame, lift up the Rewind Crank and turn it clockwise until you feel slight resistance. This takes slack out of the film path so the film is less likely to move during the multiple-exposure procedure.

With Manual Film Advance:
1. Make the first exposure.
2. Push down the Film-Rewind Button.
3. Operate the Film-Advance Lever on the camera through one full stroke. This sets the camera mechanism to make another exposure, but does not advance the film because the rewind button is down.
4. Make the next exposure.

Operating the shutter button on the camera releases the rewind button. To make another exposure on the same frame, repeat from step 2.

If you don't want to make another exposure on the same frame, just operate the Film-Advance Lever. This will advance the film because the rewind button is not depressed.

With Motorized Film Advance:
1. Tension the film and make the first exposure.
2. Push down the Film-Rewind Button.
3. Make the next exposure using the shutter button on the motor drive or power winder.

Only the shutter button on the camera releases the rewind button so, at this point, it is still depressed. To make another exposure on the same frame, just repeat step 3.

The motor drive or power winder operates immediately after each exposure. If you make the last of the multiple exposures using the shutter button on the motor drive or winder, the camera is ready to make another exposure, but the film has not been advanced because the rewind button was down when the motor operated.

To prevent another exposure on that frame, put a lens cap on the lens. Depress the shutter button *on the camera.* This releases the rewind button, opens the shutter and makes a "blank" exposure on that frame. Then the motor will advance film for the next frame, and you can make following exposures in the normal way.

A simpler procedure is to make the last of the multiple exposures using the shutter button on the camera. This will release the rewind button and the motor will advance the next frame.

Frame Counter—The frame counter advances during multiple exposures whether the film is manually advanced or driven by a motor.

FLASH

Before mounting or connecting a flash unit, be sure it is turned off.

The F-1 can use flashbulbs, ordinary electronic flash including automatic models, and dedicated Canon flash units. See the accompanying flash sync table.

Without a battery in the camera, there are no automatic features with any flash. Set the Shutter Dial to $\not{}$ for X-sync, 1/90 second, with electronic flash. Use the flash guide number to set aperture.

CANON DEDICATED FLASH

This discussion applies to an F-1 with battery installed and a Canon A-series flash mounted in the hot shoe or a G-series flash connected to the hot shoe. In this discussion, reference will be made to the viewfinder display. To see the display, it is necessary to depress the shutter button halfway. It is convenient to use the **HOLD** setting of the Meter Mode Switch to keep the display turned on.

The flash will provide "automation" the instant the flash ready-light turns on. When the ready-light is not on, the camera operates

F-1 FLASH SYNCHRONIZATION	
Flash	**Shutter Speed**
199A, 577G, 533G	1/90 or slower
188A, 177A, 166A, 155A, 133A, 011A, ML-1	1/90
Other Electronic Flash	1/90 or slower
Flashbulbs	1/30 or slower

NOTE: ⚡ symbol on Shutter Dial is 1/90 second.

as though the flash were not connected. The automatic features depend on control settings.

Flash Sets Both Shutter Speed and Aperture—With an F-1 set for Shutter Priority, which requires a motor drive or power winder, the flash sets shutter speed to the X-sync speed of 1/90, unless the Shutter Dial is set to B. It also sets lens aperture to the value required by the flash, as discussed in Chapter 16.

The flash-ready indication is either the ready-light on the flash or movement of the meter needle in the viewfinder. When the flash is ready, the needle moves up to the aperture size that will be set by the flash.

If the Shutter Dial is at B, the flash fires but the shutter remains open as long as you hold your finger on the shutter button.

Flash Sets Shutter Speed—With the camera set for manual exposure, with any viewfinder, the flash sets shutter speed to X-sync when the ready-light turns on—provided the Shutter Dial is not at B. The viewfinder indication is that the meter needle moves to the aperture size required by the flash. Turn the lens aperture ring to align the aperture needle with the meter needle. Then you can press the shutter button to make the exposure.

With the camera set for aperture-priority, which requires AE Finder FN, and the Shutter Dial not on B, the flash will set shutter speed to X-sync when the flash ready-light turns on.

Viewfinder indication is that the meter needle moves to a position equivalent to 1/90 second—that is, between 1/60 and 1/125. Observe the control settings of the flash unit to determine the required aperture. Set the lens to that aperture. Make the exposure.

Slow-Speed Automatic Flash—Some Canon flash units, the 199A, 577G and 533G, have a switch labeled:

AUTO-MANU. 1/60-30S.

When set to AUTO, the flash switches the camera to 1/90, as just discussed.

When set to MANU. 1/60-30S, you can select shutter speeds from 1/60 to 8 seconds on the Shutter Dial and the shutter will operate at the selected speed. Exposure by flash will be the same as at 1/90. Exposure by ambient light is controlled by the length of time the shutter remains open.

This requires using the camera on manual or shutter priority.

Canon Flash On Manual—Most Canon flash units can be set for manual operation using their guide numbers to determine exposure. To use this mode, set the F-1 for manual operation also. Do not set the Shutter Dial to B.

When the flash ready-light turns on, the meter needle in the viewfinder will move all the way to the top—into the overexposure zone. Disregard the overexposure indication. Use the flash guide number to calculate aperture and set that value on the lens aperture ring. Make the exposure.

Canon Flash Connected To The PC Socket—With a Waist-Level Finder, which does not have a hot shoe, it is necessary to connect flash to the camera's PC Socket using a flash sync cord. You must set both shutter speed and aperture manually. Set the Shutter Dial to ⚡ for X-sync. Set lens

aperture to the value required by the flash.

MORE THAN ONE FLASH

One flash unit may be mounted in the hot shoe and another connected to the PC Socket on the F-1. Both will fire simultaneously.

OTHER FLASH UNITS

Canon cautions that other brands of flash may not work properly and may cause damage to the camera. If you use flash of another brand, follow these precautions: Turn off the flash before connecting it to the camera, or disconnecting it. Before removing or disconnecting the flash, press the test button to fire the flash and discharge the capacitor.

Set the F-1 for manual operation. Set the Shutter Dial at ⚡ for X-sync. If the flash is manual, use its guide number to calculate aperture. If the flash is automatic, use the aperture required by the flash. Set the aperture ring to the desired value.

BATTERY CHAMBER

The Battery Chamber cover is molded to provide an Action Grip that makes holding the F-1 more comfortable and more secure. To remove the cover, depress a push-button on the bottom surface of the grip and lift the cover off.

You can then remove and replace the 6-volt battery. If the camera will not be used for three weeks or longer, remove the battery and store it separately.

BATTERY CHECK

The Battery Check Button is on the camera body, adjacent to the lens mount and convenient to operate with your left index finger.

The battery can be checked with the Shutter Dial at any setting other than A. If the Shutter Dial is set to B, you can check the battery only if film has been advanced.

To check the battery, push the check button in while observing the meter needle in the viewfinder. If it rises above the Battery-Check Index mark, opposite f-5.6, the battery is OK. If the needle is

at or below the check mark, the battery is near failure and should be replaced. If the camera works with a weak battery, operation will be correct.

The absolute indication of discharge is that the shutter will not operate when you press the shutter button. You can remove the battery and use the mechanical shutter speeds.

Three types of 6-volt batteries may be used: alkaline, silver-oxide or lithium. Electrical output is reduced in cold weather, but the lithium type performs best. In extreme cold, keep one or more spare batteries warm in your pocket and occasionally interchange one with the battery in your camera.

When To Test—It's a good idea to test the battery after installing a new one; before you install a motor drive or power winder because they make the battery chamber inaccessible; if the shutter doesn't operate when you think it should; before and after making a series of long exposures except on **B**; when using the camera in cold weather; after storing the camera; before going on a trip; and whenever you want to be sure of the next shot.

Additional Functions—When the Battery-Check Button is pressed, it cancels any electronic proce-

dures that are underway in the camera. If the Meter Mode Selector is on **HOLD** or **LIGHT**, the function is turned off just as if the 16-second holding period has elapsed. It also cancels the self-timer. If the shutter is open to make a long exposure, the timing circuit is reset to zero when you press the Battery-Check Button and the shutter will close when you release the button.

UNUSABLE LENSES

A few older lenses cannot be mounted on the F-1. They are:
FL 19mm *f*-3.5 FL 58mm *f*-1.2
R 50mm *f*-1.8 R 58mm *f*-1.2
R 100mm *f*-3.5 R 100mm *f*-2
FLP 38mm *f*-2.8

ACCESSORIES

The F-1 can use all Canon lenses except for the above, and lens accessories and all viewfinder eyepiece accessories. It can use any flash that fits a conventional hot shoe or PC socket. Special accessories include interchangeable viewfinders, interchangeable focusing screens, AE Motor Drive FN, AE Power Winder FN, Data Back FN, Film Chamber FN-100 and Battery Cord C-FN. For remote control, you can use Interval Timer TM-1 Quartz or Wireless Controller LC-1. Time Lapse Programmer Units A and B are available for time-lapse photography.

AE MOTOR DRIVE FN

This motor drive will advance single frames or expose frames continuously at rates up to 5 frames per second. It can also be used to rewind film.

The motor drive consists of a grip and a body that extends across the bottom of the camera. A separate battery case attaches to the bottom of the motor drive unit.

To Install—Turn the motor drive off before installing or removing it from the camera. To install, remove the Winding Coupler Cover, the AE Coupler Cover and the Rewind Coupler Cover from the camera bottom. These covers can be nested together and installed in a Coupler Holder on the bottom of the motor drive.

CAUTION: Do not remove the Rewind Coupler Cover or remove an installed motor drive unit with film in the camera. Either of these actions will admit light into the camera body through the rewind opening. This will cause the film that has already been exposed to become light struck and ruined.

Turn the camera upside down so the metal loop for the camera strap does not interfere with the grip of the motor drive. Hold the motor drive in correct position on the bottom of the camera. Turn the Attachment Screw into the tripod socket until the motor drive is snug against the camera.

Power Sources—Three battery cases are available.

Battery Pack FN uses 12 AA-size carbon-zinc or alkaline batteries. If the motor drive will not be used for three weeks or longer, remove the batteries and store them separately. Do not use nickel-cadmium (abbreviated Ni-Cd, NiCd or Ni-Cad) cells in Battery Pack FN.

Ni-Cd Pack FN and High Power Ni-Cd Pack FN are rechargeable power sources with built-in Ni-Cd batteries. They are recharged by Ni-Cd Charger MA/FN. The high-power pack has better cold-weather performance and will

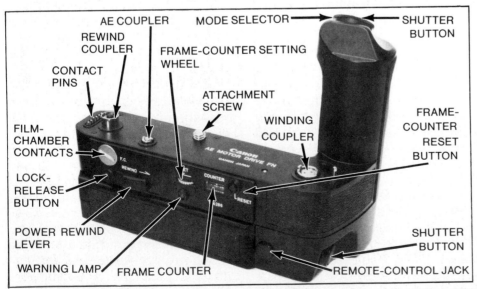

AE Motor Drive FN uses separate power source that attaches to bottom. Ni-Cd Pack FN is shown here.

operate at a higher speed, as you can see in the accompanying table.

You can use the High Power Ni-Cd Pack FN to power the camera, which is recommended for operation in cold weather. Remove the standard Battery Chamber Cover and the battery from the camera. Install Battery Cord C-FN. One end of this cord replaces the camera Battery Chamber Cover and makes contact with the electrical terminals inside. The other end plugs into a power socket on the front of the High Power Ni-Cd Pack FN.

The battery packs all mount the same way on the bottom of the motor drive. At the end near the grip, an Attachment Screw with a coin slot screws into a socket on the motor drive. At the other end, a pin fits into a socket on the motor drive and is clamped by a Lock Lever on the motor drive unit. When a red dot is visible on the Lock Lever, the clamp is released. To install, place the battery pack in correct alignment on the motor drive. Operate the Lock Lever, then turn the Attachment Screw.

Battery Check—Battery Pack FN has a Battery-Check Button with signal lights. Green means OK. Red means the batteries are nearly discharged. No illumination means the batteries must be replaced.

With either of the Ni-Cd packs, excessive discharge is indicated when the motor drive will not operate.

Insufficient Power—Shutter-priority operation of the F-1 depends on power from a motor drive or power winder. If the battery pack is discharged, all shutter buttons lock. Move the lens Aperture Ring away from **A** and you can continue to use the camera with manual or aperture-priority automatic exposure.

Mode Selector—The Mode Selector surrounds the Shutter Button on top of the grip. There are four settings: OFF, **S** for single frames, **L** for continuous exposures at

AE MOTOR DRIVE FN OPERATING SPEED (FRAMES PER SECOND)			
Power Source	MODE SELECTOR		
	S	L	H
Battery Pack FN	1	3.5	5
Ni-Cd Pack FN	1	3	4.5
High Power Ni-Cd Pack FN	1	3.5	5

AE MOTOR DRIVE FN SHUTTER-SPEED RANGE	
Mode Selector	Shutter-Speed Range
H	1/2000 to 1/60
L	1/2000 to 8 seconds
S	1/2000 to 8 seconds

slower motor speeds, and **H** for continuous exposures at faster speeds as shown in the accompanying table.

Shutter Buttons—There are three: one on the camera, one on the top of the motor-drive grip, and one on the right end of the battery pack that can be used for vertical-format shots. Each has a lock to prevent accidental operation. Only the control in use must be unlocked.

Depressing one of the buttons partway turns on the viewfinder display in the camera. Depressing it fully operates the camera shutter and the motor drive.

If the camera battery discharges and you remove it so the camera will operate mechanically, the motor drive will advance single frames only, even if set for continuous operation. Only the camera shutter button can be used to operate camera and motor drive.

If the camera is set to operate on **B**, use the camera shutter button. If you depress one of the shutter buttons on the motor drive, the shutter will operate at 1/1000 second.

Warning Lamp—On the back of the motor drive is a red LED Warning Lamp. This lamp glows red and the motor stops when the motor-drive frame counter counts down to zero or anytime the winder cannot complete a film advance. This can happen at the end of the roll, or if the film jams for any reason. When the LED lamp turns on, turn the motor drive off to conserve battery power.

Frame Counter—When loading film, press the Reset Button on the motor drive to reset the motor-drive film counter. It resets to **S**, just as the camera frame counter does.

Advance two frames to bring frame 1 into position for exposure. You can do this with the camera Film-Advance Lever or with the motor drive set for single frames. Either way, both counters operate.

This brings the camera frame counter to 1, but it brings the motor-drive frame counter to 36. From there, the motor-drive counter counts down while the camera frame counter counts up in the normal way.

The motor drive will stop advancing film when its counter reaches zero. You can set the motor-drive counter to any number of frames less than 36. If you loaded a cartridge with 20 frames, set the counter to 20.

When shooting frames continuously, you can use the counter to control the number of frames exposed in one burst. If you set it to 12, it will stop when 12 frames have been exposed. You can then reset to expose the next group of frames.

DATA BACK FN

DATA BACK FN SPECIFICATIONS

Function: Imprints date or data in lower right corner of frame automatically or by manual pushbutton.

Right Dial (Day): Selects numerals 0 to 32 or two blanks.

Center Dial (Month): Selects numerals 0 to 31, letters A to G, or blank.

Left Dial (Year): Selects numerals 0 to 9, 81 to 92, or Roman numerals I to X, or letters a to g.

Pilot Lamp: Shows unit is ready to operate.

Exposure Adjustment: Three settings: Use 1 for ASA 200 to 400 with color film and ASA 125 to 400 with b&w; 2 for ASA 64 to 160 with color film and ASA 25 to 100 with b&w; 3 for ASA 25 to 50 with color film.

Power Source: One 6V battery, alkaline (A544), lithium (PX28L), or silver-oxide (544).

each triple exposure, and so forth. You can turn off the winder and complete the roll manually. Or, use the **SET** control to reset the counter so you can shoot those frames using the motor.

Rewinding Film—When the winder counter reaches 0, it stops and the Warning Lamp glows. The simplest procedure is to begin by turning off the winder. Depress the Rewind Button on the camera, lift up the Rewind Crank and turn it clockwise until you feel the film end pull out of the takeup spool. Open the camera back and remove the cartridge. Depress the **RESET** button while reloading.

If you prefer, you can leave the winder turned on. Depress the **RESET** button. Depress the Rewind Button on the camera and use the Rewind Crank to rewind the film. Then move the Film-Advance Lever through one full stroke, which will turn off the Warning Light. Open the back, remove the film and reload.

Remote Control—A Remote Control Jack on each battery pack allows remote control by Remote Switch 3 or 60, by Interval Timer TM-1 Quartz, by Wireless Controller LC-1, a Time Lapse Programmer, or other equipment. Your Canon dealer can put you in touch with a Canon Technical Representative if you need more information about remote control.

Turn the power winder off before attaching a remote-control device to avoid tripping the shutter inadvertently.

When remote control is used, there is no viewfinder display in the F-1.

DATA BACK FN

Data Back FN replaces the back cover of an F-1 camera, which is removed by sliding the hinge pin downward. It uses a 6-volt battery in a chamber on the left side. Electrical connections between camera body and the data back are made automatically.

The data back exposes letters and numbers onto the film in the lower right corner of the frame. Data to be recorded is selected by rotating three dials marked **YEAR**, **MONTH** and **DAY**. They can be used for dating the frame, but the dials also have letters and other symbols as shown in the specifications, so other kinds of data can be encoded using the available symbols.

Exposure is made by a lamp in the data back. If the Main Switch is **ON**, each frame is exposed as the camera is operated—either manually or with AE Power Winder FN at up to 2 frames per second. An Indicator Lamp on the data back glows when it is ready to operate and goes out while it is recycling. At temperatures of freezing or below, the data back may not be able to operate at 2 frames per second. Installing a warm battery in the data back will restore normal operation.

Data printing can be controlled manually, using a Manual Button on the data back. Thus, you can print data on some frames, but not all, as you choose. If the battery is removed from the F-1, for mechanical operation, data can be imprinted only by pressing the Manual Button.

The film emulsion is exposed from the back, through the film base. The Light Intensity Dial should be set according to the accompanying table.

LIGHT INTENSITY DIAL SETTINGS	
Film Type	**Setting**
Color, ASA 200 to 400	1
Color, ASA 64 to 160	2
Color, ASA 25 to 50	3
B&W, ASA 125 to 400	1
B&W, ASA 25 to 100	2

Film Chamber FN-100 holds 100 frames but is small and light enough to handle easily. Useful for sports and action photography, or a copy-stand setup.

FILM CHAMBER FN-100

To increase the film-holding capacity of the F-1, use Film Chamber FN-100. This holds up to 100 frames of film—plus about 10 frames for leader—in a Film Magazine FN-100. The magazine must be loaded from a bulk film roll in a darkroom, using Film Loader 250.

Using the film chamber requires also using AE Motor Drive FN. You can shoot single frames with the motor drive Mode Selector set to S or at speeds up to 5 frames per second with the Mode Selector set to L or H.

Remove the cover labeled F.C. on the back of the motor drive. Store the cover in a socket on the bottom of the film chamber. This exposes electrical contacts that automatically connect to the film chamber when installed.

Attach AE Motor Drive FN to the F-1. Remove the back of the F-1 and attach the film chamber, following instructions packaged with the film chamber.

The film chamber has a grip for your right hand with a shutter button and shutter-button lock on top. You can use this, or either of the buttons on the motor drive, or the button on the camera.

You can load as many film magazines as you need. When loaded and closed, they can be handled in daylight. Following instructions, place a loaded magazine on the left side of the film chamber. Put an empty magazine on the takeup side. Pull film across and wind the end into the takeup magazine. Close the film chamber. Advance six frames to bring frame 1 into position.

The film chamber has a resettable frame counter that counts down to zero. Set it to the number of frames you have loaded, not counting leader. This counter indicates the number of frames remaining, but does not control the camera or motor drive. You can continue shooting, after the counter passes zero, until the last frame is exposed and the film is entirely wound into the takeup magazine. Then the Warning Lamp on the motor drive glows. Turn off the motor drive.

Film is not rewound into the feed magazine. Open the back and remove the takeup magazine. The back-opening procedure requires you to close this magazine so light cannot strike the film.

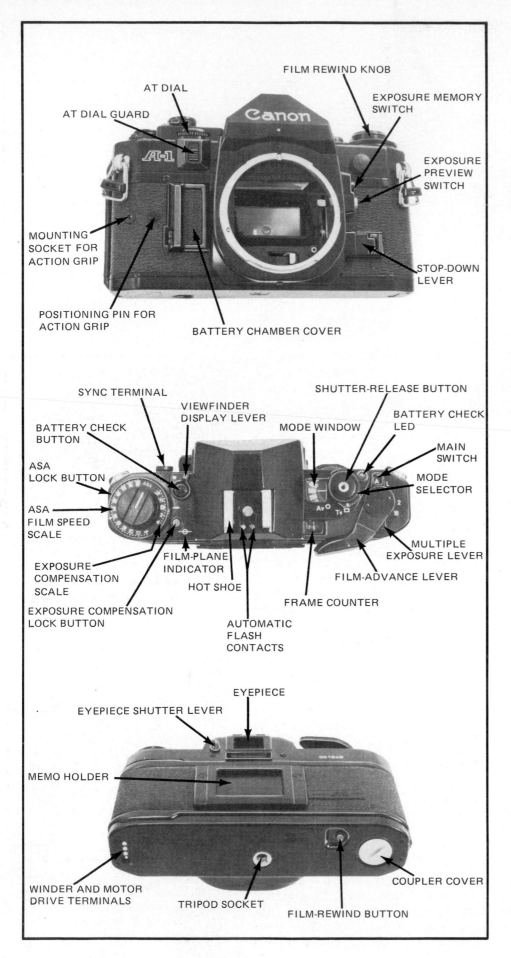

AT DIAL

AT DIAL GUARD

FILM REWIND KNOB

EXPOSURE MEMORY SWITCH

EXPOSURE PREVIEW SWITCH

MOUNTING SOCKET FOR ACTION GRIP

POSITIONING PIN FOR ACTION GRIP

BATTERY CHAMBER COVER

STOP-DOWN LEVER

SYNC TERMINAL

VIEWFINDER DISPLAY LEVER

SHUTTER-RELEASE BUTTON

BATTERY CHECK BUTTON

MODE WINDOW

BATTERY CHECK LED

MAIN SWITCH

ASA LOCK BUTTON

MODE SELECTOR

ASA FILM SPEED SCALE

EXPOSURE COMPENSATION SCALE

FILM-PLANE INDICATOR

HOT SHOE

MULTIPLE EXPOSURE LEVER

FILM-ADVANCE LEVER

EXPOSURE COMPENSATION LOCK BUTTON

AUTOMATIC FLASH CONTACTS

FRAME COUNTER

EYEPIECE

EYEPIECE SHUTTER LEVER

MEMO HOLDER

WINDER AND MOTOR DRIVE TERMINALS

TRIPOD SOCKET

FILM-REWIND BUTTON

COUPLER COVER

THE A-1 CAMERA

The A-1 is both simple and complex. This compact camera can be set to operate six different ways with FD lenses—five of them with automatic exposure! It's simple because one of the automatic modes, called Programmed Automatic Exposure (AE) sets both shutter speed and aperture size for you automatically. All you have to do is focus.

Set the lens at its hyperfocal distance and you eliminate the necessity of focusing, except for subjects very close to the camera. Add a motor drive or power winder and it advances film automatically. There's nothing left to do except operate the shutter button.

It's also complex because of all the different ways it can operate and the variety of control settings you make to select the mode of operation. The A-1 is an amazing leap forward in camera technology, with a very sophisticated digital computer built into the camera.

OPERATING MODES

The six modes of operation are briefly described here along with the reasons for choosing among them.

Aperture-Priority AE—You set aperture; the camera chooses shutter speed for correct exposure of an average scene. Use this mode when depth of field is important. If you choose small aperture to get lots of depth of field, the camera may use a very slow shutter speed that makes hand-holding difficult or impossible.

Shutter-Priority AE—You set shutter speed; the camera chooses aperture size for correct exposure of an average scene. Use this mode with moving subjects—either to stop motion or to produce a controlled amount of blur by choosing a slow shutter speed. If you choose a very fast shutter speed to stop motion, the camera may choose a large lens opening and you'll get little depth of field.

Nothing intrudes into the image area of the A-1 so you can concentrate entirely on picture composition. All data is in the digital readout below the image.

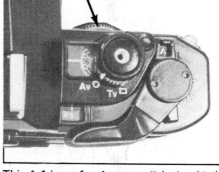

When set for Programmed AE, the A-1 makes shutter-speed and aperture changes by following the dotted line on this graph.

Programmed AE—The camera sets both shutter speed and aperture size as described in Chapter 8, following a program that is built into the camera's computer. The program is shown in the accompanying illustration.

Use this mode when you don't have a specific shutter speed or aperture in mind, or when you don't want to bother with exposure settings. You can let the camera do it while you concentrate on composition of the photo. If you allow an inexperienced person to use your A-1, set it for Programmed AE and good exposures should result.

Electronic Flash AE—Using the special Canon "dedicated" flash units, the camera is automatically set to the correct shutter speed and aperture size when the flash ready-light goes on. This gives very simple and nearly foolproof flash photography. All you have to do is consult the calculator dial on the back of the flash unit and stay within the automatic operating-distance range.

Stopped-Down AE—When using non-meter-coupled accessories between lens and camera, or an FL lens, or an FD lens not set to A, you control lens aperture manually.

You can still operate with automatic exposure. The camera will set shutter speed to give correct exposure of an average scene.

Manual Override—Exposure control is not automatic. You set shutter speed and lens aperture manually. The camera exposure-measuring system continues to work but it doesn't set any controls. The camera display shows the shutter speed you have selected and the aperture size the camera exposure meter recommends for an average scene. You can set aperture to the recommended value, or not, as you choose. You may prefer this mode when you want to use an exposure different than the camera meter suggests—perhaps because you are shooting a non-average scene or you wish to produce a special effect by over- or underexposing.

ON-OFF CONTROL

The Main Switch turns the camera on and unlocks the shutter button when set to A. In the L position, the shutter button is locked.

SHUTTER SPEEDS

The camera will time exposures from 1/1000 to 30 seconds. If you need longer exposures, use a locking cable release.

Using The Shutter Button—If

This A-1 is set for Aperture Priority (Av) and the AT Dial (arrow) is set at *f*-16. Main Switch is set to A so the camera is turned on and can be operated.

This A-1 is set for Programmed Shutter AE as you can see in the Mode Window. Main Switch is being used as self-timer control. Timer is set for 2 seconds. Battery Check LED (arrow) will flash as self-timer counts down.

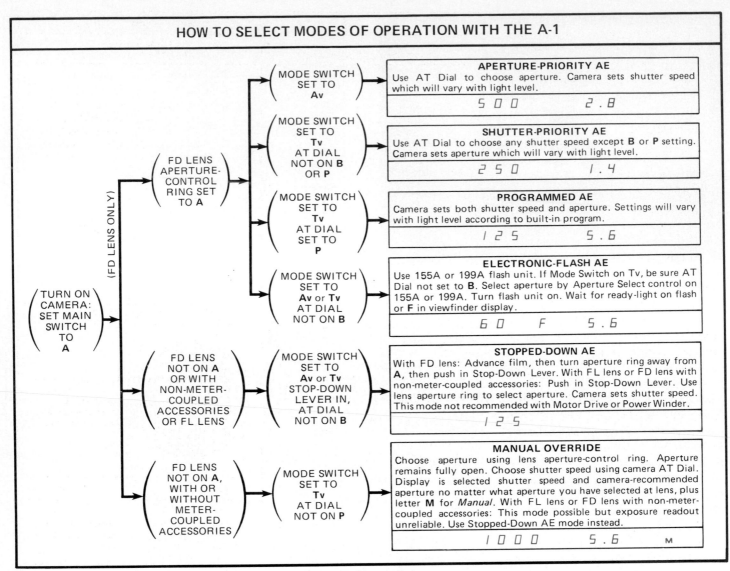

Figure 18-1/This "road map" shows how to set an A-1 for any of its modes.

you operate the button quickly, without pausing for the data display in the viewfinder, the data may not be displayed at all and the camera may hesitate before releasing the shutter. Exposure will be the same as if you had operated the button slowly. If you depress the shutter button very rapidly, the shutter may not operate at all.

Once the shutter button is fully depressed and the camera cycle of operation has started, you don't need to hold the button in, even for longer exposures. The exposure settings are memorized in the camera's digital computer at the instant of shutter-button operation and the camera will operate accordingly.

CHOOSING A MODE

Choosing the mode of operation is done by setting controls in a logical sequence as shown in Figure 18-1.

For any mode, the first step is to turn the Main Switch from L to A. The next choice is automatic or non-automatic. The control is the aperture ring on an FD lens. Set the ring to the green A or O and the camera is on automatic. Turn the ring away from A, to any f-number setting, and the camera is not on automatic. Only an FD lens that is mounted directly on the camera, or with meter-coupled accessories between lens and camera, can be set for automatic operation.

Then you choose one of two settings of the Mode Switch. As you remember from Chapter 8, Exposure Value (EV) is the combination of Aperture value (Av) and Time value (Tv). The Mode Switch has two settings: Av and Tv.

If you select Av, you control aperture; the camera will set shutter speed for correct exposure of an average scene.

If you select Tv with the camera on automatic, you set shutter speed and the camera sets aperture size automatically—with one exception, discussed later.

After setting the Mode Switch, operate the AT Dial with your right forefinger. In every automatic mode of operation, you use the

AT dial to do *your part* of setting exposure. The same control sets aperture size or shutter speed, depending on where you have set the Mode Switch. When you move the Mode Switch, a mask moves to the left or right in the Mode Window.

If you select **Av**, the mask moves to show you a scale of aperture numbers. Use the AT Dial to select aperture.

If you select **Tv**, the mask moves the other way to show a scale of shutter speeds. Use the AT Dial to select a shutter speed.

The exception mentioned earlier is Programmed AE. The setting for this mode is the symbol **P**, which is on the shutter-speed scale, just past **1000**. When you have the Mode Selector set to **Tv**, use the AT Dial to select **P** if you want Programmed AE.

In all modes of operation except one, the camera Stop-Down Lever is left in its normal position, not pushed in. To set up for Stopped-Down AE, the last step is to push in the Stopped-Down Lever.

Using Aperture Smaller Than *f*-22—When set for automatic, the smallest aperture you can select with the AT Dial is *f*-22. Some Canon lenses have smaller apertures. If you need to use a smaller aperture than *f*-22, set the camera controls for Stopped-Down AE and control lens aperture manually, using the aperture ring on the lens.

AT Dial Guard—To prevent accidentally changing the setting of the AT Dial, slide the AT Dial Guard upward. The guard covers the AT Dial completely so it can't be changed.

VIEWFINDER DISPLAY

The viewfinder display is turned on by depressing the shutter button partway—until you feel resistance—or by depressing the Exposure Preview Switch or by depressing the Exposure Memory Switch.

The display is just below the viewfinder image area. It uses digi-

tal "computer" characters formed by red LEDs. The brightness is controlled automatically, so the display is neither too bright nor too dim in respect to the focusing screen.

Camera control of shutter speed and aperture is "stepless," meaning that any value can be chosen automatically whether or not the value is a marked shutter-speed or *f*-number.

To avoid confusion, the display shows aperture and shutter speed to the nearest half-step and it changes the reading at half-second intervals or slower to give you time to read the display. If the scene illumination is changing rapidly, the viewfinder display

may be both approximate and slightly behind in reporting settings to you. However, the camera itself responds instantly to changed light values.

Most of us are not accustomed to seeing half-steps in shutter speed and aperture. For example, 180 is halfway between 125 and 250 on the shutter-speed scale, and *f*-19 is a half-step larger aperture than *f*-22.

The digital language of the A-1 camera is shown in Figure 18-2, along with the two scales set by the AT Dial.

Display Switch—When operating on automatic, or with Canon dedicated flash units, you may not be interested in seeing the view-

Figure 18-2/The A-1 uses these symbols in the digital readout.

PROBLEM	WARNING, RESULT & CORRECTION
APERTURE-PRIORITY AE	
You choose an aperture on the AT Dial that is larger than the maximum aperture of the lens.	No warning. Lens opens as much as it can. Camera chooses shutter speed for actual lens opening. Exposure is OK. Display shows max. aperture of the lens, rather than aperture on AT Dial.
You choose an aperture on the AT Dial that is smaller than the minimum aperture of the lens.	No warning. Lens closes as much as it can. Camera chooses shutter speed for aperture on AT Dial, rather than actual shooting aperture. Photo is overexposed. Display shows aperture on AT dial.
Overexposure	*1000 5.6* Camera chooses fastest shutter speed and flashes shutter-speed readout. Change to smaller aperture setting.
Underexposure	*30" 5.6* Camera chooses slow shutter speed and flashes shutter-speed readout. Change to larger aperture setting.
Light too dim for AE photography—below meter-coupling range.	*30" 1.4* Both shutter-speed and aperture readouts flash. Change to lens with larger maximum aperture; change to film with higher speed; put more light on scene.
Light too bright for AE photography—above meter-coupling range.	*1000 16* Shutter-speed readout flashes even at smallest aperture setting. Change to lens with smaller minimum aperture; change to film with lower speed; use ND filter; put less light on scene.
STOPPED-DOWN AE	
Camera Stop-Down lever locked in before FD or FL lens mounted on camera or on bellows or extension tubes that preserve automatic aperture such as Bellows FL, Extension Tubes FL, Extension Tubes FD 25 and 50.	No warning. Exposure will be incorrect. Avoid problem by always checking camera body before mounting lens. If you see red dot beside camera Stop-Down Coupling Lever, camera Stop-Down Lever is locked in. Release Stop-Down lever before mounting lens.
When switching from any other AE mode to Stopped-Down AE, lens aperture ring is turned away from A before film is advanced for next shot.	No warning. Preview metering and viewing depth of field may be done at wrong aperture because lens will not stop down smaller than shooting aperture for last exposure until film is advanced. This will not cause incorrect exposure because you must advance film before exposing next frame. When you shoot next frame, metering is done again, automatically, and exposure will be OK.
Intending to switch back to AE, you return lens aperture-control ring to A but forget to unlock camera Stop-Down Lever.	Warnings: Viewing screen is dark; display is shutter speed only. Camera will set exposure automatically but lens will remain at minimum aperture. Exposure will be correct if there is enough light. If not, shutter-speed display will flash. This is not recommended and severely strains camera mechanism.

PROBLEM	WARNING, RESULT & CORRECTION
SHUTTER-PRIORITY AE	
Possible overexposure	*125 22* An f-number from f-19 to f-32 will flash. This aperture is camera-recommended value for correct exposure. By flashing display, camera is "asking" you if the lens will stop down that much. If it will, exposure is OK. If minimum aperture of lens is larger than flashing aperture, overexposure is indicated. Correct by changing to faster shutter speed until flashing aperture agrees with minimum aperture of lens. If lens minimum aperture is f-32: Because f-32 is smallest aperture that can be displayed, a flashing f-32 is ambiguous because camera may have wanted f-64 or f-128. Test by switching to faster shutter speeds until flashing aperture readout changes to f-22. That setting will give correct exposure. Also one step slower shutter speed, with flashing f-32, will give correct exposure. If lens minimum aperture is f-16: Occasionally, f-16 may flash. Switch to faster shutter speeds until flashing aperture changes to f-11. Exposure will be OK at that shutter speed or one step slower, with f-16 flashing.
Underexposure	*500 1.4* Camera chooses large aperture and flashes aperture readout. Switch to a slower shutter speed until display stops flashing.
Light too dim for AE photography—below meter-coupling range.	*30" 2.8* Both shutter-speed and aperture readouts flash. Change to film with higher speed; increase light on scene; change to lens with larger maximum aperture.
Light too bright for AE photography—above meter-coupling range.	*1000 32* Aperture readout flashes even at fastest shutter-speed setting. Correction may be: Change to film with lower speed; decrease light on scene; use ND filter; change to lens with smaller minimum aperture.
ELECTRONIC-FLASH AE (With FD lens and Speedlite 155A or 199A)	
You set Aperture Selector on flash to call for aperture larger than maximum aperture of lens on camera.	*60 F 2.8* Display flashes maximum aperture of lens in use to indicate underexposure. Change Aperture Selector on flash to call for aperture lens can use.
You set Aperture Selector on flash to call for aperture smaller than f-16. Overexposure is possible if lens won't close down that far.	*60 F 22* Aperture requested by Aperture Selector on 155A or 199A will appear in display and numerals will flash on and off. If lens minimum aperture is equal to or smaller than flashing value, exposure will be OK. If lens minimum aperture is larger than flashing value, overexposure will result. Set Aperture Selector on flash unit to an aperture size that can be set on lens.

Figure 18-3

PROBLEM	WARNING, RESULT & CORRECTION
MANUAL OVERRIDE	
	(Camera display serves as exposure guide. If you set aperture as shown in display, these warnings and signals will apply.)
Possible overexposure	*125 `2 2`* An aperture display from ƒ-19 to ƒ-32 will flash. If you set lens at that aperture, exposure will be OK. If lens minimum aperture is ƒ-32 or ƒ-16 and camera displays flashing ƒ-32 or ƒ-16, apply same tests described in Shutter-Priority AE section.
Underexposure	*500 `1.4`* Camera displays large aperture and readout flashes.
Light level below meter-coupling range.	*`30` `2.8`* Both shutter-speed and aperture readouts flash.
Light level above meter range.	*1000 `3 2`* Aperture readout flashes even at fastest shutter-speed setting.

PROBLEM	WARNING, RESULT & CORRECTION
PROGRAMMED AE	
Overexposure or light too bright for AE photography.	*`000` `1 6`* Display flashes both fast shutter speed and small aperture.
Underexposure or light too dim for AE photography.	*`30` `1.4`* Display flashes both slow shutter speed and large aperture.
MISCELLANEOUS	
To view depth of field, you take the lens off A and push in the Stop-Down Lever. Then you unlock the Stop-Down Lever and return the lens to A.	*EEEE EE* Shutter button and Film-Advance Lever are both inoperative. Depressing shutter button partway causes display to show error signal even if display is turned off. Operate Multiple Exposure Lever and Film-Advance Lever so AE operation becomes possible again.

Figure 18-3 continued

finder display. Switch it off by turning the Viewfinder Display Lever counterclockwise. This prevents display except for the warning EEEE EE.

WARNING SIGNALS

In general, the camera will cause part of the digital display to blink on and off to warn you that something is wrong. There are exceptions.

The warning signals and what to do about them are in Figure 18-3. Even though it may appear complicated, the logic is fairly simple and obvious once you become acquainted with it.

For example, if you are choosing aperture and the camera is choosing shutter speed, the camera will display a flashing shutter-speed display if it cannot find a speed that gives correct exposure. If you are setting shutter speed, the camera will flash the aperture display to show incorrect exposure. If the camera is setting both controls, on Programmed AE, it will flash both displays to show incorrect exposure.

METERING

Canon's central emphasis metering pattern is used with a silicon sensor. Metering range is EV −2 to EV 18 at ASA 100 with an ƒ-1.4 lens.

SELF-TIMER

Rotating the Main Switch to 2 or 10 prepares the camera for self-timing with a delay of 2 or 10 seconds. To start the self-timer, depress the shutter button. If set for 10 seconds, the adjacent Battery Check LED will flash twice per second for the first eight seconds. During the final two seconds of delay, the LED flashes eight times per second. If you select a delay of 2 seconds, the flash rate is eight per second for the entire period.

Be sure film is advanced and the camera is ready to make the next exposure before starting the self-timer. If film is not advanced, the self-timer will not function.

If the self-timer cycle is in progress, you can cancel two ways: Move the Main Switch to L or depress the Battery Check Button.

When using a power winder or motor drive, you can use the self-timer as an intervalometer. Set the self-timer, then hold down the shutter button with a locking cable release. If you select a delay of 2 seconds, the camera will make an exposure every 2 seconds until it runs out of film. If you choose 10 seconds, the camera makes an exposure every 10 seconds. The power winder must be turned on; the motor drive must be turned on and set to either of its continuous-operation speeds, H or L.

EYEPIECE SHUTTER LEVER

If the A-1 is on automatic and your eye is not at the eyepiece, use the Eyepiece Shutter Lever to close an internal blind. This prevents light from entering the camera through the eyepiece and causing incorrect exposure.

MULTIPLE EXPOSURES

After the first exposure, push the Film-Advance Lever fully against the camera body. This uncovers the Multiple Exposure Lever. Push the Multiple Expo-

sure Lever fully to the left so it disappears beneath the Film-Advance Lever and uncovers a red dot on the camera top. Move the Film-Advance Lever through one full stroke as if you were advancing film.

This does not advance film. It "winds up" the camera so it can make another exposure on the same frame. Repeat for as many multiple exposures as desired. The frame counter does not advance during multiple exposures so the frame count remains accurate.

Multiple exposures are not possible when using a motor drive or power winder. If you operate the Multiple Exposure Lever, the motor drive or power winder is automatically turned off so it will not advance film.

VIEWING DEPTH OF FIELD

This procedure is affected by the way camera and lens work together as described in Chapter 10.

For any AE mode except Stopped-Down AE: After advancing film, turn on the meter. Notice the aperture size indicated in the display. Take the lens off **A** and set to the indicated aperture size.

Depress the Depth-of-Field Lever on the camera body. The viewfinder image will darken if you have selected an aperture smaller than wide open. You will see depth of field at the selected aperture.

If depth of field is too much or too little, change aperture size until you see what you want and notice the aperture selected on the lens.

Release the Depth-of-Field Lever so it moves back out. Return the lens to **A**. After you return the lens to **A**, the shutter button and Film-Advance Lever are both locked. When you turn on the meter again, the display reads **EEEE EE**.

Move the Film-Advance Lever fully against the camera body. Push the Multiple Exposure Lever to the left. Then move the Film-

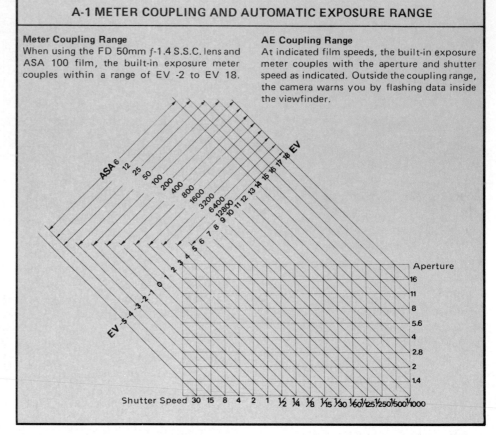

A-1 METER COUPLING AND AUTOMATIC EXPOSURE RANGE

Meter Coupling Range
When using the FD 50mm f-1.4 S.S.C. lens and ASA 100 film, the built-in exposure meter couples within a range of EV -2 to EV 18.

AE Coupling Range
At indicated film speeds, the built-in exposure meter couples with the aperture and shutter speed as indicated. Outside the coupling range, the camera warns you by flashing data inside the viewfinder.

Advance Lever through one full stroke. This does not advance the film but it resets the lens and camera mechanism to operate automatically once again.

This returns operation to whatever AE mode you had selected before viewing depth of field.

If you changed lens aperture to get the depth of field you want, then you must use that aperture to make the exposure. If the camera is on programmed AE, switch it to aperture priority and set the aperture. If the camera is on shutter-priority, change shutter speed until the display shows the aperture, or switch to aperture priority

For Stopped-Down AE: You see depth of field constantly because lens aperture is controlled manually and takes the value you set on the aperture ring.

For Manual Override: If you push in the Depth-of-Field Lever, the camera is switched to Stopped-Down AE and you see depth of field at whatever aperture you

have selected. You can make the exposure with the lens stopped down if you wish. If you prefer to return to Manual Override before making the exposure, just release the Stop-Down Lever so it moves out to its normal position.

STOPPED-DOWN METERING

There is no need to meter stopped-down with an FD lens mounted directly on the camera or through meter-coupled automatic accessories. It is possible in the Stopped-Down AE mode by moving the lens aperture ring away from **A**. With an FD lens set to **A**, the camera Stop-Down Lever is blocked so you can't push it in.

When an FD lens is used with non-meter-coupled accessories between lens and camera, or when an FL lens is being used, you can perform stopped-down metering simply by pushing in the Stop-Down Lever. This puts the camera in the Stopped-Down AE

mode as you can see by reference to Figure 18-1. To restore normal full-aperture metering with an FD lens, release the Stop-Down Lever.

MEMORY HOLD

Point the camera at the surface on which you want to set exposure. Depress and hold in the Exposure Memory Switch. Then point the camera wherever you wish and make the exposure. Then release the memory switch.

In any of the AE modes, this control actually holds the Exposure Value. While holding in the Exposure Memory Switch, you can change either aperture or shutter speed and the camera will automatically make a compensating adjustment of the other control so exposure remains the same.

FILM SPEED

The film-speed range is from ASA 6 to ASA 12,800. To turn the ASA Film Speed Scale, first depress the ASA Lock Button.

EXPOSURE COMPENSATION

With the camera in any AE mode, the best way to get more or less exposure than the camera would give automatically is to use the Exposure Compensation Scale. To turn the scale, depress the adjacent Exposure Compensation Lock Button. Compensation is indicated by numbers that are factors or multipliers: 1/4, 1/2, 1, 2, 4. These settings give 2 steps under, 1 step under, no compensation, 1 step over or 2 steps over—in that order. The subdivisions on the scale are 1/3 steps.

In effect, this control changes the film-speed setting. When you don't want exposure compensation, return the control to 1. It's important to remember to do this because there is no signal in the viewfinder.

Changing exposure-compensation changes the viewfinder display. Because the display shows half-steps and exposure compensation can be made in 1/3 steps, the viewfinder display may be approxi-

mate. Actual compensation will agree with your setting.

The limits of the film-speed range also apply to the exposure-compensation control. If you have film speed set to ASA 6, you can't get two steps more exposure by using the exposure-compensation control. See the accompanying table.

Obviously, you can provide exposure compensation by changing the film-speed setting of the camera, but there's no good reason to do that unless you need more than two steps.

When set to Manual Override, you get exposure compensation by setting the controls anywhere you choose, using the viewfinder exposure display as a guide.

When using Aperture-Priority AE, you can take an FD lens off the A setting to make an exposure compensation. The viewfinder display will show shutter-speed, camera-recommended aperture and the M symbol. Exposure will be made at the indicated shutter speed and the aperture you select on the lens.

INTERMEDIATE CONTROL SETTINGS

On automatic, the camera can make intermediate settings of both shutter speed and aperture. When setting these controls manually: Intermediate settings on the lens aperture ring are OK; intermediate settings using the AT Dial are pointless because the camera will use one of the adjacent marked settings.

BATTERY CHECK

The Battery Check Button is in the center of the Viewfinder Display Lever. With the Main Switch set to A, depress the check button and the Battery Check LED will flash rapidly if the battery is OK. If the LED flashes slowly or not at all, replace the battery.

The Battery Check Button can also be used to cancel the self-timer and to close the shutter if, for example, you inadvertently open the shutter with the controls

set for a very long exposure.

The A-1 will not operate if the battery is dead or missing. Camera batteries can fail suddenly and without warning. Always carry a spare.

UNUSABLE LENSES

A few early lenses are incompatible with the A-1 and should not be installed on the camera. These are:
FL 19mm f-3.5 R 58mm f-1.2
FL 58mm f-1.2 R 100mm f-3.5

FRAME COUNTER

Counts frames as they are exposed, up to 38. Does not advance during multiple exposures, so the count remains correct. Counts backwards during film rewind. If you stop rewinding at S, there will be about as much film leader extending from the cartridge as there was when you loaded it. No matter what the counter reads, it is automatically reset to S when you open the camera back cover.

FLASH

The A-1 can use flashbulbs, ordinary electronic flash, light-sensing automatic electronic flash, and Canon A-series and G-series dedicated flash units. See the flash sync table.

Some Canon flash units, the 199A, 577G and 533G, have a special AUTO-MANU. 1/60-30S switch. When set to AUTO, the flash switches the camera to a shutter speed of 1/60. When set to MANU. 1/60-30S, the setting of the camera AT Dial in the Tv mode affects operation. If the camera is set to 1/60 or faster, the flash selects a shutter speed of 1/60. If set to a shutter speed of 1/60 to 30 seconds, the shutter operates at the speed set on the AT dial. Flash exposure is controlled by the flash. Exposure by ambient light is controlled by the length of time the shutter remains open. If the camera Mode Selector is set to Av, the flash can select only 1/60 second.

When using Canon dedicated

flash with the camera on automatic, the flash controls both lens aperture and shutter speed, but takes control only when the flash ready-light is on. Between flashes, while the unit is recharging, the camera reverts to normal automatic operation using whatever amount of light is on the scene.

The viewfinder display changes each time the flash is ready to fire, showing shutter speed, lens aperture and the symbol F. However, the display will not change and the flash ready-light will not come on while you are depressing any of the buttons that turn on the viewfinder display. Turn the display on and off while you are watching. During one of the off periods, the display will change.

FOCUSING SCREENS

The standard screen uses a split-image surrounded by a microprism, surrounded by a matte field. The screen cannot be changed by the user but can be changed to another type by Canon factory service centers. Available screens are shown in the accompanying table. Visually, they are similar to focusing screens for the AE-1 PROGRAM that are identified with the same letter.

MAJOR ACCESSORIES

The A-1 can use all Canon lenses, lens accessories, viewfinder eyepiece accessories, electronic flash, and remote-control devices. Special accessories include Power Winders A and A2, Motor Drive MA, and Data Back A.

A-1 SPECIFICATIONS

Type: 35mm SLR with 5 AE modes and one manual mode. Focal-plane shutter, quick-return mirror and standard Canon Breech-Lock lens mount.
Standard Lenses: Canon FD 55mm and 50mm lenses.
Interchangeable Lenses: Canon FD series usable in all models, Canon FL series usable in Stopped-Down AE mode.
Viewfinder: Fixed eye-level pentaprism. Standard eyepiece is −1 diopter.
Viewfinder Information: LED digital readout shows shutter speed, aperture, manual indication, flash-ready signal, B setting, and warning signals.
Eyepiece Attachments: Angle Finders A2 and B, Magnifier S, ten Dioptric Adjustment Lenses S, Eyecup 4S. Built-In Eyepiece Shutter.
Focusing Screen: Split-image surrounded by microprism. Can be changed at Canon factory service centers.
Field of View: 93.4% vertical and 95.3% horizontal coverage of actual picture area.
Shutter: Cloth focal-plance, electronically controlled.
Self-Timer: Electronic, activated by shutter button. Can be set for delay of 2 or 10 seconds. LED indicator flashes during countdown with faster rate during last 2 seconds.
Film-Speed Range: ASA to 6 to ASA 12800.
Exposure Meter: Silicon photocell with Central Emphasis metering pattern.
Meter Coupling Range: EV −2 to EV 18 at ASA 100 with 50mm f-1.4 lens.
Exposure Memory: Exposure Memory Switch locks in EV setting.
Exposure Compensation: Two steps increase or decrease in 1/3 step increments except at extremes of film-speed range.
Exposure Preview: Viewfinder readout turned on by depressing shutter button partway or by depressing Exposure Preview Switch or by depressing Exposure Memory Switch.
Battery: One 6V #544 or equiv.
Battery Check: LED indicator.
Multiple Exposures: Use Multiple Exposure Lever as described on page 158.
Flash Synchronization: X sync at 1/60; FP and M at 1/30 or slower.
Flash connections: Hot shoe has conventional center contact plus two special contacts. Standard sync terminal on camera body.
Film-Advance Lever: Single or multiple-stroke; 120° throw, 30° standoff.
Film-Rewind: Use rewind button and crank.
Frame Counter: Does not advance during multiple exposures. Counts backward during rewind. Resets to S automatically when back cover opened.
Dimensions: Body only: 141 x 92.5 x 47.5mm (5-9/16" x 3-5/8" x 1-7/8").
Weight: Body only 620g (1.34 lbs.).

Specifications subject to change without notice.

FOCUSING SCREENS FOR THE A-1

A	Standard microprism in matte/Fresnel field
B	Biprism in matte/Fresnel field
C	Matte/Fresnel field with matte-only circle in center
D	Similar to C except with rectangular grid
E	Biprism with microprism collar in matte/Fresnel field (standard screen for A-1)
G	Microprism for smaller aperture lenses (up to f-5.6) in matte/Fresnel field
I	Cross-hair reticle in clear center spot surrounded by matte/Fresnel field

A-1 FLASH SYNCHRONIZATION

Type	Shutter Speed
199A, 577G, 533G	1/60 or slower
188A, 177A, 166A, 155A, 133A, ML-1, 011A	1/60
Other Electronic Flash	1/60 or slower
133D (non-auto)	1/60 or slower
Flashbulbs	1/30 or slower

FLASH PHOTOGRAPHY WITH THE A-1

Flash Type	Method of Operation	Flash Control Settings	A-1 Control Settings	Display
199A 188A 177A 166A 155A 133A 577G 533G	**ELECTRONIC FLASH AE** Flash sets camera to 1/60 and aperture called for by Aperture Selector on flash. Exposure controlled by light sensor in flash.	199A, 577G, 533G: Aperture Selector to red, green or yellow. AUTO-MANU. 1/60-30S to AUTO. 188A, 177A, 166A, 155A, 133A, aperture selector to red or green.	FD lens to A. Mode Switch to Av or Tv. AT Dial not on B.	`60 F 5.6` *F* indicates flash ready. Aperture readout flashes to indicate incorrect settings. See Figure 18-3.
199A 577G 533G	**ELECTRONIC FLASH AE** Camera automatically set to 1/60 when AT Dial set to 1/60 or faster. Slower shutter speed when AT Dial set from 1/30 to 30 sec. but not B. Camera aperture set automatically to value called for by Aperture Selector on flash. Flash exposure controlled by light sensor in flash. Ambient-light exposure controlled by shutter speed selection.	Aperture Selector to red, green or yellow. AUTO-MANU. 1/60-30S switch to MANU.	FD lens to A. Mode Switch to Tv. AT Dial not on B.	`2'' F 5.6` *F* indicates flash ready. Aperture readout flashes to indicate incorrect settings. See Figure 18-3.
199A 188A 177A 166A 155A 133A 577G 533G	**AUTOMATIC FLASH** with manual manual aperture control. Camera automatically set to 1/60. 1/60 to 30 sec. exposure possible with 199A, 577G, 533G. You set lens aperture manually to agree with aperture called for by setting of Aperture Selector on flash—same as aperture shown in display. Flash exposure controlled by light sensor in flash. Use FL lens, FD lens not on A or FD lens with non-meter-coupled accessories.	199A, 577G, 533G: Aperture Selector to red, green or yellow. AUTO-MANU. 1/60-30S switch to AUTO for 1/60 to MANU. for 1/60 to 30 seconds. 188A, 177A, 166A, 155A, 133A: Aperture Selector to red or green. No choice of shutter speed—it will be set to 1/60.	FD lens not on A, or FD lens with non-meter-coupled accessories or FL lens. Mode Switch to Tv. AT Dial below 1/60 for longer ambient-light exposure with 199A. AT Dial not on B.	`60 F 2.8 M` *F* indicates flash ready. *M* indicates lens aperture must be set manually. With FD lens, warnings same as Electronic Flash AE. See Figure 18-3. With FL lens or FD lens with non-meter-coupled accessories, underexposure warning is not reliable.
199A 188A 177A 166A 155A 577G 533G	**NON-AUTOMATIC FLASH** with manual aperture control. Camera automatically set to 1/60. 1/60 to 30 sec. exposure possible with 199A. You control exposure by aperture setting. Use flash guide number calculation or flash calculator dial as reference.	199A, 577G, 533G: Aperture Selector to M. AUTO-MANU. 1/60-30S switch to AUTO for 1/60 to MANU. to 1/60 for 30 seconds. Disconnect 533G Sensor Unit. 188A, 177A, 166A, 155A: Aperture Selector to MANU. or M.	FD lens not on A, or FD lens with non-meter-coupled accessories or FL lens. Mode Switch to Tv. AT Dial below 1/60 for longer ambient-light exposure with 199A. AT Dial not on B.	`60 F M` *F* indicates flash ready. *M* indicates lens aperture must be set manually. No warning signals.
199A 188A 177A 166A 155A 133A 577G 533G	**SHUTTER ON B, AE** Flash automatically sets camera aperture to value called for by setting of Aperture Selector on flash—same as aperture shown in display. Flash exposure controlled by light sensor in flash. Ambient-light exposure determined by how long you hold shutter open.	199A, 577G, 533G: Aperture Selector to red, green or yellow. AUTO-MANU. 1/60-30S switch in either position. 188A, 177A, 166A, 155A, 133A: Aperture Selector to red or green.	FD lens to A. Mode Switch to Tv. AT Dial to B.	`bu F 2.8` *b u* indicates B setting. *F* indicates flash ready. Aperture display flashes to indicate incorrect settings. Warnings same as Electronic Flash AE. See Figure 18-3.
199A 188A 177A 166A 155A 133A 577G 533G	**SHUTTER ON B, AUTOMATIC FLASH** with manual aperture control. You set lens aperture manually to agree with aperture called for by Aperture Selector on flash—same as aperture shown in display. Flash exposure controlled by light sensor in flash. Ambient-light exposure determined by how long you hold shutter open.	199A, 577G, 533G: Aperture Selector to red, green or yellow. AUTO-MANU. 1/60-30S switch in either position. 188A, 177A, 166A, 155A, 133A: Aperture Selector to red or green.	FD lens not on A, or FD lens with non-meter-coupled accessories or FL lens. Mode Switch to Tv. AT Dial to B.	`bu F 2.8 M` *b* indicates B setting. *F* indicates flash ready. *M* indicates lens aperture must be set manually. With FD lens, warnings same as Electronic Flash AE. See Figure 18-3. With FL lens or FD lens with non-meter-coupled accessories, underexposure indication is unreliable.
199A 188A 177A 166A 155A 577G 533G	**SHUTTER ON B, NON-AUTO FLASH** Flash does not control exposure or make camera settings. Make flash guide-number calculation or use flash calculator dial for reference.	199A, 577G, 533G: Aperture Selector to M. Disconnect 533G Sensor Unit. AUTO-MANU. 1/60-30S switch in either position. 188A, 177A, 166A, 155A: Aperture Selector to MANU. or M.	FD lens not on A, or FD lens with non-meter-coupled accessories or FL lens. Mode Switch to Tv. AT Dial to B.	`bu F M` *b u* indicates B setting. *F* indicates flash ready. *M* indicates lens aperture must be set manually. No warning signals.

THE AE-1 PROGRAM CAMERA

The AE-1 PROGRAM is a compact camera, similar in size and general appearance to other A-series cameras.

MODES OF OPERATION

When used with FD lenses, the camera has four operating modes:

Programmed Automatic Exposure (AE)—The camera sets both shutter speed and aperture according to a program built into the camera, as described in Chapter 8. The long-exposure time limit for the AE-1 PROGRAM is 1 second with ASA 100 and f-1.4.

Shutter-Priority AE—You choose shutter speed, the camera sets aperture.

Electronic Flash AE—Automatic exposure with Canon dedicated flash units.

Manual Override—You set both shutter speed and aperture manually.

CHOOSING A MODE

To select programmed AE, set the lens to the green letter **A** or **O** and the Shutter-Speed Dial to PROGRAM.

To choose shutter-priority AE, set the lens for automatic and the Shutter-Speed Dial to any numbered speed.

For electronic flash AE with a Canon dedicated flash, set the lens to the green letter **A** or **O** and the Shutter-Speed Dial to PROGRAM or any numbered setting. The flash sets shutter speed and lens aperture.

To use manual override, set the lens aperture ring at or between f-numbers and set the shutter speed to any setting other than PROGRAM.

LENSES

The automatic features work only with FD lenses. The TS 35mm lens or the earlier FL lenses can be used but only with stopped-down metering and manual exposure control.

FILM SPEED

ASA film-speed numbers are visible from the rear in a window below the Film-Rewind Knob.

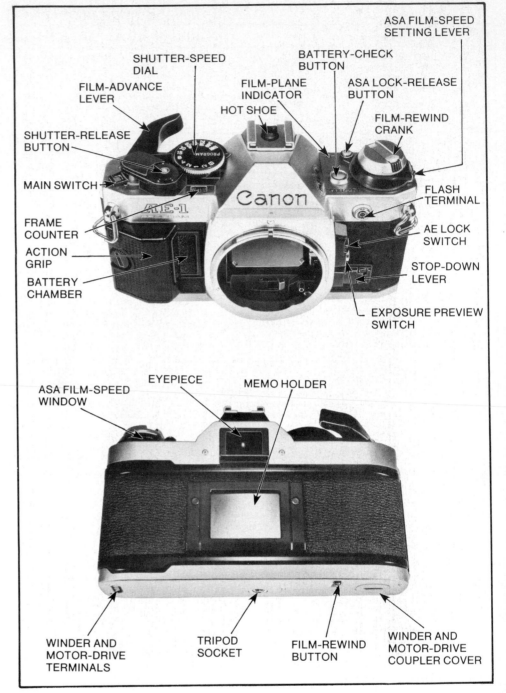

Depress the adjacent ASA Lock-Release Button while moving the ASA Film-Speed Setting Lever to place the desired ASA number opposite the index mark. ASA range is 12 to 3200.

ON-OFF CONTROL

The Main Switch is a lever extending from the hub of the Film-Rewind Lever. There are three settings:

A Turns the camera on. **L** turns the camera off. You can depress the shutter button but it does not operate the camera. **S** engages the self-timer.

METERING

The light sensor is a silicon photo diode in the viewfinder housing, viewing the focusing screen from above. The metering pattern is standard Canon central emphasis.

To Turn the Meter On—Depressing the shutter button about halfway, to the point of slight resistance, turns on the meter and viewfinder display. They remain

AE-1 PROGRAM **SPECIFICATIONS**

Type: 35mm SLR with focal-plane shutter and Canon breech-lock lens mount.
Exposure Modes: Programmed Automatic Exposure (AE), shutter-priority AE, electronic-flash AE, manual.
Interchangeable Lenses: Canon FD lenses usable in all modes. Canon FL lenses usable with stopped-down metering.
Viewfinder: Fixed eye-level pentaprism.
Viewfinder Information: Aperture selected or recommended by camera meter; P to indicate programmed AE; M to indicate manual; flash-ready signal; signal for sufficient exposure by flash; over- and underexposure.
Viewfinder Coverage: 94% vertically and 94% horizontally of image area on film. Magnification 0.83 with 50mm lens set at infinity.
Eyepiece Attachments: Dioptric adjustment lenses, rubber eyecup, angle finder, magnifier.
Focusing Screen: Supplied with type E. Seven other types are user-interchangeable.
Shutter: Cloth focal-plane, electronically controlled. Speeds from 2 to 1/1000 second, plus B. X-sync at 1/60.
Self-Timer: Electronic, 10 second delay. Audible beep tone during countdown. Frequency of beep tone increases during last 2 seconds. Can be cancelled during countdown by pressing Battery-Check Button or turning off camera Main Switch.
Film-Speed Range: ASA/ISO 12/12° to 3200/36°.
Exposure Meter: Silicon photo cell in viewfinder housing. Uses Canon central-emphasis metering pattern.
Meter Coupling Range: EV 1 to EV 18 with ASA/ISO 100/21° and f-1.4.
Exposure Memory: AE Lock Switch holds Exposure Value of metered scene.
Exposure Preview: Exposure Preview Switch turns on meter and viewfinder display.
Battery: One 6V alkaline-manganese, silver oxide, or lithium battery (Eveready 537, Eveready 544, Mallory PX28L, or equivalents).
Battery Check: Audible signal activated by Battery-Check Button.
Flash Synchronization: 1/60 second X-sync provided at hot shoe and PC terminal on camera body. Flash bulbs usable—see sync table. Hot shoe has special auxiliary contacts for Canon dedicated flash—used to set shutter speed and lens aperture automatically.
Film-Advance Lever: Single or multiple stroke. 30° standoff, 120° stroke.
Film Rewind: Use Rewind Button and crank.
Frame counter: Counts backward during rewind. Automatically resets to S when back cover opened.
Dimensions: 141 x 88 x 47.5mm (5-9/16" x 3-7/16" x 1-7/8").
Weight: Body only: 575g (1.27 lbs.).

Specifications subject to change without notice.

on as long as you hold the button depressed.

Or, depress the Exposure Preview Switch using one of the fingers of your left hand. This frees your right forefinger to set shutter speeds. There is no possibility of making an exposure by accident when using the Exposure Preview Switch.

Meter Coupling Range—This is the range of accurate meter operation. It is the same as the range of programmed exposure, shown in the accompanying graph.

VIEWFINDER DISPLAY

A column of LEDs is outside the image area, on the right. The characters displayed, along with their meanings, are shown in the accompanying table.

If there is no display, the camera is turned off, you have made an incorrect control setting, or the battery is dead or missing.

Exposure Warnings—On programmed AE, the f-number 16 blinks to indicate overexposure when the light is too bright for the smallest aperture and fastest shutter speed that can be selected. To indicate underexposure, the maximum aperture size of the lens blinks. The symbol P blinks if shutter speed will be 1/30 or slower to remind you that firm camera support is desirable.

On shutter-priority AE, the f-number 32 blinks to indicate overexposure. Choose faster shutter speeds, if possible, until the display stops blinking. To warn of underexposure, an f-number equal to or smaller than the lens maximum aperture blinks. Choose slower shutter speeds, if possible, until the display stops blinking.

On manual, M appears at the top of the display and the display operates as though the camera were on shutter-priority AE. If the display does not indicate over- or underexposure, the f-number shown is the setting recommended by the camera meter.

SHUTTER AND APERTURE RANGES

The shutter-speed range on manual or shutter-priority is 2 seconds to 1/1000 second in standard steps only. In-between settings cannot be used. In the programmed mode, the camera can choose any shutter speed, including in-between settings such as 1/217 second.

The range of aperture settings is shown on the aperture ring of the lens in use. On programmed AE, the camera will use an aperture in the range of the lens in use. The camera can set in-between aperture values.

On shutter-priority AE, the viewfinder display shows the aperture size the camera "plans" to use. If this is smaller than the minimum aperture of the lens, exposure will be incorrect. Change shutter speed until the display indicates an f-number that appears on the lens aperture ring. When making the exposure, the camera can use in-between aperture values.

On manual, you can use in-between aperture settings if you wish.

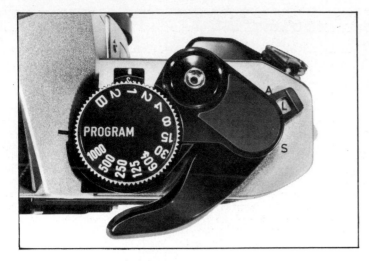

To select Programmed AE, set the lens to A and set the Shutter-Speed Dial to PROGRAM.

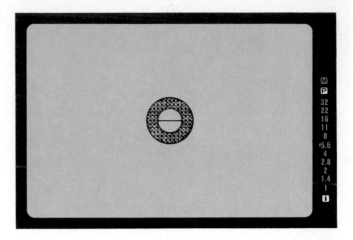

Symbols at the right of the image area give you full information.

B Setting—To make exposures longer than 2 seconds, select manual control by turning the lens aperture ring away from the green letter A or O, to the aperture setting you wish to use. Then turn the Shutter-Speed Dial to B. The viewfinder display shows M to indicate manual control. The shutter remains open as long as you hold the shutter button depressed with your finger or with a cable release.

If you set the Shutter-Speed Dial to B with the lens set for automatic, the lens remains at its *smallest aperture* and the shutter opens and closes normally when you operate the shutter button. The viewfinder LED display does not operate.

FOCUSING SCREENS

The AE-1 PROGRAM has user-interchangeable focusing screens, shown later in this chapter. These are Laser-Matte screens—about 1.5 times brighter than old-style screens. The standard screen is Type E, a split-image biprism surrounded by a microprism. The biprism is called New Split because it uses a new method—an array of small prisms discussed in Chapter 11.

Changing screens is quick and easy. It's done through the lens opening. Remove the lens and use the special tool packaged with replacement screens.

VIEWING DEPTH OF FIELD

Stopping down an FD lens with the AE-1 PROGRAM camera is complicated by the way camera and lens work together as described in Chapter 10.

I suggest starting in the shutter-priority AE mode. Advance the film if it is not already advanced. Focus on the subject of main interest. Take the lens off automatic and set it to the *f*-stop indicated by the camera display.

Push the Stop-Down Lever all the way in. The meter reading will change. The new reading is not correct. Ignore it.

If depth of field is not satisfactory, change aperture until you see the desired result. Look at the lens and remember the aperture setting on the lens.

This is essential: Turn the lens aperture ring to maximum aperture—the smallest *f*-number. Then turn it all the way in the opposite direction and set it on automatic.

You have returned to the shutter-priority AE mode. Change shutter speed until the viewfinder display shows the aperture size that gave the desired depth of field. Make the exposure.

CAUTIONS: If you follow this procedure without first advancing film, you may not see correct depth of field. The lens will not stop down smaller than the aperture used on the previous exposure. If you return to shutter-priority AE without first turning the aperture ring to maximum aperture, the next exposure will not be correct.

To view depth of field with a non-FD lens, follow the stopped-down metering procedure.

STOPPED-DOWN METERING

The camera is designed for open-aperture metering with an FD lens. With the lens switched off automatic, the camera won't prevent you from using this stopped-down metering procedure with an FD lens but it will be inaccurate.

With a lens not designed for open-aperture metering such as the TS 35mm, or with an FD lens separated from the camera by non-automatic extension tubes or bellows, you must meter stopped-down:

Be sure the Shutter-Speed Dial *is not* set to PROGRAM.

Advance the film and focus. Push the Stop-Down Lever all the way in.

Depress the shutter button halfway while turning the aperture ring so the viewfinder display shows *f*-5.6. The rectangular stop-down metering index mark adjacent to *f*-5.6 is the stopped-down metering index. Or, you can hold in the Exposure Preview Switch

AE-1 PROGRAM VIEWFINDER DISPLAY

SYMBOLS	PROGRAMMED AE	SHUTTER-PRIORITY AE	ELECTRONIC FLASH AE	MANUAL OVERRIDE
M P	**P** Indicates mode is Programmed AE. Symbol blinks if shutter speed will be 1/30 or slower.	No Symbol.	No Symbol.	**M** Indicates mode is Manual Override.
32 22 16 11 8 5.6 4 2.8 2 1.4 1	One *f*-number is displayed, such as *f*-4 to show aperture selected automatically by camera. Shutter speed is not shown.	One *f*-number is displayed, such as *f*-11 to show aperture selected automatically by camera. Shutter speed is shown on Shutter-Speed Dial.	When flash ready-light glows, one *f*-number is displayed, such as *f*-8 to show aperture selected automatically by Canon dedicated electronic flash. Shutter speed is automatically set to 1/60, which is X-sync speed for this model.	One *f*-number is displayed, such as *f*-2.8 to show aperture setting recommended by camera meter. Actual aperture setting is shown on lens. Shutter speed is shown on Shutter-Speed Dial.
⚡			⚡ Indicates flash-ready with any Canon dedicated flash. With 188A or 166A, symbol blinks after each exposure to indicate sufficient light for correct exposure.	

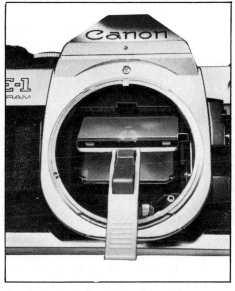

Changing focusing screens is very easy with this special tool.

and adjust shutter speed for an indication of *f*-5.6.

Operate the shutter button. Release the Stop-Down Lever.

EXCEPTION: The following lenses can be used on the AE-1 PROGRAM camera but stopped-down metering will not be accurate. These are all old lenses, no longer in production.

FL 19mm *f*-3.5 FL 35mm *f*-2.5
FL 50mm *f*-1.8 FL 58mm *f*-2.5
R 35mm *f*-2.5 R 50mm *f*-1.8
R 100mm *f*-2

SELF-TIMER

To set the timer, turn the Main Switch to **S**. Start the 10-second delay by depressing the shutter button. An audible beeper makes about 2 beeps per second for 8 seconds then speeds up for the final 2 seconds. On shutter-priority AE or programmed AE, exposure is set when the timer starts, not at the end. Don't stand in front of the camera when you start the timer because you will block the light and cause incorrect exposure. To cancel the self-timer after you have started it, depress the Battery-Check Button or turn the Main Switch to **L**.

MULTIPLE EXPOSURES

There is no "official" procedure. Here's an "unofficial" method:

Make exposure #1. Rotate the Rewind Knob to remove slack in film path. Tip up the Rewind Crank to help you hold the knob in that exact position. Hold knob that way until you complete the desired number of exposures.

Depress Rewind Button on camera bottom. Hold it down while operating the Film-Advance lever one full stroke. Release Rewind Button. Make next exposure. Repeat as desired. The Frame Counter will not advance.

After the last multiple exposure, put the lens cap on. Release the Rewind Crank so it can turn. Operate the Film-Advance Lever without depressing the Rewind Button. Depress the shutter button with the lens cap on. If you shoot with the cap off, you will expose half a frame on fresh film and half on the previous multiple exposure. Operate the Film-Advance Lever again. This advances the next full frame and advances the frame counter. Remove the lens cap and expose this frame in the normal way.

Film registration may change from shot to shot when using this procedure.

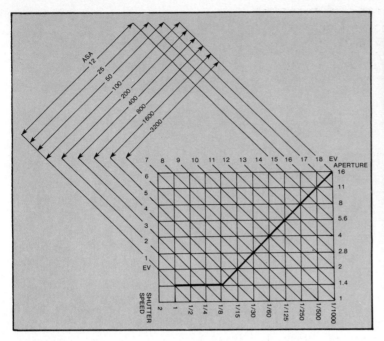

On Programmed AE, the exposure controls are set according to this graph.

The Stop-Down Lever at bottom is pushed in, revealing the chromed button that locks it in. The chromed button directly above is the Exposure Preview Switch. Above that is the AE Lock Button.

AE LOCK SWITCH

This holds an exposure reading so you can do substitute metering with the camera on AE, as discussed in Chapter 12. Point the camera at the surface on which you want to set exposure. Depress and hold in the AE Lock Switch, then point the camera wherever you wish. If you depress the shutter button halfway, you can release the switch and the reading remains locked in.

On shutter priority AE, this control actually locks in the exposure value. You can change shutter speed before making the shot and the camera will make compensating changes to aperture.

EXPOSURE COMPENSATION

When shooting non-average scenes, you may want more or less exposure than the camera would normally use on automatic. The best way to solve this problem is to use substitute metering. There are other ways:

Notice what setting the camera plans to use on automatic. Take it off automatic and use whatever setting you want.

Or, leave the camera on automatic but change the ASA film-speed setting so the camera gives more or less exposure. Don't forget to reset the correct value.

FRAME COUNTER

The counter counts up to frame 38 but does not prevent advancing film after frame 38. It counts backward on rewind. When it shows S after rewinding, about as much leader extends from the cartridge as it did when you loaded the film.

HOT SHOE
AND FLASH TERMINAL

The hot shoe has auxiliary contacts to work with Canon dedicated flash. The hot shoe is not "hot" unless a flash is installed. The Flash Terminal on the camera body accepts any standard PC connector and delivers X-sync. Keep it covered with its cap when not using it.

FLASH

The AE-1 PROGRAM can use flashbulbs, ordinary electronic flash and Canon flash units. See the accompanying flash sync table. Operation with Canon flash units is described in Chapter 16.

The viewfinder has a lightning symbol at the bottom. It glows to indicate flash-ready with any Canon dedicated flash. With the 188A flash, this symbol also flashes after each exposure to indicate that there was sufficient light for correct exposure of an average scene. Other flash units may occasionally cause this symbol to flicker after a flash. If so, it is not meaningful.

The viewfinder display changes each time the flash is ready to fire, showing lens aperture and the lightning symbol.

Between flashes with a Canon flash unit, while the unit is recharging, the camera reverts to normal automatic operation using whatever amount of light is on the scene.

BATTERY COMPARTMENT

A plastic rectangle comes with the camera to serve as a hot-shoe cover or a viewfinder cover when you are shooting on automatic with your eye away from the window. This has a small projection you can use to open the battery-compartment door.

AE-1 PROGRAM FLASH SYNCHRONIZATION	
Type	**Shutter Speed**
199A, 577G, 533G	1/60
188A, 177A, 166A, 155A, 133A, ML-1, 011A	1/60
Other Electronic Flash	1/60 or slower
Flashbulbs: M, MF, FP	1/30 or slower

To set film speed, depress the chromed button adjacent to the ASA window. Move the ASA Film-Speed Setting Lever, on the opposite side of the Rewind Knob, to bring the desired film speed into view in the window. This camera is set for ASA 400.

BATTERY CHECK

The Battery-Check Button is on top of the camera, near the rewind knob. When you depress the button, you should hear a beep-tone at about six beeps per second. If the battery needs replacement, there are three beeps per second or less.

DEAD BATTERY

The camera will not operate with a dead battery. Change the battery once a year or when indicated. Carry a fresh spare.

MAJOR ACCESSORIES

All Canon lenses and lens accessories, all viewfinder eyepiece accessories, Canon flash units, a Power Winder, Motor Drive MA, Data Back A and remote control equipment.

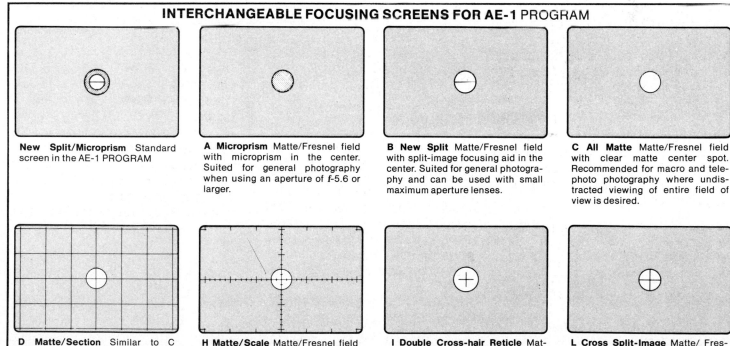

INTERCHANGEABLE FOCUSING SCREENS FOR AE-1 PROGRAM

New Split/Microprism Standard screen in the AE-1 PROGRAM

A Microprism Matte/Fresnel field with microprism in the center. Suited for general photography when using an aperture of f-5.6 or larger.

B New Split Matte/Fresnel field with split-image focusing aid in the center. Suited for general photography and can be used with small maximum aperture lenses.

C All Matte Matte/Fresnel field with clear matte center spot. Recommended for macro and telephoto photography where undistracted viewing of entire field of view is desired.

D Matte/Section Similar to C screen, but with horizontal and vertical reference lines. Recommended for architectural photography and copy work.

H Matte/Scale Matte/Fresnel field with fine matte center plus horizontal and vertical scales in mm. Recommended for copy work and architectural photography.

I Double Cross-hair Reticle Matte/Fresnel field with 5mm clear center spot containing double cross-hair reticle. Recommended for photomicrography and astrophotography.

L Cross Split-Image Matte/Fresnel field with cross split-image focusing aid in the center. Suited for general photography using large maximum aperture lenses.

THE AE-1 CAMERA

The AE-1 has three modes: shutter-priority AE, electronic flash AE and manual.

On shutter-priority, the AE-1 sets aperture automatically at any shutter-speed setting except B. At B, the camera cannot compute an aperture setting, so it flashes an LED warning light in the display.

CHOOSING A MODE

To select shutter-priority AE, turn the lens aperture ring to A. To select manual, turn the aperture ring to the desired aperture setting. Operation with Canon electronic flash is described in Chapter 16.

ON-OFF CONTROLS

When depressed halfway, the shutter button turns on camera metering.

Just above the Stopped-Down Lever is the Exposure Preview Switch. This turns on the meter circuit in the camera.

Unless one of these two buttons is depressed, the camera is turned off.

METERING

Using a silicon photo sensor above the focusing screen, the metering pattern is central emphasis. Metering coupling range is EV 1 to EV 18 with ASA 100 and *f*-1.4.

The camera is designed for open-aperture metering with an FD lens. With an FD lens mounted directly on the camera, stopped-down metering is not possible. With any lens not designed for open-aperture metering, or with FD lenses separated from the camera by accessories that do not couple the lens mechanically to the camera, stopped-down metering is used.

VIEWFINDER DISPLAY

On automatic, a meter needle moves along an *f*-number scale on the right side of the screen, indicating the *f*-stop the camera will use to make the exposure.

On manual, a red LED (Light-Emitting Diode) indicator flashes at the top of the display, illuminat-

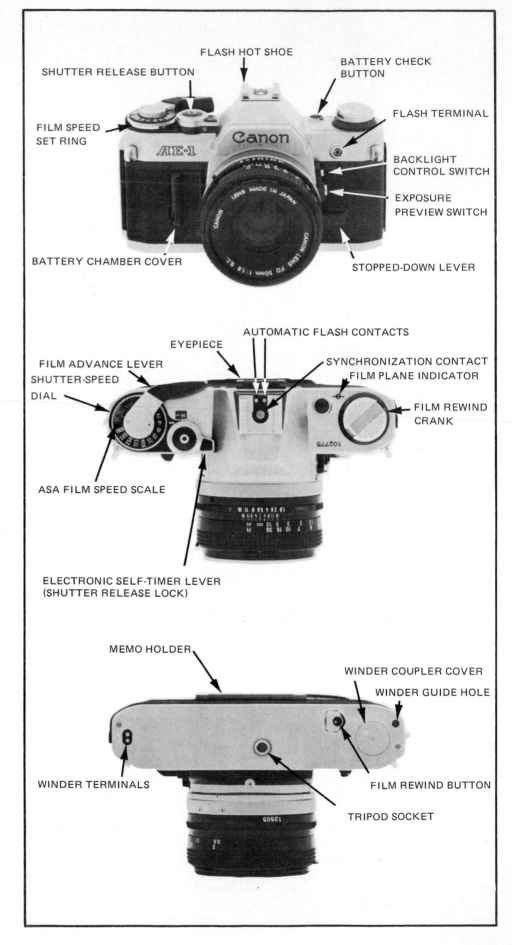

SHUTTER RELEASE BUTTON
FLASH HOT SHOE
BATTERY CHECK BUTTON
FILM SPEED SET RING
FLASH TERMINAL
BACKLIGHT CONTROL SWITCH
EXPOSURE PREVIEW SWITCH
BATTERY CHAMBER COVER
STOPPED-DOWN LEVER

FILM ADVANCE LEVER
SHUTTER-SPEED DIAL
EYEPIECE
AUTOMATIC FLASH CONTACTS
SYNCHRONIZATION CONTACT
FILM PLANE INDICATOR
FILM REWIND CRANK
ASA FILM SPEED SCALE
ELECTRONIC SELF-TIMER LEVER (SHUTTER RELEASE LOCK)

MEMO HOLDER
WINDER COUPLER COVER
WINDER GUIDE HOLE
WINDER TERMINALS
FILM REWIND BUTTON
TRIPOD SOCKET

AE-1 SPECIFICATIONS

Type: 35mm single-lens reflex AE (Automatic-Exposure) camera with focal-plane shutter, quick-return mirror and Canon Breech-Lock lens mount.

Standard Lenses: Canon FD 50mm f-1.4 S.S.C., Canon FD 50mm f-1.8 S.C.

Interchangeable Lenses: FD series: AE (Automatic Exposure) photography. FL series: Stopped-down metering with automatic disphragm operation. R series: Stopped-down metering with manual diaphragm operation.

Viewfinder: Fixed eye-level pentaprism. Standard eyepiece is −1 diopter.

Viewfinder Information: Aperture scale with meter needle, over-exposure warning marks, stopped-down metering and battery-check index mark, flashing red LED indicates underexposure and outside of meter coupling range. Flashing red M indicates camera is in manual mode.

Viewfinder Attachments: Angle finders, magnifier, eyecup and 10 Dioptric Adjustment Lenses -4 to +3 diopters.

Focusing Screen: Similar to Screen E, page 149: Center split-image/microprism rangefinder surrounded by matte screen with Fresnel lens.

Field of View: 93.5% vertical, 96% horizontal of actual picture area. 0.86x magnification with standard 50mm lens at infinity.

Self-Timer: Set by moving lever forward around shutter button. Shutter delayed 10 sec. after pressing shutter release button. LED flashes while self-timer is operating.

Film-Speed Range: ASA 25—3200.

Exposure Adjustment & Meter: Shutter-preferred AE (Automatic Exposure) photography with FD series lenses. Aperture adjusted automatically after ASA and shutter speed are set. Silicon photocell used with central-emphasis metering system.

Exposure-Meter-Coupling Range: With ASA 100 film, EV 1—EV 18 (f-1.4 at 1 sec. to f-16 at 1/1000 sec.).

Backlight Control Switch: +1.5 f-stops for backlit subjects.

Battery: One 6V (544) silver oxide battery.

Flash Synchronization: X (electronic flash) sync at 1/60 sec. and slower. FP, M, MF bulbs sync at 1/15 sec. or slower.

Flash Connections: Hot shoe has contacts for Canon Speedlite 155A and for conventional electronic-flash units. PC socket provided at front of camera body.

Speedlite 155A & Speedlite 199A: Automatic thyristor-controlled electronic flash provides choice of two apertures, automatically selects aperture and sets shutter speed to 1/60 regardless of shutter-speed setting.

Frame Counter: S-1-38; automatically resets to S when back cover is opened, counts backward sequentially as film is rewound. Counter does not advance on multiple exposures.

Multiple Exposures: Follow procedure on page 169.

Film Loading: Uses multi-slot take-up spool. Accepts any standard 35mm film roll in cartridge.

Film-Advance Lever: Single or multiple-stroke, 120° throw, 30° stand-off.

Film Rewind: Uses rewind button and crank.

Dimensions: Body only: 141 x 87 x 47.5mm (5-9/16" x 3-7/16" x 1-7/8"). 141 x 87 x 99.5mm (5-9/16" x 3-7/16" x 3-7/8") body with FD 50mm f-1.4 lens.

Weight: Body only: 590g (1.31 lbs.); with FD 50mm f-1.4 lens: 895g (1.97 lbs.).

Specifications subject to change without notice.

ing a red **M**. The exposure display continues to work the same way, except for the flashing **M**. The meter needle does not indicate manually-selected apertures as you rotate the aperture ring on the lens.

On manual, consider the exposure display as a separate exposure meter that you can read to help decide what aperture to set at the lens.

Two red bands at the top of the f-number scale indicate overexposure. The band near f-16 is used with lenses having minimum aperture of that value; the band near f-22 is used with lenses that stop down to f-22.

A few Canon lenses have f-32 aperture settings. If the light is bright enough to drive the needle into the over-exposure band for an f-22 lens, do this: Use faster shutter speed to move the needle out of the f-22 red band. Then switch to the next slower shutter speed and disregard the meter indication.

At the bottom of the f-number scale is a red flashing LED indicator—the Underexposure and Coupling Range Warning Lamp. It tells you something is wrong.

The LED flashes to warn of underexposure. Switch to a slower shutter speed. If the light stops flashing, that was the problem. It flashes to indicate control settings beyond the meter coupling range and the meter needle goes off-scale at the bottom. Consult the accompanying Meter Coupling Range Table. The LED flashes when the camera exposure computer wants larger aperture than the lens can provide. Compare the f-number indicated by the meter needle to the maximum f-stop of the lens and you'll see the problem. If you select **B** on the shutter-speed dial with the camera set for automatic, the needle drops below scale and the LED flashes. Change to another shutter speed.

The warning lamp at the bottom of the f-number scale may flash to

AE-1 FLASH SYNCHRONIZATION

Type	Shutter Speed
199A, 577G, 533G	1/60 or slower
188A, 177A, 166A, 155A, 133A, ML-1, 011A	1/60
Other Electronic Flash	1/60 or slower
133D (non-auto)	1/60 or slower
Flashbulbs:	1/15 or slower

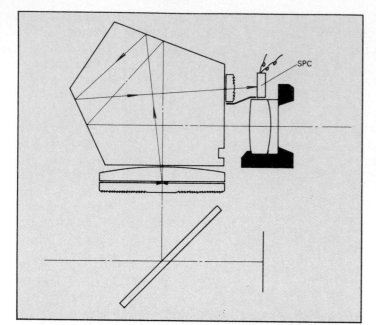

Silicon Photocell (SPC) in AE-1 camera is above viewing eyepiece. It "looks at" the image on the focusing screen and is strongly center weighted, which Canon calls Central Emphasis.

Starting with maximum sensitivity in the center, sensitivity pattern for AE-1 meter shows strong central emphasis. Each zone represents one exposure step, so main reading is taken in central band and slightly below center.

ASA	25	•	•	50	•	•	100	•	•	200	•	•	400	•	•	800	•	•	1600	•	•	3200
		(32)	(40)		(64)	(80)		(125)	(160)		(250)	(320)		(500)	(650)		(1000)	(1250)		(2000)	(2500)	

There isn't enough room on the film-speed dial to show all settings. Figures in parentheses appear as dots on the dial.

indicate a problem with a Canon flash unit. When the flash is controlling the camera, as described in Chapter 16, it may select aperture automatically. If you set the flash to demand larger aperture than the lens has, the LED warning lamp will blink.

FOCUSING AID

The focusing aid is a biprism, surrounded by a microprism, surrounded by ground glass. This focusing screen is standard and not interchangeable.

BACKLIGHT CONTROL SWITCH

Above the Exposure Preview Switch is the Backlight Control Switch, used for exposure compensation when photographing a subject against a bright background such as the sky. Depress it to get 1.5 steps more exposure, with the camera on automatic, than it would normally give.

BATTERY CHECK

The Battery-Check Button is on top of the camera, near the rewind knob. When you depress the button, the meter needle in the viewfinder should point to f-2.8. If the needle points at or near the index at f-5.6, replace the battery with a new one. If battery voltage gets too low, the camera becomes inoperative.

VIEWING DEPTH OF FIELD

Advance the film.

On manual, you can see depth of field just by pressing in the Stopped-Down Lever. Adjust aperture for the desired effect. Return the Stopped-Down Lever to its normal setting. Adjust shutter speed for correct exposure and make the shot.

To view depth of field with an FD lens and the camera on automatic: Advance the film, focus, and notice the f-stop the camera

indicates. Take the lens off A and set it to the indicated f-stop. Push the Stopped-Down Lever all the way in. Ignore the meter reading—it is not correct.

Change aperture as needed and make compensating changes in shutter speed. Continue to ignore the meter.

When you get it right, depress the shutter button. Release the Stopped-Down Lever. Put the lens back on the automatic setting. Advance the film.

CAUTIONS: If you follow this procedure without first advancing film, you may not see correct depth of field. The lens will not stop down to an aperture smaller than the aperture used on the previous exposure.

If it is necessary to put the camera back on automatic without operating the shutter, rotate the lens aperture control ring all the

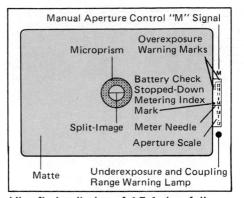

Viewfinder display of AE-1 gives full information about what's happening except for shutter speed. However you choose shutter speed beforehand, so you should know what it is.

AE-1 METER COUPLING RANGE	
ASA Film Speed	Coupling Range
25–50	2 to 1/1000 sec.
100	1 to 1/1000 sec.
200	1/2 to 1/1000 sec.
400	1/4 to 1/1000 sec.
800	1/8 to 1/1000 sec.
1600	1/15 to 1/1000 sec.
3200	1/30 to 1/1000 sec.

way to maximum aperture first, then set it on automatic.

SELF-TIMER AND SHUTTER LOCK

A collar around the shutter button has three positions. When set at L, the shutter button is locked and cannot be depressed.

To use the self-timer, set the index mark to S. A red LED lamp becomes visible. Start the timer by depressing the shutter button. Exposure settings are locked in the camera computer at the instant the shutter button is depressed. A delay of 10 seconds is timed electronically, then the shutter operates. The LED flashes while the self-timer is counting down.

If you return the self-timer lever to the off position while the countdown is progressing, the shutter will operate immediately.

To cancel the self-timer, depress the Battery-Check Button. Then you can return the self-timer lever to the off position. Or you can start the timer again by depressing the shutter button.

HOLDING AN EXPOSURE READING

While metering on the substitute surface, start the self-timer. This holds the reading at the instant the timer started. Then point the camera to the scene you intend to shoot. When the shutter operates it will be at the exposure setting determined by metering the substitute surface.

Or, while metering on the substitute surface, notice the f-stop the camera plans to use. Set the camera for manual and use the lens at that f-stop.

EXPOSURE COMPENSATION

When shooting non-average scenes, you may want more or less exposure than the camera would normally give.

If the subject is backlit, you can use the Backlight Control Switch without taking the camera off automatic. This gives 1.5 steps more exposure than the camera would otherwise use.

Or, notice what setting the camera plans to use on automatic. Take it off automatic and use whatever setting you want.

Or, leave the camera on automatic but change the ASA film-speed setting so the camera gives more or less exposure. Don't forget to reset to the correct setting.

MULTIPLE EXPOSURES

There is no "official" procedure. Here's an "unofficial" way that usually works.

Make exposure #1. Rotate rewind knob to remove slack in film path. Hold knob that way. Depress rewind button on camera bottom. Hold it down. Operate Film-Advance Lever one full stroke. Release everything. Make next exposure.

Film registration may change from shot to shot with this procedure. Also, the rewind button on the bottom of the camera may stay depressed of its own accord, forcing you to make three exposures before the film will start advancing again. If you only intend two exposures, put on the lens cap for the third. The frame counter will not advance during multiple exposures.

STOPPED-DOWN METERING

The Stopped-Down Lever won't operate with an FD lens installed and the lens set to automatic. With the lens switched off automatic, the camera won't prevent you from using the stopped-down metering procedure but it will be inaccurate.

With a lens not designed for open-aperture metering such as an FL, or when an FD lens is separated from the camera by non-automatic extension tubes or bellows, you can meter stopped-down:

Advance the film and get the camera ready to shoot. Push the Stopped-Down Lever all the way in. Adjust aperture or shutter speed until the meter needle aligns with the special stopped-down index mark near f-5.6 in the display. Operate the shutter button. Release Stopped-Down Lever.

EXCEPTION: The following lenses can be used on the AE-1 camera but stopped-down metering will not be accurate. These are all old lenses, no longer in production.

FL 19mm f-3.5 FL 35mm f-2.5
FL 50mm f-1.8 FL 58mm f-2.5
R 35mm f-2.5 R 50mm f-1.8
R 100mm f-2

MAJOR ACCESSORIES

All Canon lenses and lens accessories, all viewfinder eyepiece accessories, Canon flash units, a Power Winder, and remote control equipment.

A-SERIES ACCESSORIES

Power Winder A attaches to bottom of A-series cameras by turning screw into tripod socket on camera base. First remove Winder Coupler Cover from bottom of camera—store it in special clip on top of Winder A (arrow).

CANON POWER WINDER A SPECIFICATIONS

Winding Speed: Up to two frames per second for sequence shooting. Single-frame winding for intermittent shooting possible.
Operation: Activated by the shutter-release button.
Shutter Speed Coupling Range: 1/60 to 1/1000 sec. for AE sequence shooting. B or 2 sec. to 1/1000 for single-frames. No AE photography at B.
Frame Counting: Frame counter of the camera shows the number of frames run.
Safety Circuit: When the film is completely wound or when the battery power fails, the Power Winder A automatically stops and its LED flashes.
Power Source: Four AA size batteries (over 20 rolls of 36-exposure films at normal temperature and with fresh batteries).
Attachment: Power Winder A fastens to the tripod screw at the bottom of the camera.
Size: 141mm W x 22mm D x 34mm H.
Accessories: Carrying case and Battery Pack A (spare).

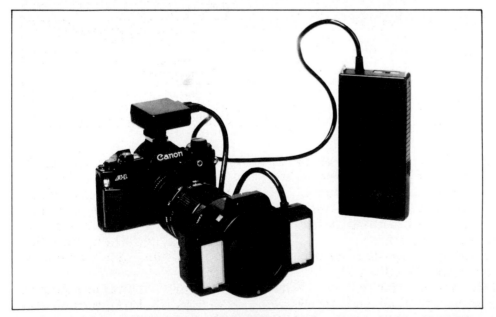

This Canon A-1 is equipped with the FD 80-200mm *f*-4.0 zoom lens and the Macrolite ML-1 flash. The ML-1, described in Chapter 16, is a good accessory for use in medical and dental photography, and general close-up work.

A-SERIES ACCESSORIES

A-series cameras can use any Canon accessory that attaches to the lens or lens mount. All Canon SLRs use Canon viewfinder-mounted accessories such as diopter lenses for eyesight correction, angle finders, magnifiers and eyecups.

Small accessories are the spare-battery holder for attachment to the camera strap, and Tripod Adapter A, which is a small washer that fits between camera and tripod to increase clearance between tripod and lens.

MARINE CAPSULE A

An underwater housing, Marine Capsule A, can be used with A-series cameras and Power Winder A to depths of 200 feet. Interchangeable front housings permit use of lenses from fisheye to telephoto.

POWER WINDER A

Power Winder A is triggered by the shutter button on the camera and advances film automatically after each exposure.

When firing single shots, you can select any shutter speed other than **B** and use the Power Winder to advance the film. Exposing a single frame is done with your trigger finger. Don't hold the shutter button down too long.

When exposing frames continuously by holding the shutter button down, the frame rate is 2 per second at shutter speeds faster than 1/60. The winder waits for the shutter to open and close before it advances film, so slower shutter speeds slow down the winder.

Warning Lamp—On the back of the winder body is a red LED Warning Lamp that has several functions. The winder motor turns off and the lamp glows red anytime the winder cannot complete a film advance. When you have shot the last frame of film in the cartridge, the light turns on and the motor turns off. If the film jams or if the batteries become too weak to advance film, the same

thing happens. When the warning light turns on, turn the winder off until the problem is corrected.

When the LED warning lamp is indicating end-of-roll, turn off the winder. Depress the rewind button on the bottom of the camera and rewind as usual.

Anytime during a roll of film, you can turn the winder off and advance film manually, leaving the winder attached to the camera bottom.

Attachment Procedure—Remove the Winder Coupler Cover from the bottom of the camera. A spring clip on the winder body holds it so it doesn't get lost. Place the winder against the bottom of the camera, properly oriented, and turn the Fastening Screw until snug. Battery Pack A is part of the winder, removable to replace batteies or to keep the batteries warm in cold weather. The winder should be turned off when you install it on the camera.

POWER WINDER A2

Power Winder A2 offers continuous shooting at 2 frames per second or single exposures. It has a switch to select C for continuous or S for single shots. It is triggered by the shutter button on the camera and advances film after each exposure. It has a connector for remote control.

When firing single shots, you can select any shutter speed and use the Power Winder to advance the film. When exposing frames continuously by holding the shutter button down, the frame rate is 2 per second at shutter speeds faster than 1/60. The winder waits for the shutter to open and close before it advances film, so slower shutter speeds slow down the winder.

Anytime during a roll of film, you can turn the winder off and advance film manually, leaving the winder attached to the camera bottom.

Not all camera models use all of these features as you can see in the accompanying table. On some models, Power Winder A2 oper-

With some cameras, the switch on Power Winder A2 can be used to select single frame or continuous exposures. See the table below.

POWER WINDER A2 SPECIFICATIONS

Operation: Single-frame or continuous film advance selected by switch on winder. See accompanying table. Triggered by shutter button on camera. Remote control possible using Remote Switch 3 or 60, or Wireless Controller LC-1. Some camera models operate on continuous only with single frames possible by control of shutter button.
Winding Speed: Up to 2 frames per second.
Shutter-Speed Coupling Range: For continuous advance at 2 fps, use shutter speeds of 1/60 second or faster. Continuous advance possible at slower shutter speeds, but at slower rates. For single-frame advance, use any shutter speed or B.
Frame Counting: Use frame counter on camera.
Safety Circuit: At end of roll, or when winder cannot advance next frame for any reason, motor stops and LED Warning Lamp glows.
Power Source and Capacity: Four AA-size batteries. Alkaline batteries will advance about 40 cartridges of 36 exposures; carbon-zinc, about 20 cartridges; NiCad, 60 to 80 cartridges.
Attachment: Attaches to tripod screw on bottom of camera.
Size: 141 x 27.5 x 53.4mm (5.6" x 1.1" x 2.10").
Weight: 275g (9.7 oz.) including batteries.
Accessories: Case.

POWER WINDER A2 CAPABILITIES

CAMERA	WINDER ON S	WINDER ON C
A-1	Single frames by switch setting plus remote control.	Continuous by switch setting plus remote control.
AE-1 PROGRAM	Single frames by switch setting plus remote control.	Continuous by switch setting plus remote control.
AE-1 AV-1 AL-1	Continuous or single frames by finger control of shutter button. No remote control.	Continuous or single frames by finger control of shutter button. No remote control.

ates only in the continuous mode, the same as Power Winder A, but you can get single frames by removing your finger from the shutter button before the second frame is exposed.

Warning Lamp—On the back of the Power Winder body is a red LED Warning Lamp. The winder motor turns off and the lamp glows red anytime the winder cannot complete a film-advance. When you have shot the last

frame of film, the winder can't pull out another frame so the light turns on. If the film jams or if the batteries become discharged, the same thing happens. When the warning light turns on, turn the winder off until the problem is corrected.

When the LED warning lamp is indicating end-of-roll, turn off the winder. Depress the rewind button on the bottom of the finder and rewind as usual.

A-SERIES ACCESSORIES

Remote Control—As shown on the accompanying table, some camera models can be used with Power Winder A2 and remote control. You can use Remote Switch 3 or 60 or Wireless Controller LC-1, connected to the Remote Control Socket.

Attachment Procedure—Be sure the winder is turned off. Remove the Winder Coupler Cover from the bottom of the camera. Put it in the threaded holder on top of the winder. Place the winder against the bottom of the camera, properly oriented, and turn the Fastening Screw until snug.

MOTOR DRIVE MA

This motor drive works with the A-1 and AE-1 PROGRAM. The motor drive is a very small package consisting of the grip, which contains the motor, and a thin wafer that extends across the bottom of the camera and contains the gears. The battery case is separate.

To install, first remove the Coupler Cover from the camera bottom. A holder on the motor drive gives you a place to put the cover. Hold the motor drive unit on the bottom of the camera. Lift the handle on the Attachment Screw and turn until the motor drive is snug against the camera.

Two battery cases are available: Battery Pack MA uses 12 AA-size throwaway batteries. Ni-Cd Pack MA has a built-in rechargeable nickel-cadmium battery. Ni-Cd Charger MA or MA/FN recharge the unit using power from a wall outlet.

Both battery cases mount the same way: Push the battery firmly in place over the locating pins on the bottom of the motor drive unit. Depress the Attachment Slide Lock Button on the motor drive and the Attachment Slide automatically moves to the left, covering the red dot on the motor drive and simultaneously locking the battery case in place. To remove the battery, depress the button and move the slide with your finger.

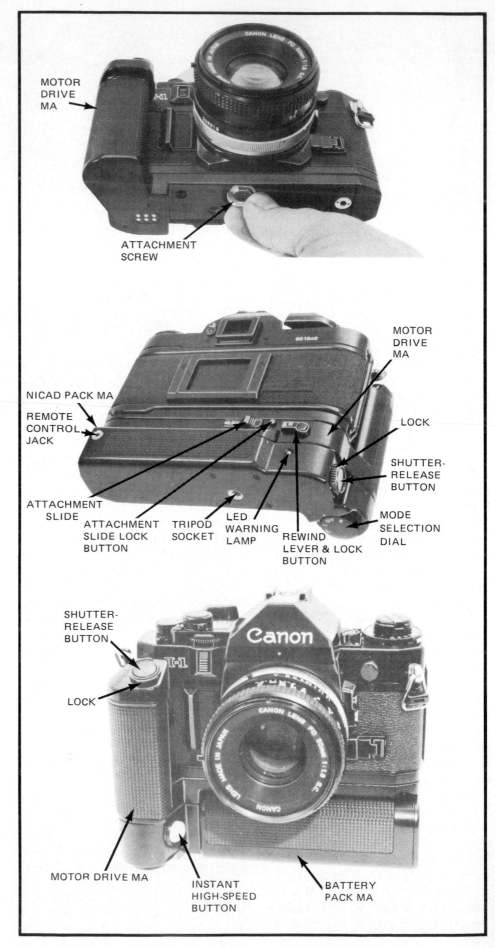

CANON MOTOR DRIVE MA SPECIFICATIONS

Power Source: Uses either Battery Pack MA or NiCad Pack MA.

Operating Speeds: S—Single Frame; H—High; L—Low. With NiCad Pack MA, H is 4 frames per second; L is 3. With Battery Pack MA, H is 5 frames per second; L is 3.5.

Instant High-Speed: Only the Battery Pack MA has this feature. Depress the Instant High-Speed Button and the motor drive is automatically switched to maximum frame rate.

Controls: Motor drive can be operated by Shutter-Release Buttons on camera, on motor drive handle or on power pack unit. Selection of operating speed is by Mode Selection Dial on power pack.

Battery Life: Normal temperature with 36-exposure film rolls: With NiCad Pack MA, 60 rolls or more; with Battery Pack MA, 60 rolls or more. Low Temperature (−10°C): With NiCad Pack MA, 15 rolls or more; with Battery Pack MA, 5 rolls or more.

Operable Temperature Range: −10°C to +45°C.

With a motor drive and either of the battery cases installed, there are three shutter buttons you can use: the shutter button on the camera, the button on the top of the motor-drive handle and a button on the end of the battery case, just below the motor-drive handle. Each of these has a lock to prevent accidental operation. Only the control in use must be unlocked.

Depressing any one of the buttons partway turns on the viewfinder display in the camera. Depressing it fully operates the camera shutter and the motor drive unit. Use whichever button is convenient. The button on the battery case is handy for vertical-format shots.

On the bottom of the battery case is the Mode Selection Dial, which has four positions. When set to OFF, the camera behaves as if the motor drive were no longer attached. H sets the motor drive to operate at maximum speed, exposing and advancing frames continuously up to 5 per second. L is a slower operating speed but still continuous as you can see in the accompanying specifications. S is for single-frame operation.

A feature of Battery Pack MA that is not on the Ni-Cd pack is the Instant High-Speed Button. No matter which operating mode you have selected, depressing the Instant High-Speed Button causes the motor drive to operate at maximum speed.

On the back of each battery case is a red LED Warning Lamp. This lamp glows red and the winder motor turns off anytime the winder cannot complete a film-advance. This can happen at the end of the roll, when the battery is weak or if the film jams for any reason. When the LED lamp turns on, turn the winder off until the problem is corrected.

If the LED is indicating end-of-roll, turn off the winder. Depress the Rewind Lever Lock Button and then rotate the Rewind Lever clockwise. This prepares the camera to rewind film. Rewind and reload in the usual way, then turn the motor drive back on.

Remote Control—The Remote Control Jack allows remote control by a pushbutton on the end of an extension cord, by Interval Timer L, by Wireless Controller LC-1, or by special equipment to suit special applications. Your Canon dealer can put you in touch with a Canon Technical Representative if you need more information.

CANON EXTERNAL BATTERY PACK A

For cold weather use, a special Ni-Cd battery pack is available. It plugs into the battery compartment of any A-series camera and also furnishes power to Power Winder A. The external battery pack connects to the camera and winder through cables so you can keep the external batteries warm by carrying them in your pocket.

WIRELESS CONTROLLER LC-1

Motor Drives MA and FN can be controlled from a distance by the hand-held LC-1 Transmitter, which sends an infrared control signal to an LC-1 Receiver unit mounted in the camera hot shoe for convenience, and cord-connected to the Remote Control Jack on the motor drive. Using infrared requires that there be direct line-of-sight between the transmitter and receiver, but it avoids possible interference when several photographers are using radio-controlled units in the same vicinity.

To avoid interference among LC-1 systems in the same area, each can be set to a different channel, choosing among three operating channels. More than one LC-1 Receiver can be controlled by the same transmitter, either all on the same channel or on different channels.

A-SERIES ACCESSORIES

Wireless Controller LC-1 is compact, with three-channel versatility.

NiCad (Ni-Cd) Charger MA operates on household electric current to recharge NiCad Battery Pack MA.

Canon External Battery Pack A supplies power for an A-series camera body and Power Winder A. In cold weather, you can maintain battery efficiency by keeping battery case in your pocket so it stays warm.

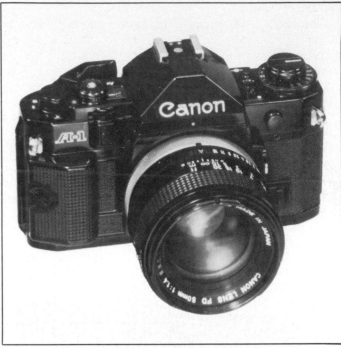

Action Grip attaches to camera body below A-1 symbol. This grip and motor drive cannot be used simultaneously.

Battery Pack MA, for Motor Drive MA, uses eight AA-size batteries in a slide-in battery holder.

External Battery Pack A connected to an AE-1 with Power Winder A.

DATA BACK A

The Data Back replaces the back cover of A-series cameras, removed by sliding the hinge pin downward. The Data Back exposes letters and numbers onto the film in the lower right corner of the frame. Data to be recorded is selected by rotating three dials marked YEAR, MONTH and DAY. They can be used for dating the frame, but the dials also have letters and other symbols as shown in the specifications, so other kinds of data can be encoded using the available symbols.

Exposure is made by a battery-powered lamp in the data back, triggered by a cord connection to the flash socket on the camera. This exposes each frame as the camera is operated—either manually or with a power winder at 2 frames per second. A red lamp on the Data Back flashes each time data settings are exposed onto film.

Data printing can be controlled manually, using a pushbutton on the data back. Thus, you can print data on some frames, but not all, as you choose. The film emulsion is exposed from the back, through the film base. Switches on the data back set up the unit to give proper exposure depending on the type of film being used.

Data Back A replaces the camera's back cover.

CANON DATA BACK A SPECIFICATIONS

Data Setting: Done by three rotating dials.
Right Dial: 32 figures and blank (0 to 31 and □).
Center Dial: 39 figures and blank (0 to 31, A to G and □).
Left Dial: 39 figures and blank (0 to 9, 76 to 87, Roman numerals I to X, a to g, and □).
Data Imprinting: By special synchronization cord. Manual imprinting of the data with the manual imprint button.
Exposure Adjustment: Three different positions. Black and white and 2 color positions.
Color 1: ASA 64 to 160 color films.
Color 2: ASA 25 to 10 color films.
Power Source: One 6V silver oxide battery #544.
Size: 144mm W x 33mm D x 54mm H.
Weight: 110 g (including battery)
Accessories: Special synchronization cord and case.

INDEX

A

A-1, 4, 13, 60, 182-191
Aberrations, 41
AE Lock Switch, 61
AE Motor Drive FN, 176
AE Power Winder FN, 178
AE-1, 5, 13, 61, 198-201
AE-1 PROGRAM, 6, 13, 61, 192-197
Aperture, 7
 automatic, 47
 maximum, 21
 priority, 34
 ring, 12
Atmosphere, effects, 97
Average scene, 56

B

Backlight Control Switch, 59
Bellows, 75

Biprism, 50
Bounce flash, 115

C

Camera care, 127
Camera controls, 36
Close-up, 67-71
Color, 96
Color temperature, 94
Command Back, 141-144

D

Data Back A, 207
Data Back FN, 180
Depth of field, 29
Diffraction, 41
DX coding, 11

E

EV number, 28, 63
Exposure, 7-13, 28-35
 compensation, 59
 controls, 10, 28-35
 metering, 54-66
 multiple, 65
 programs, 34
Extension tubes, 72
External Battery Pack A, 205

F

F-1, 5, 13, 167-176
F-1 viewfinders, 53
Field of view, 29
Film, 7, 99-101
 handling, 24-27
 loading, 24
 rewinding, 27

INDEX

Film speed, 10, 64
 ASA, 11
 DIN, 11
 ISO, 11
Film Chamber FN-100, 181
Filter, 99-107
 factor, 102
 haze, 101
 neutral-density, 104
 polarizing, 105
 UV, 101
Flash, 109-126
 auto, 115
 bounce, 115
 connections, 118
 dedicated, 118
 fill, 113
 guide number, 110
 second-curtain sync, 116
 slow-sync, 116
 TTL auto, 115
Flatness of field, 40
f-number, 7
 series, 11
Focal-plane shutter, 14, 16, 112
Focusing, 49
 aids, 50
 screen, 49

G
Guide number, 110

H
Hyperfocal distance, 46

I
Inverse square law, 111

L
Lens, 17-23, 38-48, 83-93
 aberrations, 41
 angle of view, 20

 autofocus, 91
 categories, 83-92
 close-up, 67
 coating, 40
 controls, 36
 FD, 18-20
 field of view, 29
 fish-eye, 84
 focal length, 20
 focusing, 40
 L-type, 41
 macro, 87
 macrophoto, 78
 magnification, 20
 mirror, 44
 mount, 18
 nodes, 42
 retrofocus, 43
 standard, 21, 86
 telephoto, 43, 89
 tilt and shift, 45, 84
 wide-angle, 84
 zoom, 44, 90
Light, 94
 color temperature, 94
Lighting ratio, 112

M
Macro, 71-82
Macrophoto Coupler, 74
Magnification, 21, 67, 71
Metering, 54-66
 patterns, 54
 stopped-down, 18
 substitute, 58
Microphotography, 81
Microprism, 51
Motor Drive MA, 204
Multiple exposures, 65

P
Pentaprism, 14, 52

Power Winder A, 202
Power Winder A2, 203
Programmed exposure, 34

R
Reciprocity law, 8, 33

S
Shutter priority, 33
Shutter speed, 12
SLR, 14
Speedlite
 166A, 120
 188A, 119
 199A, 118
 277T, 145
 299T, 147
 300TL, 163
 533G, 123
 577G, 121

T
T50, 6, 13, 61, 129-132
T70, 4, 12, 61, 133-140
T80, 5, 13, 150-153
T90, 6, 13, 62, 154-162
Tele-extenders, 43
Time exposures, 12

V
Viewfinder, 12-13
Viewing, 49-53
 aids, 52

W
Wireless Controller LC-1

X
X-sync, 112

Z
Zoom lens, 44